THE CLEANER

THE CLEANER

HATJE
CANTZ

MODERNA MUSEET

LOUISIANA MUSEUM OF MODERN ART

BUNDESKUNSTHALLE

MARINA ABRAMOVIĆ

CONTENTS

FOREWORD

Marina Abramović is the most important performance artist of our time. Without her, performance art would not have achieved the prominence in art museums and at art schools it has today. Marina Abramović has not just conquered this position, she has mastered it and is constantly developing her medium.

Art is transformation of matter. This is the artist's own statement which could be a motto for the retrospective exhibition that Moderna Museet, Louisiana Museum of Modern Art and Bundeskunsthalle have produced together with her. The artist's oeuvre is by no means finished; quite the contrary, the works live on through repeated stagings—*reperformances*—and in new constellations spanning more than five decades.

Marina Abramović poses questions—at once provocative and moving—about power and hierarchies, about art and existence. Over half a century of work is being brought together here as part of an organic whole encompassing painting, photography, film, objects, and installations, as well as, of course, an unprecedented body of performance work. The list of works is extensive, and still the artist says: *The process is more important than the result.* These words leave room for the encounter with the public that is so central to the artist. We are all very much looking forward to seeing how, at long last, *Marina Abramović—The Cleaner* will be received by its audience and will emerge in dialogue with the artist.

First and foremost, we offer our thanks to Marina Abramović herself, who with uncompromising and committed engagement shared everything one could hope for in a retrospective—from her legendary early works to those that are brand-new and untested. A special thanks goes to the artist's office with Giuliano Argenziano at the helm, tirelessly contributing knowledge and dexterous guidance in the realization of the seemingly impossible, together with Polly Mukai-Heidt, Cathy Koutsavlis, Paula Garcia, and Allison Brainard. Warm thanks to the choreographer Lynsey Peisinger, who in collaboration with the artist produced the exhibition's live performances, from planning to execution in all three venues. As curators, Lena Essling, Moderna Museet, and Tine Colstrup, Louisiana Museum of Modern Art, have shared the responsibility for the exhibition's conceptualization and production; at a later stage this duo was joined by Susanne Kleine, Bundeskunsthalle. We are grateful to the three curators for their ability to resolve the many challenges inherent in turning a plan into a reality in the gallery. A special thanks to Olga Krzeszowiec Malmsten, Moderna Museet, who assisted throughout the entire production in an exceptionally skilled and constructive way, and an equally special thanks to Catrin Lundqvist, Moderna Museet, for her outstanding work on the performative part of the exhibition, together with Sofia Jonsson, and many thanks also to MDT and Eric Ericson International Choral Centre, Stockholm, for their contributions.

We offer our warm thanks to the institutions and private lenders that have made this exhibition possible by entrusting us with a number of key works: Kunstmuseum Bern; Galleria Lia Rumma, Milan; LIMA, Amsterdam; Lisson Gallery, London; Luciana Brito Galeria, São Paulo; Babette Mangolte, New York; Musée d'art contemporain de Lyon; Sean Kelly Gallery, New York; S.M.A.K., Ghent; Statens Museum for Kunst, Copenhagen; Stedelijk Museum, Amsterdam. A special thanks to Claus Robenhagen, Lisson Gallery, for his great support and involvement. Moderna Museet would also like to express our gratitude to

our partners for their generous support of this exhibition: Mannheimer Swartling and Panasonic Business.

The catalog includes a number of new essays, and alongside the curators' insightful contributions, Bojana Pejić and Devin Zuber have supplied us with texts that offer important access points to the art of Marina Abramović as set against the backdrop of history and politics. Thank you for these, and thank you to Adrian Heathfield, who interviewed the artist with an openness and erudition that allows readers to feel like they are part of the conversation. Thank you to the catalog's designer, Miko McGinty, and her team, whose work in collaboration with Hugo Huerta Marin has captured the spirit of these texts and images, and thanks to Teresa Hahr, Moderna Museet, who has managed the entire production of the catalog across several language editions together with the team at Hatje Cantz.

In this catalog's interview, Marina Abramović offers an answer to the question of the artist's function: to be *consciousness-raising*. This is precisely how we hope the exhibition will be perceived at our respective museums. Welcome!

Daniel Birnbaum and Ann-Sofi Noring
Moderna Museet, Stockholm

Poul Erik Tøjner
Louisiana Museum of Modern Art, Humlebæk

Rein Wolfs
Bundeskunsthalle, Bonn

THE CLOUD IN THE ROOM

Lena Essling

There is a state of luminosity. Only when you exhaust your own energy can it enter. The similarity between human rituals and performance art: it's transformative. Sometimes my question is: "How is this art"?[1]

<div align="right">Marina Abramović, 2016</div>

Only on condition of a radical widening of definition will it be possible for art and activities related to art to provide evidence that art is now the only evolutionary-revolutionary power. . . . A SOCIAL ORGANISM AS A WORK OF ART.[2]

<div align="right">Joseph Beuys, 1973</div>

Even Marina Abramović's earliest works refuse to yield to existing boundaries—in scale, medium, or the relationship to the audience. Her sound environments and conceptual works from the early seventies have clear connections to her public performance work from later years in their focus on the now and the presence of each person who participates. One point of departure is always the location: a transformed space, occupied together and charged with new connotations by the artist and the audience. This movement across her body of work, which has its starting point in the audience's responsibility and participation, describes if not the closing of a circle, then a curve pushed to its extreme.

Abramović works at the intersection between performing arts and visual arts, placing equal focus on physicality and temporality. Her work poses questions about power and hierarchies without being overtly political. At times the pieces ask us to let go of a linear understanding of time or the idea of autonomous individuality. And yet the self-as-subject—individual experience, personal responsibility—is central to her work. Questions about existence and art are brought to a head in ways that are provocative and moving. Her work probes the core of words such as loss, memory, being, pain, endurance, trust.

As a student, however, Marina Abramović worked intensely with painting, almost maniacally repeating series of motifs such as violent car crashes or abstract studies of clouds—clouds that float over physical, geometric shapes or become human, faceless figures. She also sought out other forms of expression and was inspired by avant-garde artists such as the Slovenian OHO Group,[3] who questioned conventional views of art and asserted that only the artist can define what the work can be. Her refuge was the SKC *(Studentski Kulturni Centar)*, a cultural center opened by Tito in 1968 that, by virtue of its institutional character, allowed a space for art to flourish. At once a testing ground and reactor, the cultural center was meant to shelter and thereby keep watch over what was forbidden in so many other Eastern states at the time: the young front line of free art.

Drangularium [Trinketarium] at SKC in 1971 was a turning point for Abramović. For this exhibition, a number of artists were invited to present everyday objects that they felt were catalysts for their practice. Someone exhibited a door; another had his girlfriend sit on a chair in the gallery. Marina showed three found objects titled *Clouds I–III,* a reference to her painting. Among them was perhaps her simplest, most delicate work: a peanut shell nailed to a wall, its shadow echoing the shape of a cloud. How does one manifest a cloud in a space? Guillaume Apollinaire or Boris Vian could not have solved this problem more concretely and in a more dreamlike way. This simple presentation neatly bypassed the object and reached for the temporal and immaterial.

Throughout her artistic career, Abramović has returned to artworks that seem to want to

annul themselves, dissolving all physical forms and becoming pure sensory experiences while being monumental in their manner of annexing and electrifying a place or an immeasurable space. Her touch is light, modest, yet the ambition endless, and the scale inconsequential. Consider her early instructive work *Connect the Stars* (1969)—an invitation to travel the breadth of the universe distributed via flyers in Zagreb: *1 Connect stars and planets by pencil. 2 Describe your adventures in cosmos?*—or utopian concepts, such as the meticulous diagrams meant to coordinate the paths of fourteen airplanes in relation to the horizon and sun so as to turn the entire sky into a canvas and paint with their vapor trails. After she personally reached out to the air force and anti-air defense of the Yugoslav People's Army (JNA), her father, Vojo Abramović, a decorated war hero, was asked to reason with her, and the idea for *Sky Project* ultimately shelved.

In sound she found a medium that was able to charge a physical space with completely new conditions and transform it through the simplest of means. During one exhibition she managed to "raze" the cultural center using only the sound of a building collapsing. In other virtual soundscapes, the center's foyer was transformed with a simple airport lounge announcement, turning its visitors into travelers in transit; and she filled the city air with birdsong in winter. Works with strong political undertones that resounded with the longing for freedom.

During the nineteen-fifties and -sixties, performance art was on the rise in a number of locations, independent of each other. For a young artist in Yugoslavia, domestic inspiration came from avant-garde theater and dance, and internationally from artistic practice at the intersection of performance, film, and objects—for instance, Chris Burden and Vito Acconci

Marina Abramović, *Traces of Planes and Sun Rays, Study for Sky Project*, ca. 1970

Ulay/Marina Abramović, *The Citroën Van, Art Vital (Detour)*, 1977

in the USA and Gina Pane and the Vienna Actionists in Europe. There were, as Zdenka Badovinac has determined, no significant differences in the degree to which Western and Eastern body-art artists were making use of their nudity or shock value. They were differentiated by their sociopolitical contexts. To perform undressed or with unrestrained anarchism is by definition a political act in a system of control and surveillance.[4]

After Marina Abramović found performance art, she soon left all other forms of expression behind. She went further than most and repeatedly subjected herself to pain in order to open her senses, pushing beyond physical limitations to a higher state of consciousness. The artist-as-shaman had been previously manifested by Josef Beuys, whose work often has strong overtones of ritual and is charged with archaic or entirely personal meanings. Already in her earliest and most unsettling performance pieces, such as *Lips of Thomas* or *Rhythm 0*, Abramović created a strict dramaturgical framework—a number of carefully chosen objects and predetermined conditions, like those of the martyr or the mystery play. The ice cross in *Lips of Thomas* is a shape that Beuys also used in works that explore questions around a historical separation between East and West, Byzantium and Rome.[5] Similarly, Abramović repeatedly used the communist star, sometimes rotated so as to resemble an occult pentagram, in works such as *Rhythm 5* or, much later, *Count on Us*.

In her performances, too, she worked with sound as a structural layer, a rhythmitization of

an act or a seizure and dissolution of time. Abramović's works can be sensorial temporal pieces or vanitas beyond the physical act—in the metronome's slowing pendulum, the return of ice to liquid, drops of water vaporizing as they land on a hot plate. Comparable to her early sound installations, in which a metronome set the tempo for the gallery space, in her early performances she used knife, whip, and breath. As with John Cage, sound became a raster through which silence becomes audible, if we are attentive.

When she finally made a break from Belgrade, Marina Abramović stepped out into Europe, to Amsterdam and the German artist Ulay, but not before performing a transition ritual. The performance pieces *Freeing the Voice, Freeing the Memory,* and *Freeing the Body* constituted an exorcism in three stages in which she drove the place and her affiliation to it from her body and mind. Thereafter, she and Ulay decided to unite in Prague—a point on the map that is equidistant from their hometowns, neutral ground with no charge but their own. As part of a larger radical project that aimed to dissolve the boundaries between high culture and subculture, there was a tendency in the nineteen-seventies to allow life to be art and art life. But rarely was this so consistently realized as it was with Abramović and Ulay—the Prague encounter marked the start of a life together that was also an ongoing work of art.

Abramović and Ulay described themselves as having mutated into one organism, a two-headed creature that performs its charged works around duality and symbiosis at exhibitions and festivals. Their performances were electric, unforgettable, and impossible to look away from. They shared an extreme ability to endure and a joint artistic vision to push their practice to the extreme. The *Relation* series seems to melt into a single work in which time is phrased in rhythms and pauses—breathing, blows, screams, the meeting of bodies or of the body and dead matter. They were thorough with documentation and only made exceptions to their rule about not repeating a piece when they had the chance to do it in front of film or television cameras in order to reach an audience beyond the narrow world of art. Between performances, they lived a nomadic life, from hand to mouth, traveling through Europe in a transit van, in a constant state of movement in accordance with their shared manifesto.

During the nineteen-eighties these trips went farther, to Thailand, India, Australia, China, and Tibet. The traveling lifestyle became one of discovery and anthropology; they deepened their knowledge of meditation in dialogue with Tibetan monks, Sikhs, and Australian Aborigines. Developing a technique for sitting for hours, for days, in the *Nightsea Crossing* series, they became increasingly engaged with stretching the temporal elements of their work. They experimented with hypnosis and various tools that Abramović would continue to develop in her later work—talismans in alchemically charged materials such as gold and rock crystal or clothing in bright colors taken from Vedic charts. They went from the anarchism and physical vulnerability of the nineteen-seventies to the eighties' interest in a more distanced position and the fluidity of roles and identities.

In Abramović and Ulay's collaborative work there was also a strong relationship to architecture and place—take, for example, *Imponderabilia*'s human portico or the annexation of the exterior of the Musée d'art moderne de la Ville de Paris, which becomes the stage for *Relation in Movement*. At the third Sydney Biennale they enacted the pared-down and tranquil *The Brink* (1979), in which Ulay wandered to and fro on a wall, while below Marina followed the edge of the wall's shrinking shadow throughout the day. Architecture, light, and shadow—in the simplest way the work encompassed the movements of the heavens and became infinitely larger than two individuals.

The most tangible example of how a place could become both a stage and a protagonist is Abramović and Ulay's final joint performance, *The Lovers*. The Great Wall of China is an

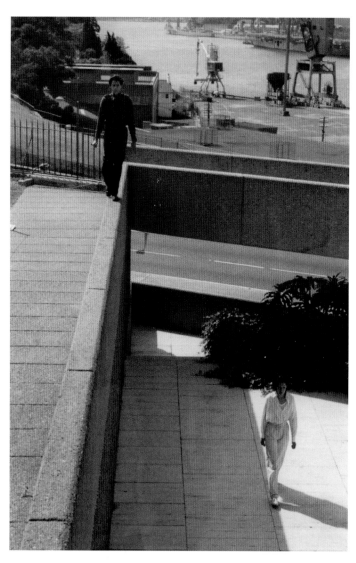

Ulay/Marina Abramović, *The Brink,* 3rd Biennale of Sydney, 1979

enormous border fortification, or if you will, a politically charged land-art piece from a time long before the term was conceived. According to Chinese legend, giant dragons move beneath the wall, and their energy is absorbed through the soles of those who walk it, giving the two artists the power they needed for the task at hand: traveling in order to meet and to part. A monumental end to a shared life's work; an end that seemed to turn the artists into two moving but directionless solitaires for a time. How does one act alone when one's entire expression is built up around duality? Among their final collaborative works is *The Sun and the Moon*—two vases, two static bodies; one matte, the other reflective. Twin vessels no longer able to communicate.

A retrospective of Marina Abramović's work to date spans more than five decades of work and encompasses painting, photography, objects, installation, film, performing arts, and—at its heart—an almost unprecedentedly influential catalog of performance pieces. A body of work that offers a number of entry points and interpretations, as well as many objects or "remnants." Matter that is inescapable in its role as tool and bearer of content, but that risks weighing down the idea and obstructing the work itself in its representation of an artist whose greatness lies in her flawless intuition in the unmediated encounter between audience and performer.

Performance exists in the moment; as an art form it can fall by the wayside of the idea of being able to preserve, collect, and sell. How can one retrospectively capture and visualize works that in their essence are pure exchanges of energy, moments of total presence? As Peggy Phelan points out, as soon as one documents or describes the work in language, even, the transition to another form has begun: "[P]erformance's only life is in the present. Performance cannot be saved, recorded, documented . . . Performance's being . . . becomes itself through disappearance."[6] And yet that

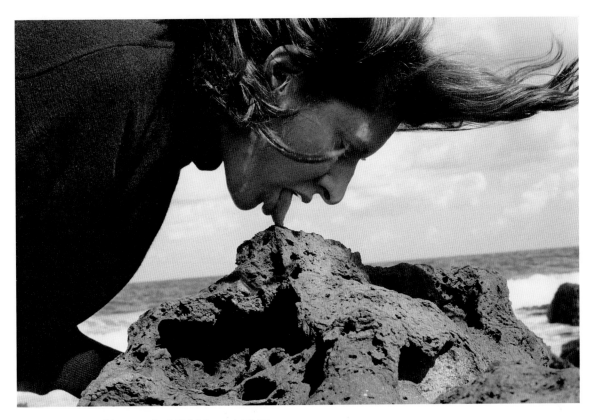

Marina Abramović, *Stromboli III (Volcano)*, 2002

which has been captured on film or through photography holds the status of an artwork, as per an agreement between the artist and audience. There is an understanding about this time as conceptually pure and as having its own materiality—a somewhat rasterized, viscous image that also speaks to the history of film-as-medium. Later, Abramović went on to create a long line of performance works especially for the camera, in films such as *The Kitchen: Holding the Milk* and *Sleeping Under the Banyan Tree,* or photographic works like *Stromboli III (Volcano).* But alongside lens-based documentation, there are other relics—the physical archive.

Josef Beuys related to his archive as an anthropologist and shaman, and his vitrines containing mystically charged objects came to resemble icon boxes. He described his objects as "stimulants for the transformation of the idea of sculpture . . . or art in general."[7] To engage

with a work's scenography and remains is to also engage with a wider discussion about their status as bearers of experience. Only an object can carry the memory of the act, as Rebecca Schneider summarizes: "In the archive, flesh is given to be that which slips away. Flesh can house no memory of bone. Only bone speaks memory of flesh. Flesh is blindspot."[8] The Western mode of recording history, she points out, seems to rely on objects or documentation—a notion that is, to an extent, taboo in performance, which has the immaterial act at its center.

In Marina Abramović's work, there is often a fixed set design, a constellation of objects, each with its own energy, operating as keys or portals into the work. In her earliest performance pieces, select references were taken from Eastern Orthodox and communist iconography—the cross and the star; wine and honey; fire

13

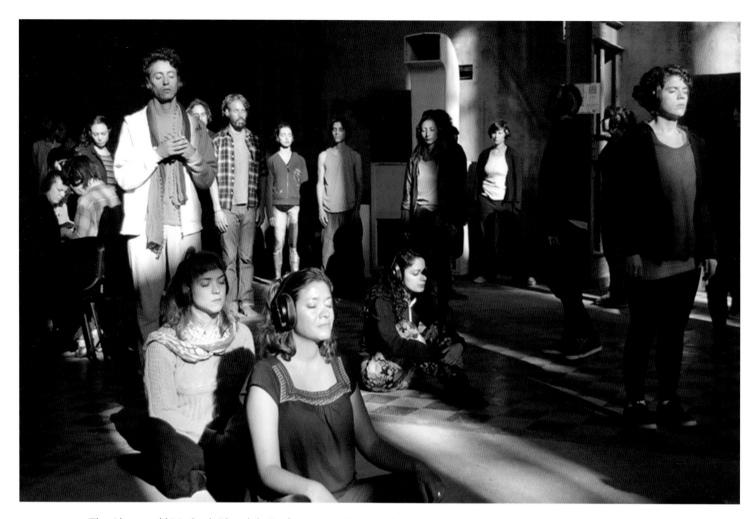

The Abramović Method, Bienal de Performance, Buenos Aires, 2015

and ice. During the nineteen-eighties, talismans in materials charged with special powers and traits, like those in use during *Nightsea Crossing,* were introduced for meditation and transcendence. Real bones, as in *Balkan Baroque,* and medical skeletons were used in the nineteen-nineties in several of her confrontations with violence and conflict in former Yugoslavia. Around the same time, she also developed the so-called *Transitory Objects,* meant for public use, such as *Shoes for Departure* carved from amethyst or the four ladders of *Double Edge* with their various trials. These objects are never thought of as sculp-

tures, but rather as vessels for inner journeys, tools that can be dispensed with once you have embarked on your personal passage.[9] They are in a sense related to the simple props that later became part of the so-called Method's exercises: cots, hearing protectors, color fields, blindfolds. The Method was developed by Abramović during years of travel, research, and instruction and then refined around the turn of the century when she established the MAI (the Marina Abramović Institute)—meant to serve as a foundation for long durational performance.

Marina Abramović has called the present exhibition *The Cleaner*—a title that says some-

thing about her views, not least of working with the physical remnants in archives and storage, the debris of an artistic life that has been about reducing and scaling back everything but the here and now. On a similar note, a key aspect of her later work is the systemization of the ways performance art is managed and lives on—for instance, through reperformance, an approach that was first tested and presented as part of *Seven Easy Pieces* at the Guggenheim in New York.[10] But the title also encompasses lines of thinking regarding a refinement and intensification of our mental focus that the artist has been pursuing for decades and that lie close to ideas found in Buddhism or mysticism. Cleaning and purification are present as themes throughout her oeuvre, from the never-performed piece *Come Wash with Me* to the act of ritual rejection expressed in the *Freeing* works; from the compulsive scrubbing away of guilt and sin in *Balkan Baroque* to the transitory crystal brushes—silent sound pieces "for spirit use" that are about the idea of purification more than its practice.

After a period in the nineteen-nineties and two-thousands during which Abramović explored dramaturgy and persona in her autobiographical stage productions and established relational, interactive projects such as the Japanese *Dream House,* she put herself and her public to the test with a return to live performance. In *House with the Ocean View* she entered into an existence of extreme solitary exposure with twelve days of silence and fasting at the Sean Kelly Gallery. From the edges of the compartments with their rudimentary interiors and dressed in constructivist-inspired *Energy Clothes,* over the course of the project she developed a wordless channel to her audience that generated the power needed for this piece—as did the dragons in the Chinese mountains so many years before.

Only once she internalized this knowledge and this strength could she take the step towards a personal encounter with the public as a sort of "everyman" in *The Artist is Present,* at first from across a table and later in a com-pletely open situation. This bilateral meeting developed over the course of a few years in collaboration with Ulay was tested here over a longer period of time and on a much larger scale, with an endless stream of people flowing into MoMA in New York. The work—already a performance art classic—burst the dams of Abramović's reach, which had until this point been limited to the art world.

What can be seen as a trilogy of open, public performance works was pushed to its limits in *512 Hours* at the Serpentine Gallery in London. A project in which the artist chose to further reduce the character of her own presence—from the pillar-saint or oracle's front-and-center position as a mirror for the individual—becoming one of the many participants and facilitators. All so as to open up the traditionally fixed position between artist, audience, and institution: "My work functions only if the public has a relationship with me . . . The basic problem is the passive and voyeuristic relationship of the public to the artist and to the museum."[11] The idea was to jointly create conditions for a work that builds on taking personal responsibility for the encounter with one's self and a greater context. Paradoxically, the work is similar in many ways to theater—which is otherwise often described as a direct antithesis to performance—not least in how the fourth wall seems both collapsed and restored in a piece in which everyone witnesses each other's work on finding and confronting themselves.[12] Common to these three artworks was also the presence of a documenting camera, the focus of which shifted increasingly away from the artist to the participants.

Marina Abramović's late public works have many parallels with the open dialogue of social sculpture and its boundary-breaking forms, which made it possible to reach out to people and allow art to fundamentally change their lives, even if Beuys's impact was certainly more political.[13] As part of her ambition to extend her reach, Abramović refuses to accept existing boundaries and actively opens chan-

nels beyond the initiated art world—via popular culture, stage productions, or science projects. The interest she demonstrated in her early works in developing new platforms for human interaction beyond the body indicates a technological optimism that might seem paradoxical. It is reminiscent of another free-thinking Serbian in whom the artist was interested, the inventor Nikola Tesla, who had ideas about how the laws of mechanics could be applied as a way forward for mankind and through to other planes:

> Life is and will ever remain an equation incapable of solution, but it contains certain known factors. We may definitely say that it is a movement even if we do not fully understand its nature. Movement implies a body which is being moved and a force which propels it against resistance . . . we may multiply the energy of the human mass by enchaining the forces of the universe, like those of the sun, the ocean, the winds and tides.[14]

From her earliest conceptual and immaterial experiments to a mode of expression in which the artist herself is, generally, the epicenter, Marina Abramović now reconfigures her position so as to become a silent partner in dialogue or a catalyst for another's engagement—the spark that sets the engine running. A shift that opens up the participant's choices and abilities to let go of lifelines and limitations, to turn inwards in order to open up outwardly. The work seems to be realized in precisely this process, when the individual becomes part of an endlessly faceted collective that together generates a force field of presence and energy—like a cloud in the room.

Notes

1. Marina Abramović in conversation with Adrian Heathfield in this catalog.

2. Joseph Beuys, "I am Searching for Field Character" (1973), in *Energy Plan for the Western Man: Joseph Beuys in America*, ed. Carin Kuoni (New York, 1993), pp. 21–23.

3. A play on the Slovenian word for ear [*uko*] and eye [*oho*]. The group introduced what they called "reism" (from the Latin *res*, thing), which questioned the utilitarian relationship we have to language and everyday objects. Ksenya Gurshtein,"The OHO Group, 'Information,' and Global Conceptualism *avant la lettre*," in *Post—Notes on Modern and Contemporary Art Around the Globe*, http://post.at.moma.org/content _items/850-part-1-the-oho-group-information-and -global-conceptualism-avant-la-lettre (accessed November 30, 2016).

4. Zdenka Badovinac, *Body and the East: From the 1960s to the Present* (Cambridge, MA, 1999), p. 16.

5. RoseLee Goldberg, *Performance Art* (New York, 2001), p. 150.

6. Peggy Phelan, *Unmarked: The Politics of Performance* (New York, 1993), p. 146.

7. Joseph Beuys, "Theory of Social Sculpture" (1979), as cited in Chris Thompson, *Felt: Fluxus, Joseph Beuys, and the Dalai Lama* (Minneapolis, MN, 2011), pp. 88–89.

8. Rebecca Schneider, *Performing Remains: Art and War in Times of Theatrical Reenactment* (Abingdon, 2011), p. 102.

9. See Beatrix Ruf and Markus Landert, eds., *Marina Abramović—Double Edge*, exh. cat. Kunstmuseum des Kantons Thurgau (Sulgen, 1996), pp. 39–41.

10. In November 2005, Marina Abramović reperformed select works by Vito Acconci, Joseph Beuys, Valie Export, Bruce Nauman, and Gina Pane at the Guggenheim, as well as her own *Lips of Thomas* and *Entering the Other Side*.

11. Marina Abramović, in *The Discursive Museum*, ed. Peter Noever (Ostfildern, 2001), p. 159.

12. Sophie O'Brien, "A Resonant Emptiness," in *Marina Abramović: 512 Hours* (Cologne, 2014), p. 43.

13. "I think art is the only political power, the only revolutionary power, the only evolutionary power, the only power to free humankind from all repression," Joseph Beuys in Robert C. Morgan, "The Role of Documentation in Conceptual Art: An Aesthetic Inquiry" (PhD diss., New York University 1978), p. 176.

14. Nikola Tesla, "A Machine to End War," as told to George Sylvester Viereck, *Liberty*, February 1937.

KEY FORMULAS PAINTED OUT: COLLISION AND CONTEMPLATION

Tine Colstrup

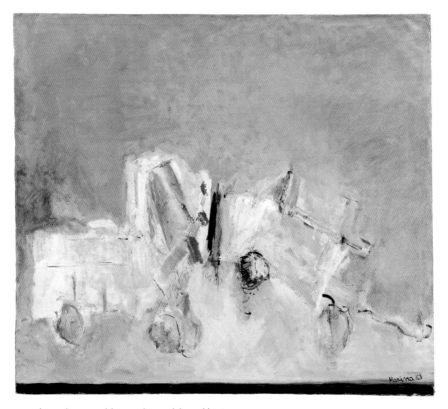

Marina Abramović, *Truck Accident (I)*, 1963

Marina Abramović devised one of her most frequently used work formulas with crystal clarity in paintings she made of trucks at the age of seventeen: the frontal collision between two entities. Soon after, with equal clarity, another often used basic shape and subject emerged in a series of paintings with clouds as the principal motif: individual contemplation and an interest in immateriality.

Even for Marina Abramović, it all began with painting. When she was fourteen, in 1960, she asked for, and got, her first set of paints. At the same time, she also received her first painting lesson from the artist Filo Filipović, one of her father's old partisan friends. Filipović showed up, poured various materials onto a canvas on the floor, topped them off with a splash of gasoline, and a lit match, leaving the young, aspiring artist with a painting, literally ablaze, which he called "sunset."[1] Take that, teenage girl. Having received this lesson in anti-painting, temperament, experiment, unpredictability, energy, transformation, and process, Abramović could start working. But despite this early, no-nonsense instruction in art as something other than easel painting, that was what she

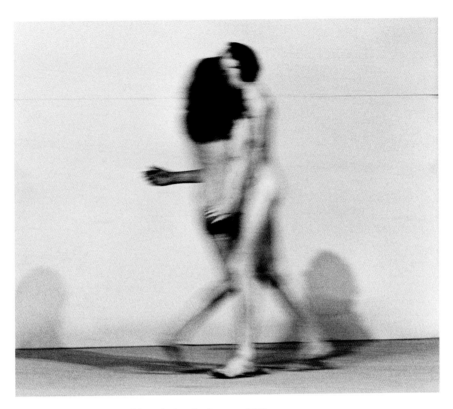

Ulay/Marina Abramović, *Relation in Space*, 1976

first took up, graduating ten years later with the title of "Academic Painter" from the Academy of Fine Arts in Belgrade.[2] Before long, she would abandon painting and its two-dimensional limitations for good.

Nonetheless, this text will dwell for a moment on paintings Abramović made from around 1963 to 1970. Even while curbing one's teleological urges, it is still possible to single out these paintings as surprisingly clear sketches of the main strands and interests running through the artist's work. Notably, both the violently physical and the immaterially spiritual are already clearly manifested at this early point. These two temperaments, between which her work is suspended, have long since become standard in describing the dynamism of her oeuvre, and can likewise be illustrated with the classic Dionysian-Apollonian dichotomy.[3]

The early paintings of truck accidents from around 1963 are often mentioned in passing in texts and interviews, but have never yet been given much attention in exhibitions or catalogs. Which is curious, really, because this series, like the subsequent "cloud paintings," whose reception has been a more common point of

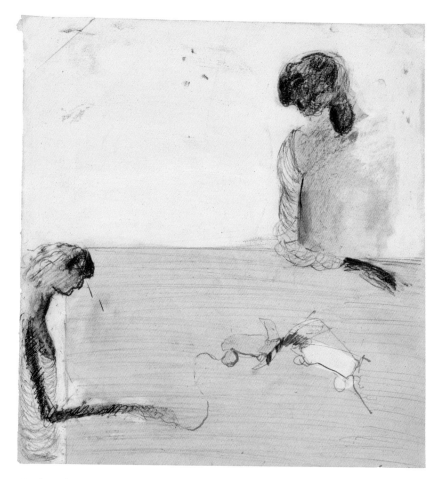

Marina Abramović, *The Truck Accident Game,* ca. 1960

reference in the artist's early work, appears to be the first artistic formulation of a recurring key motif: the head-on collision. It seems completely obvious once one has seen it—perhaps so obvious that it is easily overlooked; even the artist reacted with surprise when she was presented with the observation.[4]

The motif is remarkably weird: crashing trucks. Not just cars, but trucks. A good, profane *povera* subject for painting in the sixties, naturally, in which what collides is neither mythological figures nor—as in some of the classic "collision images" in the history of art—the

armies and heroes of warring nations, advancing from either side of the canvas and clashing in the middle. Crashing trucks are a far cry from the clichéd subject matter of painting and the radical opposite of the flower paintings Abramović was churning out at the same time, as she herself described it, to make a few bucks and, perhaps, reassure her parents.[5]

In the artist's archive—and now, in this exhibition—are two paintings of truck accidents along with a number of related drawings. The paintings are fairly large, 150 × 170 cm and 151 × 132 cm, respectively. The style is expressive,

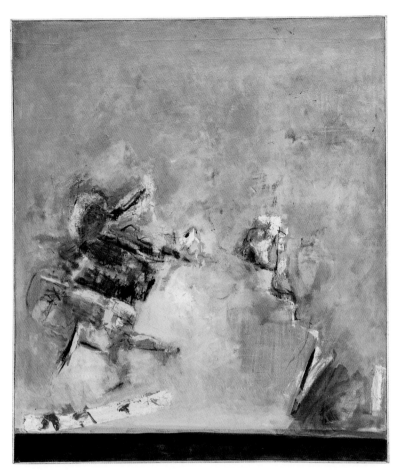

Marina Abramović, *Truck Accident (II)*, 1963

the brushwork loose and vibrant, unlike the subsequent paintings of clouds, which are rendered with a linear, more Magritte-like clarity. Abramović painted more than these two collisions, though today she does not remember exactly how many, and the whereabouts of the other paintings, some of which she gave away, are unknown.

The subject is most clearly rendered in the painting, which shows a white truck and a yellow truck colliding head-on, horizontal to the picture frame and seen from the side (p. 18). The painting depicts the exact moment of collision. Crash-bang! Both vehicles are airborne, their front sections crumpling. The yellow truck is vibrating, while the white truck, with its slightly greater density, appears to be withstanding the collision better. Abramović does not mess with the laws of physics. Her representation, with almost textbook clarity, shows two bodies colliding and exerting force on each other. Moreover, in a crash like this—a so-called inelastic collision—some of the kinetic energy is transformed into internal energy, or heat, in each of the colliding bodies.

We see the collision of two trucks. No more, no less. The pictorial space is almost flat, the subject surrounded by gray paint instead of the Belgrade cityscape. The collision is thus isolated, cut off from any context, and nothing explains the "before" and "after." Instead of relating a story, the artist focuses on a highly charged situation and a dramatic "now." The painting's formula can be distilled as follows: without explanatory references, two bodies collide head-on, exerting force on each other. That is all.

In the other painting from the series (p. 21), the subject is considerably more abstract. We seem to be a few moments further into the collision process. The bodies have separated again but are still airborne and vibrating, while the energy is transmitted into the gray, empty space between and around them.

The artist has recounted how she was fascinated by the big, green Yugoslav trucks she used to see on the streets of Belgrade and how she would go to the site of traffic accidents involving trucks as soon as she heard about them and try to get as close as possible to observe and photograph them.[6] Such accidents were not everyday events, however, so she got hold of some toy trucks to have something to work with and add to her empirical experience of the subject. Placing the toy trucks in the street, she would wait for real trucks to run over them and then make paintings in which the large trucks were smashed while the small ones were undamaged. She also tried to re-enact truck collisions at home with toy trucks.[7] This did not work, as many will know from experience, because toy trucks are at once too light and too solid to bring real force to the collisions. A number of drawings seem to show the artist staging these crashes on a large tabletop (p. 20). Representations of representations of truck crashes. However, as the artist was forced to realize, there was real energy only in actual, live collisions, and there were no shortcuts to the powerful exchanges of force that interested her.

The formal schema and work formula Abramović devised in the *Truck Accident* paintings would become a constant in her work, also in the work she created together with German photographer and performance artist Ulay in their extremely productive collaboration from 1975 to 1988. The duo defined several of their performances as "relation works," but the term "collision works" could aptly be applied to several of them. Witness Abramović and Ulay's own description for their performance *Relation in Space* in July 1976 at the Venice Biennale (p. 19):

> In a given space.
> Two bodies repeatedly pass, touching each other.
> After gaining a higher speed they collide.

The nude bodies move toward each other in a straight line from opposite ends of a room and meet in the middle. To begin with, they pass each other, their bodies only grazing, but as they ramp up the speed, they collide violently head-on. Over and over again. Each time, the collision happens in approximately the same spot against a uniform backdrop, which is white or gray, as far as one can tell from the black-and-white video and photo documentation. Showing only the zone where the bodies collide, both the video and the photos are composed so that the pictorial space is relatively flat, with the bodies entering the frame from either side in profile to us, leaving out the run-up. Everything but the actual collision is cropped out, the uniform backdrop and floor erasing any trace of the context in which the work was performed. Without explanatory references, two bodies collide head-on—smack!—exerting force on each other. Minimal and violent. And, as in the truck collisions, we see tiny differences in density and velocity between two otherwise close to identical bodies that ultimately produce differences in impact.

Obviously, the premise of a man and a woman colliding and exchanging energy is a lot more charged than when the objects are trucks. But what exactly the charge is, and what it

does, is open to interpretation owing to the work's minimal formula, in which nudity is just another erasure of a specific time and place.

Many of the duo's subsequent performances adhere to the minimal setup of two bodies, or poles, isolated in a head-on encounter and impacting each other in the exchange of both physical and mental momentum and energy. Just as the paintings have no "before" and "after," the duo usually began their performances with themselves in position and in "motion" before the audience was admitted, a device Abramović also employs in her later performances. What counts is the "timeless" situation, the energy field here and now.[8]

In Abramović and Ulay's *Nightsea Crossing* performances, 1981–87, the physical exchange of energy has been replaced by an exchange of gazes and a mental exchange of energy—still in profile relative to the audience, as if to underscore that the "collision" is head-on and that the moment occurs in a horizontal field of tension between two poles.

Fast forward to the duo's last collaborative work, *The Great Wall Walk*, 1988, which was a slow-motion version of a collision: walking towards each other for three months from opposite ends of the Great Wall of China, the two artists collided—although now in an exhausted way—in the middle.[9]

From the early nineteen-sixties to the present, 2017, one of Abramović's most consistent basic formulas has been: two bodies colliding—or, less violently confronting each other—head-on and exchanging force, impacting each other and transforming energy. The "collision works" made with Ulay, including, for example *AAA-AAA* (1978) and *Imponderabilia* (1977), which pushed the audience through the field of energy created between two poles, are variations on this theme. Abramović returned to the matrix again in the now-iconic three-month-long *The Artist is Present* that took place at the Museum of Modern Art in New York in 2010. As in *Nightsea Crossing*, this can also be seen as a variation on the formula of the early *Truck Accidents*.

Returning to the starting point of this essay, the early paintings reveal another subject that has continued to interest Abramović throughout her career. The violent collision paintings were followed by a series of paintings with clouds as the main motif, a series of works that quietly—yet radically—countered the explosive energy of the former.

It seems obvious to regard these works as early embodiments of the artist's interest in the relationship between matter and immateriality, and in the mental transformations that might be experienced along with one's quiet, concentrated presence in the world. A number of paintings and works on paper could seem to depict a process of transformation almost diagrammatically, with a cloud-like shape emerging from a square block of seemingly solid matter (p. 24). The cloud-like shapes are often black, like mysterious lumps of hovering density, in contrast to the more atmospheric white clouds. The artist has described the black shapes as a kind of black hole[10]—that is, as extreme condensations of matter and energy. In several works, a nude figure seen from behind, a classic "Rückenfigur," has been positioned as an observer of what is happening—or, perhaps more accurately, as the agent making it happen.

These pictures function almost as illustrations of much later works, which were made as an extension of the investigations of meditation techniques and the spiritual traditions of various non-Western cultures that Abramović and Ulay started together in the late nineteen-seventies, and that Abramović continues to draw on in her work today. As in, for example, works that situate an observer—sometimes the artist's body, sometimes the public's body—before chunks of exceedingly material minerals, such as crystals, on the assumption that perhaps the compressed energy of the earth can be felt and can affect the observer's own energy.

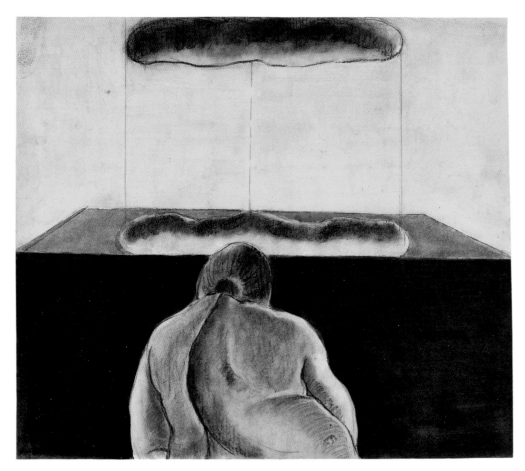

Marina Abramović, *Cloud with its Shadow,* ca. 1965–70

Marina Abramović, *Waiting for an Idea,* 1991

Variations on the motifs of collision and contemplation that crystallized in the early paintings appear throughout Abramović's work. In the nineteen-sixties, the artist discovered methods and basic shapes in painterly form that she later carried over into other media, concepts that to this day continue to generate different physical manifestations in performances, photographs, videos and interactive works and situations with or without the inclusion of objects.

Both strands—the destructively violent and the contemplatively spiritual, the Dionysian and the Apollonian—are essentially about the same thing: the transformation of energy, head-on exchange between different bodies, poles entities. Between trucks, bodies, man and woman, Abramović and Ulay, Abramović and minerals, the audience and minerals, Abramović and the audience, the audience among themselves. Between East and West, communism and capitalism, matter and spirit, light and heavy, human and nature. Between . . .

The two strands, their "collision" *and* fusion in the transformer of Abramović's oeuvre, have been described and theorized in the existing literature on the artist. The aim here has been to point out just how clearly Abramović articulated these two central and recurring formulas in her early paintings. Crash-bang. Shhh.

Notes
1. Marina Abramović, *Walk Through Walls: A Memoir*, with James Kaplan (New York, 2016), pp. 30–31.
2. Marina Abramović, *Walk Through Walls* (see note 1), p. 45.
3. Thomas McEvilley uses these paired terms to describe the artist's range between the intuitively driven and the strictly rule-bound, but the opposition is readily applied in a general sense. See Thomas McEvilley, "The Serpent in the Stone," in *Marina Abramović: Objects, Performance, Video, Sound*, ed. Chrissie Iles, exh. cat. Museum of Modern Art Oxford and 5 other museums (Oxford and Stuttgart, 1995), p. 45.
4. In conversation with the author.
5. Marina Abramović, *Walk Through Walls* (see note 1), pp. 36–37.
6. Klaus Biesenbach, "Interview: Klaus Biesenbach in Conversation with Marina Abramović," in Kristine Stiles, Klaus Biesenbach, Chrissie Iles, *Marina Abramović* (London, 2013 [2008]), pp. 8–9.
7. Conversation with the artist, and Klaus Biesenbach, "Interview" (see note 6), p. 9.
8. RoseLee Goldberg simply uses "Here and Now" as the title of her essay introducing the artist's work in Iles, *Marina Abramović: Objects, Performance, Video, Sound* (see note 3).
9. Thomas McEvilley, "The Serpent in the Stone" (see note 3), p. 48, also notes that the project can be seen as a slowed down version of a "relation work."
10. Klaus Biesenbach, "Interview" (see note 6), p. 8.

LIQUID KNOWLEDGE

Marina Abramović in Conversation with Adrian Heathfield

Adrian Heathfield: Where to begin?

Marina Abramović: Let's start here: the way that my father taught me to swim really marked me for life. To leave me in the middle of the sea and never look back. With the little boat going off. And I'm literally drowning. He doesn't look back. I am six years old and I understand that I am on my own. From anger I swim back, and he still didn't look, just pulled me out with his hand. It wasn't just the partisans' way of teaching children to be tough. I knew from the beginning I couldn't rely on anybody, as the love was not there. My mother never kissed me. But I turned out ok. I really should be more fucked up than I am.

AH: So you start in a situation where life is all about survival. You have a taste of experiential limits and physical stress. You know you can be in absolute extremity, without love, and you can come back. The world gets configured differently for you from that moment in time. That simple biographical fact makes me start to re-think your work, particularly your use of the elements and isolation, wounding and endurance.

MA: Well a lot of people only know me through art world celebrity, and think it's all about vanity. I worked so hard for everything. I am seventy now and it's only in the last twelve years that I actually had anything. This is why the memoir, *Walk Through Walls,* is important to me. And I hope inspirational for young artists. Who knew back in those days that performance was any kind of art, or that it was going anywhere? We had to go to hell to prove it until now.

AH: I always think of you as a nomadic artist: a person constantly on the move. You are someone who has left many homes, from Belgrade, to Amsterdam, to New York, then there's your life on the road with Ulay in the van. You are on a quest: a mission to find new ideas, new forms and territories. But then, here you are at seventy, with over five decades of work, and of course everything accumulates, gets heavier. There is a lot of retrospection surrounding you: your memoir, this current retrospective. In each you are looking back into your history to find something new: a different version of those pasts that keep piling up. How do you feel about this tension between retrospection and your quest for the new?

MA: I think because I never really had a happy home in my childhood, I always wanted to re-create this kind of abstract home. My nomadic nature allows me to make work in different locations around the world. Every place I go, every city, every country, I create that home. Ideas can appear to me anywhere, and I can develop these ideas in different locations as I travel. In the middle of mineral mines in Brazil, observing sacred rituals in Sri Lanka, or just simply sitting and looking into the explosion of a volcano in Stromboli . . . but I am not physically or emotionally attached to these places at all. It's like I create a set, and then I leave. My house in Amsterdam was a huge proof to my family that I could actually succeed. Then I left the house with all the furniture in it, just gave the new owner the key. For me it's important that I set up something, but then I leave for the new territory. It's like a snake shedding its skin.

Just the same with the theater piece *The Life and Death of Marina Abramović*, playing even my own mother, going through all that emotional trauma, crying during rehearsals. But then I played it so many times, it doesn't touch me any more. This memoir: I put everything I can think of from my childhood and from the past in it, all the people who touched me or hurt me; I even dedicate the book to friends and enemies. But once it's out there I am free. I don't feel the weight. I am constantly creating the systems that allow me to be free again. Right now, looking back in this particular moment, I am freer, with less baggage, than I have ever been in my life. So seventy is like a new beginning.

When Lou Reed died, Laurie Anderson made a wonderful tribute. In the beginning of the speech she said that the two of them discovered three of the most important things in life: first, have a good bullshit detector. Everything that's bullshit: cut it out of life. Second, don't be afraid of anything or anyone. Third: be tender. These are great principles to live by. For me, inner freedom is the most important thing. We are the prisoners of ourselves. We imprison ourselves in situations we can't take ourselves out of, in habits, in repeated bad decisions, in things we think we are obliged to do but are not. Actually *you* make all these decisions and *you* can also break them. So to me retrospection—making theater pieces, memoirs, retrospective exhibitions, curating my own death—it's a way to freedom.

AH: You ask what is your belonging to this place or object, but then you detach?

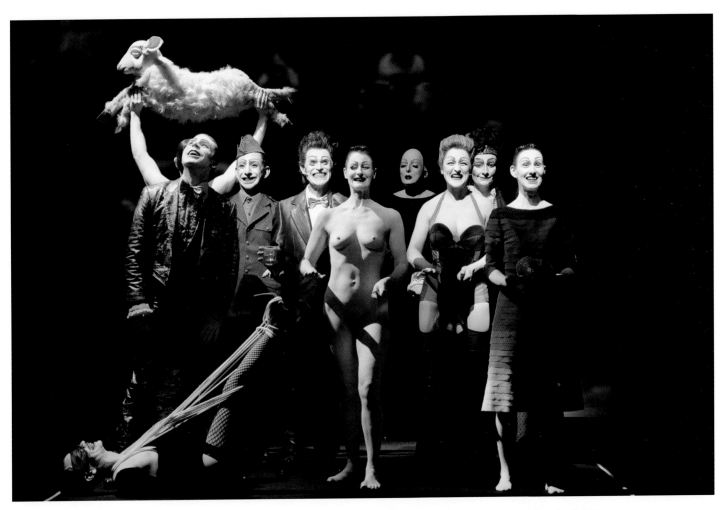

The Life and Death of Marina Abramović by Bob Wilson, performed at the Manchester International Festival, 2011

MA: Immediately. This house: I have been here a year and a half and I'm already thinking I have to move! There isn't anything that really grounds me in a space. But I need a kind of simple security, somewhere a home, but then I'm free to go. There is no attachment. This whole idea of a husband, children, relationships: for a big part of my life I felt guilty that I worked too much, that I had unbelievable passion for what I was doing. There was always somebody there waiting for me, because I was not finished with this or that work. Now I am free from this too. It's intoxicating. But what is the new beginning, now that I have done the memoir, and the retrospectives?

Actually before this retrospective in Stockholm, after the MoMA retrospective, there was a major retrospective in the Garage Museum of Contemporary Art in Moscow. The space was built around the work, and I presented almost everything I've ever done. I got so depressed: everything was there, and I felt now I could just die. It was overwhelming. So I've lived that already . . .

AH: Maybe when you get a retrospective like that it's too complete, then everything has an even weight; what you need is a new angle from new relations between works. Then suddenly your history realigns, and there is new potential. But I am wondering, are there works or processes in your past that you recognize as unfinished, that you want to make anew?

MA: Seventy is physically, mentally, and emotionally a preparation for the last stage of your life. You don't know if it's going to be five, ten, thirty years, who knows? You have to be aware of this and prepare. I want to go back into the

innocence of my childhood. When I was a child I believed in parallel realities. I would sit at home looking at the particles of dust in rays of light. Thinking there are other galaxies inside our planet. I believed in the spirit world: not only a belief but I could see it, I felt the existence of it. I never played with toys, but I played with the shadows. That's why I was so fascinated with Nikola Tesla, and the strange mystical relationship between technology and spirituality. Spirituality travels so far in front of science, then science finally finds devices to measure its realities. I want to deal with intuitive knowledge. I want to live in synchronicity, where you are so attuned to existence, your self and your surroundings, that things happen without effort. To have this last period of life, but to see it the way a child sees it. That fresh view: where everything is possible. This is my biggest dream. This is something that is unfinished. I grew up and my childhood was so controlled: I didn't live the childhood I wanted to live. So I want to relive it.

AH: That's why I like the title of your memoir: *Walk Through Walls.* I guess there are only three types of creature that can walk through walls: the very brave ones, the ghosts, and children. A child is always passing through boundaries because they don't know that such boundaries exist.

MA: I remember we were in some hotel, and my brother was four years old; my mother called him, and he just went through the glass wall, the glass crashed behind him, and he was completely unhurt. But a little story I was told in my childhood: the circus arrives in the village. Everyone is so happy to see this circus; the whole village is there, waiting in expectation. A mother brings her little boy to this circus. There are lions, jugglers, acrobats, and then there is a magician. The magician asks for a child to come

from the audience, and the mother takes the boy to the magician. The magician opens a big coffin and puts the child in. Abracadabra, he opens the coffin, and it is empty. Everybody says "wow." Again he closes the coffin, says his magic words, and the child comes out smiling and runs to the mother, who is so happy. Nobody, not even the mother, notices that it is not the same child.

AH: *(laughs)* So childhood is really an unstable, immaterial condition, and specific children are interchangeable.

MA: I like this changeover. I have to go back to childhood, but differently, with the knowledge I have.

AH: I was struck by another story that you have told, from your teenage years, regarding a painter: Filo Filipovic. Your father arranged for him to give you some personal art tutorials. He put the canvas and paints on the floor, applied red and yellow and black pigments, some sand and gasoline, and then lit the painting.

MA: Yes, then he said: "This is a sunset."

AH: I wonder if this art-life lesson is not somehow being carried through much of your work: not just the move to action painting, but the investment in energetic intensity, and then the value of the trace or residue of that burning life. You mentioned the color of the "painting" changed over a number of days . . .

MA: It became just trash.

AH: There's alchemy there too . . .

MA: The idea that the artist has freedom to make anything out of dust. From nothing comes something. The magician takes an iron ring, mixes it with sand, and it turns into diamond. This is what artists do;

they have this capability. It's like Michael Craig-Martin's conceptual piece, *An Oak Tree* (1973). Beautiful. It's just one glass of water on a shelf. The idea of the trust that art has to generate: if I tell you this is an oak tree it is an oak tree. Art is a transformation of matter.

AH: Perhaps you saw in the sunset that a work of art could be an event, or could take its own time?

MA: Yes, but also that the process is more important than the result. It's like in lovemaking: orgasm is the last thing, but everything else is much more important. Creating mystery in front of your eyes . . .

AH: Is there a burden to retrospection, or a point at which you will say enough: "too much looking back"?

MA: There are so many works that don't fit anywhere. They are always excluded. I need somebody who will pick up all the misfit works. They are very important for me because they brought me in different directions. Maybe they were experiments that didn't succeed, but actually they are vital to my growth. Those works never find a place, because people always need to see linear development. But my whole existence is completely circular. I don't think in straight lines. Working with James Kaplan on the memoir, I didn't speak chronologically; I would talk about one thing and then associate it with something else in a completely different time and place. Somehow everything matters and everything is connected. So something like *Eight Lessons in Emptiness with a Happy End* (2008), the piece I made in Laos with children, I never show this work in any context because it just doesn't fit in. There are plenty of pieces that have never left the studio. I would love to make a misfit exhibition: because I still feel a misfit.

Ulay/Marina Abramović, *Imponderabilia,* Galleria Communale d'Arte Moderna, Bologna, 1977

AH: I was thinking of this axial work *Rhythm 0* (1974), which holds a proposition in relation to the audience and the artwork: that the audience *makes* the work and the artist is the audience's material. You moved away from this proposition almost immediately, but then you returned to it towards the end of your collaborations with Ulay, when the couple is clearly no longer enough. An audience makes the work. I'm am thinking of *Imponderabilia* (1977), when the audience perform by entering the gallery between your and Ulay's naked flesh, or the later versions of *Nightsea*

Crossing (1981–87), which you called *Conjunction* (1983), when the two of you are joined by others who sit with you in long durational meditations.

MA: Lately, I am saying that the public is my work. I am removing myself and the public becomes the work. Everything comes out of each performance experience as a natural flow: I could not get to this idea before.

AH: For me the idea reaches its apex in the experience of *Generator* (2014). Where the spectator signs a contract,

gives over all of their possessions and enters an unknown, unseen and silent space, blindfolded and wearing headphones. Experientially you are thrown back into your other senses—touch and smell—so you realize that the artwork is nothing but this deeply sensuous experience, which *your* body produces. It's a space of invention within constraints, and a complex sensual encounter in a void space with others. In a virtual way you are everywhere in that work, but also in practice you are nowhere.

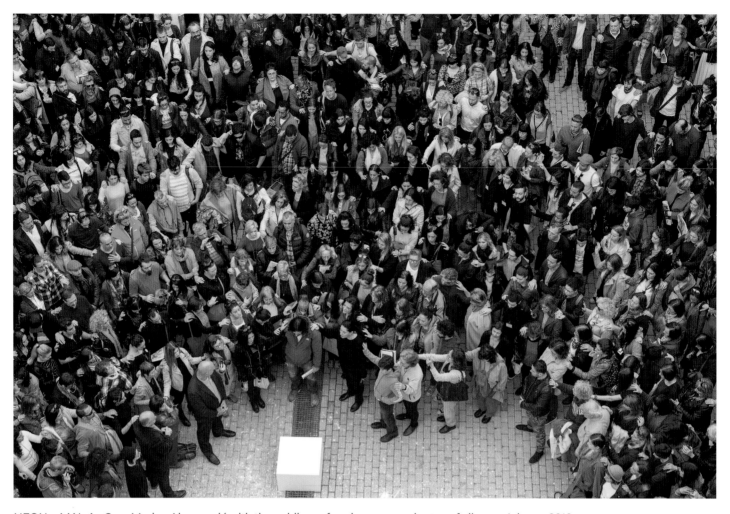

NEON + MAI, *As One*, Marina Abramović with the public performing seven minutes of silence, Athens, 2016

MA: So many people have said, "Oh, I felt you touch me," or, "You hugged me." But I absolutely was not there. Now it's similar with the Abramović Method. If I am there, it fucks up the structure by making people pay attention to me: people lose focus. So I am not there. I am trying to create systems to give people tools for themselves. You are not experiencing something *because* I am there. *You* are the trigger.

AH: So these are methods for self-transformation.

MA: The progression of the public for this work is incredible. Going from twenty or thirty people, to now hundreds of thousands. This is a general public. I don't even understand if what I am doing is art. But a general public is open and moved to the core with their own experience. I am not telling them anything and they are not looking at me.

Look at this photograph of what happened in Greece: three thousand people holding hands. Look at the feeling. Normal humans. There's so much pain here. Everybody is there for their own reason. Just to be present: an unbelievably mov-

ing experience. Seven minutes in total silence. The silence of the silence. You know how much pain there is in Greece and what a mess it is economically, socially. They just came to the museum and something happened. The trust you establish to do that, it's a responsibility. You have to carry that, you have to do the right things, you can't make a mistake. This is also going back to the honesty of the child. The Benaki Contemporary Museum usually has seventy visitors per week, but 53,000 people came to see the exhibition. Kids would bring their parents from the islands, just to do the

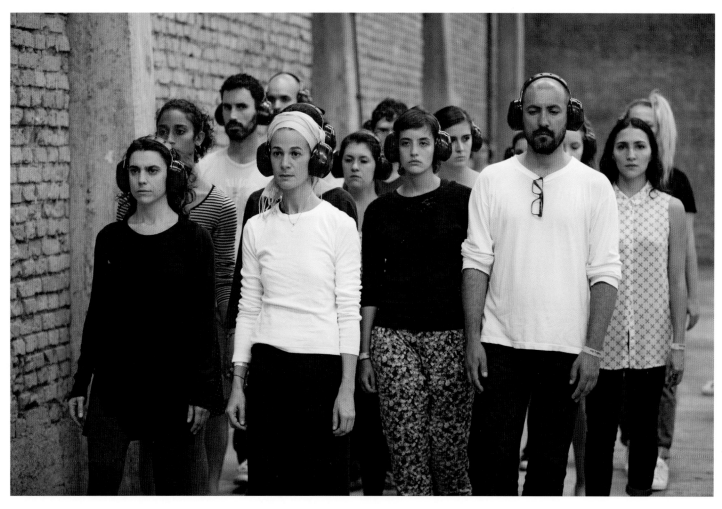

The Abramović Method, Terra Communal, Marina Abramović + MAI, SESC, São Paulo, 2015

Method, then to see all the young artists in long durational performances. We prepared the audience with workshops, training, talking to them. In the end it was a cathartic experience for many people because they were really changing. You can't change without doing it, there's no book to be read on it, all that matters is doing it.

AH: I'm interested in the fact that these techniques that you are pursuing in the Method are means for spectating or witnessing art, ways of attending to material things, but also life-methods and tools with which you could make art.

MA: First of all, to see long durational pieces of art, the public has to be prepared. A certain kind of conditioning is required. One needs to learn how to concentrate, to watch a performance where perhaps very little is happening over a long period of time. Maybe it's just a ray of sun crossing the room, the sound of a heartbeat, the blink of an eye . . . I am developing the Method to serve this purpose to prepare the public to leave their busy life and enter into a concentrated state of mind. On the other hand, artists have to go through a similar process to make their work. In order to create a state of mind that they can communicate with the public and have a dialogue, the preparation has to take place for them, too. Long durational works are so important, because artists have plenty of time to adapt to that state of concentration in their work, and the public does as well. the Method serves this dual purpose because performance does not exist without the public, they both complete the work, and both parties have to be prepared.

AH: You are pursuing a communal aspiration in very different ways to much social practice in art. It is a communion of elemental affinities, very embodied and affective, without preconditions. This is not so readily available to people in other forms of organized sociality. It's also not a route taken by many social practice artists, who have an interest in discourse, social difference, political processes, resolution of antagonisms . . .

MA: Long durational performance engages the public in a completely different way. In a normal exhibition of paintings or sculpture, you come to see it and you leave. You are not interested to come every day to look again. There is no process involved. In a long durational performance that is performed every day during the open hours of a museum, there is a process. The public is following process, not only coming every day to see the development of the work, but also bringing new friends, creating a new community of support for the performers. This is a phenomenon that long durational performance can generate. I'm so committed to community. It's remarkable how simple it is and how needed. In the Method there is furniture and architecture to help create these communal situations. Everyone is together without even knowing who they are. There are platforms that create energy fields. We train facilitators to do this work. In some cases it's eighty or ninety facilitators: it's an army. They have to have the right energy to deal with huge amounts of people. They are all from different professions and come for different reasons and they stay a month or two months. They are dealing with people eight hours a day, giving them unconditional love. It doesn't work any other way.

AH: You've been teaching art almost as long as you have been making it, and you also come from a cultural upbring- ing in communism in which social and behavioral training has a distinct shape. From the perspective of Western capitalist cultures in which individual freedom and competition are the key values, the approach you have to social participation in art feels quite alien. You want to train the community, heavily structure their experience . . .

MA: Give them discipline . . .

AH: Yes, drill them. It's quite counter to Western cultural values . . .

MA: Completely. His Holiness the Dalai Lama said how difficult it is to work on spirituality in Western society. Someone asked why. He just gave an example: you go to the supermarket and you want to buy toothpaste. You stand in front of a shelf with a huge choice of toothpastes. You forget what you want. Everyone is so messed up by this and it's the same with spirituality: you are lost in choices. People no longer understand what they want, or how to get to experience it.

There are two ways to get to an experience. If you want to go to the top of the mountain but don't know the road you can do it by yourself and it will take you forever. Or you can have a guide who will bring you to the top. Then you still have your own experience. Everything I've done over all these years—physical training, in the desert, meditation, in retreats—I've understood those structures and applied the simplest ones that I think can work for everybody. Counting rice is my own invention, slow motion walking is from *vipassana*. I made a mix that you can use to get there faster without losing the road. When you get there, you do whatever you want with that gift. Control and discipline are necessary in order to do this. In every spiritual culture it's the same: there is strict discipline, there is some kind of master who is a god. It's difficult because we like to think we have freedom to do whatever we want. But we are lost. It's a question of trust. If I got there I probably know the road.

I do make less structure now than in the beginning. For instance, the lab coats for participants were once important: they were democratic, we all looked the same, it gave us unity, changed us from viewers to experimenters. Now it's not important to me. But the headphones to block the sound are an absolute must. You start hearing your heartbeat. You block out the immediate environment and concentrate yourself. The second thing, electronic devices have to go away: watches, telephones, computers. You lock these things away, then you gain free time. I'm much less militant about this: there are only a few little things that are necessary for you to enter into this state.

AH: So freedom is a myth, and you only arrive at a sense of freedom through constraints. In *Generator* you put severe limitations around the participants' senses. So as a participant I discovered that inside those limitations was a vast space of play, and an invisible and anonymous community, where I could create and receive new encounters with other bodies that were not available to me . . .

MA: . . . in that freedom that you once thought was freedom.

AH: The artist is absent.

MA: Yes, it's just the other side of the coin. *The Artist is Present* (2010) led to *512 Hours* (2014), and it was in that piece that I understood I had to remove myself from the public. People came just to see me; then I became the center of their focus, rather than their own experience. I tried to melt it and melt it. In *Generator* the absence is really important: you are out there alone. As in whatever we do, finally we are alone. Everything I do in art,

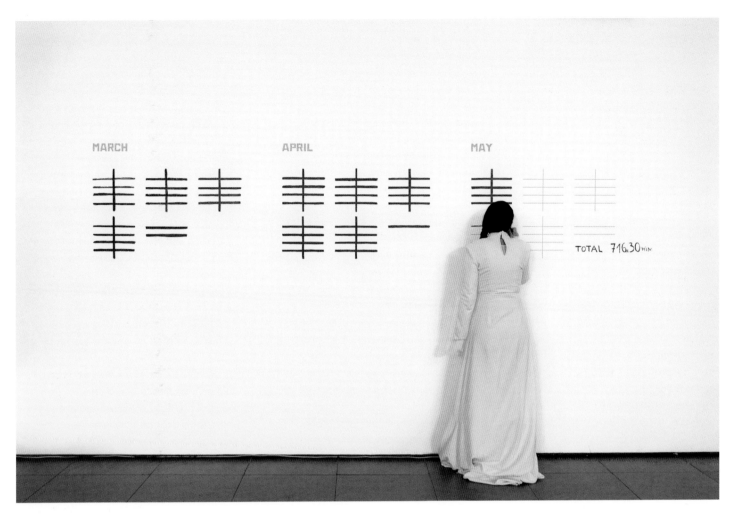

Marina Abramović, *The Artist is Present*, 2010

the knowledge came to me from doing it myself.

AH: In a way, we are back to that little girl struggling to swim in the sea.

MA: Yes, but there are a few things that should not be mixed up: isolation and solitude. Isolation can lead to melancholy and sadness, but solitude is the condition that I believe an artist has to take for a longer period of time in order to create her own work. Solitude is a conscious choice. I speak about this in my *Artist's Manifesto,* that silence and solitude have

to enter into my work, into any artist's work; this is why I propose looking into waterfalls, exploding volcanos, into the night sky . . . In the early workshops for *Cleaning the House,* I would have the students blindfolded and left in the middle of the forest to find their way home. You have to be able as an artist to see as a blind person, to see with your whole body. What is the function of an artist? Each artist you ask will probably have a different answer. But mine is definitely consciousness-raising. Start with yourself; change yourself. If you change yourself you can change thousands.

AH: Throughout your career you've invested in creating different ways of being in and attending to time—the long durations and the slower times of art experience. I was intrigued to discover that this shift to longer durations originated in your experiences in the Australian outback in extreme temperatures. So there is a link between durational aesthetics and environmental consciousness, being attuned to the elements . . .

MA: But also attuned to physical restriction. If I had walked any faster in that heat,

my heart would have exploded. Because of restriction you get the new step in experience.

AH: Knowing your life a little, I know it's hectic, saturated, accelerated. But then in your work you are in the still center of slow time.

MA: The crazier my life becomes the longer the durational works I do. You enter into a work where time almost stops, then your life gets three times speedier. But now I go every year to a place for one month, somewhere between a monastery, a prison, and a sanitorium. These are my ideal spaces. Everything runs on exact time, so the body becomes like a machine. Precise, like a clock. You wake up, eat, shit, always the same time. That kind of time structure is so great because I don't have it in life. Wake up every morning 5 o'clock, meditate, always eat too little so you are always a little bit hungry, don't talk. It's a dream for me: because the body is taken care of, the mind can be free. Another way that mind functions very well is when you exhaust the body: sleep deprivation, starvation.

AH: So either in deep ritual or when physical habit is stalled: you are just existing.

MA: This is why performance art is such a transformative art. You don't have this in painting or sculpture. A different kind of energy is brought there. Here is life energy, molecular, cellular life. You are interconnected to the other life energies around you. Everything is in a living unity.

AH: Watching _The Artist is Present,_ it is very clear that you spent a very long

time in an utterly exhausted place; you've reached an absolute limit, but somehow you are still continuing. What is it that you find in those experiences that is so generative?

MA: I call it liquid knowledge. When the body is exhausted you reach a point where body doesn't exist anymore. Your connection with a universal knowledge is so acute. It's not even awareness: things come to you, an avalanche of deep understandings, of life on this planet, of simply being here. You can't put it in words. Somehow a clarity is there. There is a state of luminosity. You really need to prepare the body and mind for this kind of understanding. It's such a difficult task to actually get there. It's rare, but artists and scientists sometimes have this. It's something I can't explain, like a divine knowledge, but it's not religious. I believe in that kind of energy that is so subtle that our own energy obstructs its entrance. Only when you exhaust your own energy can it enter and become that kind of realization. It gives an immense feeling of tranquility. I enter it through pain. When I discussed this with a Tibetan monk, he said that years and years of meditation leads to the realization that we are all molecules and light. This is why I love Van Gogh: he saw that. That's why the paintings are vibrating. Or a certain energy in a Rothko painting that always makes me cry.

AH: So we come to what some people would think of as the religious dimension of your work. But it has little to do with formalized religions; let's say it's a spiritual dynamic, not simply transcendent, but very enfleshed and material, coming from within and without, from an experience of bare existence.

MA: I can only talk about this from really being there. So many people talk about spiritual experiences from reading about them, but not by having them. So, this experience within can be delivered by drugs, or by putting your body in a position that no other human being would do. Then by confronting this experience directly and honestly. The moment when you know the pain is so unbelievable, you say I can't take it anymore, I am going to lose consciousness, that's the moment pain has disappeared and everything changes. Pain is the door of secrets. That's why shamans' rituals in many different cultures deal with extremely painful experiences—cutting, bleeding, piercing, burning, burying—to get to that point and to learn from that. The similarity between human rituals and performance art: it's transformative.

Sometimes my question is: "How is this art?" I went through very personal ways of doing performance. I've turned everything around and now the public becomes the main work. The response is so emotional. Kids come up to me, saying, "you've changed my life"; they start crying and holding me. There's something so lost and wounded in the human spirit. It has to be restored. This must be the state of things today: I don't think this kind of response was possible in the seventies. The need for community now is huge. Long durational performance really brings people together. As an audience member you know someone is going through hell every day and you give your energy to them to support them, you bring others. It creates a unity that other art forms don't have.

PLATES

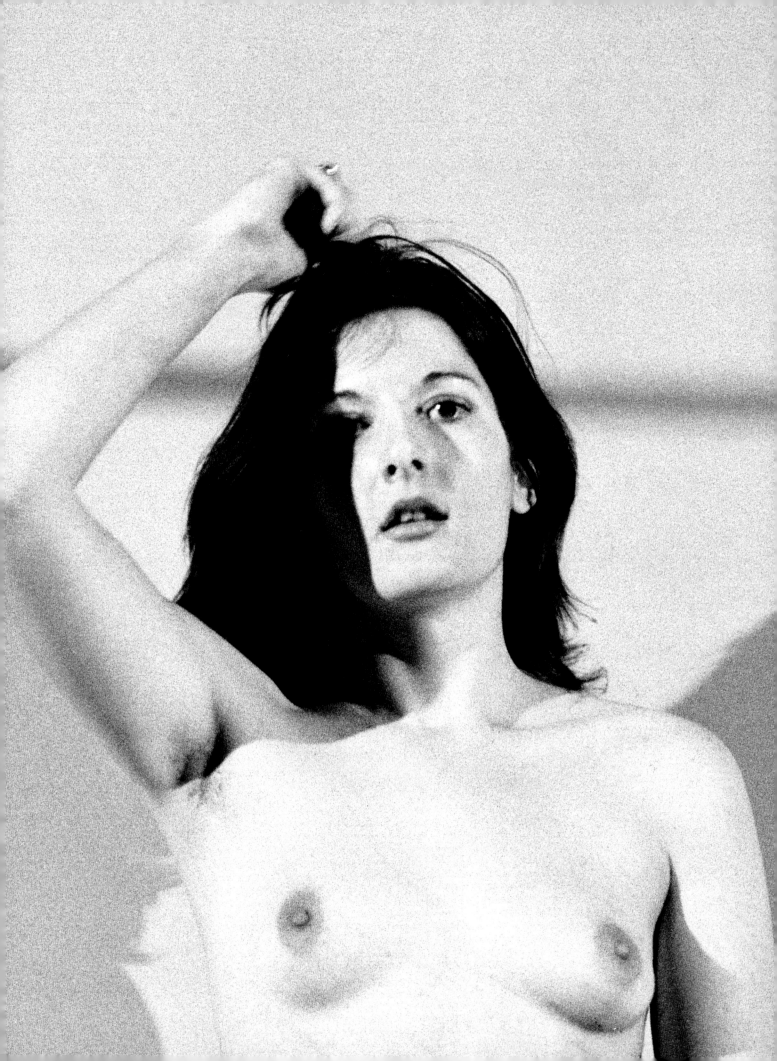

EARLY SOLO WORKS
1965–1975

Untitled, ca. 1970
Pen and colored pencil on paper, 25 × 35 cm

Untitled, ca. 1970
Pen and colored pencil on paper, 25 × 35 cm

Untitled, ca. 1970
Pen and colored pencil on paper, 24 × 35 cm

Untitled, ca. 1970
Pen and colored pencil on paper, 30 × 42 cm

Traces of Planes and Sun Rays,
Study for Sky Project, No. 2, ca. 1970
Pen and colored pencil on paper, 20.5 × 12 cm

Traces of Planes and Sun Rays,
Study for Sky Project, No. 5, ca. 1970
Pen and colored pencil on paper, 20.5 × 12 cm

Traces of Planes and Sun Rays,
Study for Sky Project, No. 1, ca. 1970
Pen and colored pencil on paper, 20.5 × 12 cm

Traces of Planes and Sun Rays,
Study for Sky Project, No. 3, ca. 1970
Pen and colored pencil on paper, 20.5 × 12 cm

Untitled, ca. 1970
Pen and colored pencil on paper, 35 × 50 cm

Untitled, ca. 1970
Pencil on paper, 25 × 35 cm

Untitled, ca. 1970
Pen and colored pencil on paper, 30 × 42 cm

Clouds Collage, ca. 1965
Mixed-media collage on paper, 40.5 × 37 cm

Self-Portrait, 1965
Oil on canvas, 102 × 83 cm

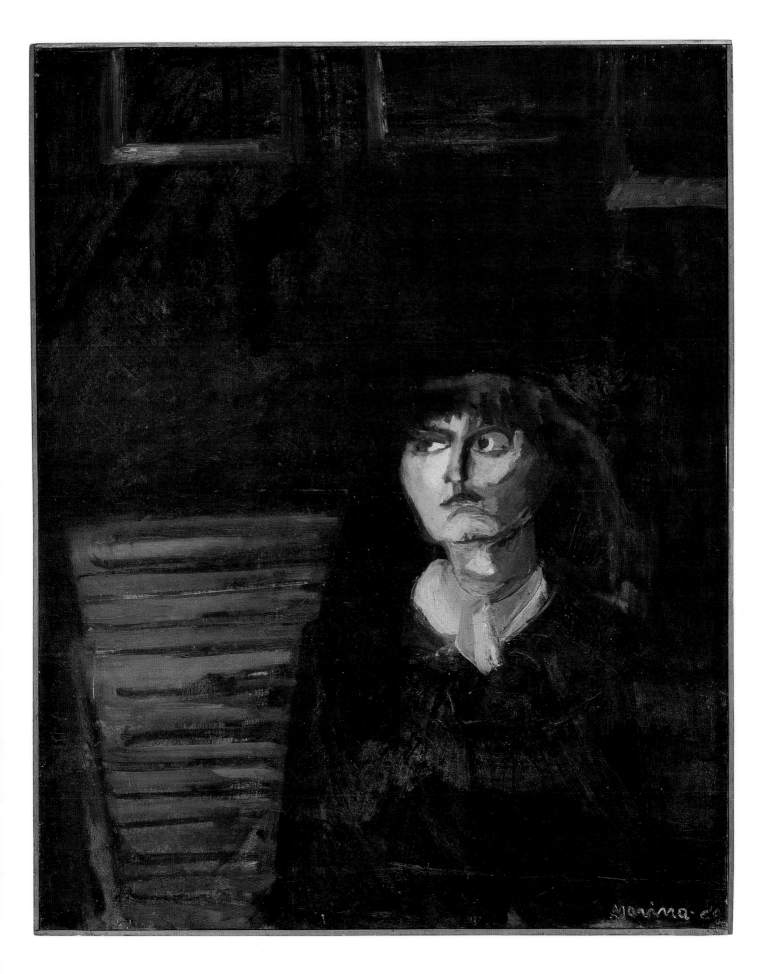

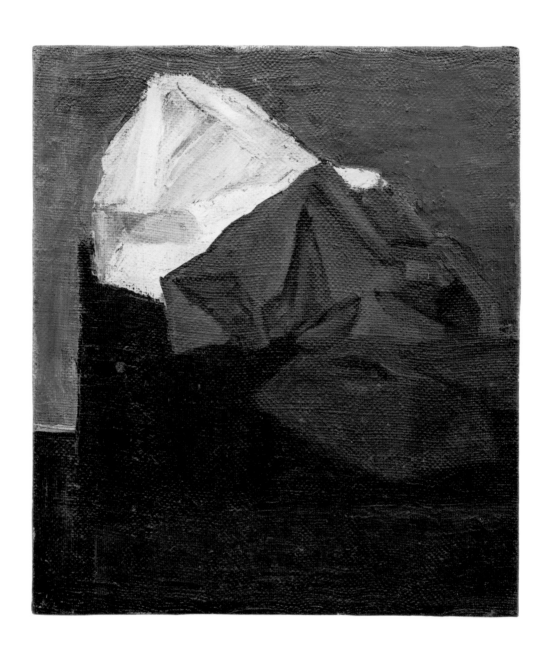

Three Secrets, 1965
Oil on canvas, cotton cloth, 51 × 45 cm

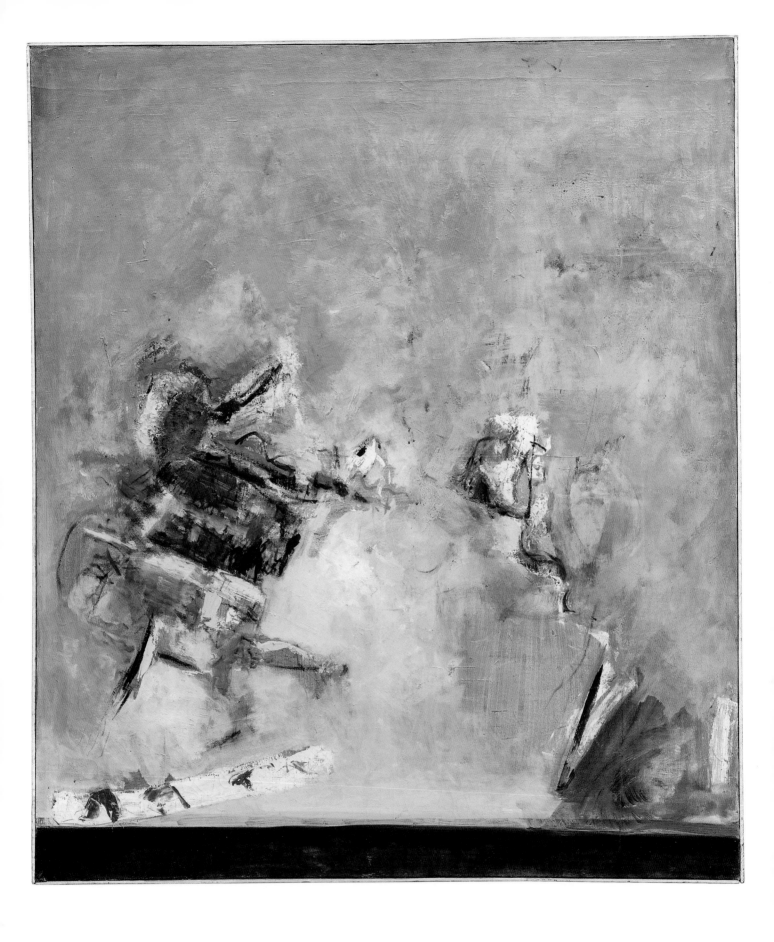

Truck Accident (II), 1963
Oil on canvas, 151 × 132 cm

Truck Accident (I), 1963
Oil on canvas, 150 × 170 cm

48

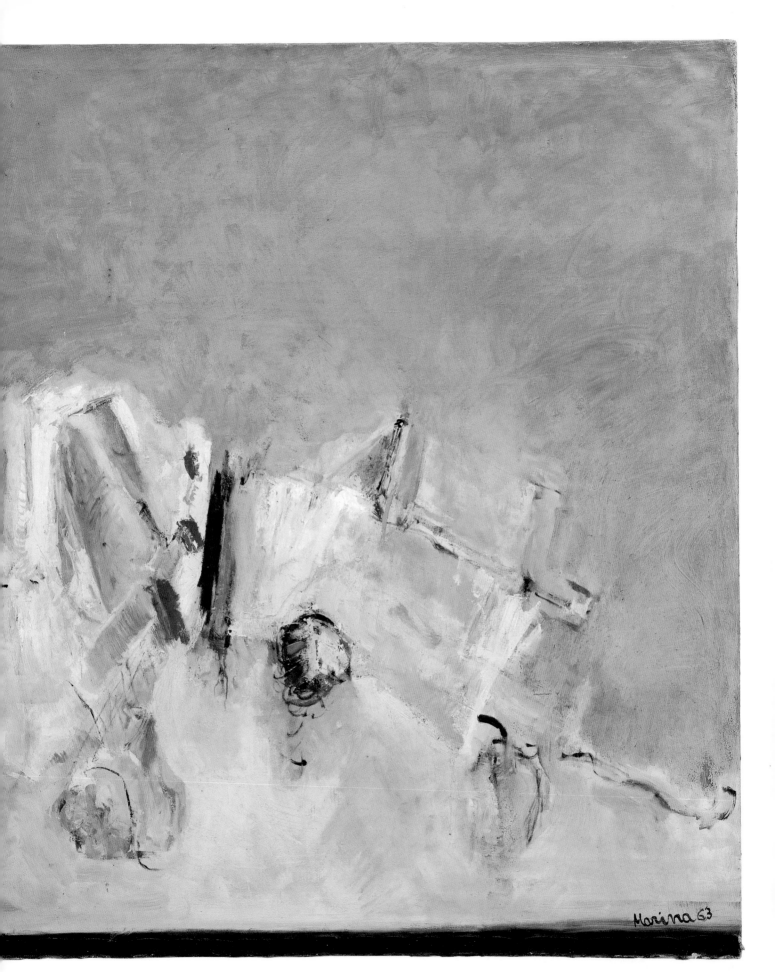

Marina 63

Clouds in the Shadow, 1969
Oil on canvas, 177 × 146 cm

Overleaf: *Connect the Stars,* 1969
Printed invitation, 32 × 44 × 3 cm (framed)

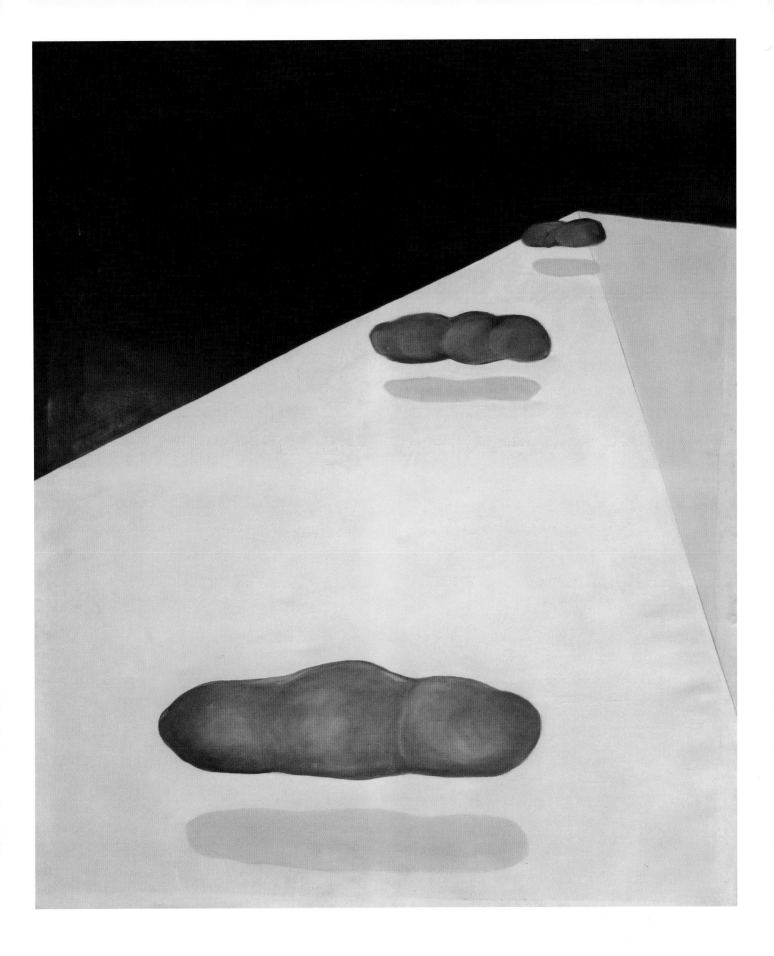

1 **connect stars and planets b**
2 **describe your adventures ir**
1 **unisci con la matita le stelle**
2 **scrivi cosa hai vissuto nel fir**
1 **spoji olovkom zvezde i plane**
2 **napiši šta si doživeo u kosm**

pencil
cosmos?
d i planeti
namento?

su ?

adress:
marina abramović
41000 z a g r e b
zamenhofova b.b
yougoslavie 1969

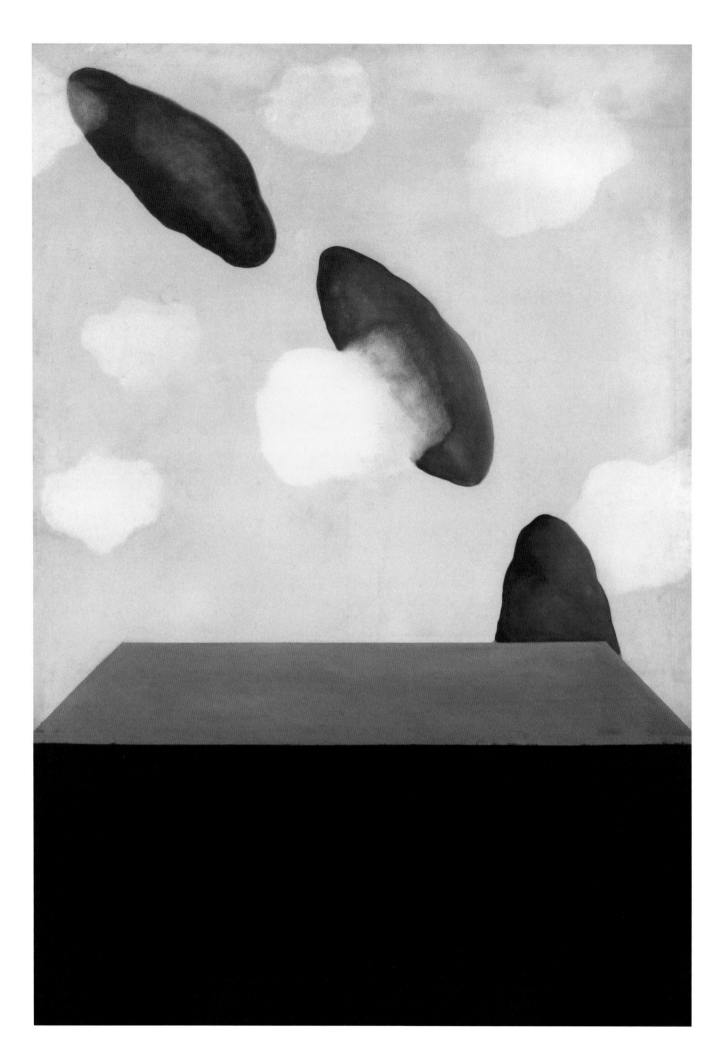

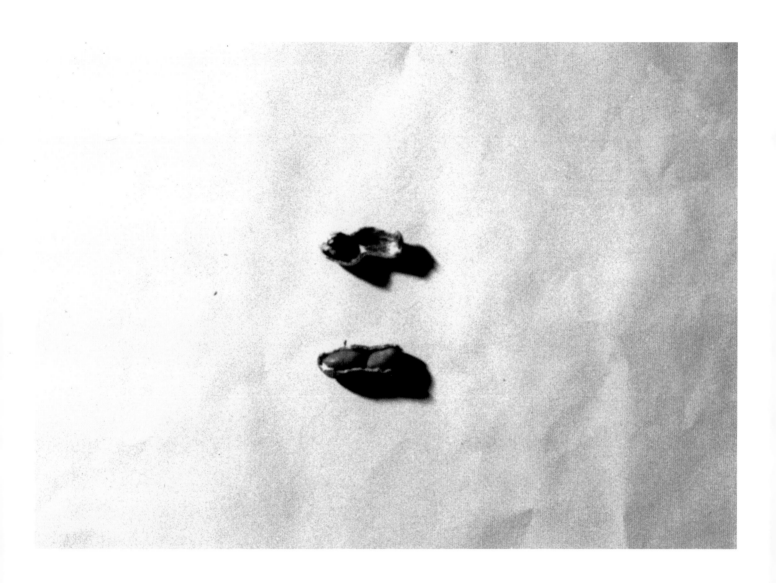

Opposite: *Black Clouds Coming,* 1970
Oil on canvas, 200 × 140 cm

Cloud with its Shadow, 1970
One peanut, two pins, ca. 8 × 4 × 1 cm

The Tree, 1971/2017
Sound environment, 10:00 min, loop
The park at Louisiana Museum of Modern Art, Humlebæk, Denmark

Metronome, 1971
Sound environment, metronome, 22 × 11 × 11.5 cm

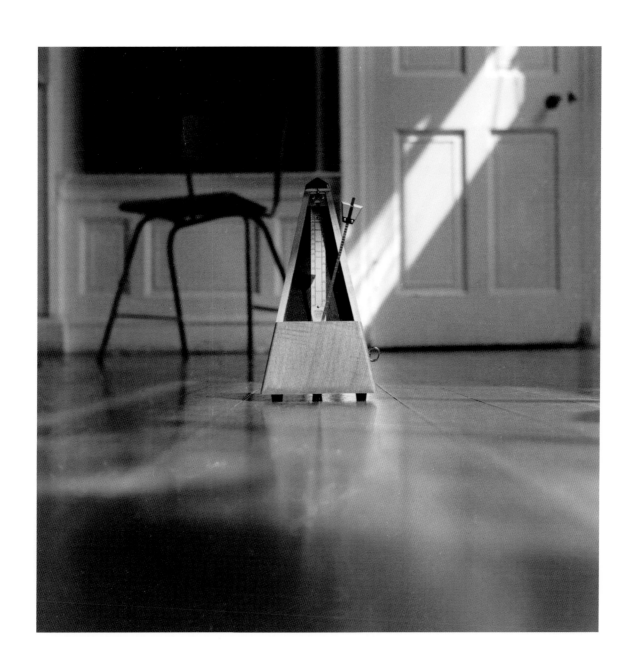

Freeing the Horizon

I photographed the important buildings
of central Belgrade.
Then I removed the buildings from the
photographs, freeing the horizon.

I made a slide installation in an oval room
with eight slide projectors, showing the
360-degree perspective.

Looking back at this piece, I was struck
by the realization that some of the
buildings from this project had been
bombed and destroyed during the war
in 1999.

Performance
Duration: 3 hours
Student Cultural Center (SKC), Belgrade, 1975

Freeing the Horizon, 1971
29 paintings on Agfa color prints, each 7.8 × 10.6 cm

The Airport

Instructions for the public:
All passengers on the JAT flight are
requested to go to gate 343.
The plane is leaving immediately for
Tokyo, Bangkok, and Hong Kong.

The Airport is a historical sound
environment that I first realized at
Belgrade's Student Cultural Center
(SKC) in 1972.
The work then consisted of a single
loudspeaker installed in the common
social area of the building.
At looped intervals, my voice could be
heard announcing flight departures
throughout the day.

Sound environment
Student Cultural Center (SKC), Belgrade, 1972

The Airport, 1972/2017
Sound environment, loop

Sound Environment—Sea

I produced a record of the sound
of the sea

45 rpm record sleeve
Belgrade, 1972

Sound Environment—Sea, 1972
45 rpm record and sleeve, 17.8 × 17.8 cm

Галерија Студентског културног Центра
Gallery of Student Cultural Center
11000 Beograd, Maršala Tita 48

SUUND ENVIRONMENT-SEA
ZVUČNI AMBIJENT-MORE
1972.
BEOGRAD
YUGOSLAVIJA

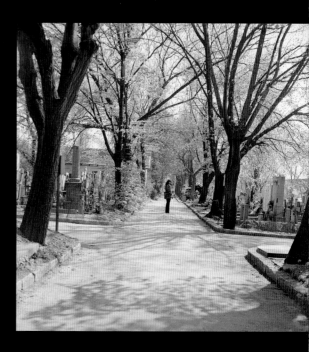

Coming and Going, 1973/2017
Silver gelatin prints; 9 photographs;
each 18 × 18 cm

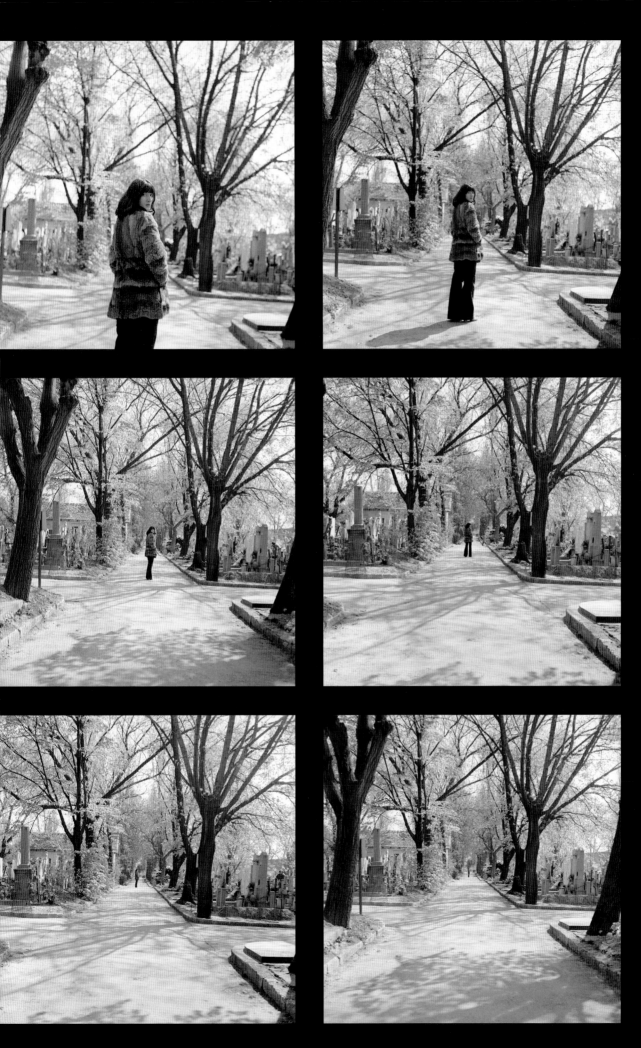

Rhythm 10

I place a white sheet of paper on the floor.
I place 20 knives of different sizes and
shapes on the paper.
I place 2 tape recorders with microphones
on the floor.
I turn on the first tape recorder.
I take the first knife and stab in between
the fingers of my left hand as fast
as possible.
Every time I cut myself, I change the knife.
When I've used all of the knives (all the
rhythms), I rewind the tape recorder.
I listen to the recording of the first part
of the performance.
I concentrate.
I repeat the first part of the performance.
I take the knives in the same order, follow
the same order, follow the same rhythm,
and cut myself in the same places.
In this performance the mistakes of time
past and the time present are
synchronized.
I rewind he second tape recorder and
listen to the double rhythm of the knives.
I leave.

Performance
Duration: 1 hour
Museo d'Arte Contemporanea Villa Borghese,
Rome, 1973

Rhythm 10, 1973/2010
Silver gelatin prints, text
21 photographs; overall dimensions:
124.5 × 898 cm (framed); text: 21.6 × 27.9 cm

Rhythm 10, 1973/2017
Sound installation, loop

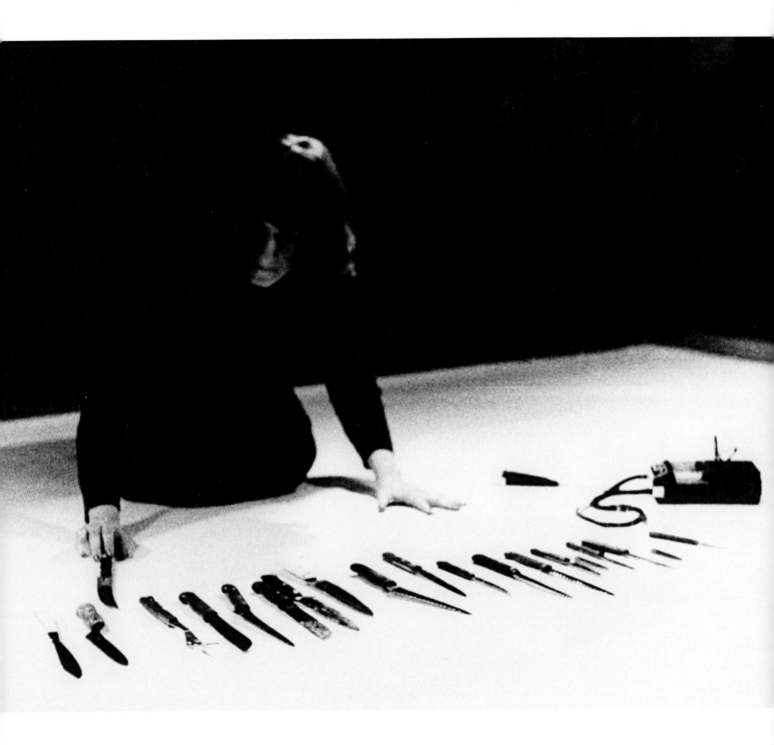

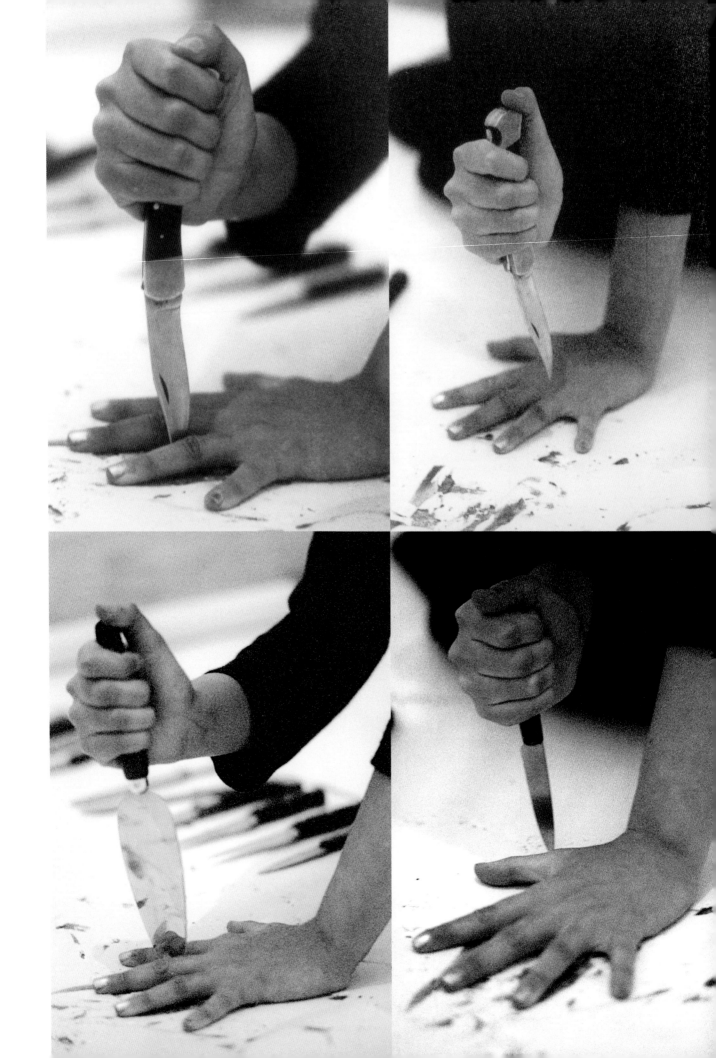

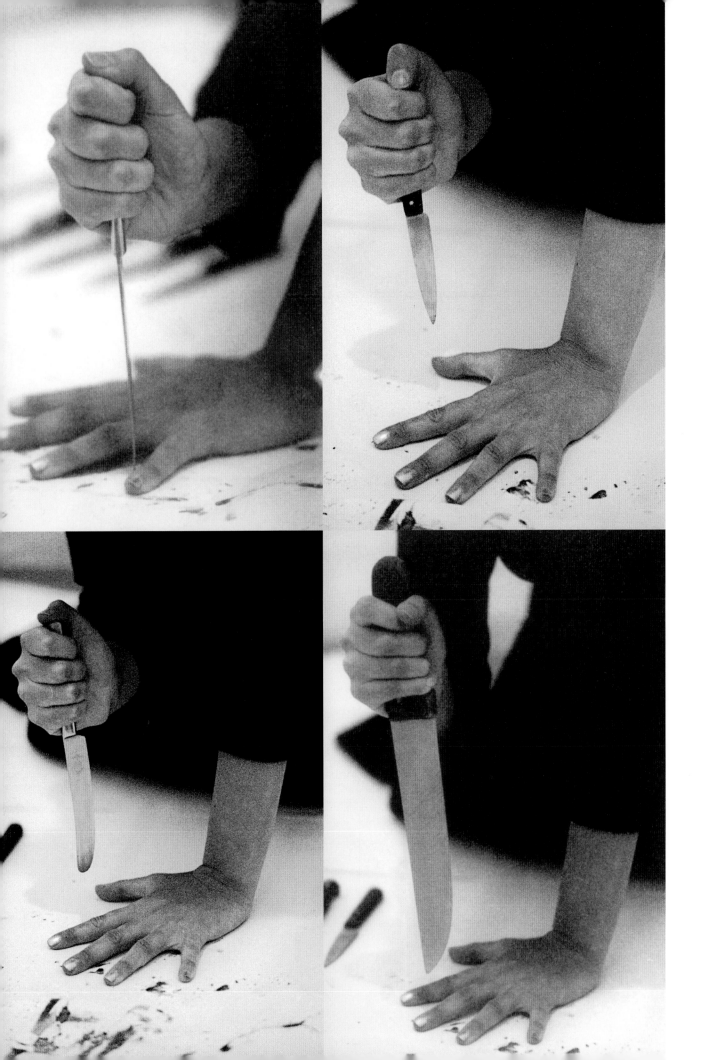

Rhythm 5

I construct a five-pointed star. The construction is made in wood shavings soaked in 100 liters of petrol.

I light the star. I walk around the star. I cut my hair and throw it into each end of the star. I cut my fingernails and throw them into each end of the star. I enter the empty space in the star and lie down.
I don't realize the fire has consumed all of the oxygen when I lay down in the star.
I lose consciousness. Because I am lying down the public does not react.

When a flame touches my leg and I still don't react, two people from the public enter the star and carry me out.

The performance is interrupted.

Performance
Duration: 90 minutes
Student Cultural Center (SKC), Belgrade, 1974

Rhythm 5, 1974/2011
Silver gelatin print, text panel
8 prints; overall dimensions: 125 × 908 cm (framed); text: 21.6 × 27.9 cm

Rhythm 5, 1974
8 mm film transferred to digital video (b/w, no sound), 8:12 min

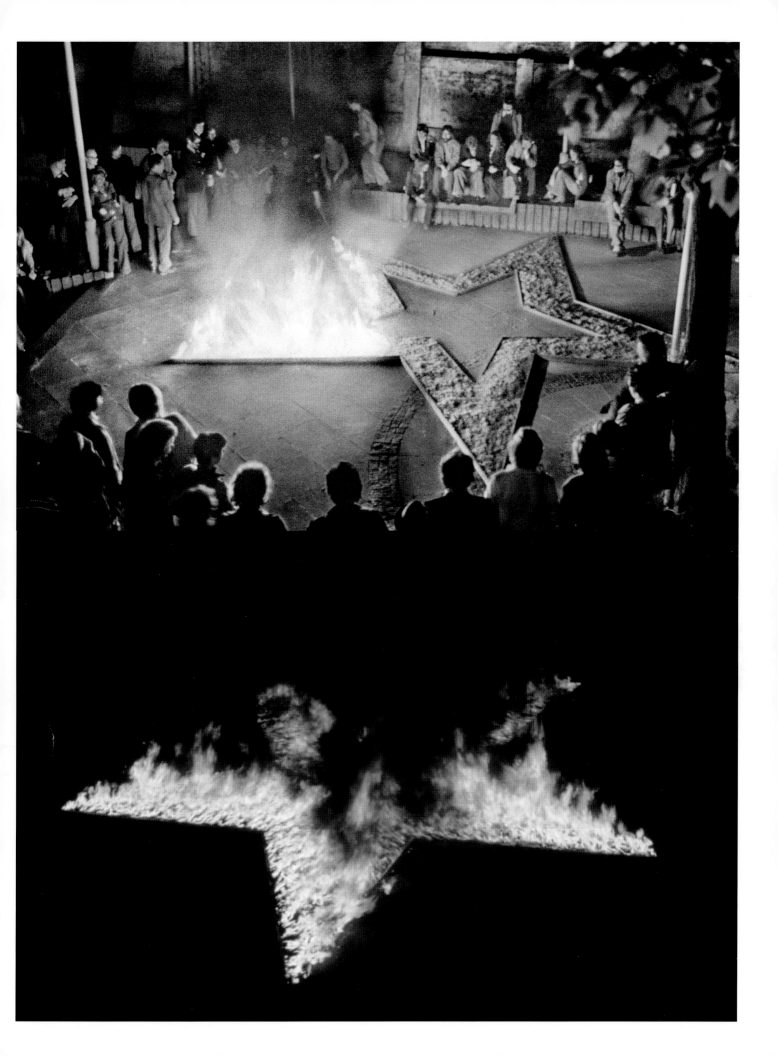

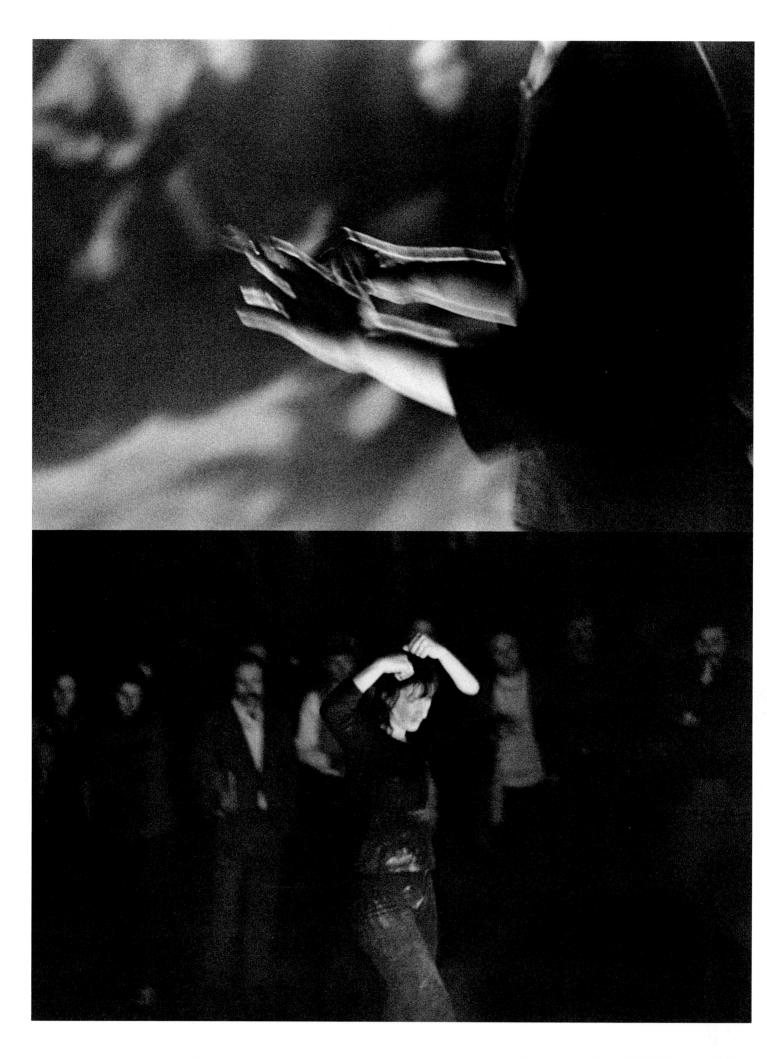

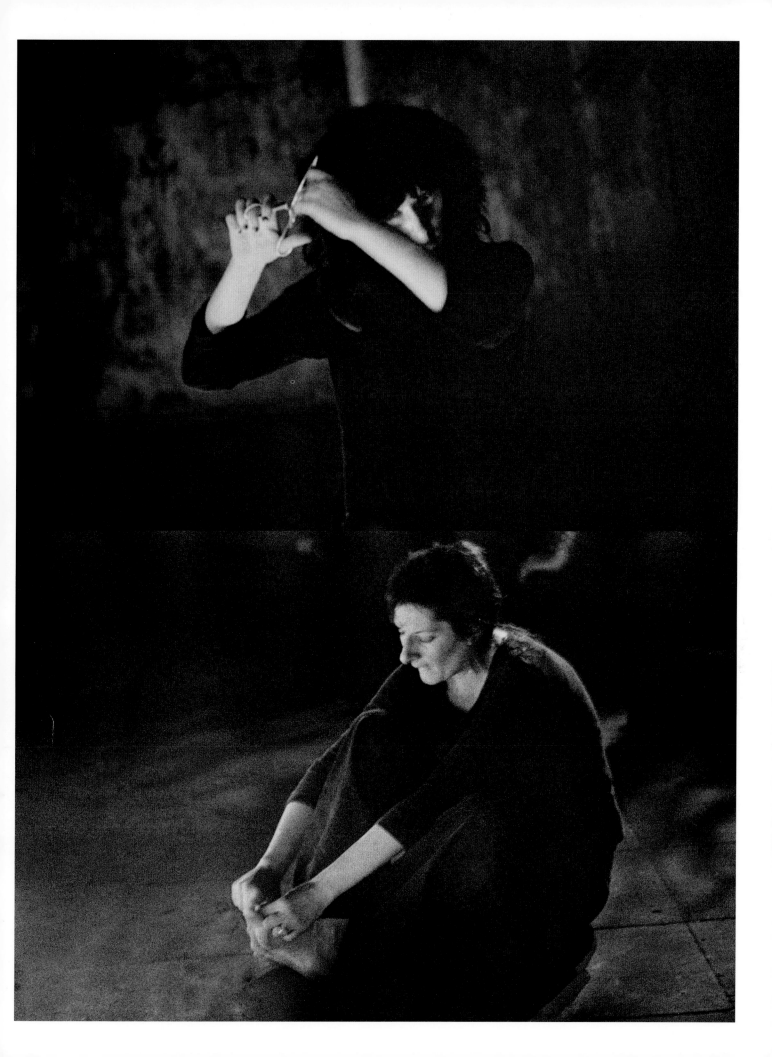

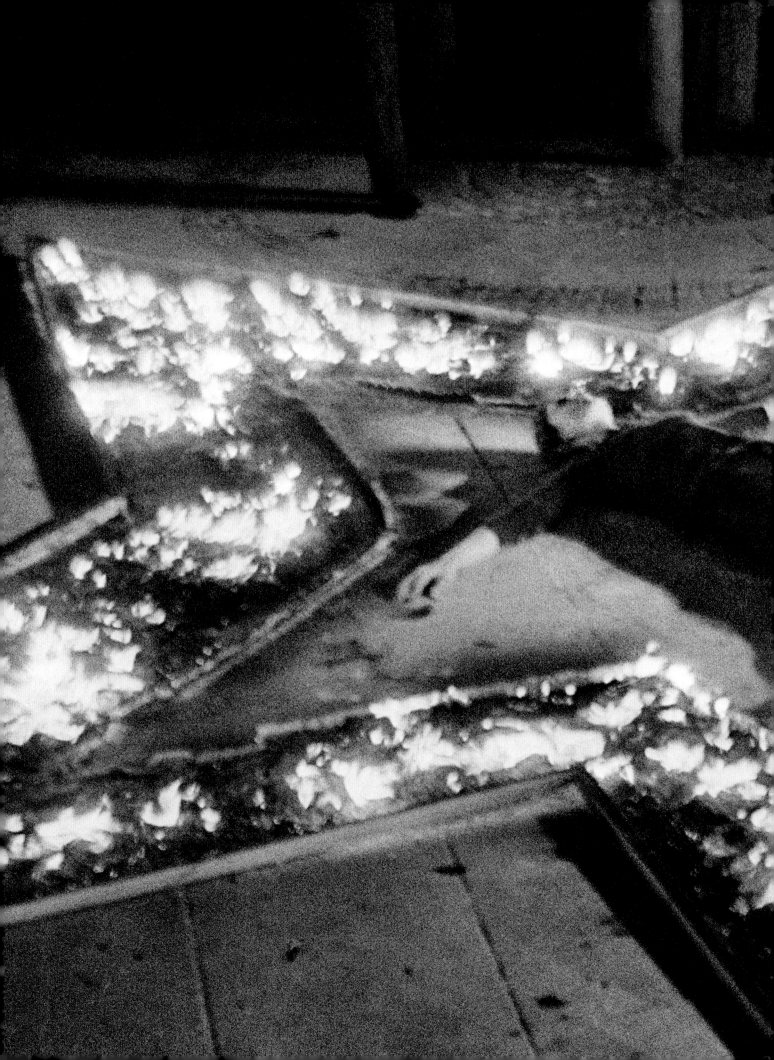

Rhythm 2

I use my body for an experiment.
I take the medication used in hospitals
for the treatment of acute catatonia and
schizophrenia, which puts my body in
unpredictable states.

Part I
Facing the public, I take the first
medication.

This medication is given to patients who
suffer from catatonia to force them to
change the positions of their bodies.
Shortly after taking the medication, my
muscles begin to contract violently, until
I completely lose control.
Consciously I am very aware of what is
going on but I can't control my body.

Performance
Duration: 50 minutes

Break
I turn the radio to a random station.
While preparing for the second part,
the public listen to Slavic folksongs
on the radio.

Duration: 10 minutes

Part II
Facing the public, I take the second
medication.

This medication given to schizophrenic
patients with violent behavior disorders
to calm them down.
Shortly after taking the medication, I first
feel cold and then completely lose
consciousness, forgetting who and
where I am.
The performance finishes when the
medication loses its effect.

Performance
Duration: 6 hours
Galerija Suvremene Umjetnosti, Zagreb, 1974

Rhythm 2, 1974/1994
Silver gelatin print, letterpress text panel
Two photographs; each 100 × 76 cm (framed); text: 26 × 18 cm

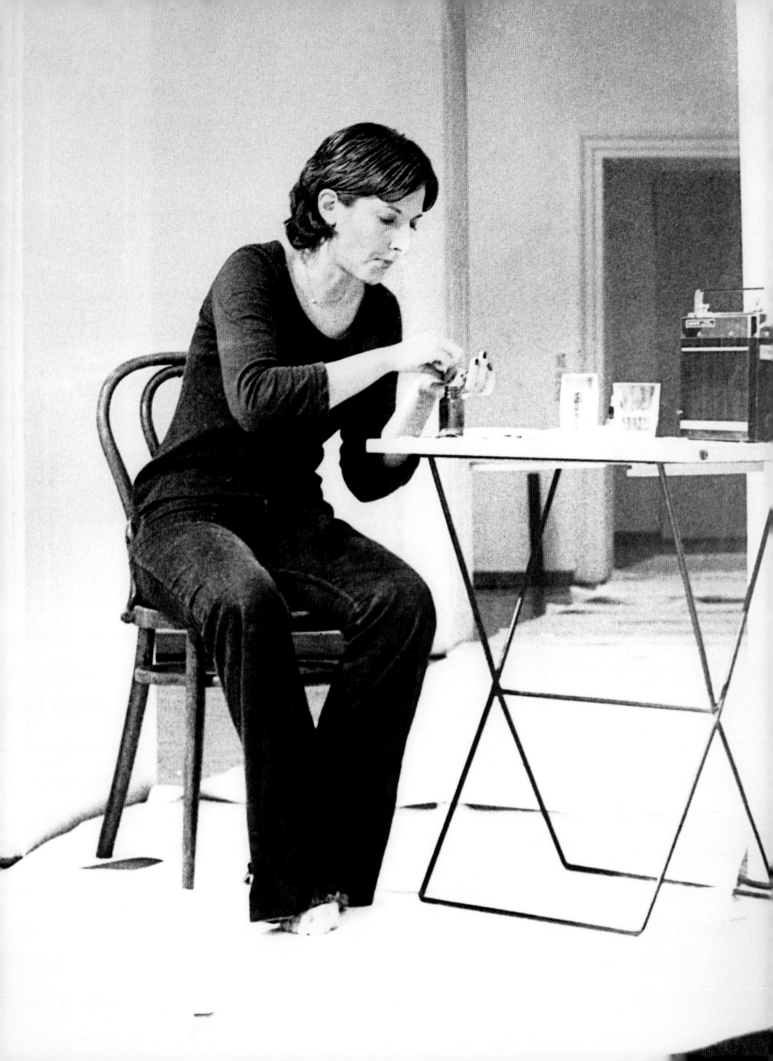

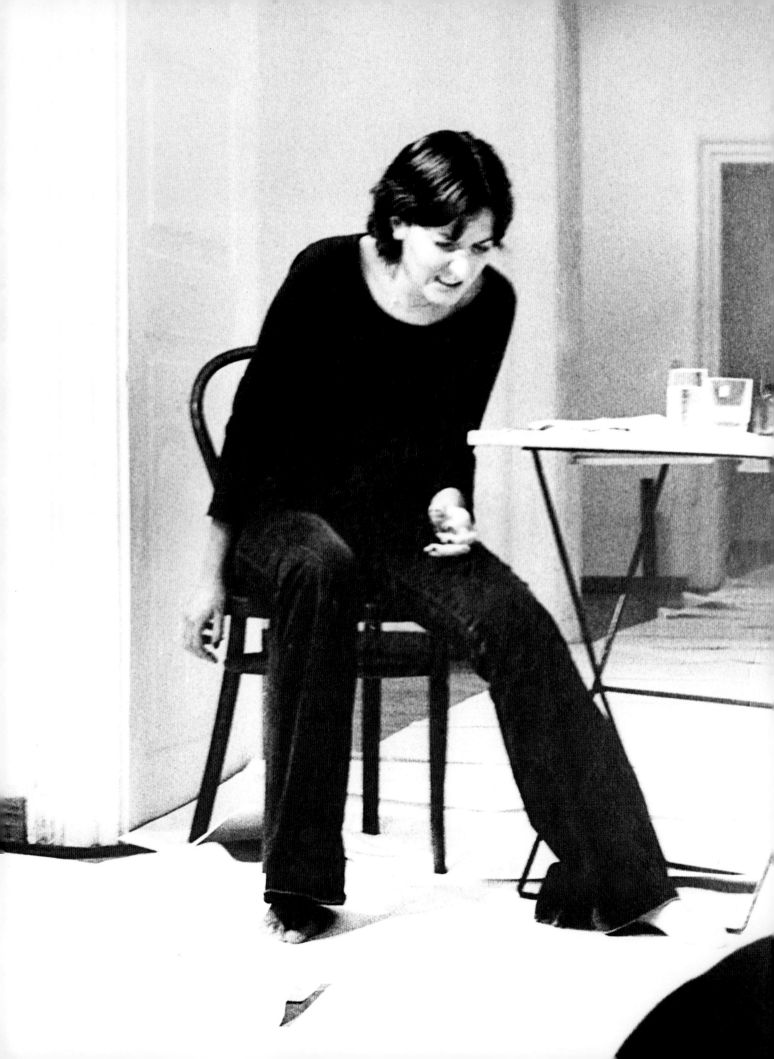

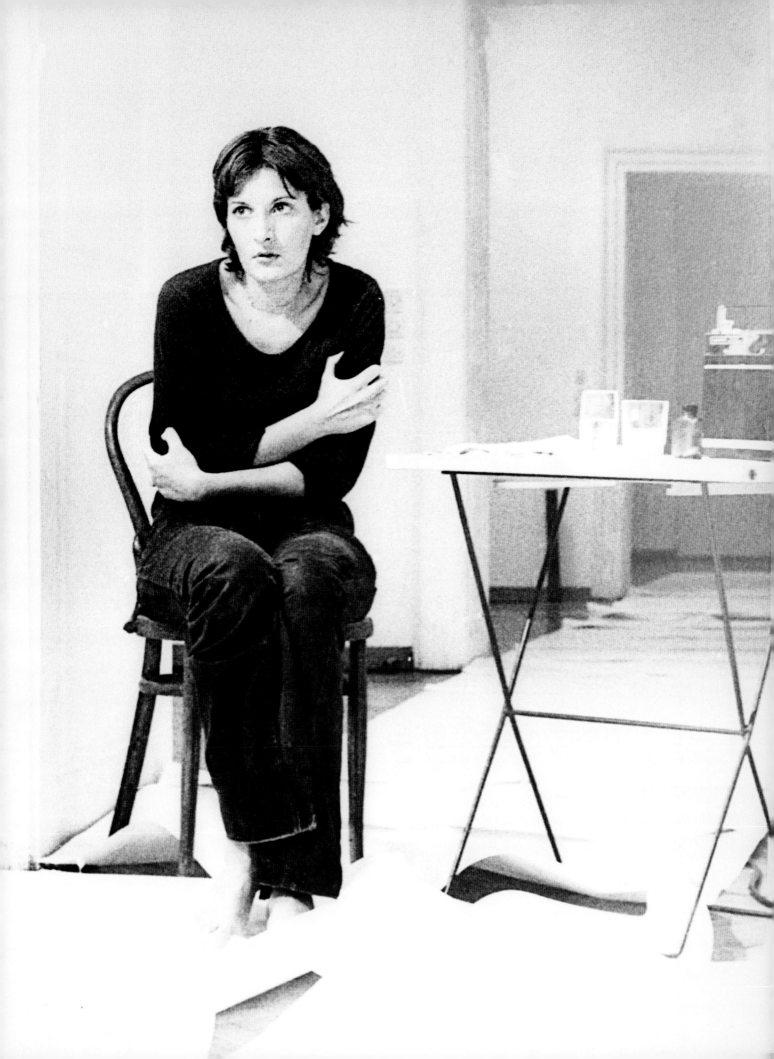

Rhythm 4

Space A

I slowly approach the industrial fan,
taking in as much air as possible.
As I reach I the opening of the blower,
I lose consciousness because of the
extreme air pressure.
This does not interrupt the performance.
After falling sideways onto the floor, the
blower continues to change and move
my face.

Space B

The video camera is focused on my face
and does not show the fan.
The public, looking at the monitor, is given
the impression that I am underwater.

After I lose consciousness, the
performance continues for three more
minutes, during which time the public
is unaware of my state.

In the performance I succeed in using
my body in and out of consciousness
without interruption.

Performance
Duration: 45 minutes
Galleria Diagramma, Milan, 1974

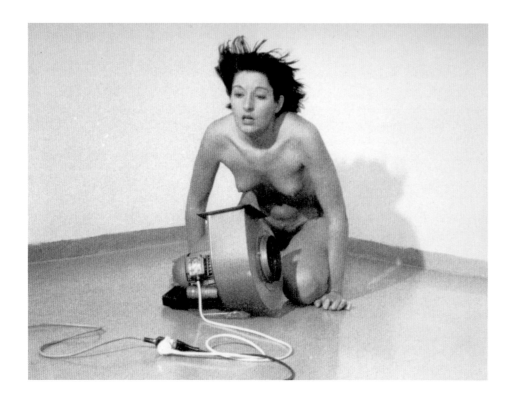

Rhythm 4, 1974
Silver gelatin print, letterpress text panel
76 × 100 cm (framed); text: 26 × 18 cm

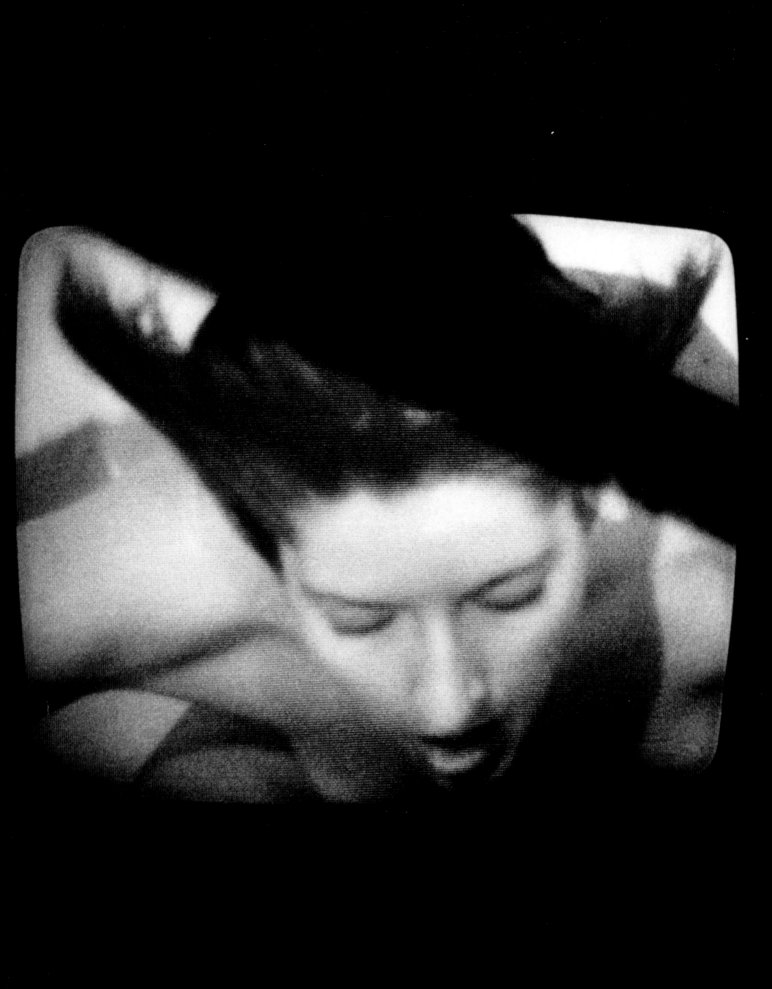

Rhythm 0

There are seventy-two objects on the table that one can use on me as desired.

I am the object.

During this period I take full responsibility.

This performance is the last in the cycle of rhythms (*Rhythm 10, Rhythm 5, Rhythm 2, Rhythm 4, Rhythm 0*).

I conclude my research on the body when conscious and unconscious.

Performance
Duration: 6 hours
Studio Morra, Naples, 1974

List of Objects on the Table

gun	needle	salt
bullet	safety pin	sugar
blue paint	hairpin	soap
comb	brush	cake
bell	bandage	metal pipe
whip	red paint	scalpel
lipstick	white paint	metal spear
pocket knife	scissors	box of razor blades
fork	pen	dish
perfume	book	flute
spoon	hat	band aid
cotton	handkerchief	alcohol
flowers	sheet of white paper	medal
matches	kitchen knife	coat
rose	hammer	shoes
candle	saw	chair
water	piece of wood	leather strings
scarf	ax	yarn
mirror	stick	wire
drinking glass	bone of lamb	sulphur
polaroid camera	newspaper	grapes
feather	bread	olive oil
chains	wine	rosemary branch
nails	honey	apple

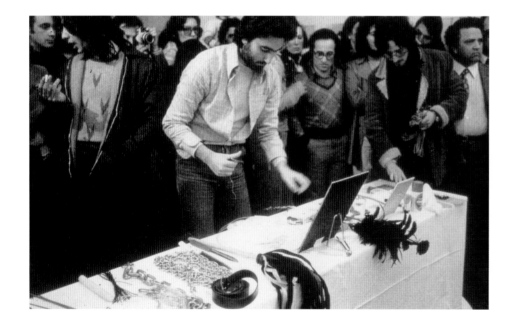

Rhythm 0, 1974
Slide show, table with 72 objects, text panel
Dimensions variable

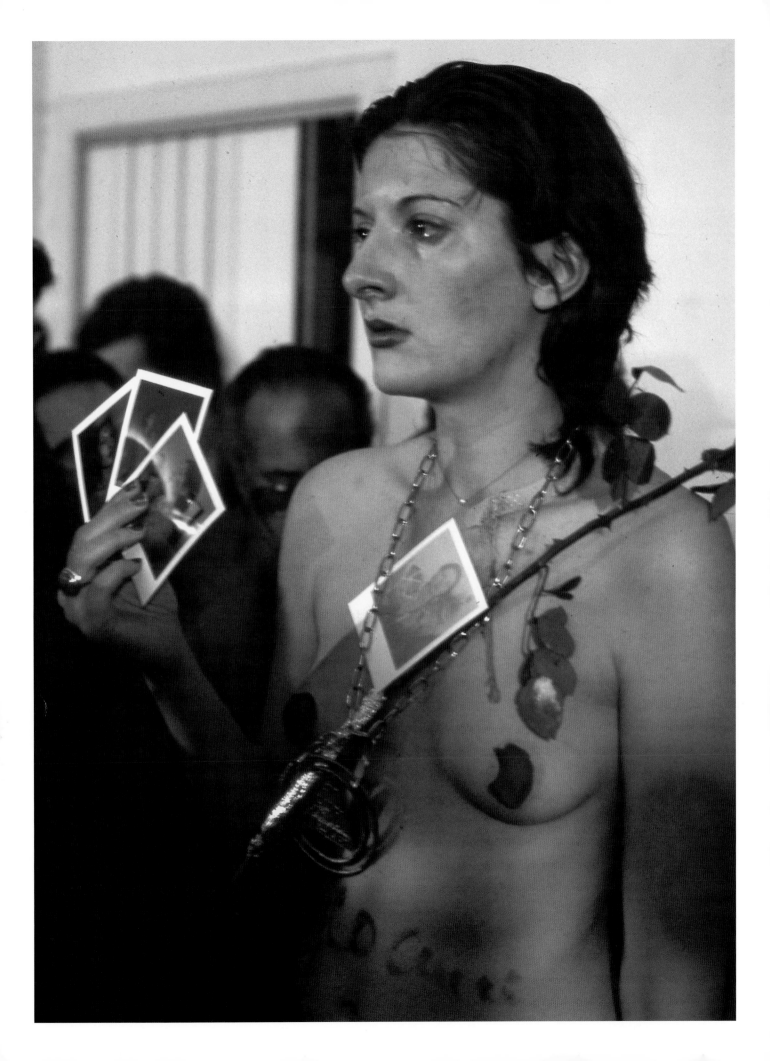

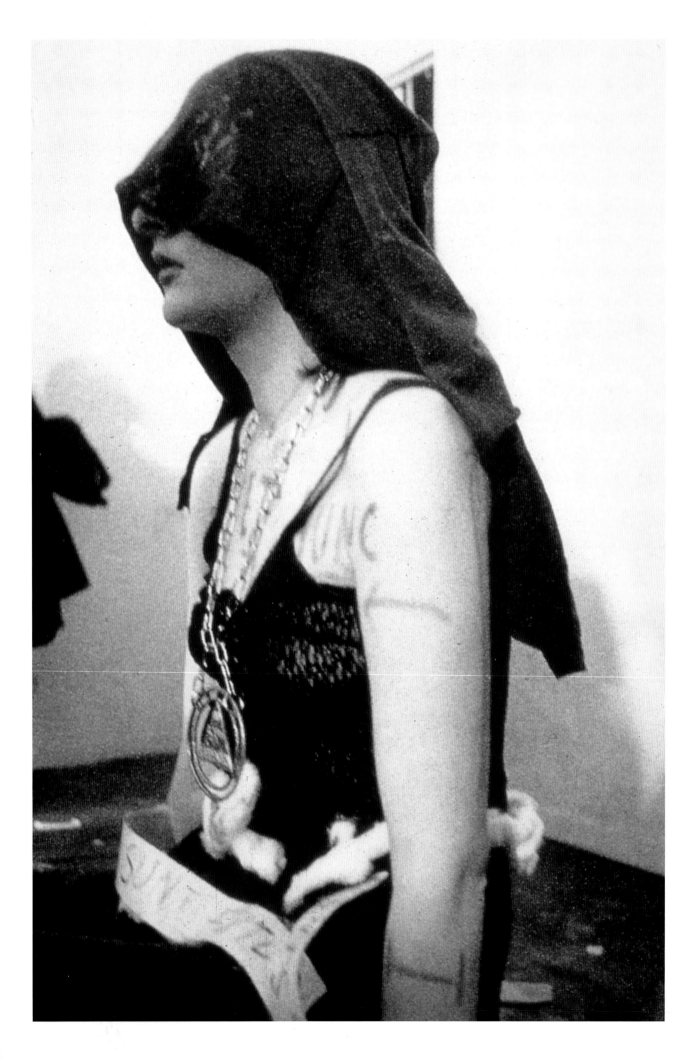

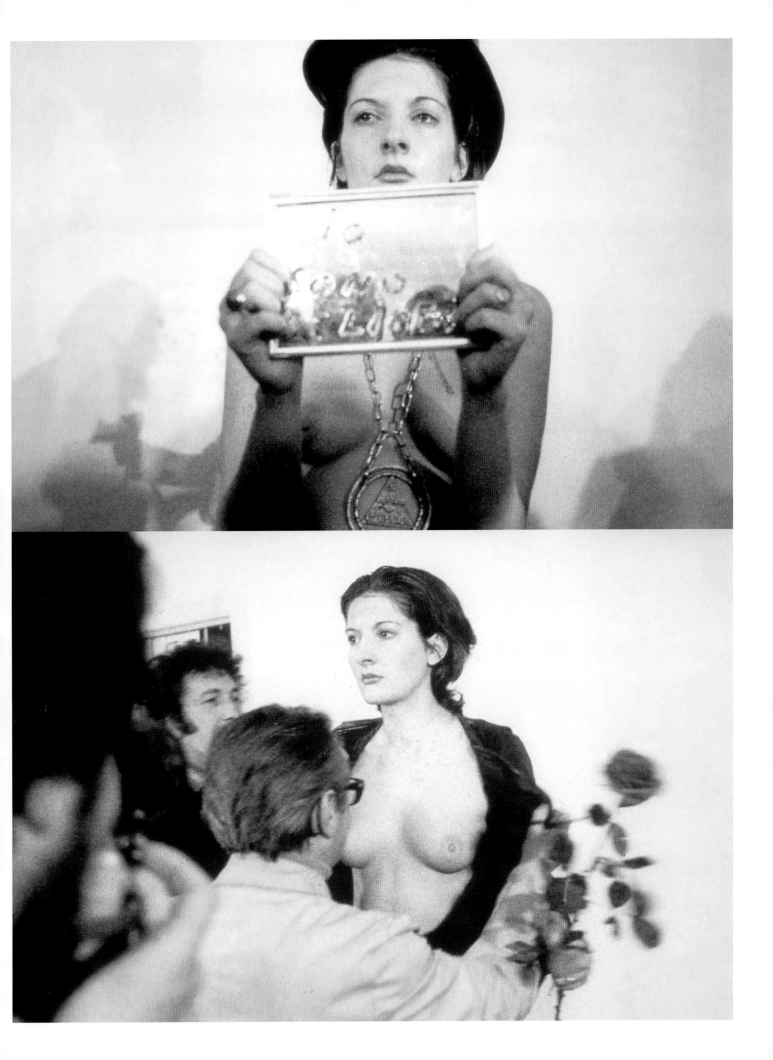

Lips of Thomas

I slowly eat 1 kilo of honey with a
silver spoon.

I slowly drink 1 liter of red wine out of
a crystal glass.

I break the glass with my right hand.

I cut a five-pointed star on my stomach
with a razor blade.

I violently whip myself until I no longer
feel any pain.

I lay down on a cross made of ice blocks.

The heat of a suspended heater pointed
at my stomach causes the cut star
to bleed.

The rest of my body begins to freeze.

I remain on the ice cross for thirty
minutes until the public interrupts
the piece by removing the ice blocks
from underneath me.

Performance
Duration: 2 hours
Krinzinger Gallery, Innsbruck, 1975

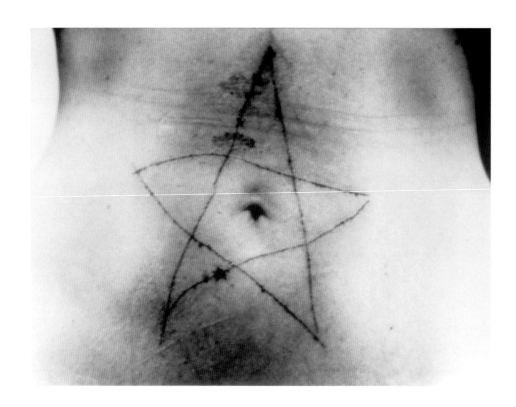

Lips of Thomas, 1975/2017
Slide show, cross made of ice, wine bottle, wine glass, whip, honey, silver spoon,
razor blades, wooden table, wooden chair, white table cloth, overhead metal heating lamp
Dimensions variable

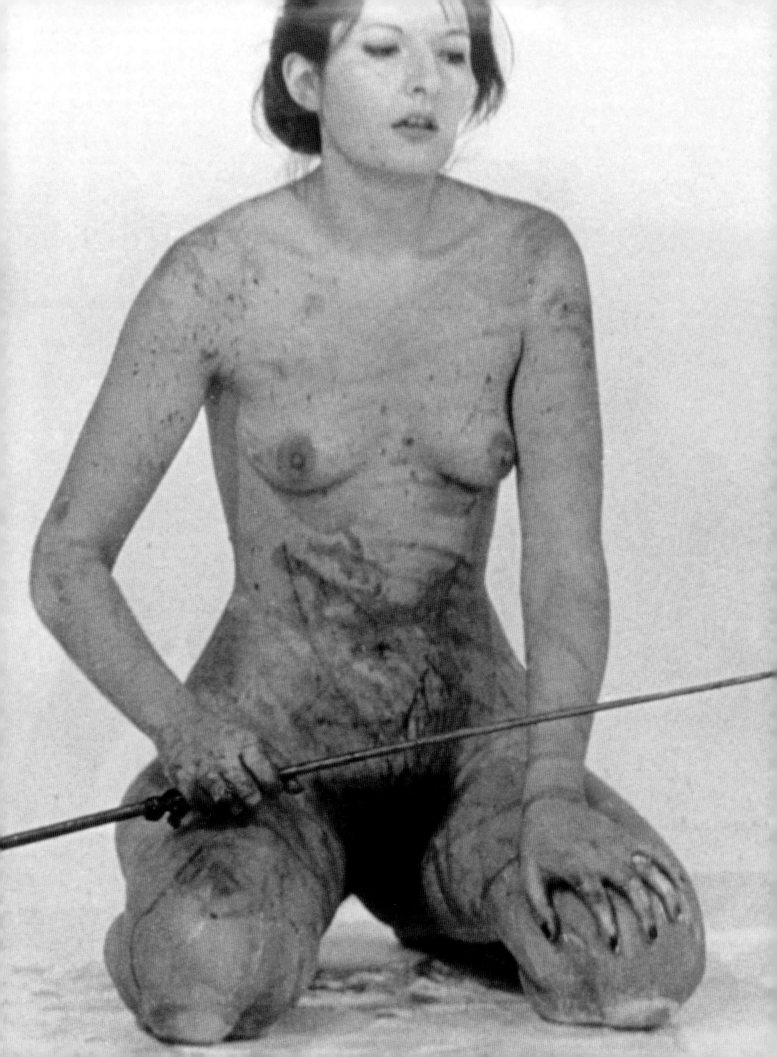

Art Must Be Beautiful,
Artist Must Be Beautiful

I brush my hair with a metal brush in my
right hand and simultaneously comb
my hair with a metal comb in my left
hand. While doing so, I continuously
repeat "Art must be beautiful, artist must
be beautiful" until I hurt my face and
damage my hair.

Performance
Duration: 1 hour
Kvindeudstillingen, Charlottenborg,
Copenhagen, 1975

Art Must Be Beautiful, Artist Must Be Beautiful, 1975
Video (b/w, sound), 23:36 min

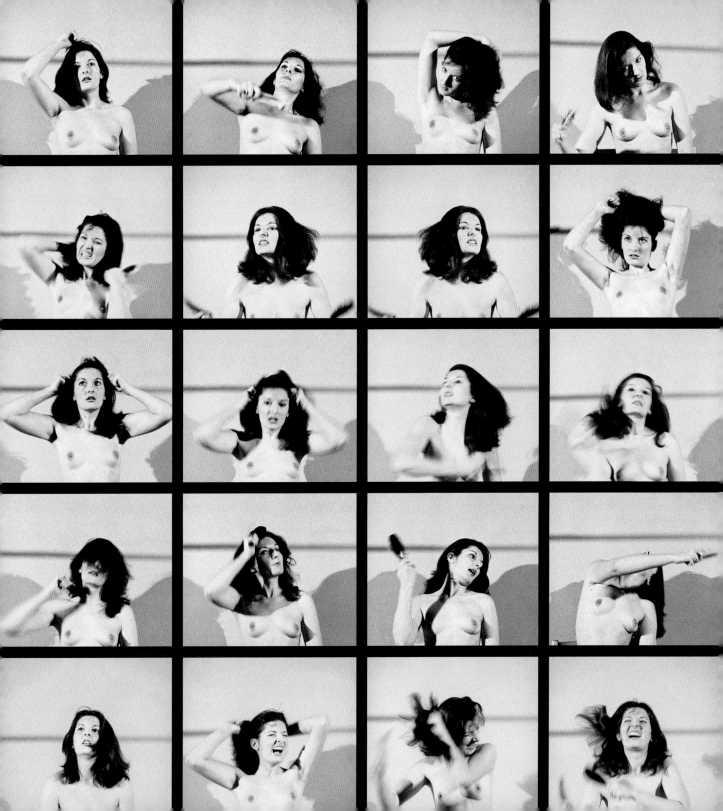

Role Exchange

I find a woman who has worked as a professional prostitute for ten years.

At this point I have also worked as an artist for ten years.

I propose to exchange roles.

She accepts.

Performance.

The woman replaces me at my opening at the De Appel Arts Centre in Amsterdam.

At the same time I sit in her place in a window of the red light district in Amsterdam.

We both take total responsibility for our roles.

Performance
Duration: 4 hours
De Appel Arts Centre and Red Light District,
Amsterdam, 1975

Role Exchange, 1975/1995
Silver gelatin print, letterpress text panel
Diptych; each photograph: 76 × 100 cm; text: 26 × 18 cm

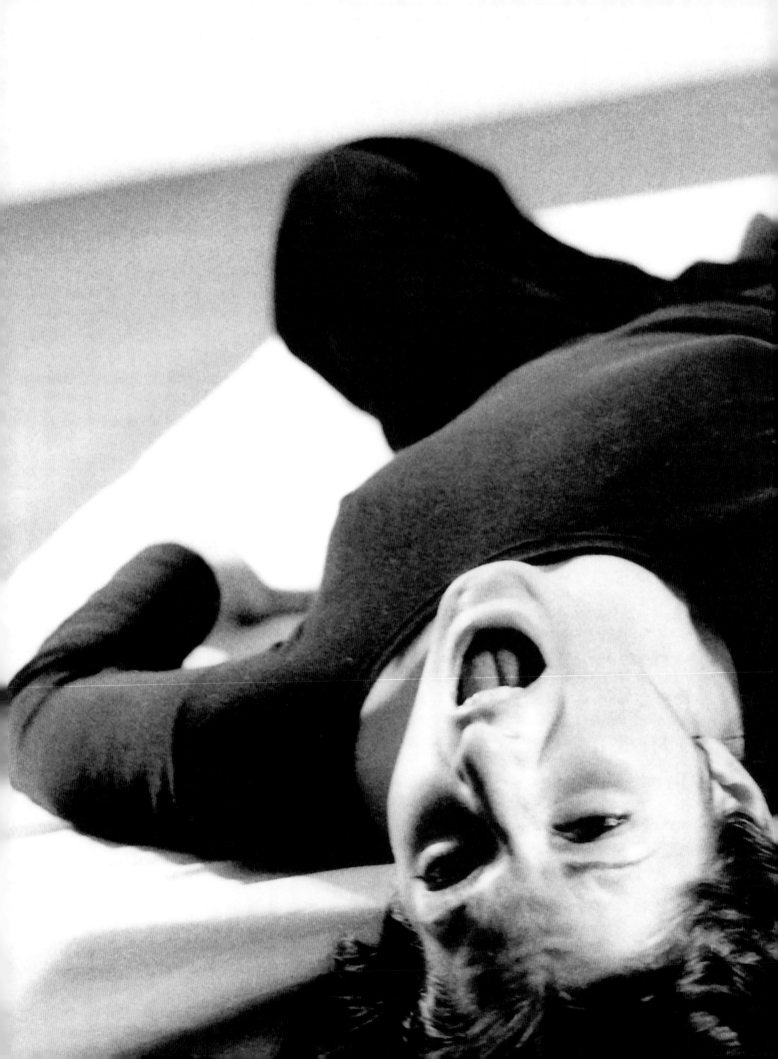

Freeing the Voice

I lie on the floor with my head tilted backwards.
I scream until I lose my voice.

Performance
Duration: 3 hours
Student Cultural Center (SKC), Belgrade, 1975

Freeing the Voice, 1975
Video (b/w, sound), 35:26 min

Freeing the Memory

I sit on a chair with my head tilted
backwards.

Without stopping, I continuously speak
the words that come to mind.

When words no longer come to mind
the performance ends.

Performance
Duration: 1.5 hours
Dacić Gallery, Tübingen, 1975

Freeing the Memory, 1975
Video (b/w, sound), 50:17 min

relo,kucati,noge,cmar,nokat,stopala,cipele,peta,rahitis,tuberkolo
demija,lepra,grip,prehlada,koracati,soba,linoleum,stolica,fotelj
gistul,bronza,kvaka,metal,mladez,kljuc,zid,ugao,linija,til,organ
opikal,zavesa,grombi,skure,roletne,labirint,kvadrat,kandinski,cr
deo,Sony,Sany,koza,presvlaka,plastika,sat,zila kucavica,papagaj
kund,minut, ... da,ostava,slat

rhelada,kuhin ... enja pita,kva
cin,nestajan ... vlaznost,Ana
tanazija,raz ... rdura,blagos
nda Lee,Buk ... alidrvce,Pan
edeo,pejzaz, ... agovest,trava
tinje,korov ... ,kisa,orkan,
ce,roditelj, ... rvoprolice,p
stanak,arist ... cka drama,pr
ina,Rodos,os ... iti,rastrgnut
erezati,zile ... uti,popustiti
licija,zatvo ... dragulj,drag
aragd,cilibar ... rulet,nostal
eticno,pris ... ,imena,ljudi
oko,mladost, ... ada,putovati,
la,Folcvagen ... ,razmimoila
liticar,funk ... tasa,cetnik,
tralijanac, ... ai sada,Kirb
-Budizam,El ... ,opipljivost,
agocenost,le ... azduh,visorav
nja,grom,sev ... iti,zabranjen
nst-hale,pro ... a,krastavac,
erarhija,Obr ... aran,aligator
njaca,hilja ... a,Sutomor,sin
or,zatvoriti ... iknik,pikanta

ak,mitraljez,oruzje,top,kugla,metak,prodreti,puskarati,kometa,rah
soc,mladost,mesec,nikada,fotelja,dugme,prasina,Francuska opera,Bo
cu, odbiti,odbaciti,odraditi,radnik,nadnicar,kukuruz,kadilak,nes
tisak,cudo,cik,cicak,caroban,nedvosmislenost,jedva primetna pome
,grupa,demostracija,revolucija,sta,desavati,svetlucavo,sindikal
sanje,Karter,Ford,Filipini,fudamentalan,frizider,Zermen,Uwe,izgu
i,cist,mleko,ljubomora,sakal,sudoppra,deterdjent,plavi radion,op
ldozer,okreciti,gasiti,pozar,vatra,visestruk,vrednost,ukoriti,uci
ogamator,pleyboy,Pistoletto,prljavstina,Tubingen,Dacic,Ingrid,Jul
la,svetlo,prostor,kuda,detalj,ciniti,poplocan,kaldrma,antika,star
ipulacija,pokositi,seno,kosac,srp,cekic,zastava,petokraka,Holan
lapljivost,zedj,glad,povracati,prepisati,postici,kurac,Kladovo,kr
dnapovanje,mikrokosmos,mokar,macka,mis,magarac,Miodrag,manastir,
alje,Kristo,kukavica,golicati,ja,ti,mi,vi,oni,mnozina,latinski,l
garitam,srecka,kladjenje,grad,velegrad,New York,plakar,ostava,pr
rusiti,ves,gace,vuna,obradjena,bunda,lisica,srebro,zlato,olovo

Freeing the Body

I wrap my head in a black scarf.

I move to the rhythm of the black
African drummer.

I move until I am completely exhausted.
I fall.

Performance
Duration: 8 hours
Künstlerhaus Bethanien, Berlin, 1975

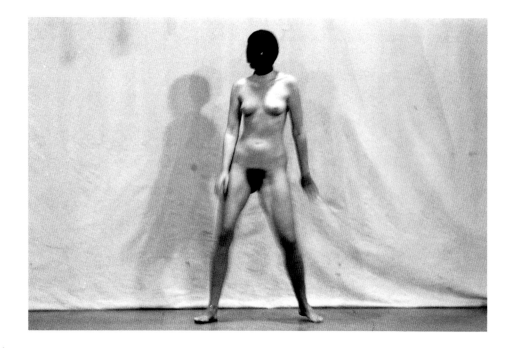

Freeing the Body, 1975
Video (b/w, sound), 51:41 min

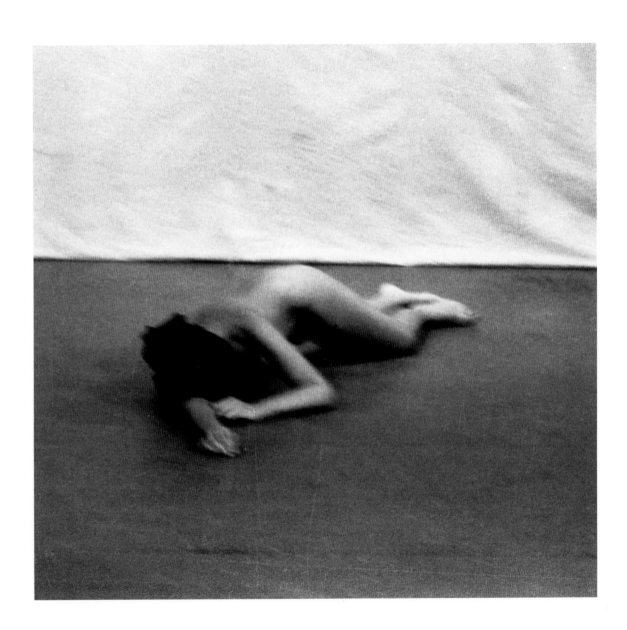

WORKS WITH ULAY
1976–1988

ART VITAL
NO FIXED LIVING PLACE
PERMANENT MOVEMENT
DIRECT CONTACT
LOCAL RELATION
SELF-SELECTION
PASSING LIMITATIONS
TAKING RISKS
MOBILE ENERGY

NO REHEARSAL
NO PREDICTED END
NO REPETITION
EXTENDED VULNERABILITY
EXPOSURE TO CHANCE
PRIMARY REACTIONS

Relation in Space

In a given space.

Two bodies repeatedly pass, touching
each other.
After gaining a higher speed they collide.

Performance
Duration: 58 minutes
35th Venice Biennale, Giudecca, July 1976
Visitors: 300

Ulay/Marina Abramović
Relation in Space, 1976
½" video transferred to digital video (b/w, sound), 59:28 min

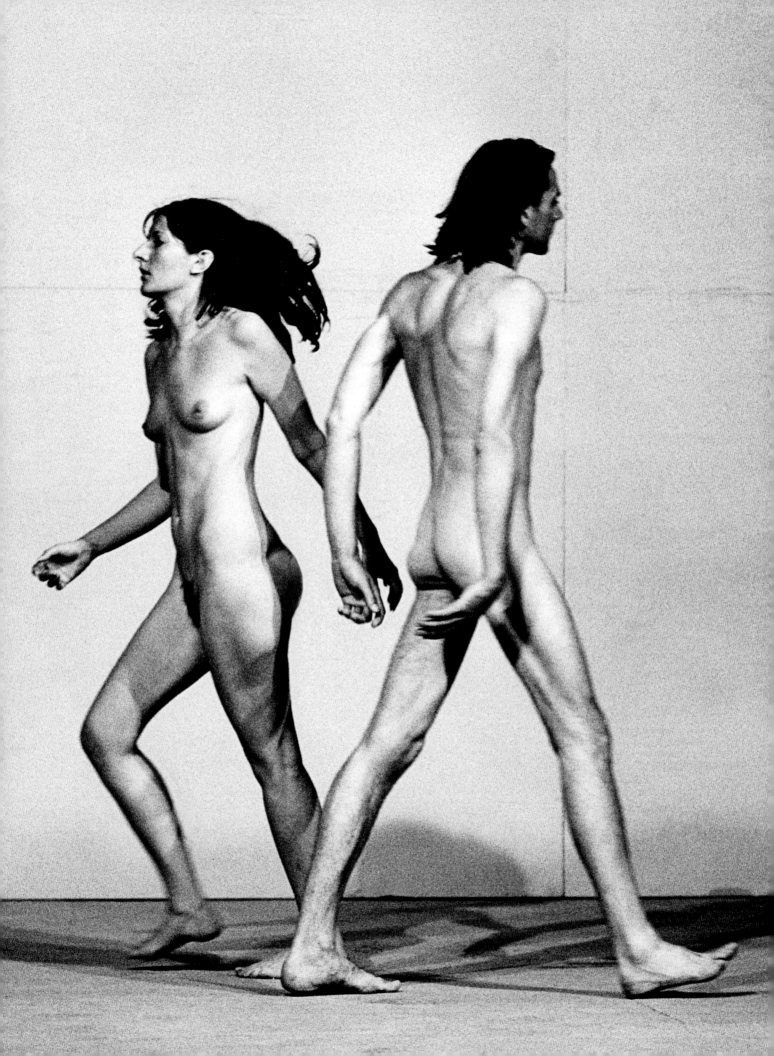

Breathing In/Breathing Out

In a given space.

We are kneeling face to face, pressing our
mouths together.
Our noses are blocked with filter tips.

Ulay
I am breathing in oxygen.
I am breathing out carbon dioxide.

Marina
I am breathing in carbon dioxide.
I am breathing out carbon dioxide.

Ulay
I am breathing in carbon dioxide.
I am breathing out carbon dioxide.

This performance was performed twice.
The first time Ulay started the
performance by breathing in oxygen.
The second time Ulay started the
performance by breathing out carbon
dioxide.

Performance
Duration: 19 minutes
Student Cultural Center (SKC), Belgrade, April 1977
Visitors: 250

Ulay/Marina Abramović
Breathing In/Breathing Out, 1977
½" video transferred to digital video (b/w, sound), 10:49 min

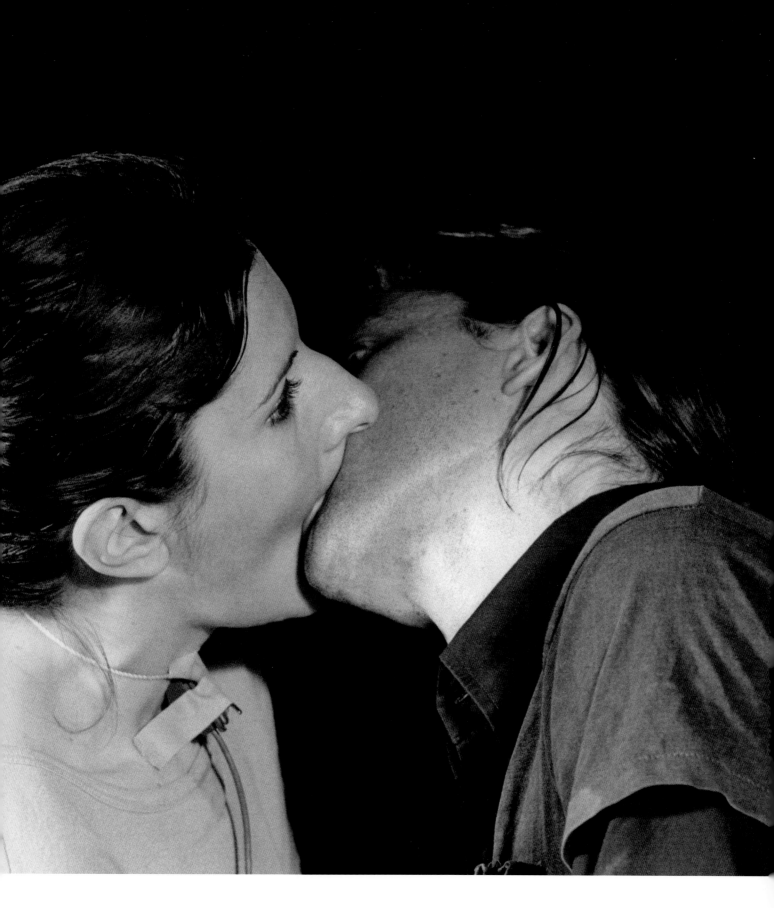

Imponderabilia

In a chosen space.

We are standing naked in the main
entrance of the museum, facing
each other.
The public entering the museum have
to pass sideways through the small
space between us.
Each person passing has to choose
which one of us to face.

Performance
Duration: 90 minutes
Galleria Comunale d'Arte Moderna
Bologna, June 1977
Visitors: 350

The performance was interrupted
and stopped by the police.

Text on the wall:
Imponderable.
Such imponderable human factors
as one's aesthetic sensitivity the
overriding importance of imponderables
in determining human conduct.

Ulay/Marina Abramović
Imponderabilia, 1977
½" video transferred to digital video (b/w, sound), 50:25 min

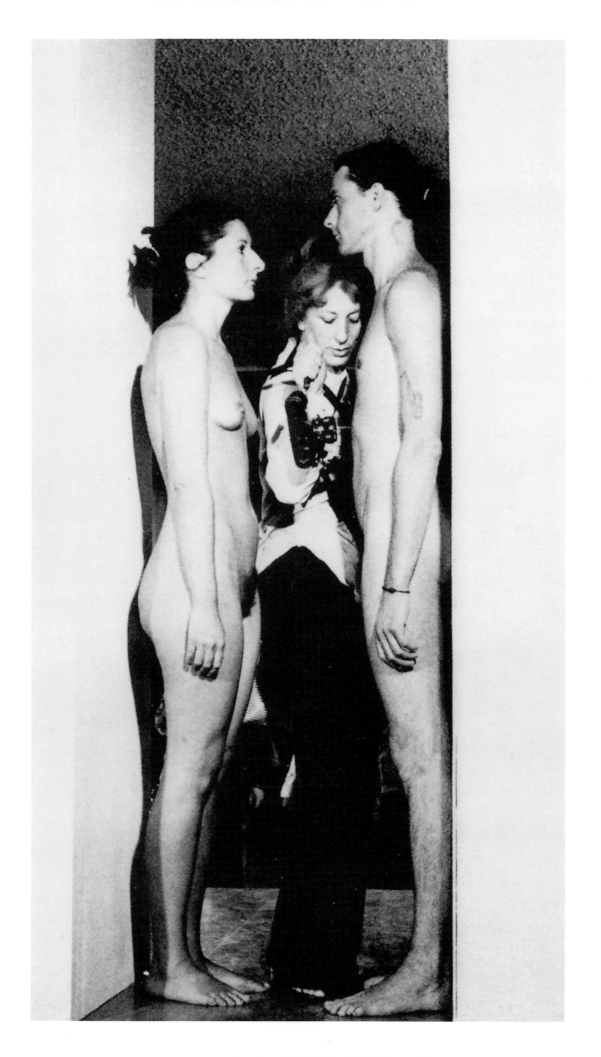

Expansion in Space

In a chosen space.

Two mobile columns are installed among
stationary columns.
The stationary and mobile columns look
identical.
The mobile columns are twice the weight
of our bodies.

We stand back to back between them.

We move simultaneously towards the
mobile columns hitting them repeatedly
with our bodies and moving them
towards the stationary columns.

Performance
Duration: 32 minutes
Documenta 6, Kassel, June 1977

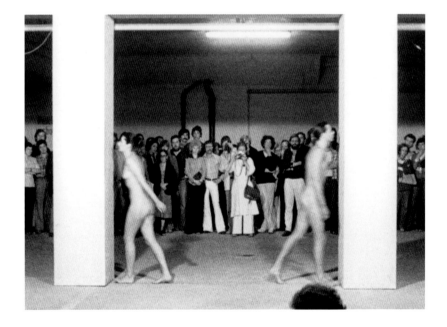

Ulay/Marina Abramović
Expansion in Space, 1977
½" video transferred to digital video (b/w, sound), 25:05 min

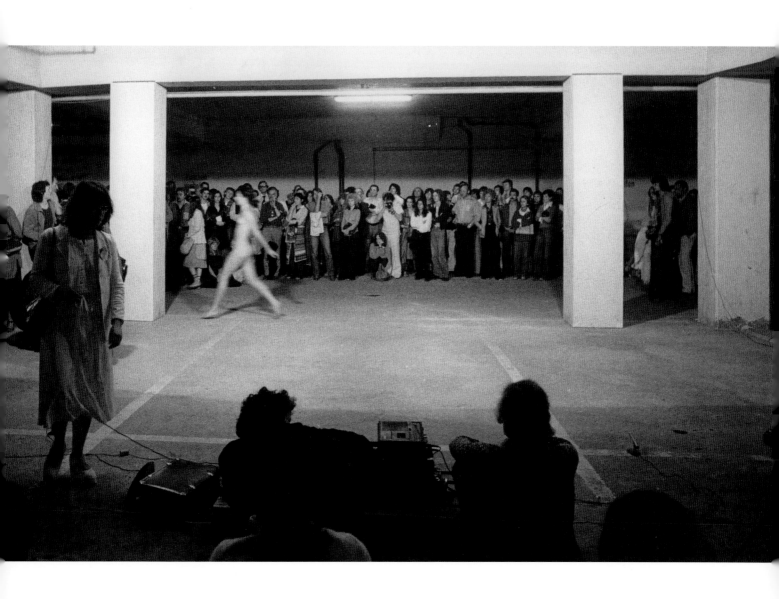

Relation in Movement

In a chosen space.

Ulay
I am driving the car for an indefinite time
in a circle.

Marina
I am sitting in the car, moving for an
indefinite time in a circle, announcing the
number of circles by megaphone.

Performance
Duration: 16 hours
10e Biennale de Paris, September 1977
Visitors: 200

Ulay/Marina Abramović
Relation in Movement, 1977
Analogue video transferred to digital video (b/w, silent), 34:19 min

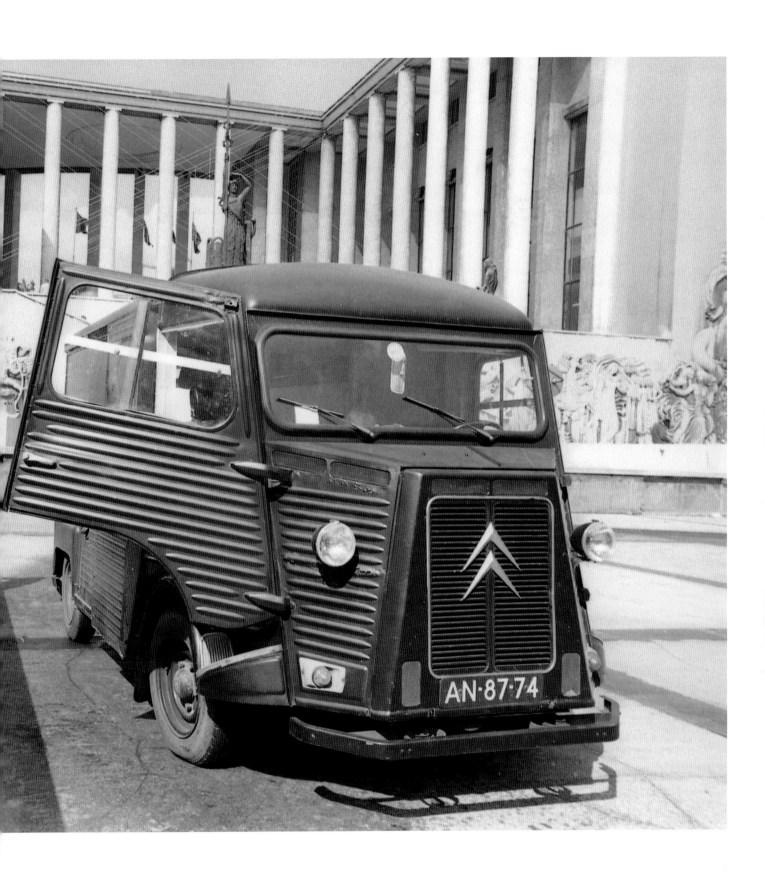

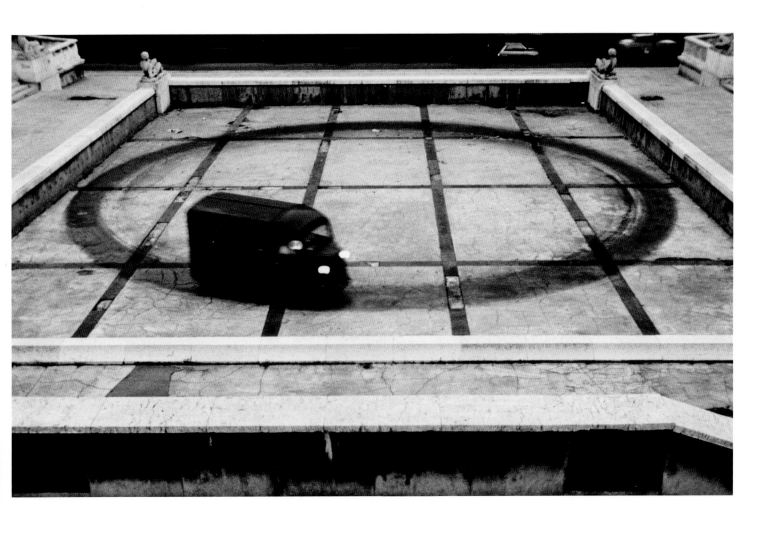

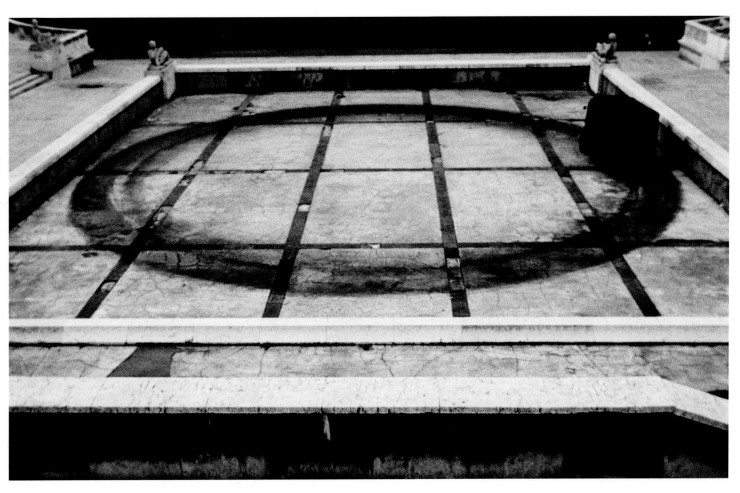

Light/Dark

In a given space.

We kneel, face to face.
Our faces are lit by two strong lamps.
Alternately, we slap each other's face until
one of us stops.

Performance
Duration: 20 minutes
Internationale Kunstmesse, Cologne, October 1977
Visitors: 70

Ulay/Marina Abramović
Light/Dark, 1977
16 mm film transferred to digital video (b/w, sound), 8:15 min

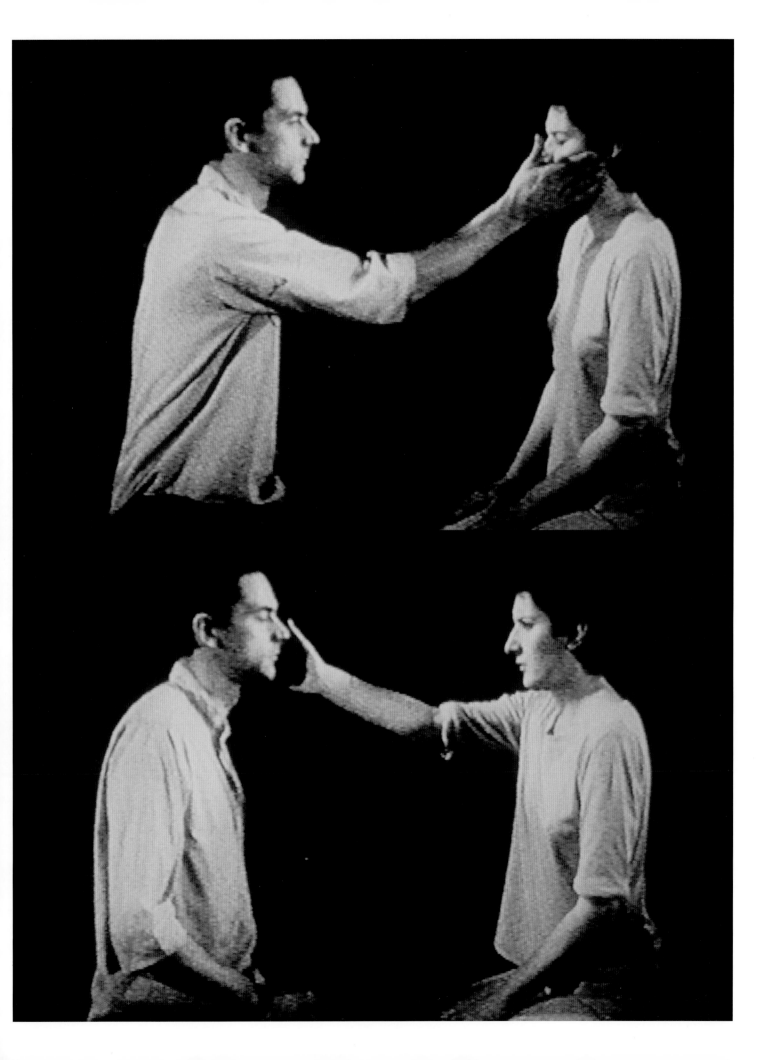

AAA-AAA

In a given space.

We are facing each other, both producing
a continuous vocal sound.
We are slowly building up the tension,
our faces coming closer together until
we are screaming into each other's
open mouths.

Performance
Duration: 15 minutes

RTB Television Studio, Liège, Belgium,
February 1978
Performed for television.

Amsterdam, March 1978
Performed for film.

Ulay/Marina Abramović
AAA-AAA, 1978
2" video transferred to digital video (b/w, sound), 12:57 min

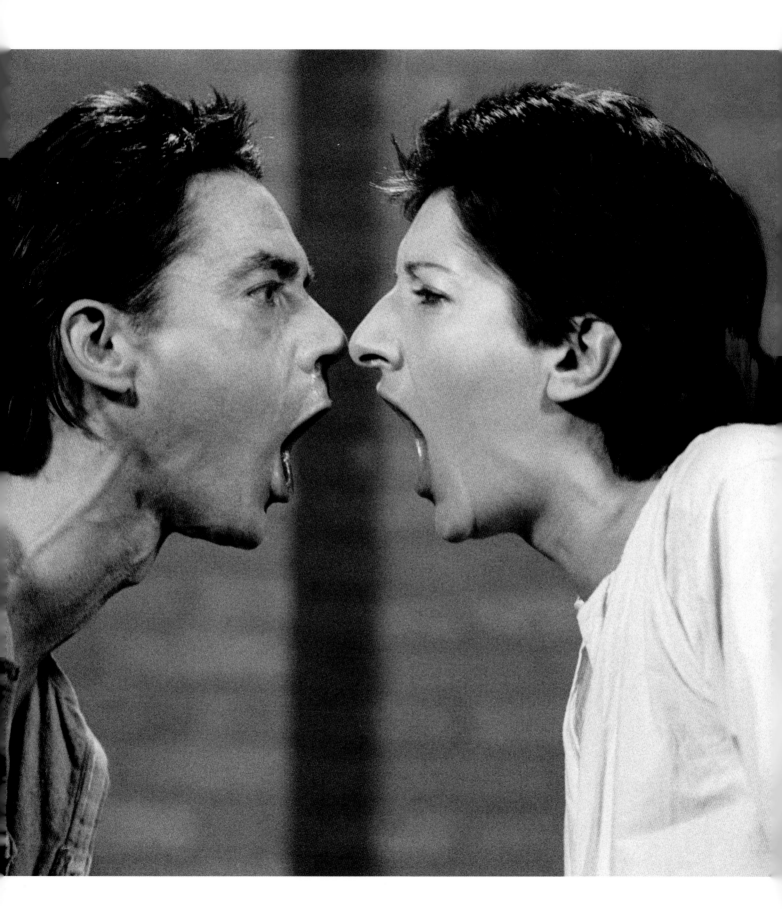

Installation Two

An electric hot plate is installed in the
center of the floor. Drops of water fall
continually from the center of the ceiling
on to the hot plate.

Duration: 33 days

Ulay/Marina Abramović
Installation Two, 1979/2017
Hot plate, water; dimensions variable

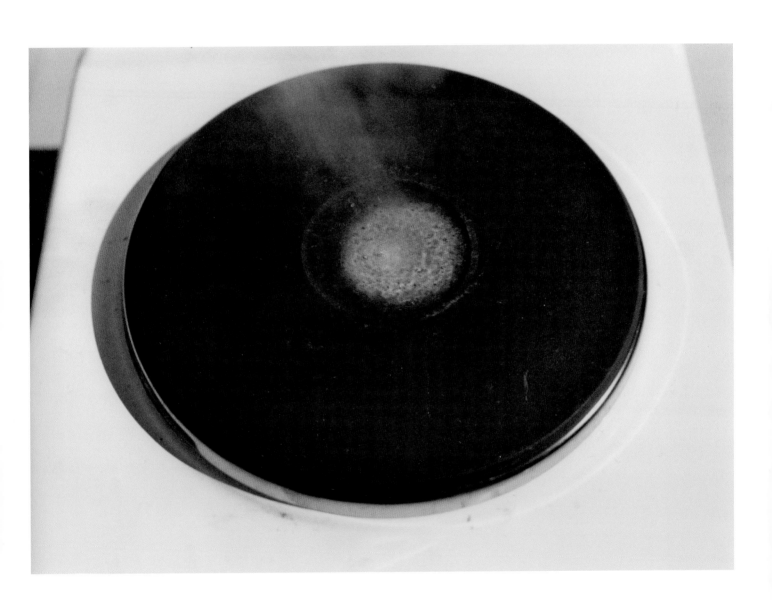

Rest Energy

Together we held a taut bow and a
poised arrow.
The weight of our bodies put tension
on the bow.
The arrow pointed at Marina's heart.

Small microphones were attached to
both our hearts recording the increasing
number of heartbeats.

Performance
Duration: 4 minutes, 10 seconds
ROSC'80, Dublin, August 1980
Visitors: 150

Ulay/Marina Abramović
Rest Energy, 1980
16 mm transferred to digital video (color, sound), 4:04 min

Everything Will Be Alight

Transcript of the soundtrack

Some of us are sentenced to death.
Our graves are ready.
They are shaped like shoe soles floating
on a river.
They are made out of some kind of
gray clay.
We are told to stand with our left leg on
the floating shoe sole and to walk with our
right leg in the river till we die.

Ulay/Marina Abramović
Everything Will Be Alight, ca. 1980–81
16 mm film transferred to digital video (color, sound), 4:00 min

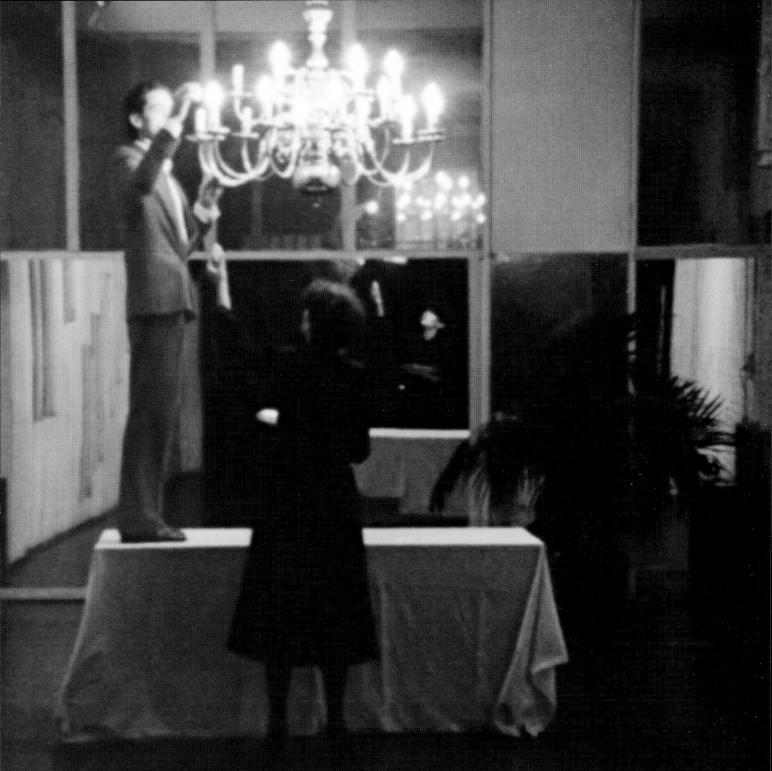

Nightsea Crossing

Presence.
Being present, over long stretches
of time,
Until presence rises and falls, from
Material to immaterial, from
Form to formless, from
Time to timeless.

Performance
We are sitting motionless at either end of
a rectangular table facing each other, our
profiles turned to the audience.

Most museums in the world are open
from 10 am to 5 pm. We decided to sit for
the entire opening time of the museum
(7 hours).
The audience never witness the
beginning or the end of the performance.

During the entire period in which the
performance takes place both inside and
outside the museum we remain silent
and completely abstain from food, only
consuming water.

22 performances, 1981–87

Performance
First International Biennial, Ushimado, Japan, 1985

Marina Abramović/Ulay
Nightsea Crossing, 1982–86
Slideshow of 20 sittings: Sydney 1982; Marl 1982; Düsseldorf 1982; Berlin 1982;
Cologne 1982; Amsterdam 1982; Chicago 1982; Toronto 1982; Kassel 1982; Kassel 1982;
Kassel 1982; Helsinki 1982; Ghent 1984; La Furka 1984; Bonn 1984; Middelburg 1984;
Ushimado 1985; São Paulo 1985; New York 1986; Lyon 1986

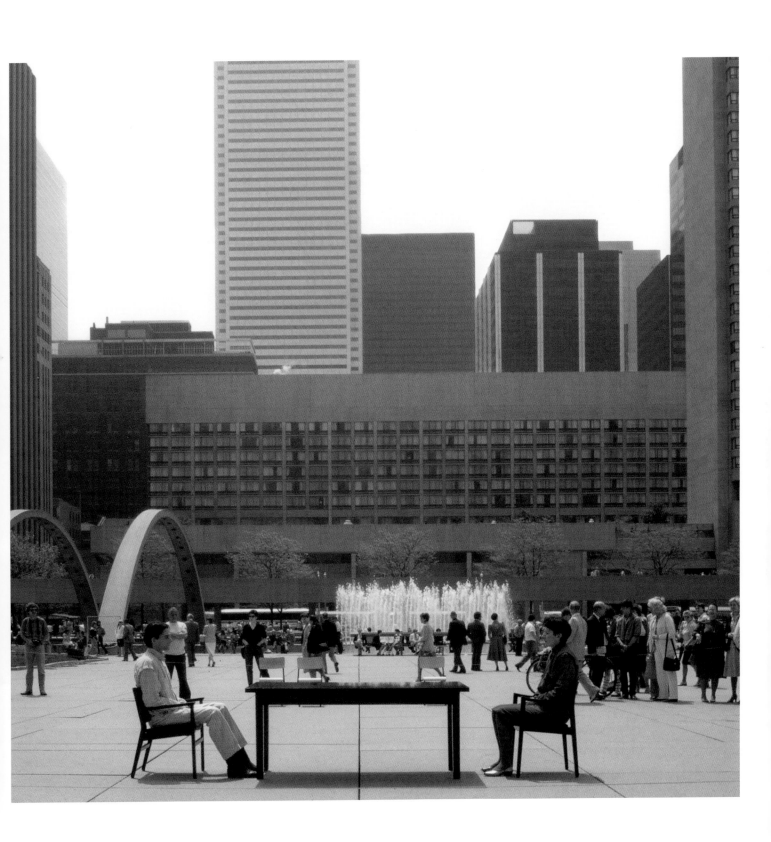

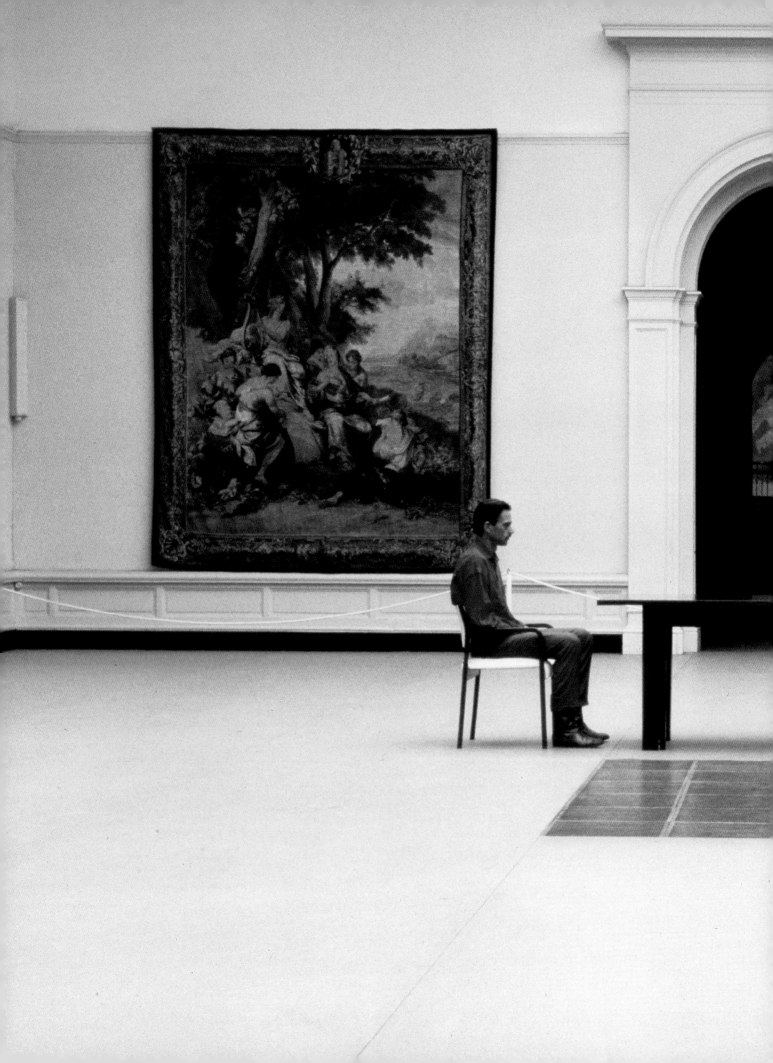

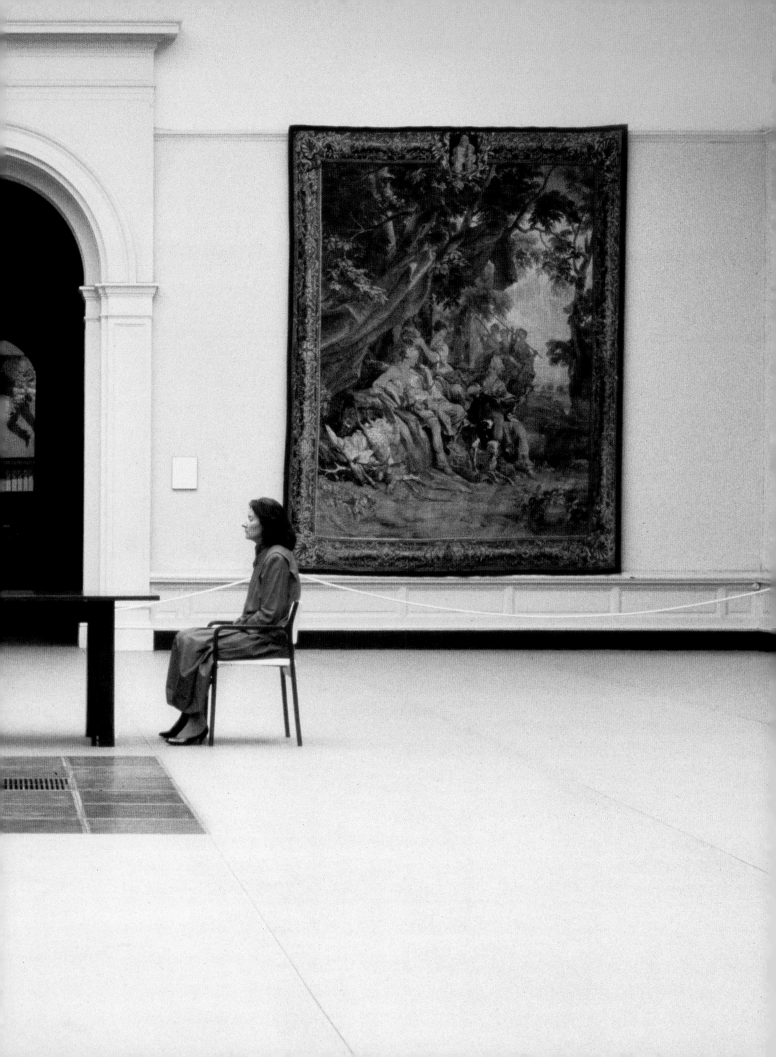

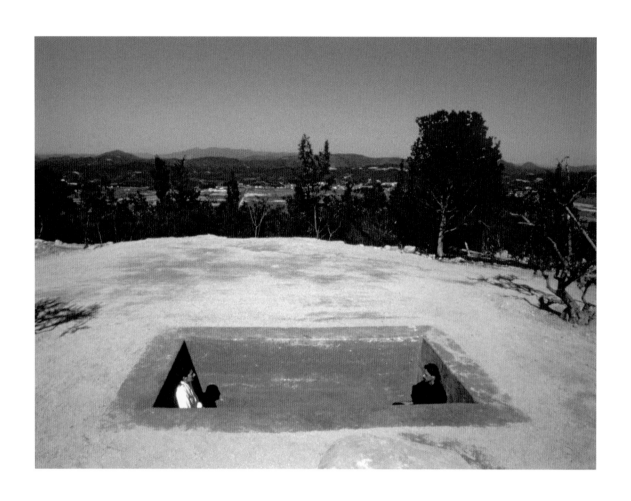

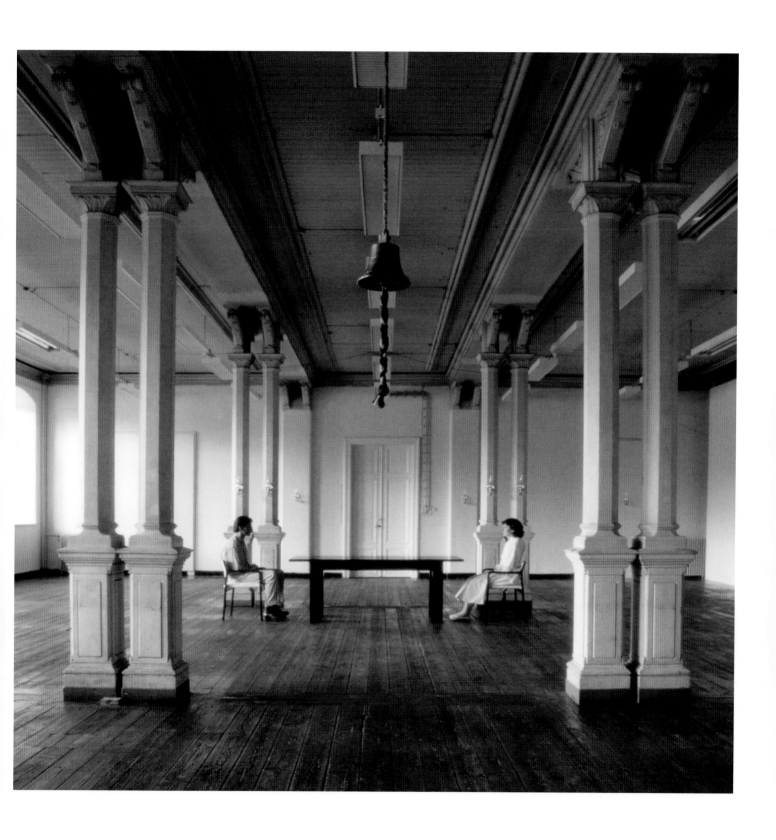

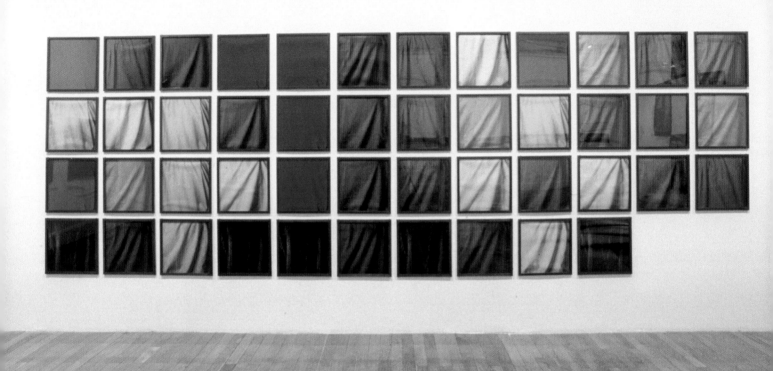

Marina Abramović/Ulay
Nightsea Crossing, 1981–88
46 Silver dye bleach prints (Cibachrome) referred to as "colors"; each 42 × 42 cm

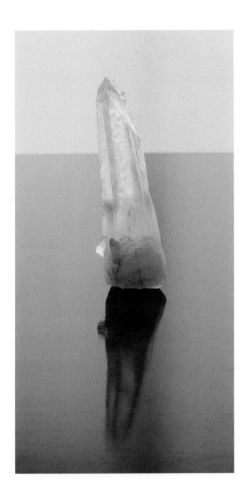

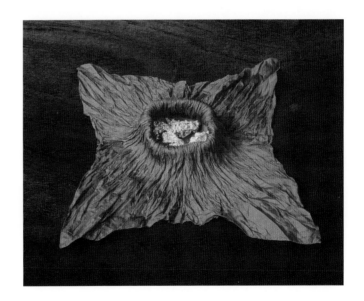

Marina Abramović/Ulay
Nightsea Crossing, 1982
Various symbolic objects, sometimes placed on the table during the performance.

List of objects: 6-sided quartz crystal, white sheet of paper folded in the shape of a boat, Chinese scissors, elephant modeled in clay, four boomerangs in black painted pine; dimensions variable

Nightsea Crossing Conjunction

For this piece we invite a Tibetan Lama
and a high-degree medicine man of the
Pintupi tribe from the Central Australian
Desert to perform with us.
We construct a round table (diameter:
4 meters) covered with pure 24-carat gold
leaf for the occasion.

With Watuma Taruru Tjungarrayi,
Ngawang Soepa Lucyar

In a given space.

In the center of a large dome of a former
Lutheran church, a gilded round table
is installed. Around the table in the
directions north, south, east, and west,
four seats are placed.

The four participants are seated on each
of the seats and remain motionless, silent.

The first sitting starts at sunrise and lasts
for four hours. The second sitting starts
the next day at noon and lasts for four
hours. The third sitting starts on the third
day at sunset and lasts for four hours.
The fourth sitting starts at midnight
on the fourth day and lasts for four hours.

Performance
Duration: 4 days of 4 hour sessions
Sonesta Koepelzaal, Museum Fodor
Amsterdam, April 1983

Marina Abramović/Ulay
Nightsea Crossing Conjunction, 1983
16 mm film transferred to digital video (color, no sound), 3:02 min

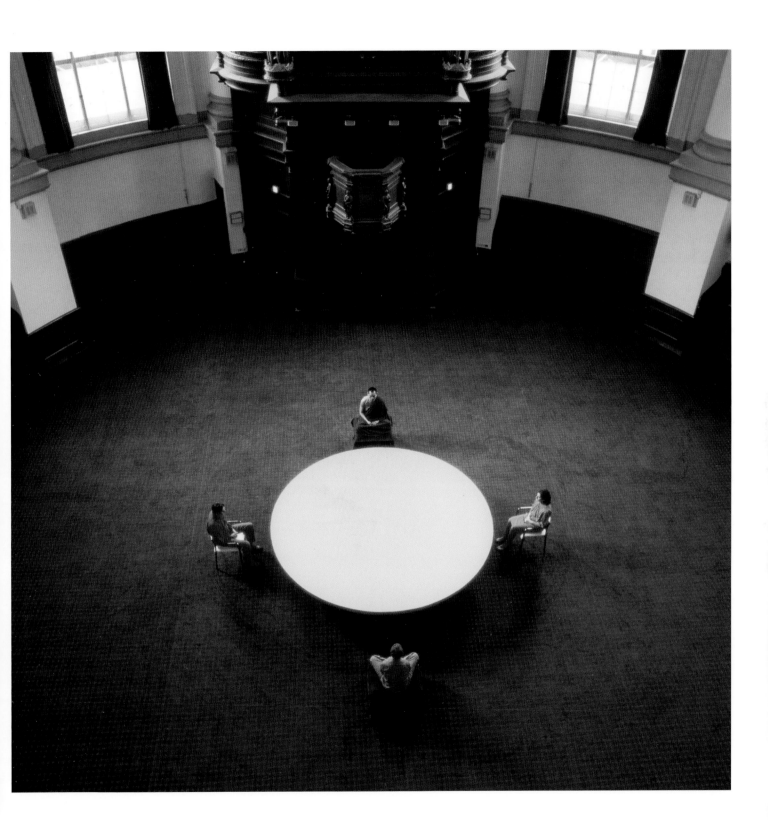

The Observer

In *The Observer*, we were joined by the
Swiss artist Rémy Zaugg. Earlier, in
Nightsea Crossing Conjunction (April
1983), we performed together with a
Tibetan Lama and a medicine man of the
Pintupi tribe from the Central Australian
Desert. However, Zaugg's role in *Nightsea
Crossing: The Observer* was different
from that of the two extra participants
in *Nightsea Crossing Conjunction*, as he
explicitly played the role of a spectator,
not of a participant.

"Marina and Ulay invited me to join
them for the performance of *Nightsea
Crossing*. They suggested that I act as
an observer. What could be easier than
acting as a observer? You don't need to
be an actor in order to observe. Anyone
at all could play that part.

Doesn't one look everywhere all the time,
despite oneself?
Isn't it the destiny of anyone who has
eyes? To observe all you need is to be
present. That is the only condition you
have to satisfy provided you can just keep
quiet. The easy, carefree, unavoidable
act of seeing does not leave any faithful
material trace of the observer or what
he observes. Nothing certifiable or
accountable could rise from this activity,
nothing that can be discussed, nothing
remarkable survives.
It is an act which adds nothing to the
congestion in the world, not even
the tiniest trace. However ephemeral.
These arguments were advanced to
tempt me and I yielded to temptation.
I accepted the role offered to me. I would
be an observer, I would observe. As I
observe a ray of sunshine on the bare
wooden floor of my studio."

Rémy Zaugg
Middelburg, the Netherlands, October 1984

Marina Abramović/Ulay, with Rémy Zaugg
The Observer, 1984
Video (color, sound), 6:02 min

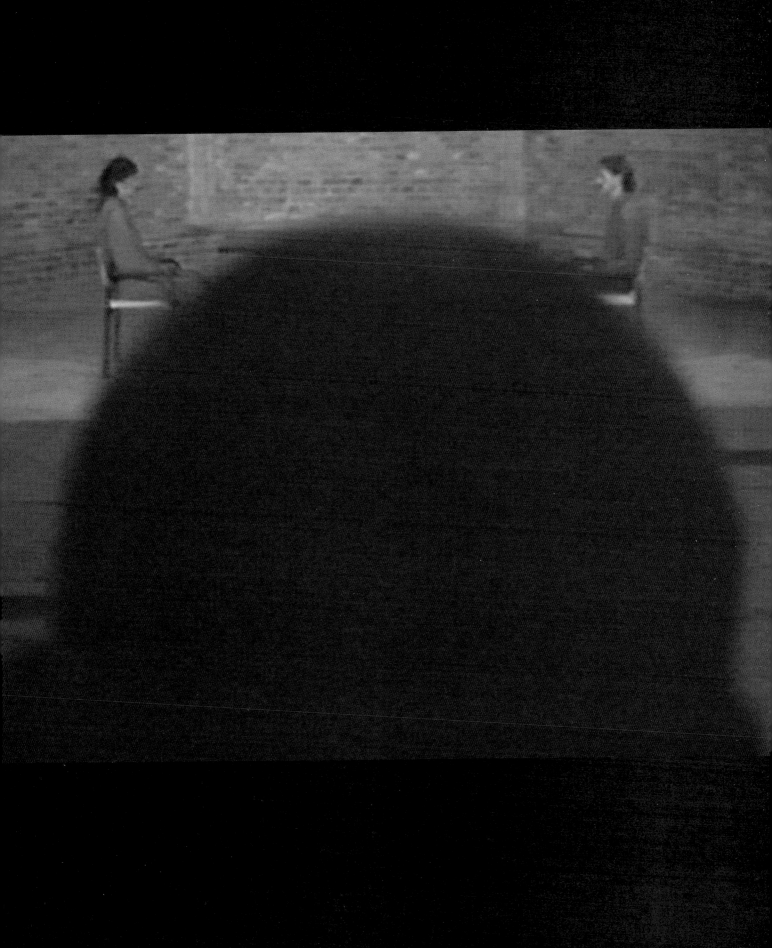

The Sun and the Moon

We could not perform anymore and instead we made two vases the size of our bodies.

One reflected the light and the other absorbed it.

We titled them the Sun and the Moon.

Kunstmuseum Bern, 1987

Marina Abramović/Ulay
The Sun and the Moon (Die Mond, der Sonne), 1987
Polyester, two parts, high-sheen and matte varnish; each 180 cm (h), ca. 110 cm (d)

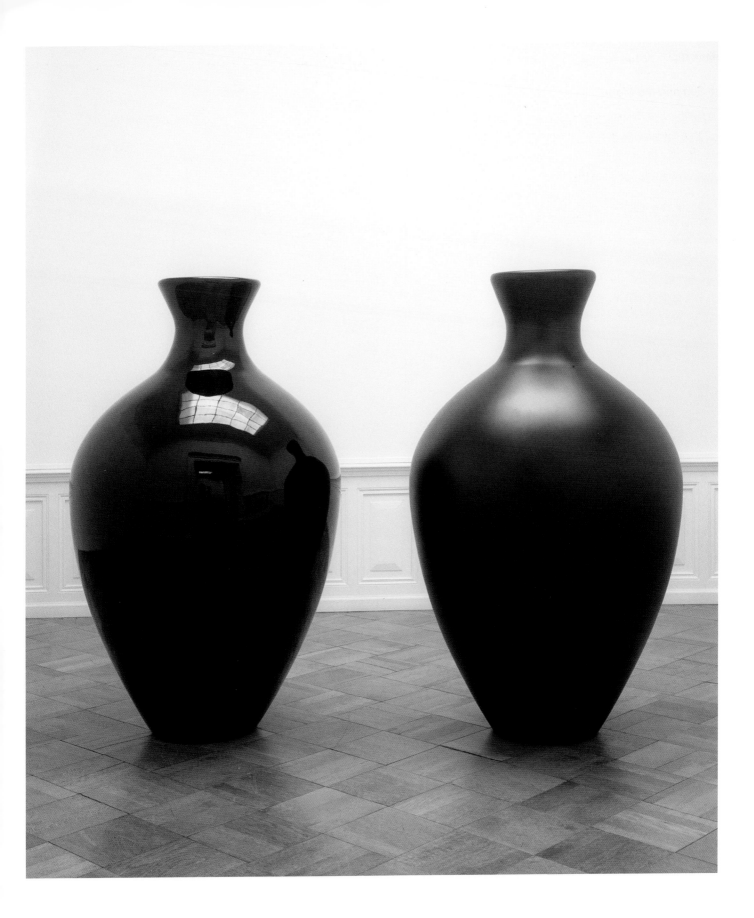

Great Wall Walk

At a chosen location.

We walked the entire length of the
Great Wall of China.

We started on March 30, 1988.

I started walking at the eastern end of
the Wall, at Shan Hai Guan, on the shores
of the Yellow Sea, Gulf of Bohai, walking
westward.

Ulay started walking at the western end of
the Wall, at Jai Yu Guan, the south-western
periphery of the Gobi Desert, walking
eastward.

We walked until we met.

After we both continuously walked for
90 days, we met at Er Lang Shan, in
Shen Mu, Shaanxi province.

Performance
Duration: 90 days
The Great Wall of China
March–June, 1988

Marina Abramović/Ulay
The Lovers, 1988
16 mm film transferred to digital video (color, silent),
2-channel, 15:41 min

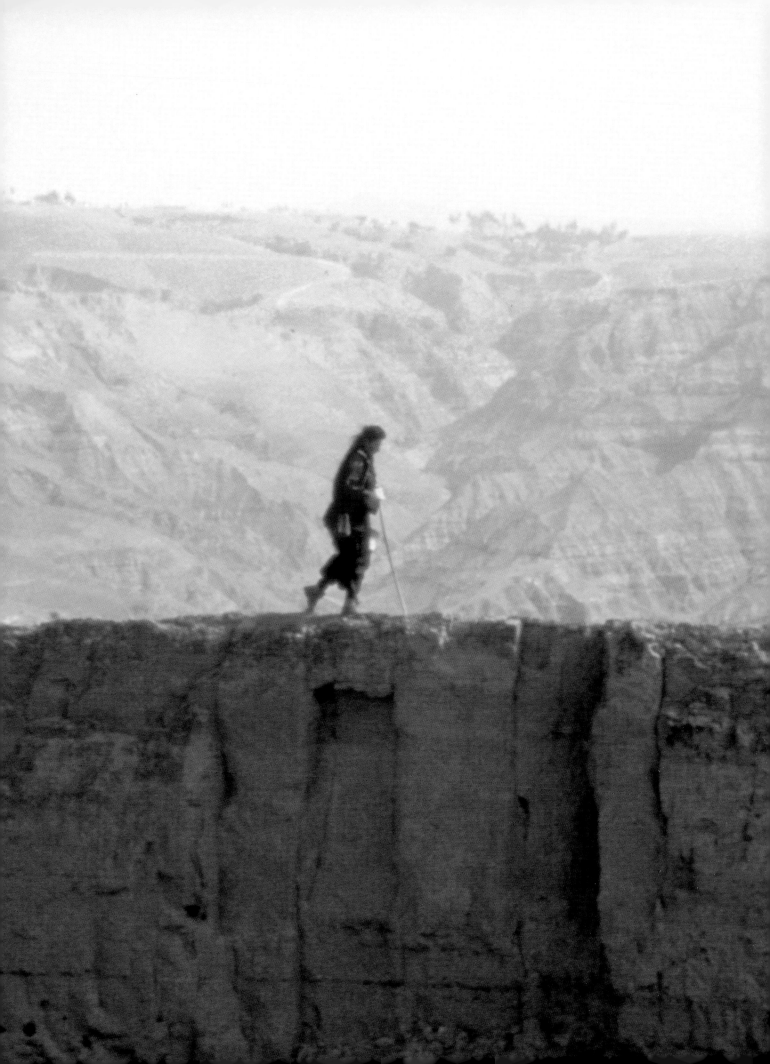

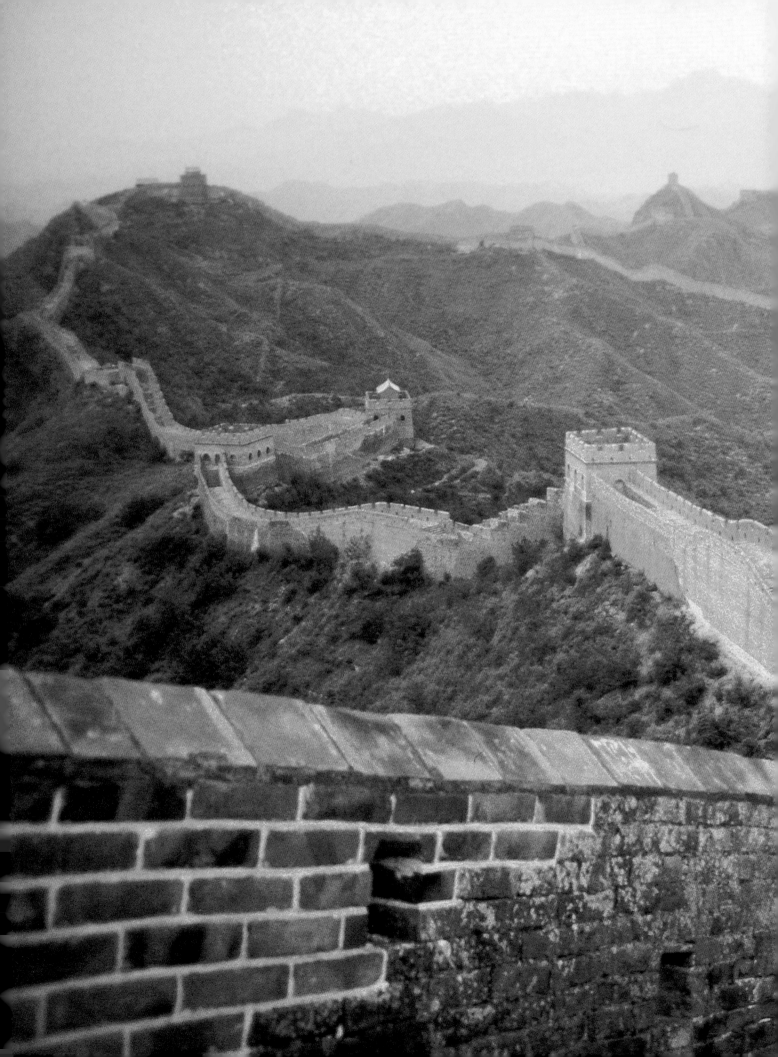

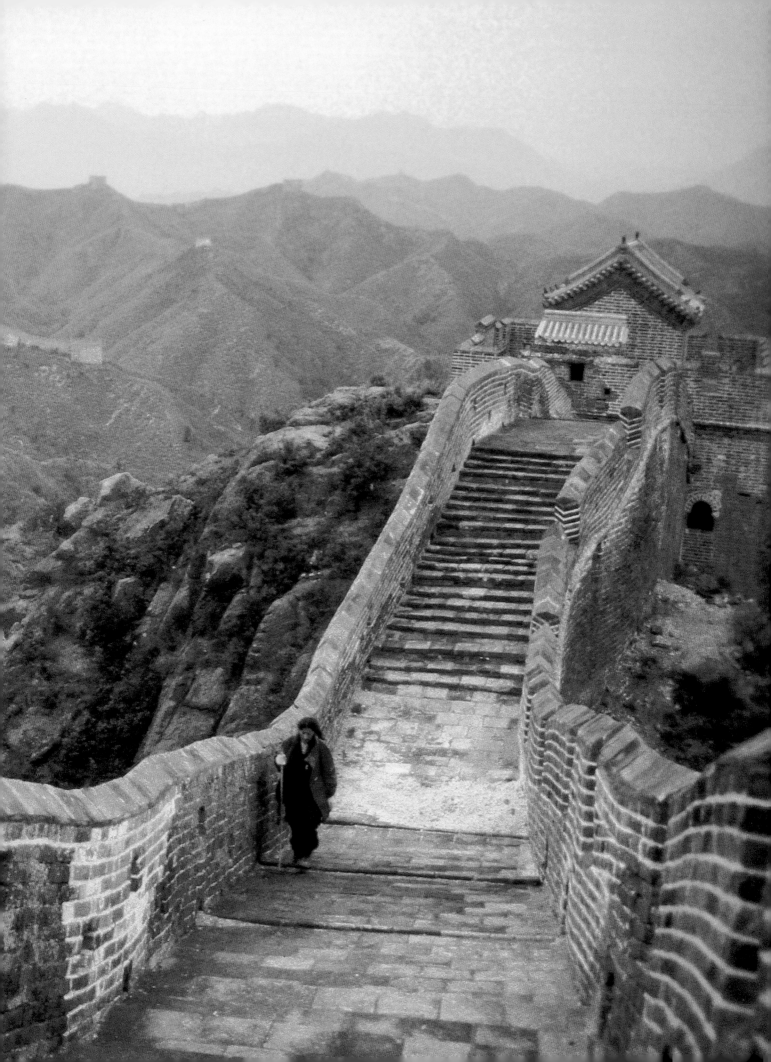

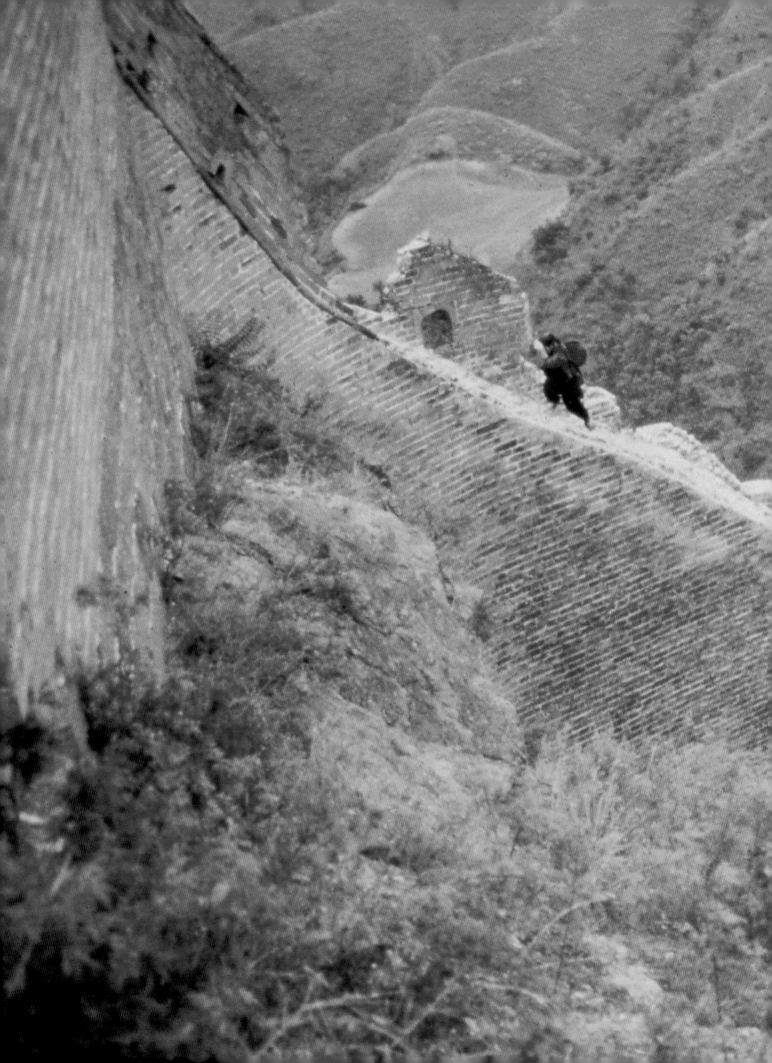

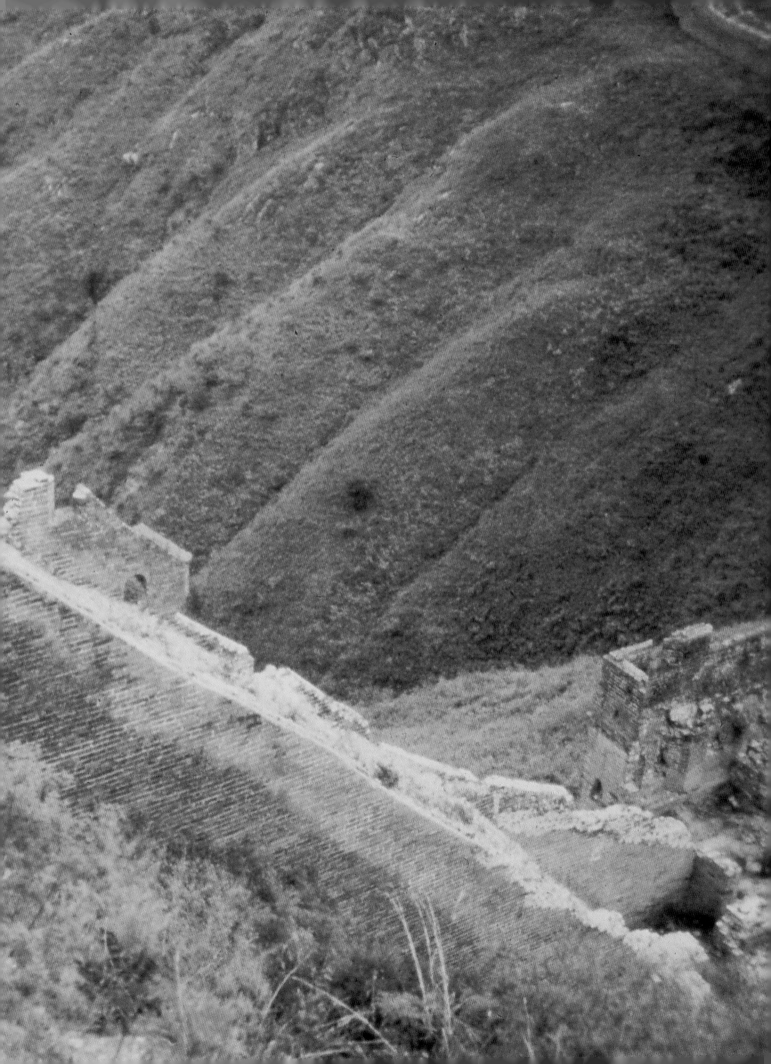

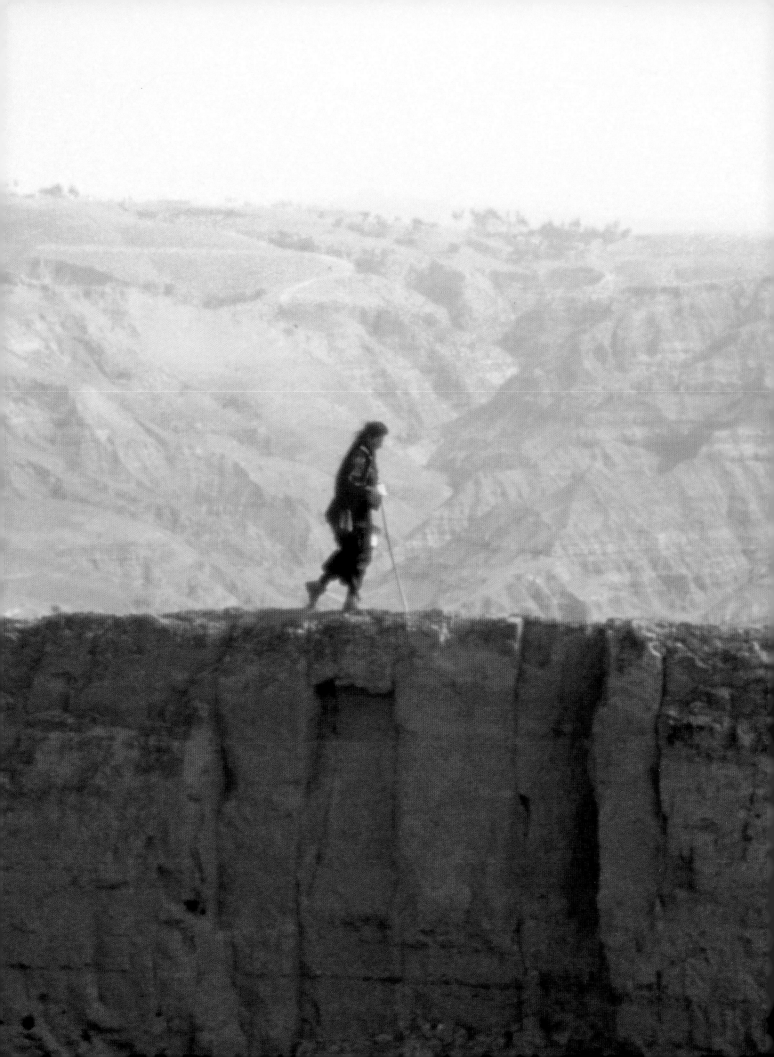

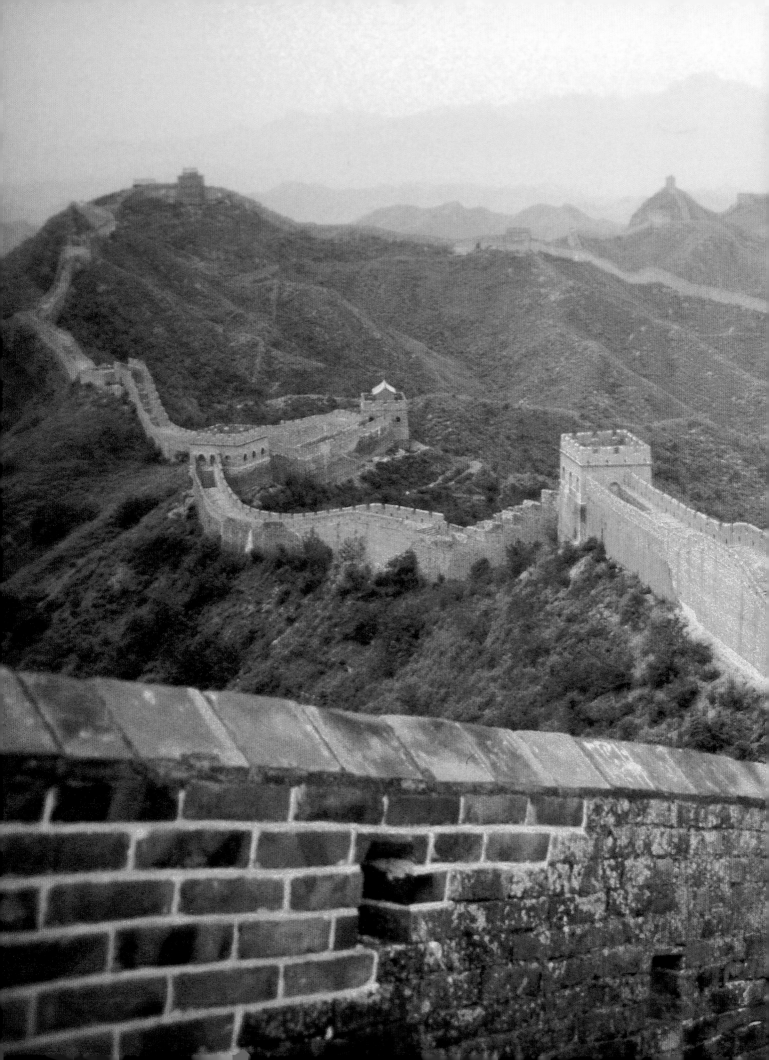

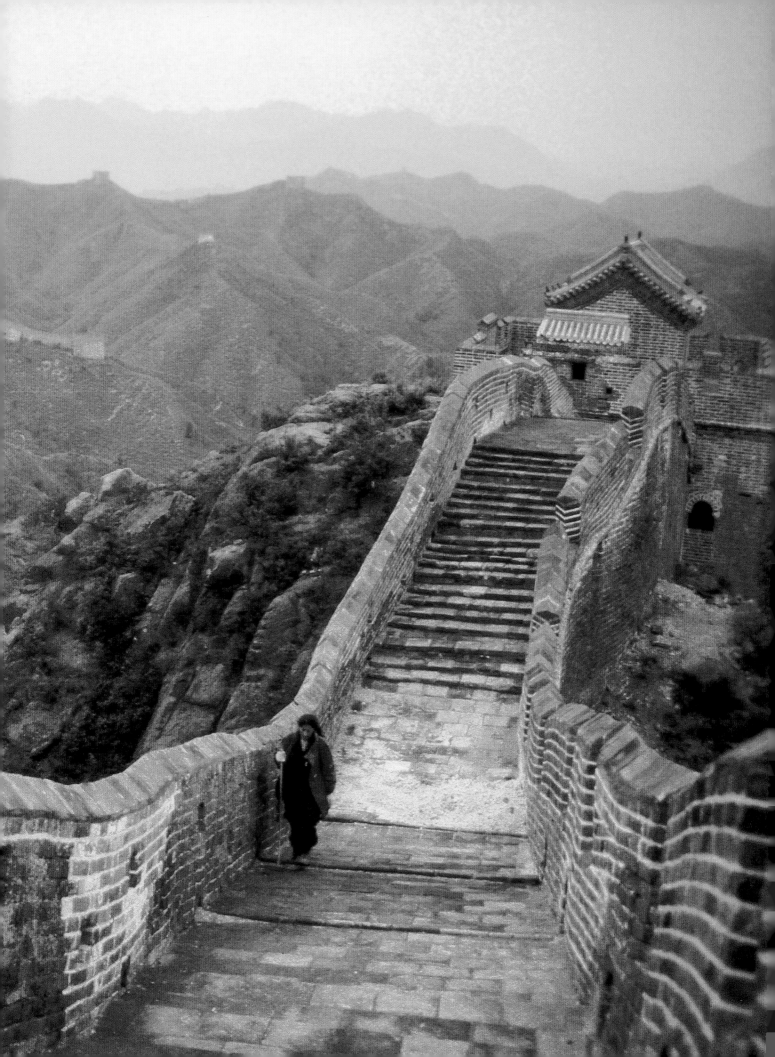

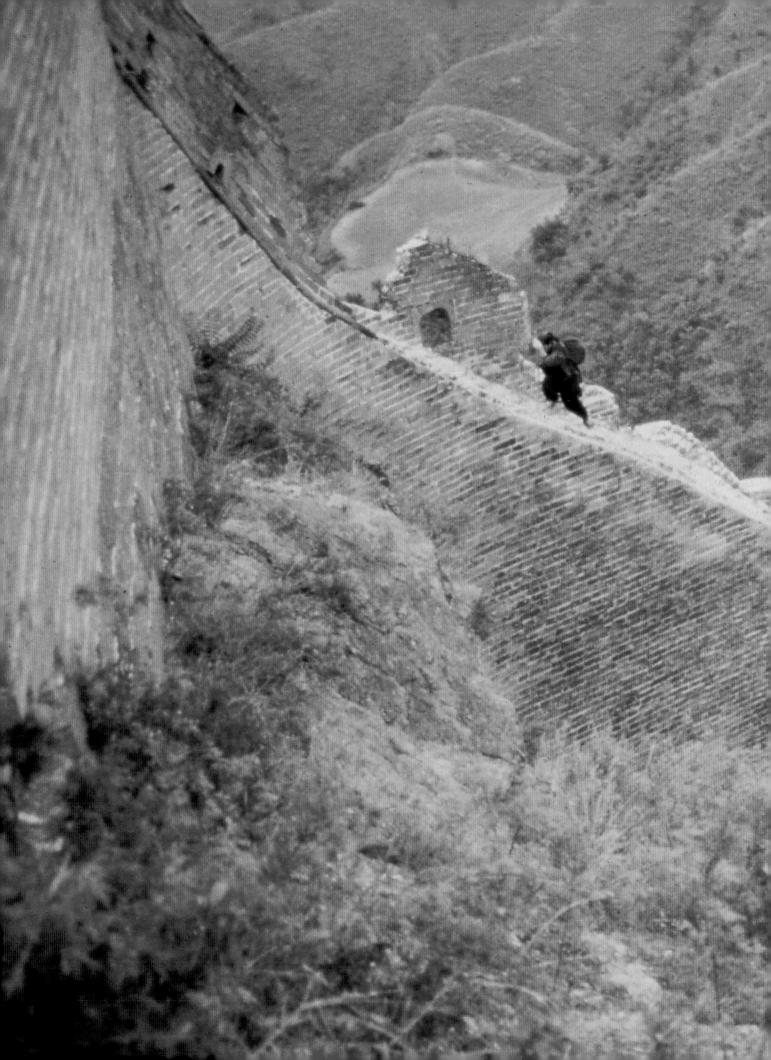

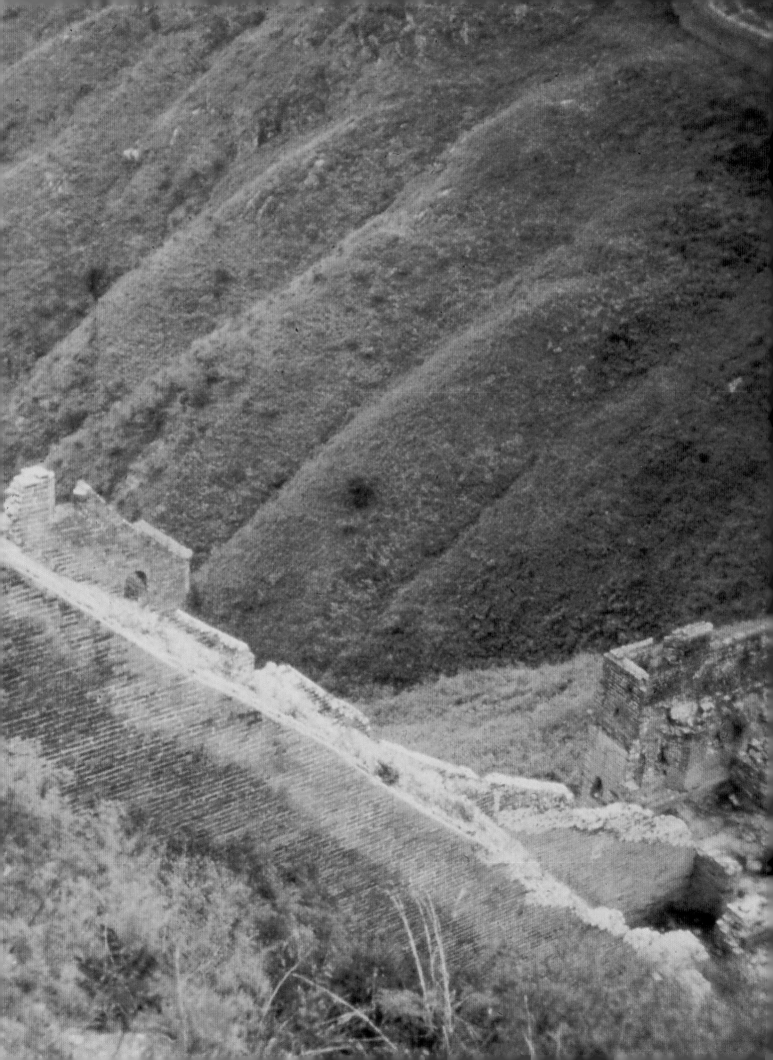

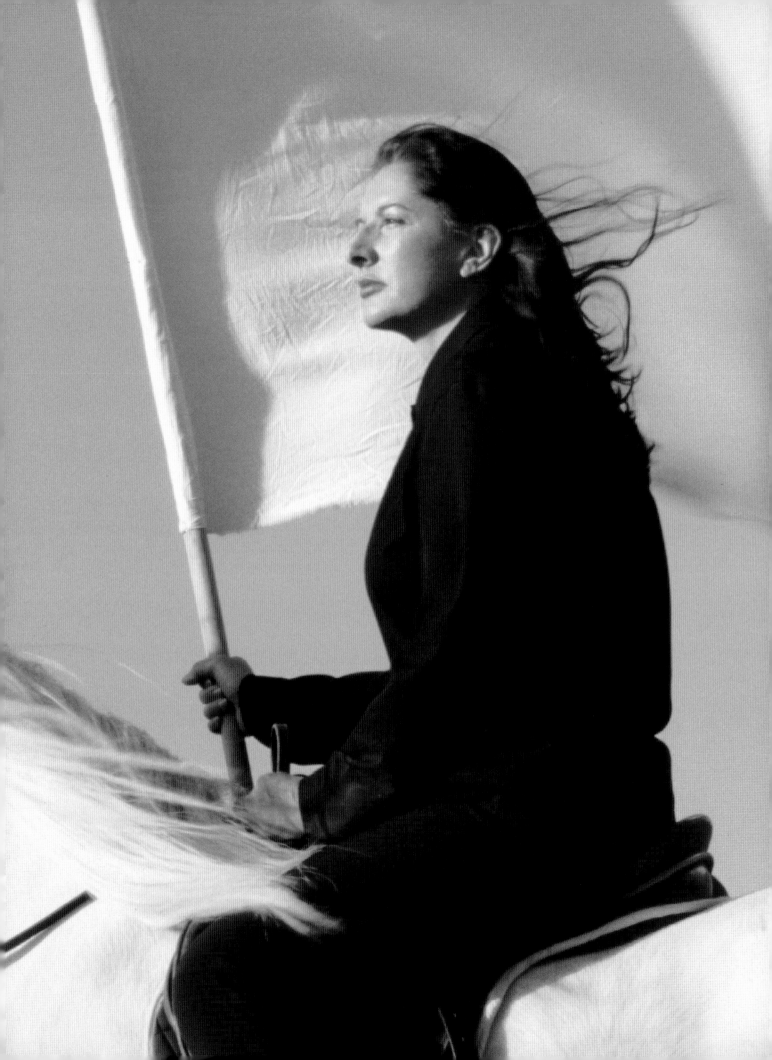

SOLO WORKS
1991–2017

Waiting for an Idea

During several journeys to Brazil to work
on Transitory Objects using minerals,
I trained myself to enter a clearer state
of mind.
These exercises I call *Waiting for an Idea.*

Performance
Soledade and Marabá, Brazil, 1991

Lying in front of the amethyst crystals
without moving.

Duration: 1 day
Inside the mine, Soledade, Brazil, 1991

Sitting in front of the amethyst crystals
without moving.

Duration: 7 hours
Inside the mine, Soledade, Brazil, 1991

Waiting for an Idea, 1991
Silver dye bleach print (Cibachrome); diptych, each 127 × 334.5 cm

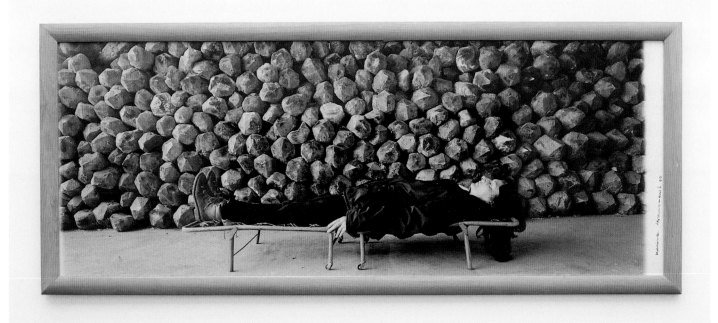

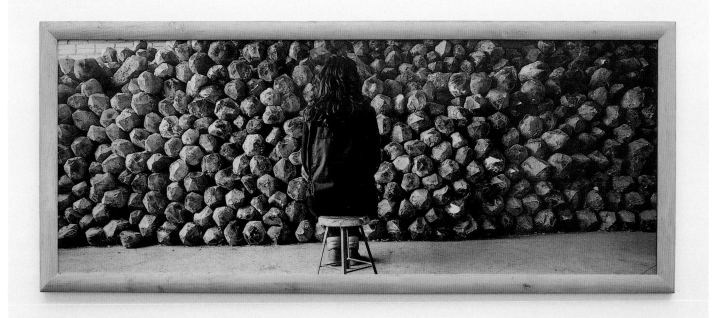

*Shoes for Departure—Transitory
Objects for Human Use*

Instructions for the public:
Enter the shoes with bare feet.
Eyes closed.
Motionless.
Depart.

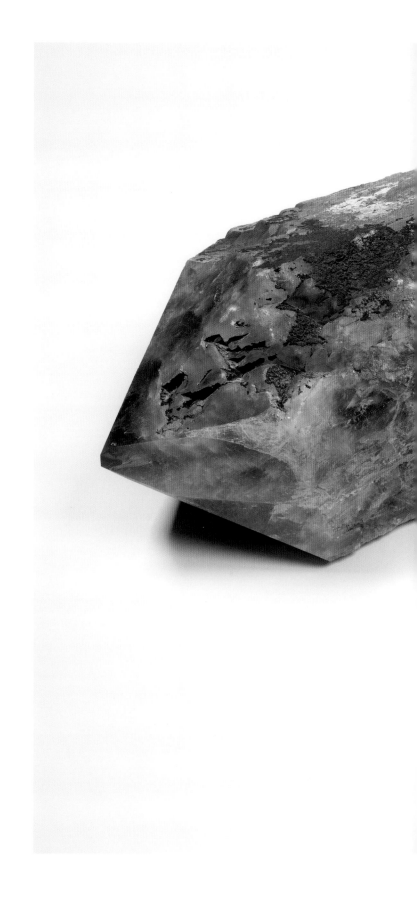

Shoes for Departure, 1991
Amethyst objects, installation, 17 × 51 × 53 cm

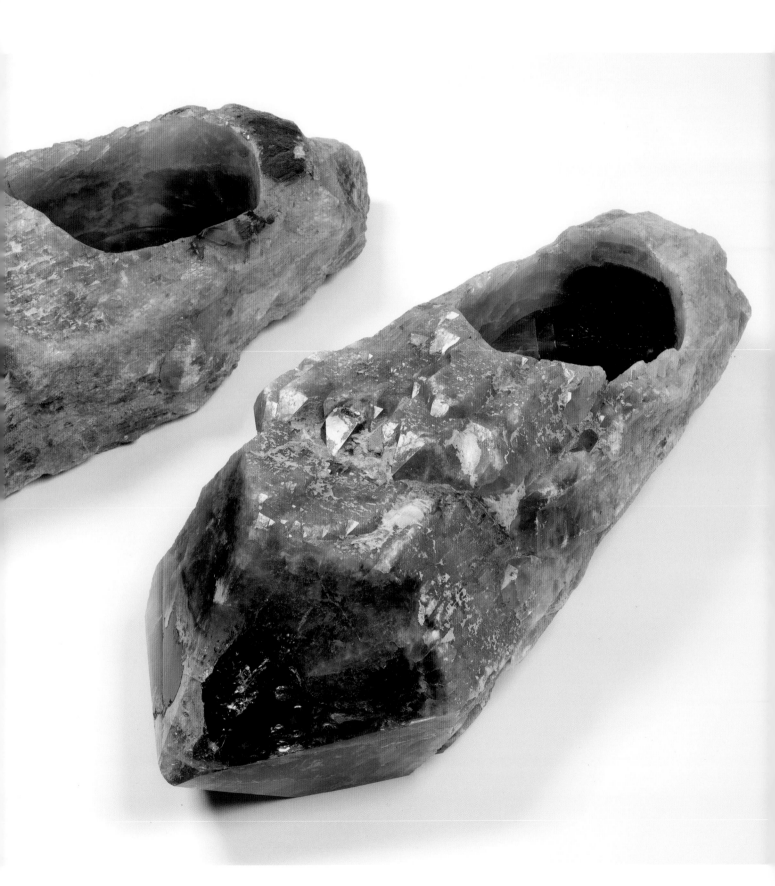

*Black Dragon—Transitory Objects
for Human Use*

Instructions for the public:
Face the wall.
Press your head, heart, and sex against
the mineral pillows.

Duration: limitless

Black Dragon, ca. 1990–94
Blue quartz, chrysocolla, green quartz, hematite, snowflake obsidian;
15 objects, each ca. 11 × 19 × 11 cm

The Onion

I eat a large onion with the skin, with my
eyes looking up to the sky and complaining
about my life.

Transcript of the sound track:
I am tired from changing planes so often,
waiting in the waiting rooms, bus
stations, train stations, airports.
I am tired of waiting for endless passport
controls.
Fast shopping in the shopping malls.
I'm tired of more and more career
decisions, museum and gallery openings,
endless receptions, standing around with
a glass of plain water, pretending that
I'm interested in conversations.
I'm so tired of my migraine attacks, lonely
hotel rooms, dirty bed sheets, room
services, long distance telephone calls,
bad TV movies.
I'm tired of always falling in love with
the wrong man; tired of being ashamed
of my nose being too big, of my ass being
too large; ashamed about the war in
Yugoslavia. I want to go away, somewhere
so far that I'm unreachable by telephone
or fax.
I want to get old, really old, so that nothing
matters anymore.
I want to understand and see clearly
what is behind all of this. I want not to
want anymore.

Performance for video
Duration: 10 minutes
UTA Dallas, 1995

The Onion, 1995
Video (color, sound), 20:03 min

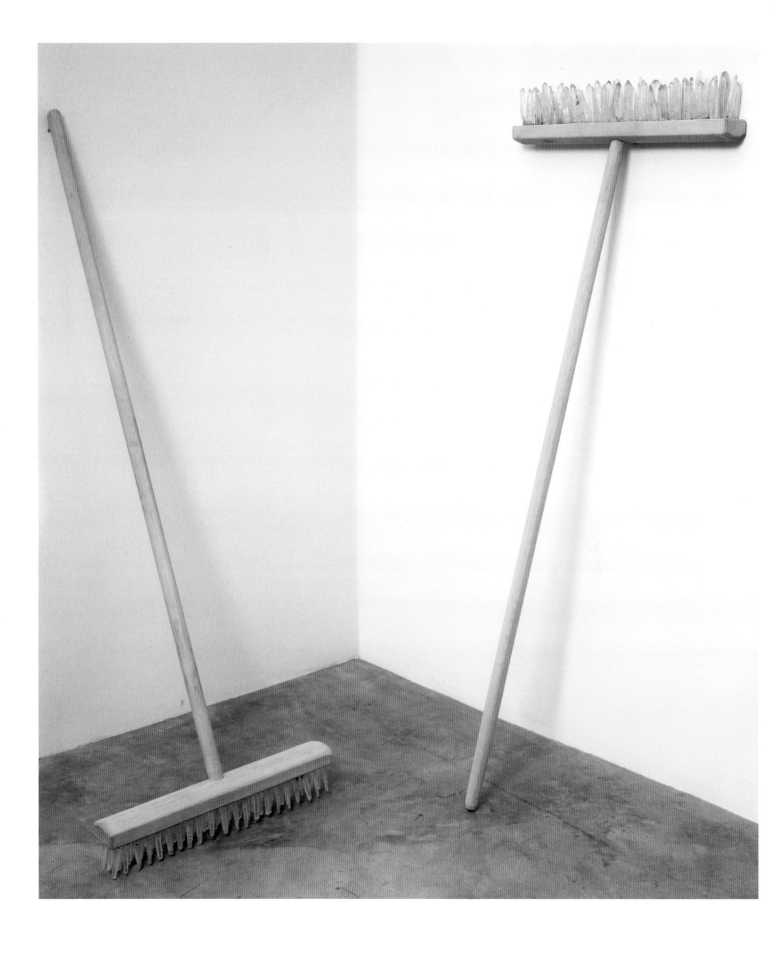

Crystal Broom, from the series *Transitory Objects for Non-Human Use,* 1995
Wood, quartz crystal; two brooms, each 156.2 × 58.4 × 43.2 cm

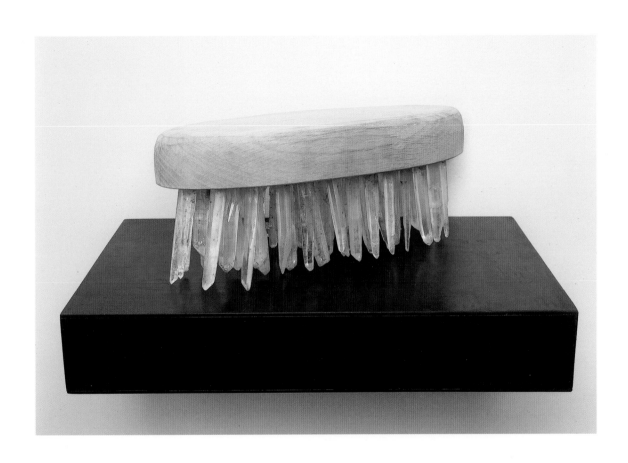

Crystal Brush, from the series *Transitory Objects for Non-Human Use,* 1995
Wood, quartz crystal, lacquered metal base, 4.5 × 10.5 × 11 cm, base: 34 × 22.8 × 8.5 cm

*Double Edge—Transitory Objects
for Human Use*

Instructions for the public:
Climb the ladders one by one in
this order:
I – wooden ladder
II – knife ladder
III – hot iron ladder
IV – ice ladder

Double Edge, 1996
Wood, knives, steel, heating elements, freezing elements;
4 ladders, each 400 × 60 × 7 cm

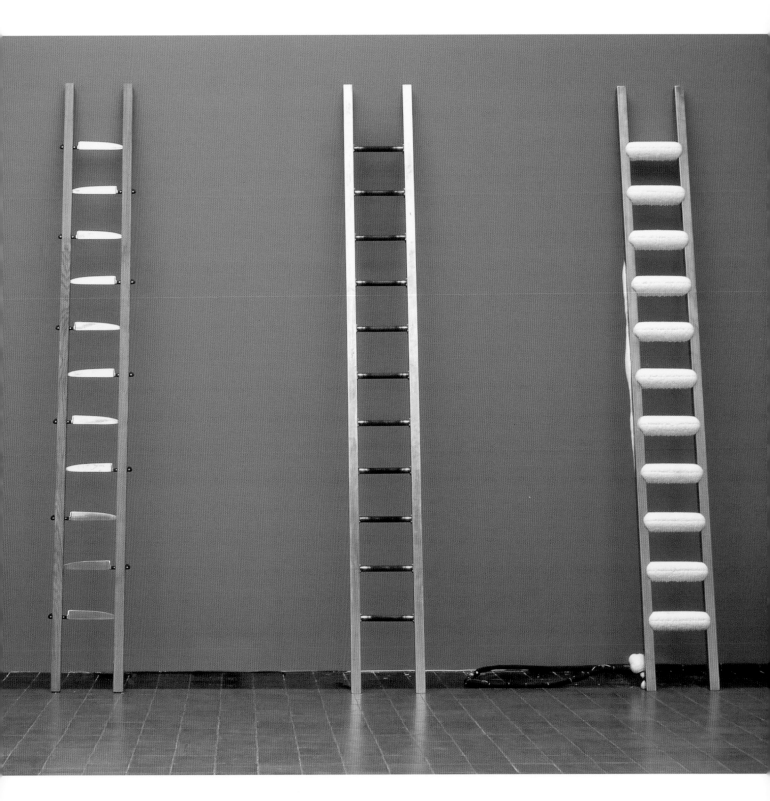

Balkan Baroque

The installation
Images are projected onto the three walls of the space.

My mother, my father, and myself.

On the floor are two copper sinks and one copper bathtub filled with water.

Performance
In the middle of the space I wash 1,000 fresh beef bones, continuously singing folksongs from my childhood.

Excerpts from the folksongs that I sing in *Balkan Baroque*:

First Day
"When we stopped next to our Russian tree the snow had already covered everything . . ."

Second Day
"You sing beautifully, you sing beautifully, blackbird, blackbird . . . What else can I do, what else can I do when my feet are bare . . ."

Third Day
"Hey, Kato, hey my treasure, come with me to pick sage . . . I can't, master, I can't. There is no bright moon . . ."

Fourth Day
"All the birds from the forest, all the birds from the forest, come down to the sea. Only one stays, only one stays, to sing to me about unhappy love."

I sing these lines continuously over a period of six hours every day.

Performance
Duration: 4 days, 6 hours
47th Venice Biennale, June 1997

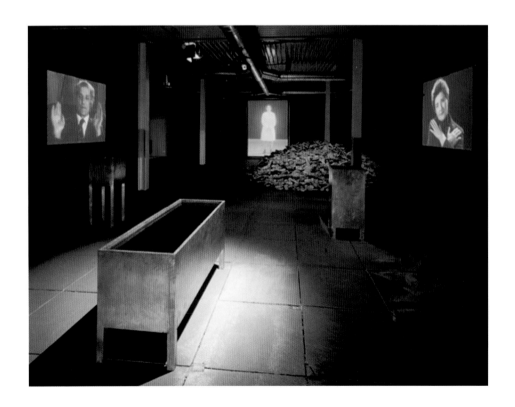

Balkan Baroque, 1997
3-channel video installation (color, sound), cow bones; dimensions variable, 12:38 min

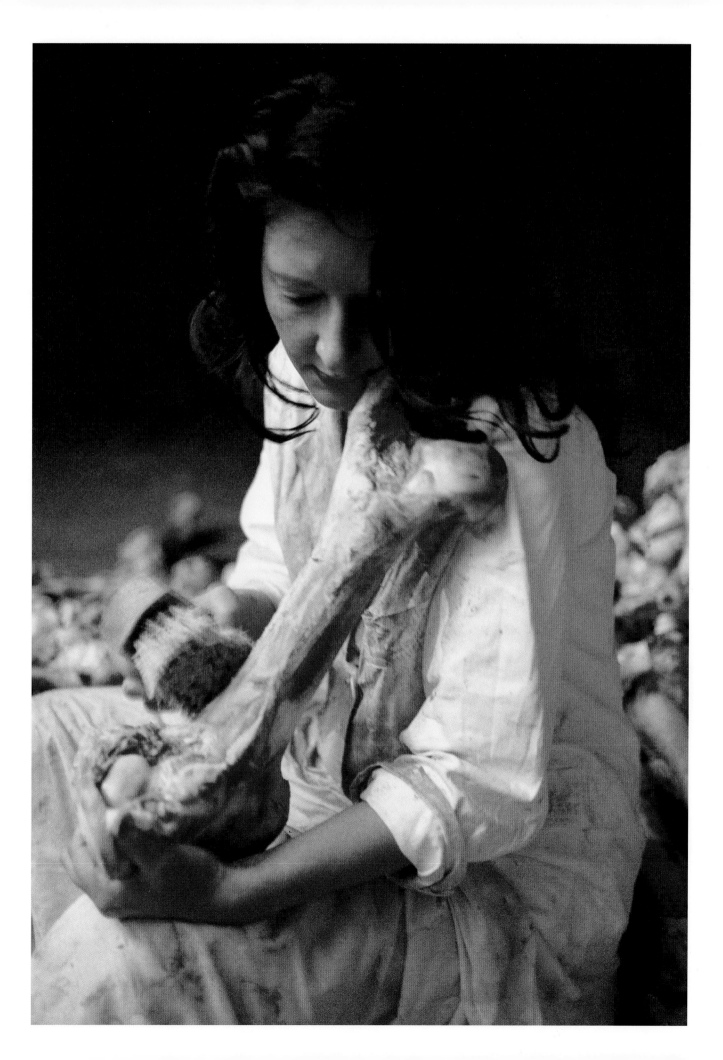

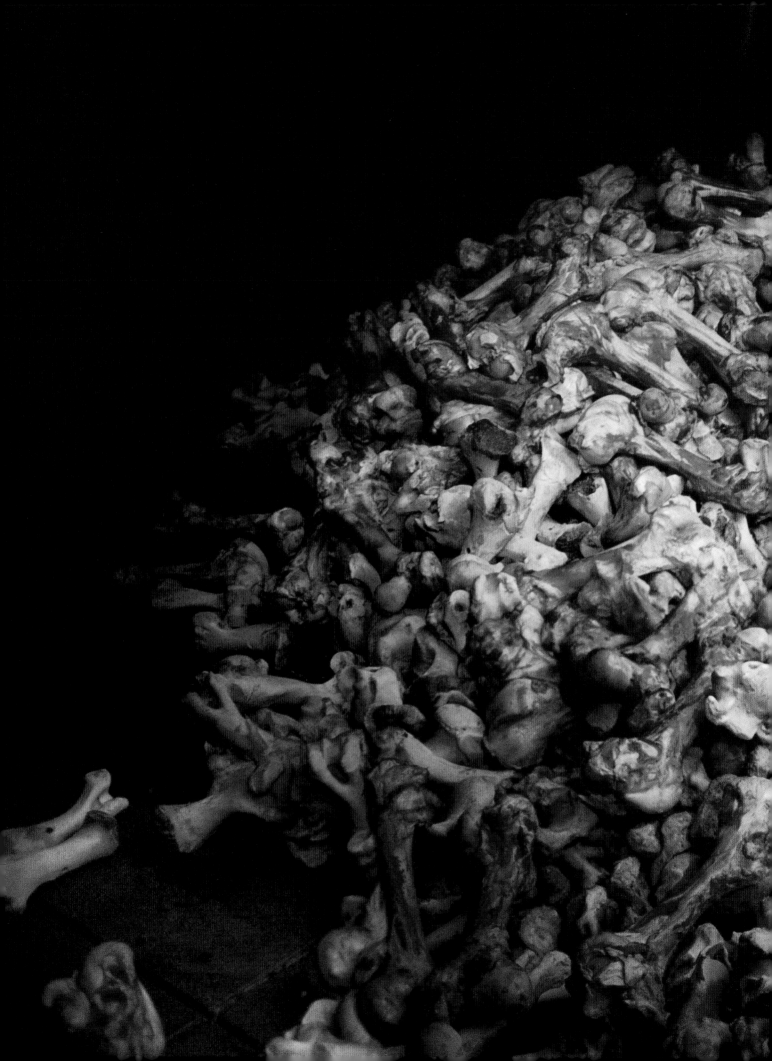

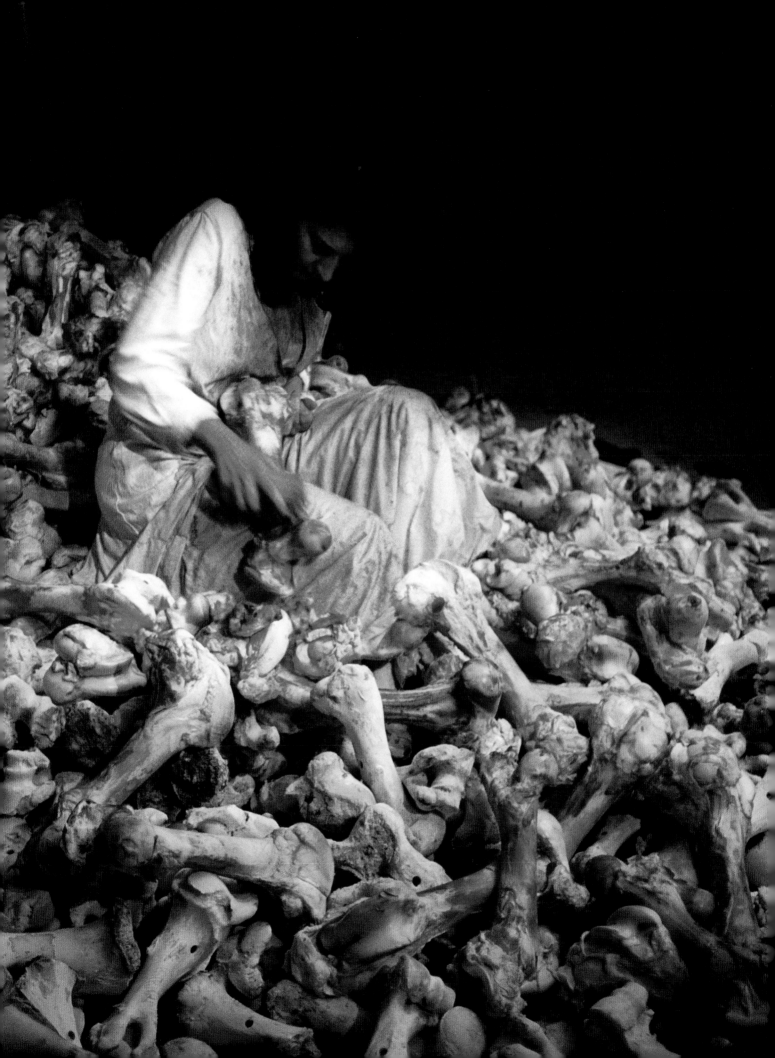

Private Archaeology

Private Archaeology is my reflection on the sources of my work. I bring together objects and artifacts, excerpts from books, photographs of other artists' performances, and portraits of people and places. They are represented in fifty-nine annotated collages, thematically arranged: Places of Power, Food, Preparation to Enter the Other Side, Death, and Entering the Other Side.

Private Archaeology, 1997–2015
4 white oak cabinets, drawers containing mixed-media drawings, each cabinet 138 × 98.5 × 60 cm

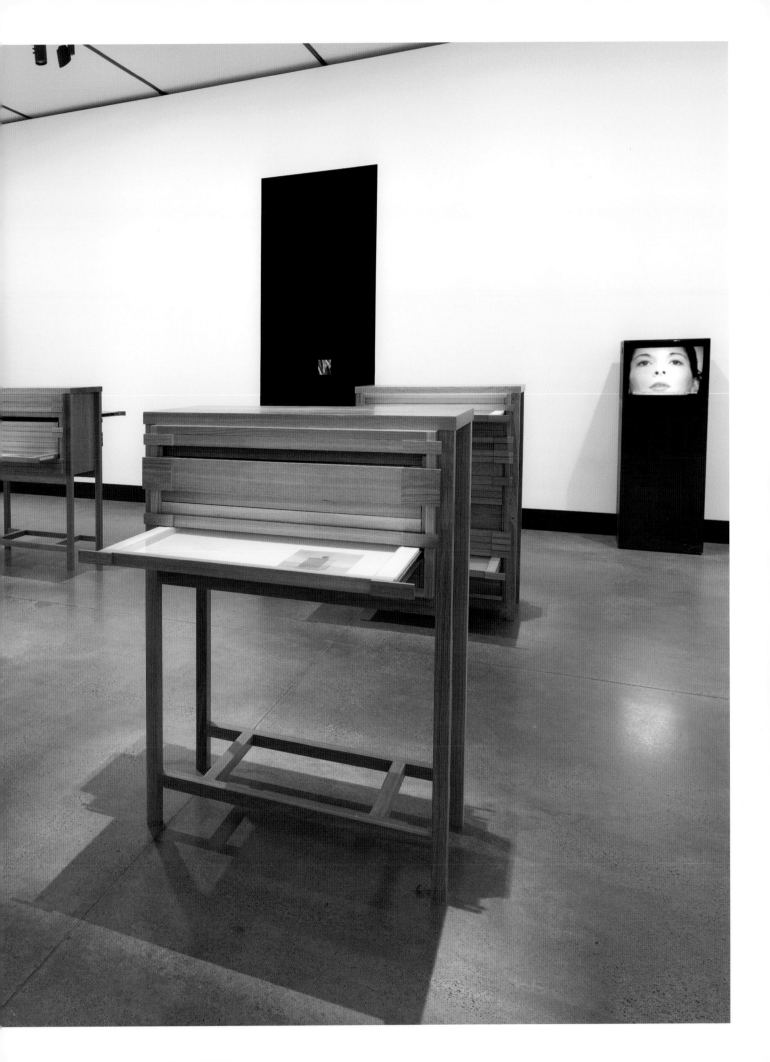

Dream House

Out of respect for the traditional structure of old Japanese houses, I decided only to change their purpose and function. I have given the spaces names like Instruction Room, Dressing Room, Bathroom, Kitchen, Dream Library, Dreaming Rooms I, II, III, IV, and Spirit Room. I work with objects and clothes using magnets and mineral stones.

The visitors have to interact, stay overnight in the house, write down their dreams in the dream book, and follow instructions using the given possibilities of the house. *Dream House* is open to the community where it is situated and also to any visitors passing through the area.

This is my continuing attempt to create a cultural dialogue about and to reconnect with our need to ritualize the simple actions of everyday life like walking, standing, sitting, lying, eating, washing, drinking, dressing, undressing, sleeping, dreaming, writing, and thinking. *Dream House* should function as such a place.

Site-specific project
Echigo-Tsumari Art Triennial
Tokamachi and Tsunan, Japan, 2000

Dream House, 2000/2017
2 dream books made of leather and paper, slideshow; dimensions variable

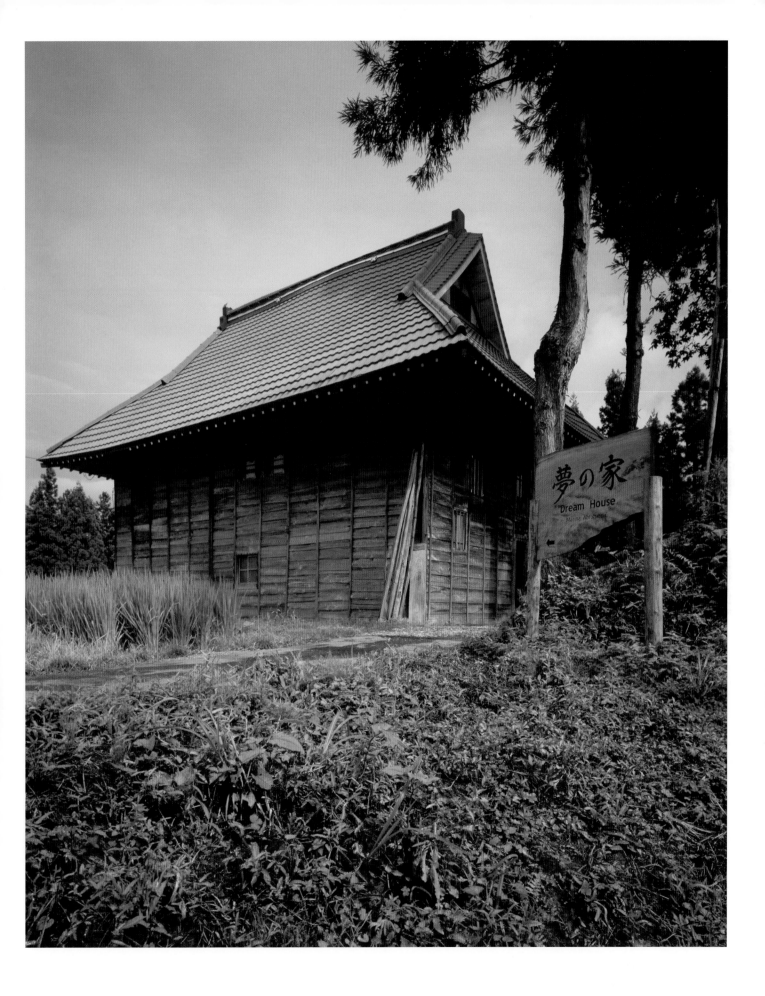

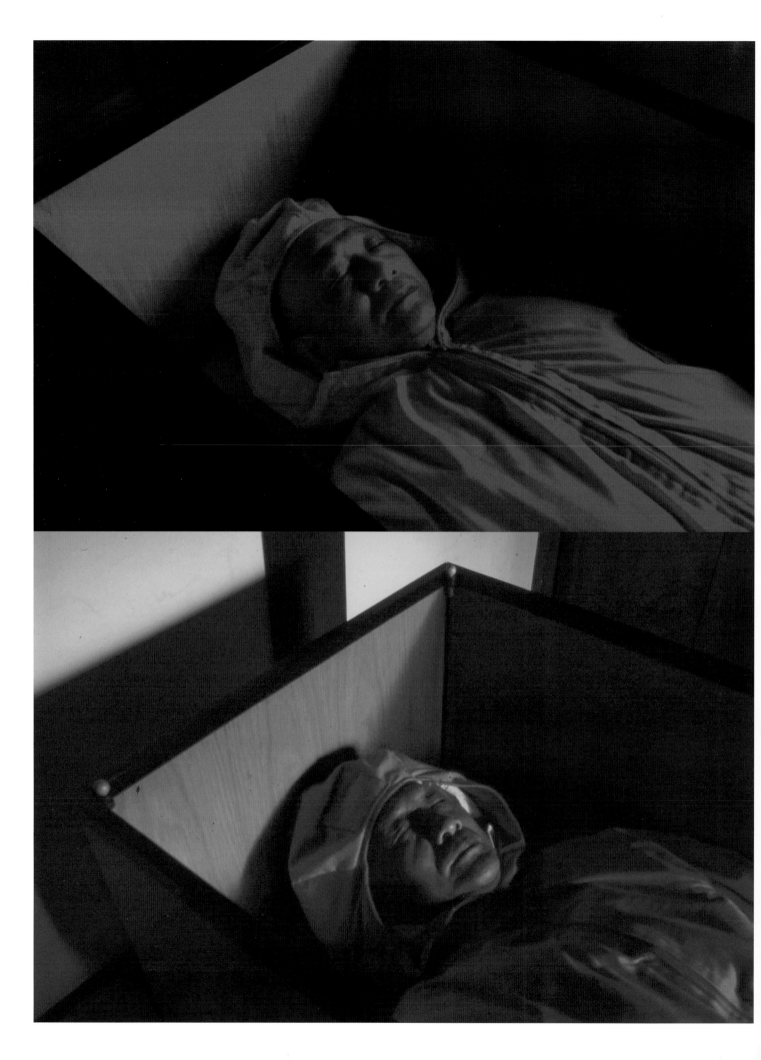

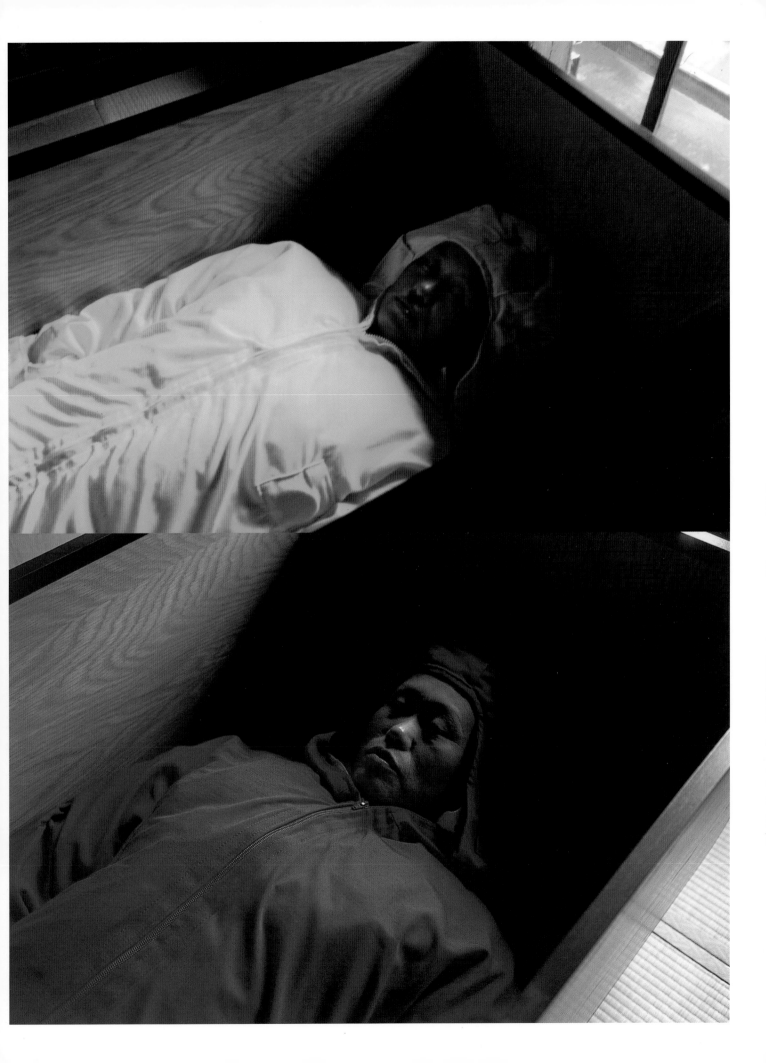

The Hero

My father died very disappointed by the
political changes in the former Yugoslavia.
Throughout his life, he never surrendered,
making him a national hero.
The Hero is dedicated to him. I sat on a
white horse, my hair and a white flag
blowing in the wind. This image recalls
another narrative from my life—the story
of how my parents met.
My father found my mother, wounded,
and took her to a hospital on his white
horse; later, my mother saved his life when
she found him unconscious, among other
wounded soldiers. The song heard in
The Hero is "Hej Sloveni," the Yugoslavian
national anthem from the era of Tito,
beautifully sung by Marica Gojevic.

Performed for video: 14 minutes
Hirshhorn Museum and Sculpture Garden,
Washington, DC, 2001

The Hero, 2001
Single channel video (b/w, sound), vitrine containing objects that belonged
to Vojo Abramović: small pigskin leather bag, pencil sharpener, 2 coins,
6 documents, 2 post cards, soap box, 1 magazine clipping, 1 newspaper clipping,
14 military medals, 6 fabric military objects, 107 photographs; dimensions vitrine:
152 × 61 cm, 14:21 min

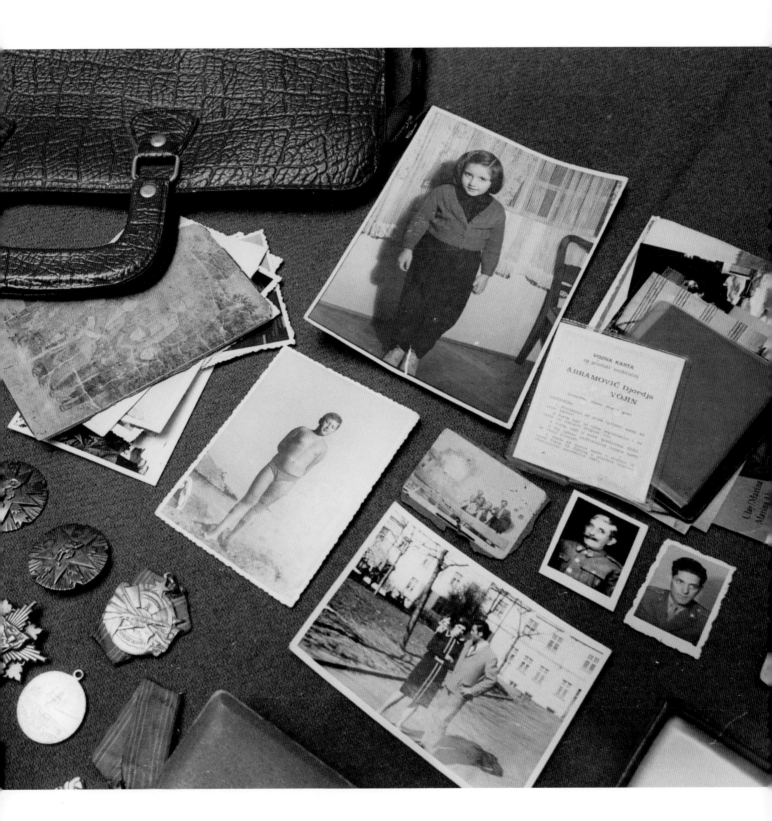

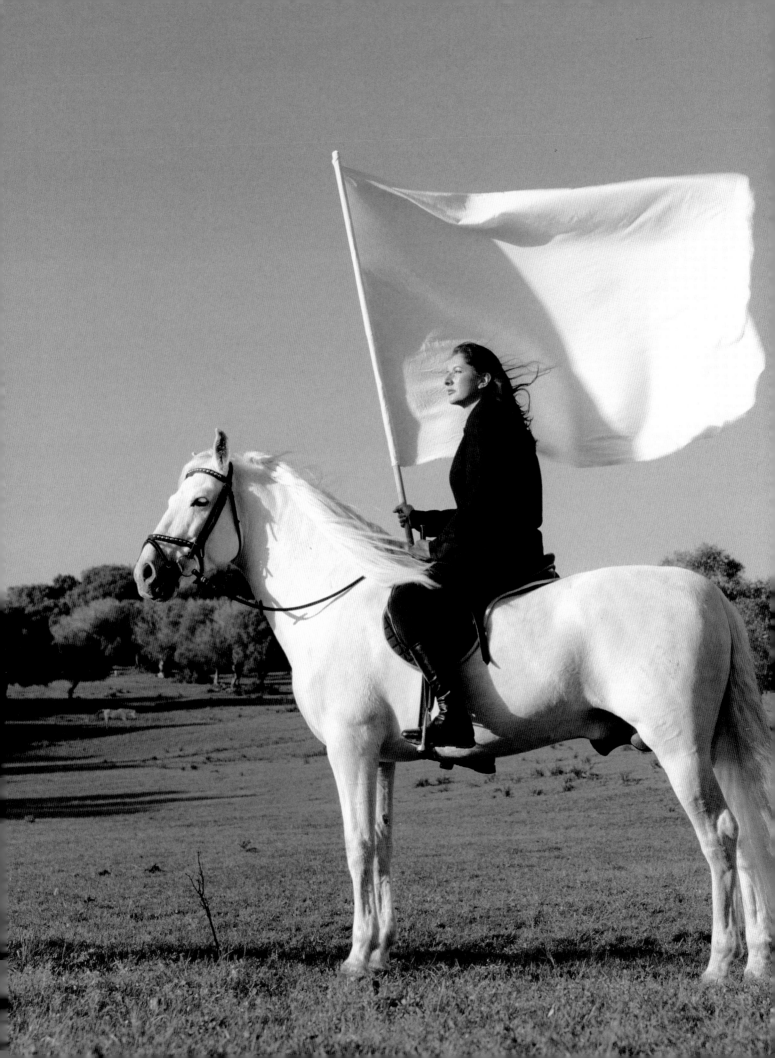

Energy Clothes—Transitory Objects
for Human Use

Instructions for the public:
Stand naked under the cold running
water until you can't stand it anymore.
Dry.
Put on the energy clothes.
Motionless.

Duration: limitless

Energy Clothes (Cone Hats), 2001
Red, yellow, green, pink, and purple silk paper, fabric, magnet; each 123 × 17 × 22 cm

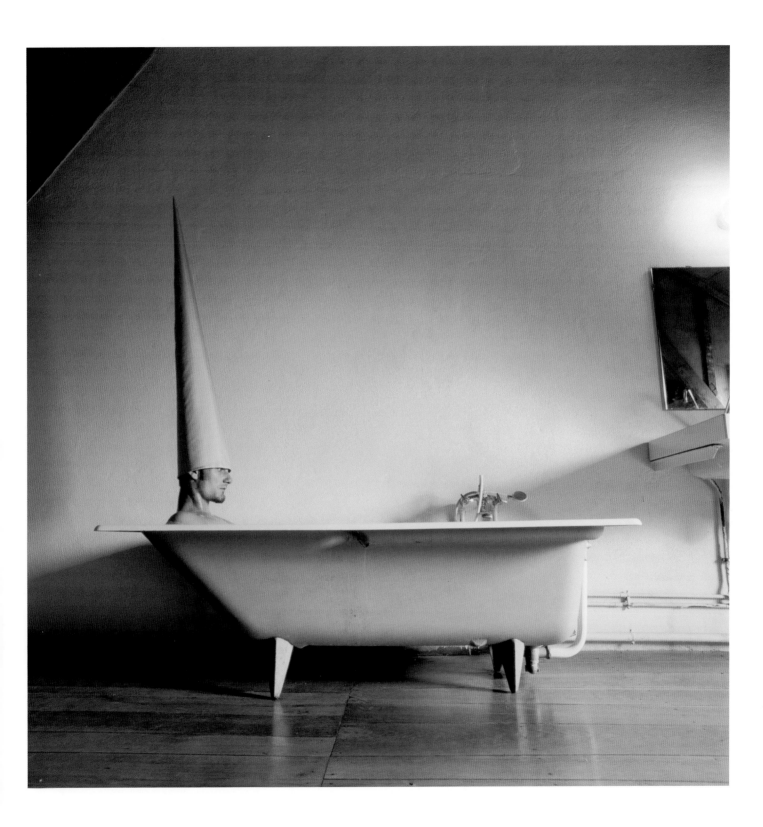

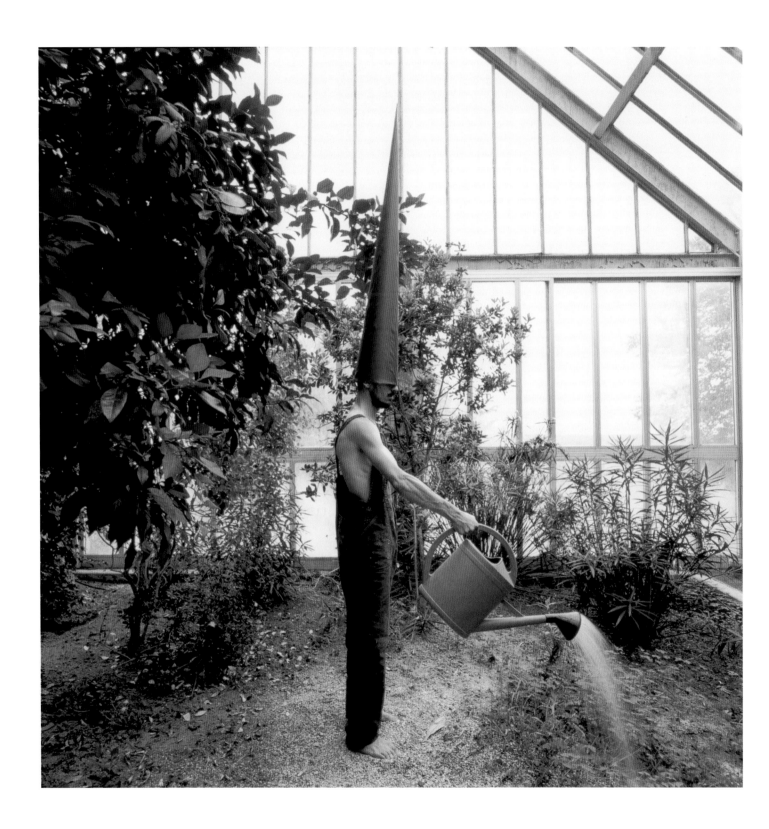

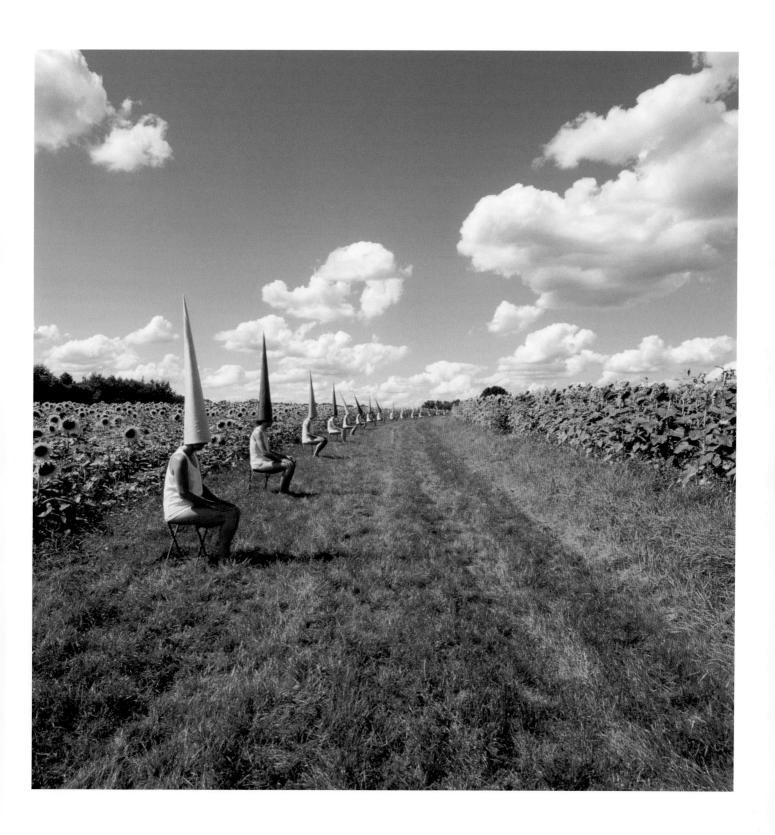

Stromboli, 2002
Video (b/w, sound), 19:33 min

184

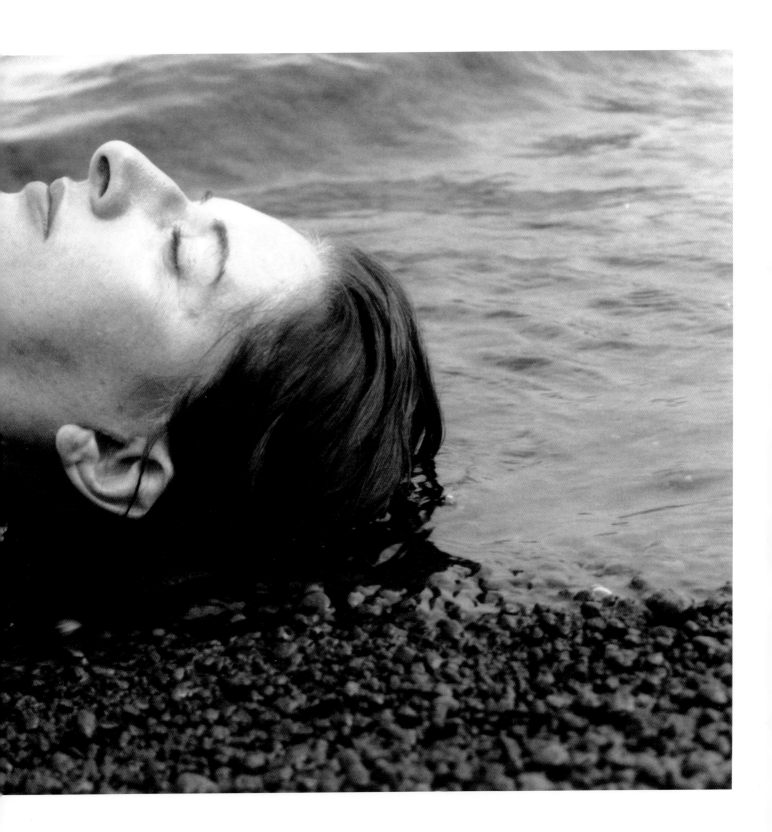

Stromboli III (Volcano), 2002
Digital print, type C (Lambda), 50 × 75 cm

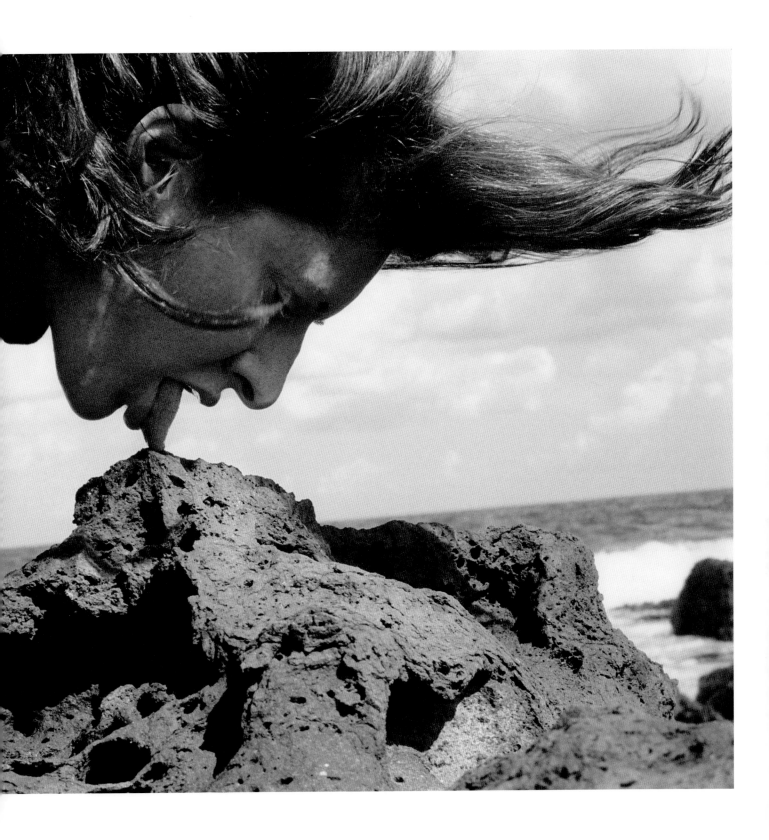

The House with the Ocean View

The House with the Ocean View was
performed at the Sean Kelly Gallery in
New York in 2002.
Three suspended rooms were built facing
the street. The only thing separating artist
and audience were three ladders with
rungs made of upturned butcher's knives.
I lived in this space for twelve days, without
eating or speaking. The audience could
see me sleeping, meditating, showering
or using the bathroom. The performance
was a declaration on transparency and
the state of helplessness, and afforded
an energy dialogue between performer
and spectators.

The idea
This performance comes from my desire
to see if it is possible to use simple daily
discipline, rules, and restrictions to purify
myself. Can I change my energy field?
Can this energy field change the energy
field of the audience and of the space?

Installation: artist
Duration of the performance: 12 days
Food: no food
Water: large quantity of mineral water
Talking: no talking
Singing: possible and unpredictable
Writing: no writing
Sleeping: 7 hours a day
Standing: unlimited
Sitting: unlimited
Lying: unlimited
Shower: 3 times a day

Installation: audience
Use telescope
Remain silent
Establish energy dialogue with the artist

Clothes
The clothes for *The House with the Ocean
View* were inspired by Alexander
Rodchenko. The colors of the clothes
were selected in accordance with the
principles of the Hindu Vedic square. The
boots are the ones I wore for the walk on
the Great Wall of China in 1988.

Supplies
1 bottle of pure almond oil
1 bottle of rose water
1 bar of natural soap
1 wooden comb
12 fine cotton towels
12 pairs of cotton panties
12 cotton t-shirts
7 cotton pants
7 cotton shirts

Performance
Duration: 12 days
Sean Kelly Gallery, New York, November 15–26, 2002

The House with the Ocean View, 2002/2017
Sound installation, bed with mineral pillow, sink, chair with mineral pillow, table, toilet, shower basin,
shower, three ladders with knives, metronome, water glass, clothes; dimensions variable

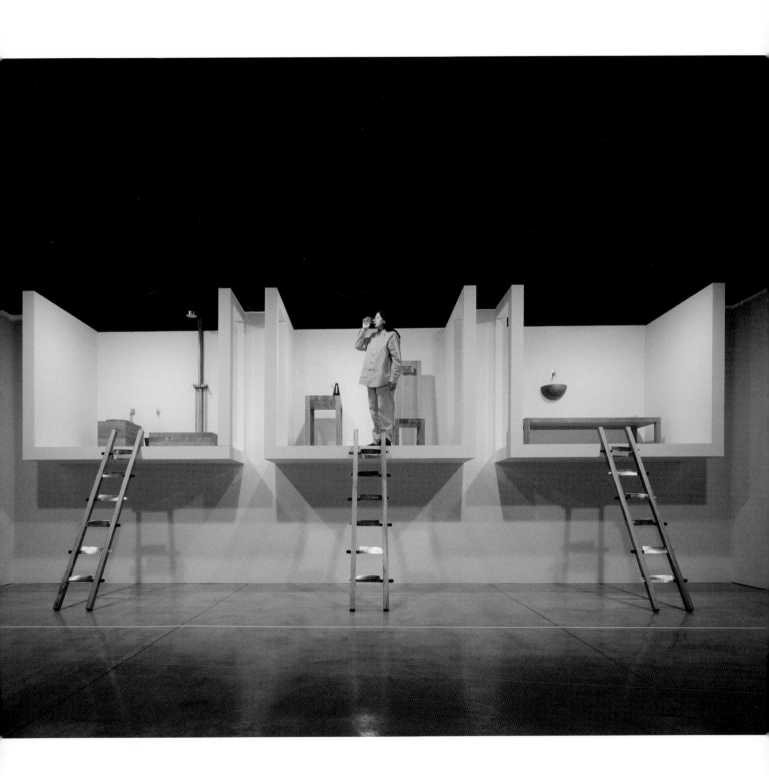

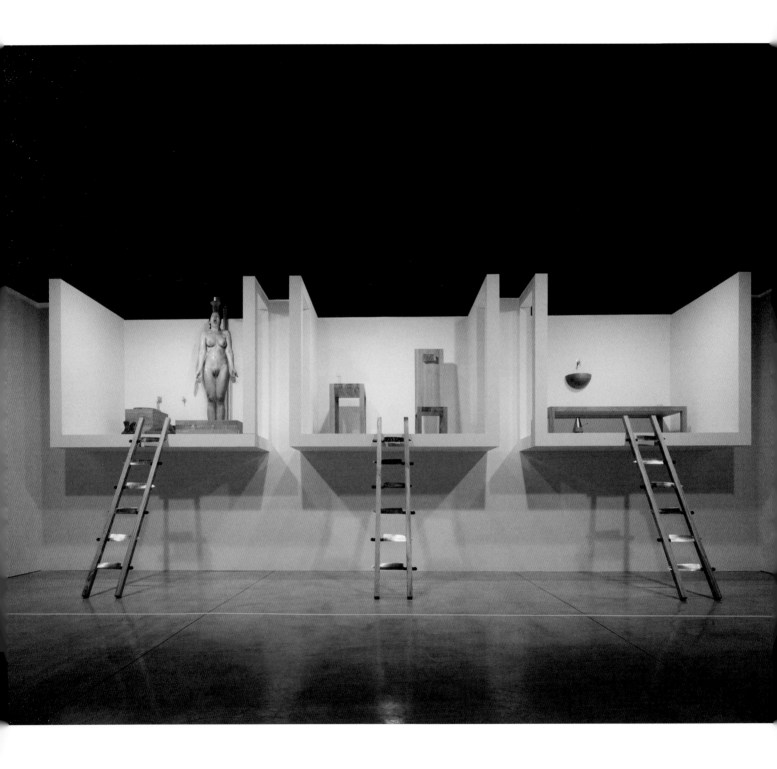

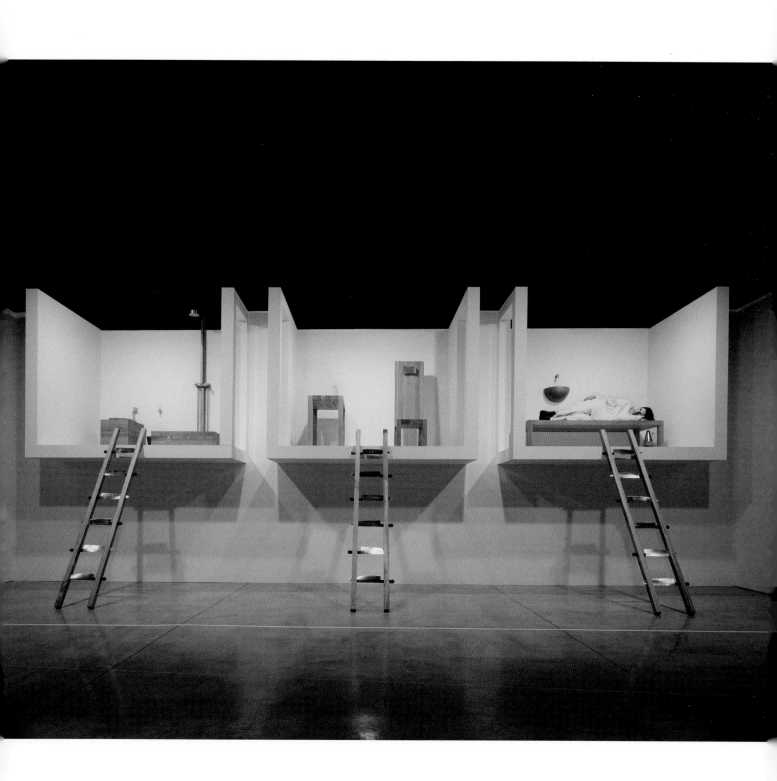

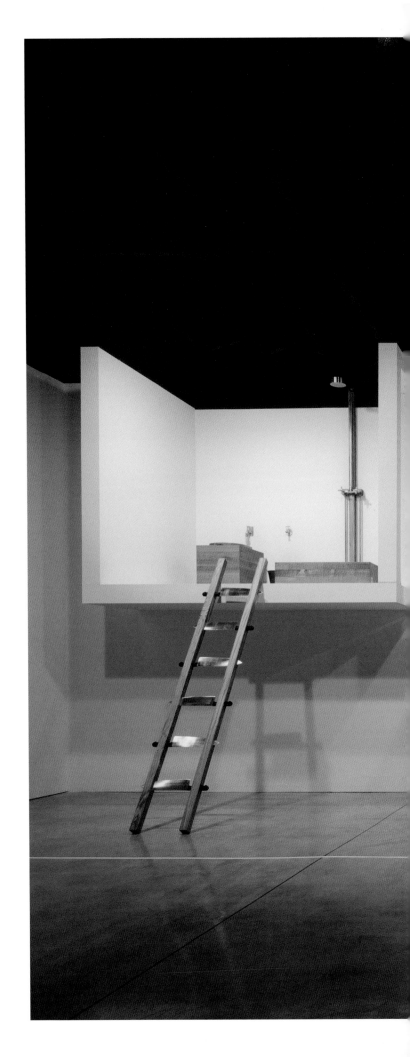

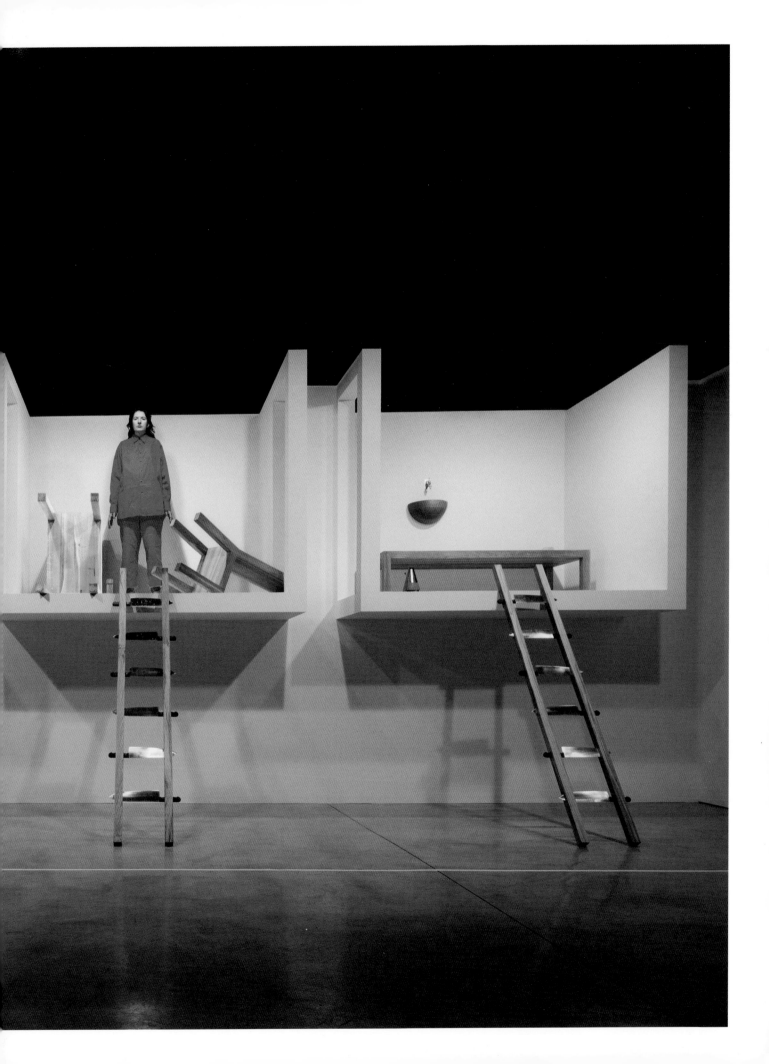

Count on Us

The multiscreen video installation *Count on Us* consists of five parts:

Boy: a boy singing a love song.

Girl: a girl singing a song of longing.

The Star: children are seen making the formation of a star on the ground, around a skeleton.

Tesla Coil: I am holding in my hand a bare neon light, without any wires. In front of me, running through two large copper coils, are 35,000 volts of electricity, charging the space, passing through my body and illuminating the neon light in my hand.

The Chorus: a choir made up of children dressed in black, singing the hymn of the United Nations, conducted by a skeleton.

Count on Us, 2004
4-channel video installation, sound, 16:11 min

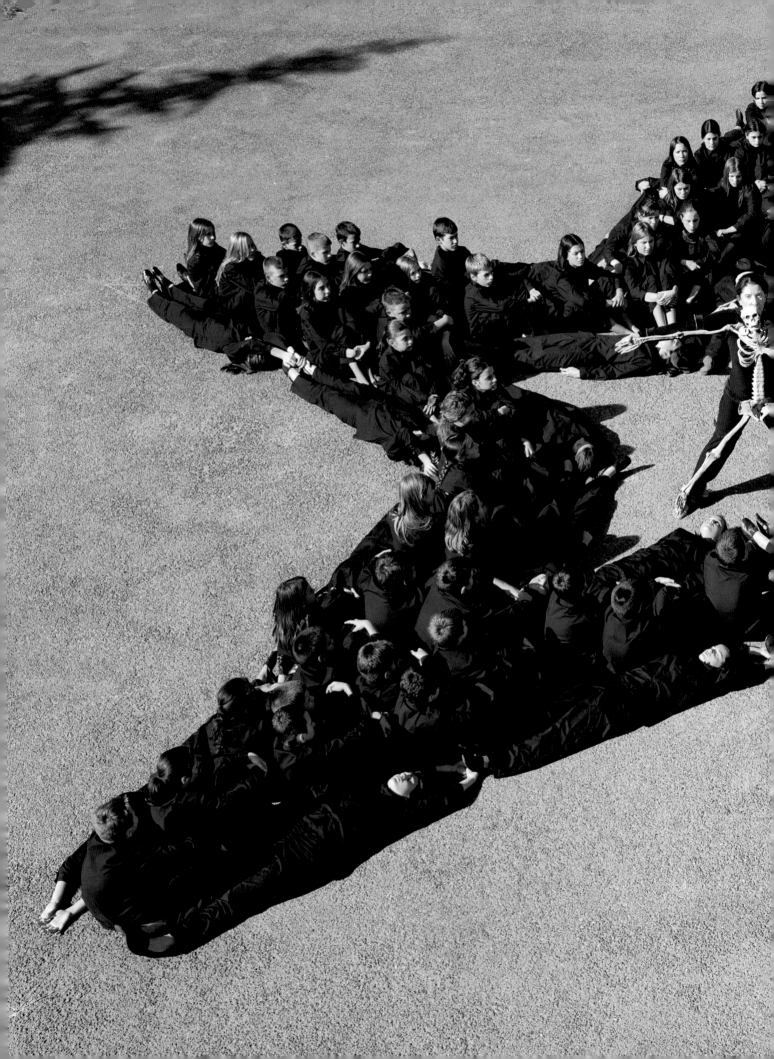

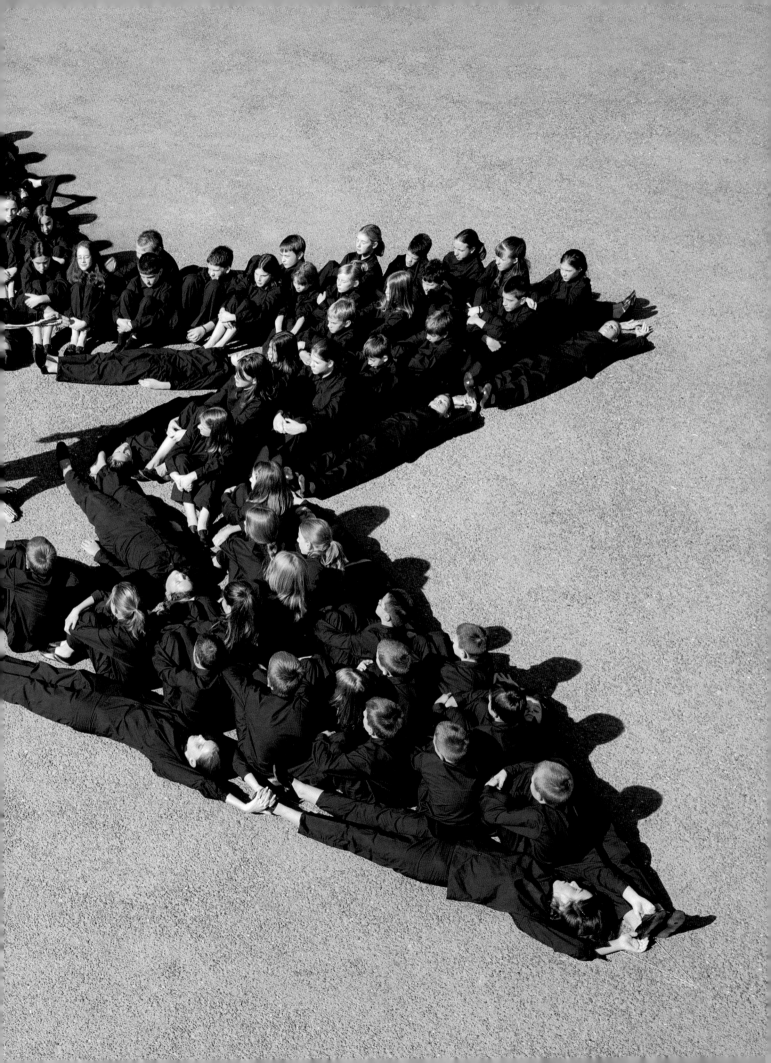

Balkan Erotic Epic

Balkan Erotic Epic is based on my research into Balkan folk culture and its use of the erotic. Through eroticism, the human tries to make himself equal with the gods. In folklore, the woman marrying the sun or the man marrying the moon is to preserve the secret of creative energy and get in touch through eroticism with indestructible cosmic forces. People believed that in the erotic there was something superhuman that doesn't come from us but from the gods.

Obscene objects and male and female genitals have a very important function in the fertility and agricultural rites of Balkan peasants. They were used very explicitly for a variety of purposes.

Women would show openly their vaginas, bottoms, breasts, and menstrual blood in the rituals. Men would openly show their bottoms and penises in the ritual in acts of masturbation and ejaculation.

Balkan Erotic Epic, 2005
Multichannel video installation (color, sound); duration variable

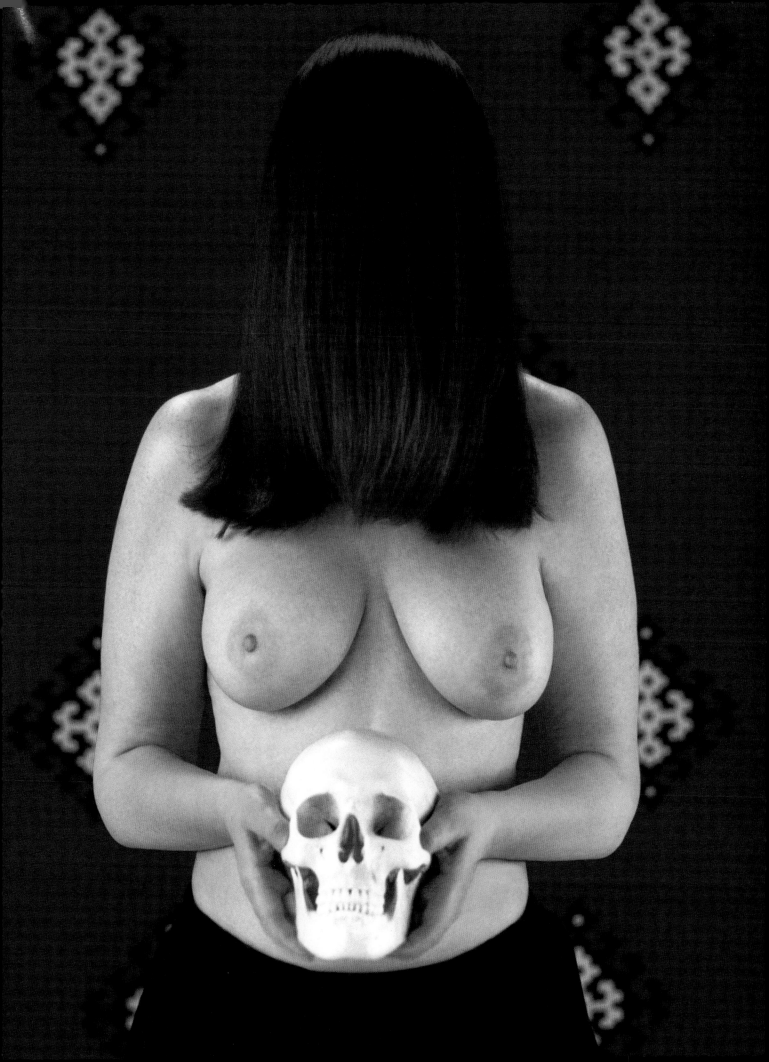

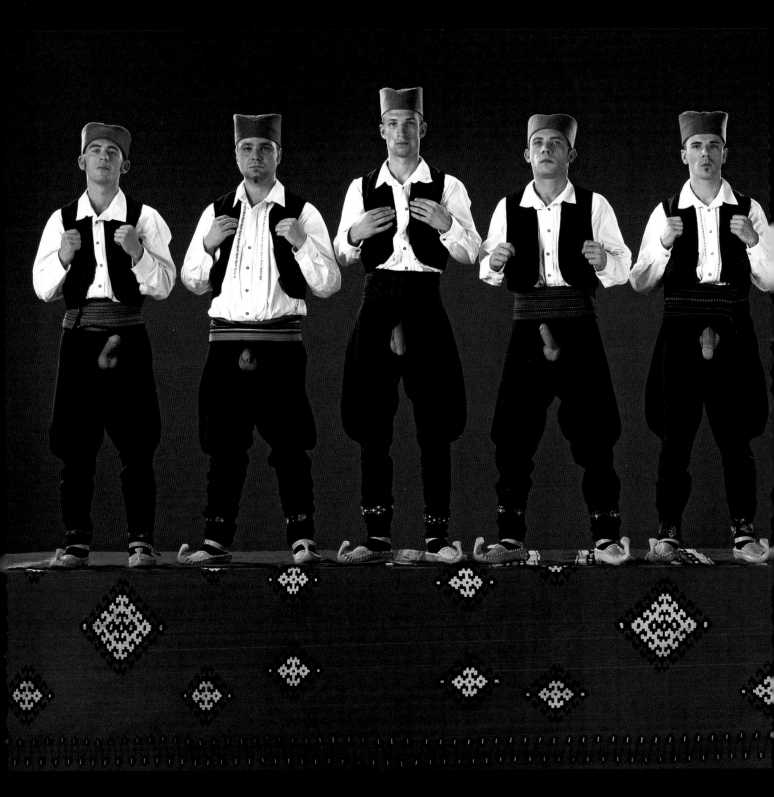

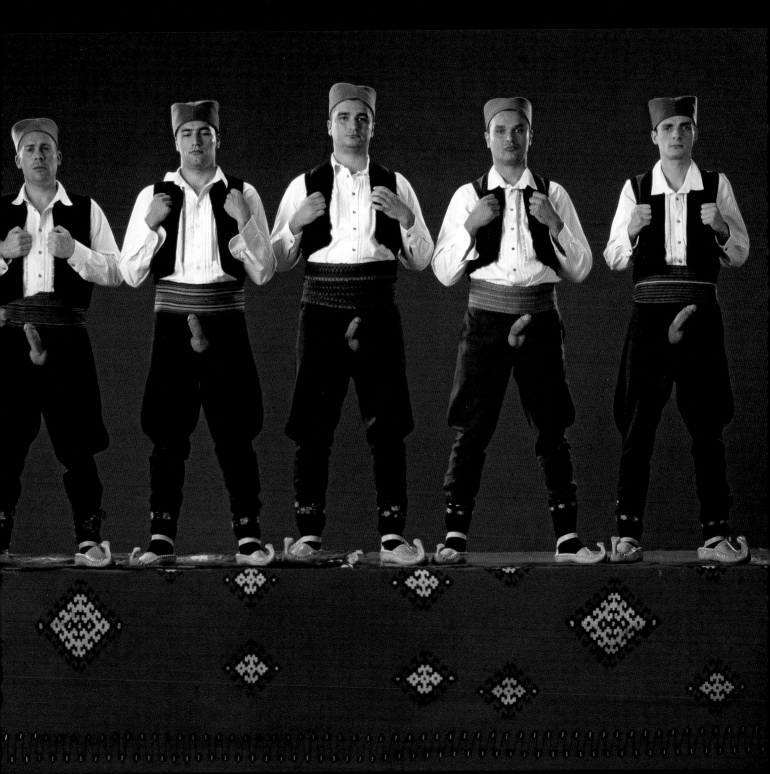

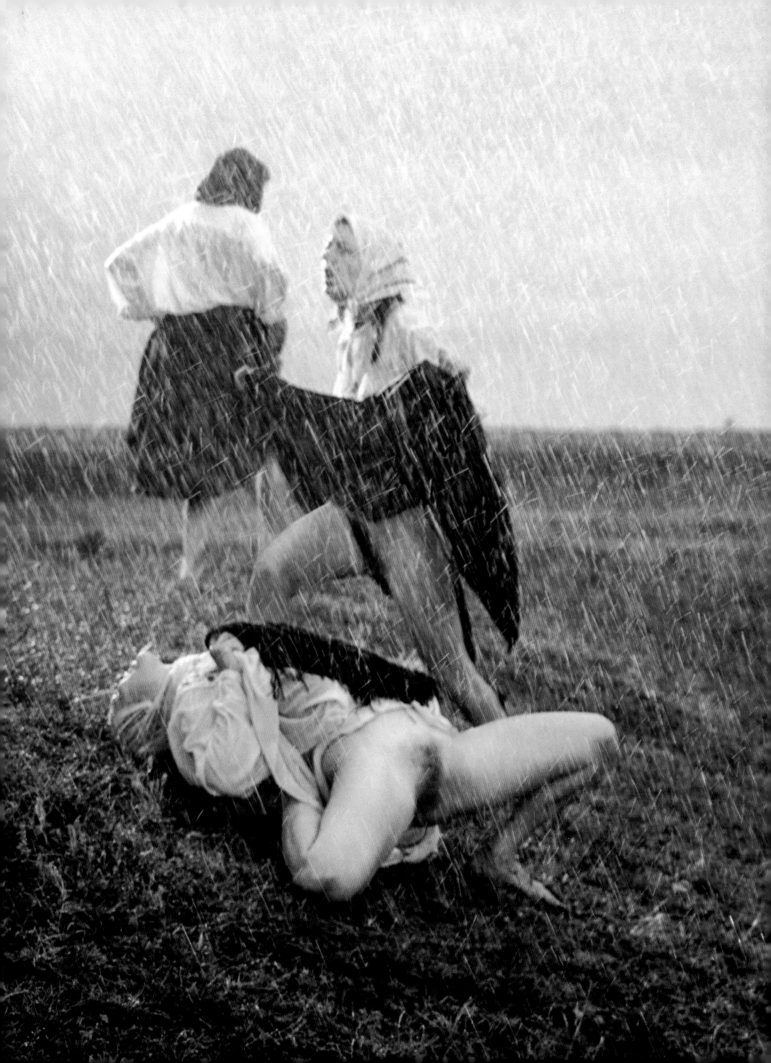

Seven Easy Pieces

For seven consecutive nights at the
Solomon R. Guggenheim Museum
I reenacted seminal performance works
by my peers dating from the nineteen-
sixties and -seventies. The project
was premised on the fact that little
documentation exists for most
performances from this critical early
period; one often has to rely upon
testimonies from witnesses or
photographs that show only portions
of any given piece. *Seven Easy Pieces*
examines the possibility of redoing
and preserving an art form that is,
by nature, ephemeral:

1. Bruce Nauman, *Body Pressure* (1974)

2. Vito Acconci, *Seedbed* (1972)

3. VALIE EXPORT, *Action Pants: Genital Panic* (1969)

4. Gina Pane, *The Conditioning: First Action of Self-Portrait(s)* (1973)

5. Joseph Beuys, *How to Explain Pictures to a Dead Hare* (1965)

6. Marina Abramović, *Lips of Thomas* (1975, Galerie Krinzinger, Innsbruck)

7. Marina Abramović, *Entering the Other Side* (2005)

Marina Abramović, *Seven Easy Pieces*, 2007
HD video (color, surround sound), 92:50 min; directed by Babette Mangolte

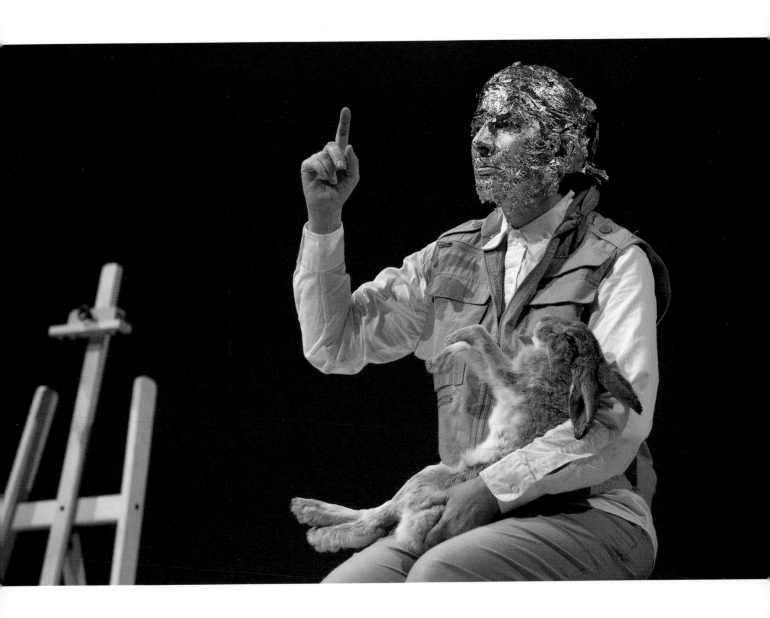

Marina Abramović performing Joseph Beuys, *How to Explain Pictures to a Dead Hare*
Solomon R. Guggenheim Museum, New York, 2005

Original work: Joseph Beuys, *Wie man dem toten Hasen die Bilder erklärt*
Gallery Alfred Schmela, Düsseldorf, 1965

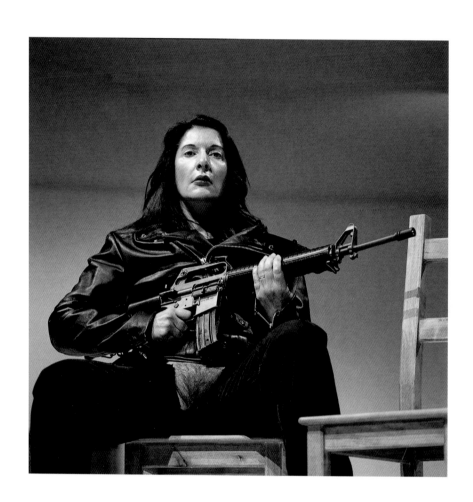

Marina Abramović performing VALIE EXPORT, *Action Pants: Genital Panic*
Solomon R. Guggenheim Museum, New York, 2005

Original work: VALIE EXPORT, *Aktionshose: Genitalpanik*
Stadtkino, Munich, 1968. Original photo by Peter Hassman, Vienna, 1969

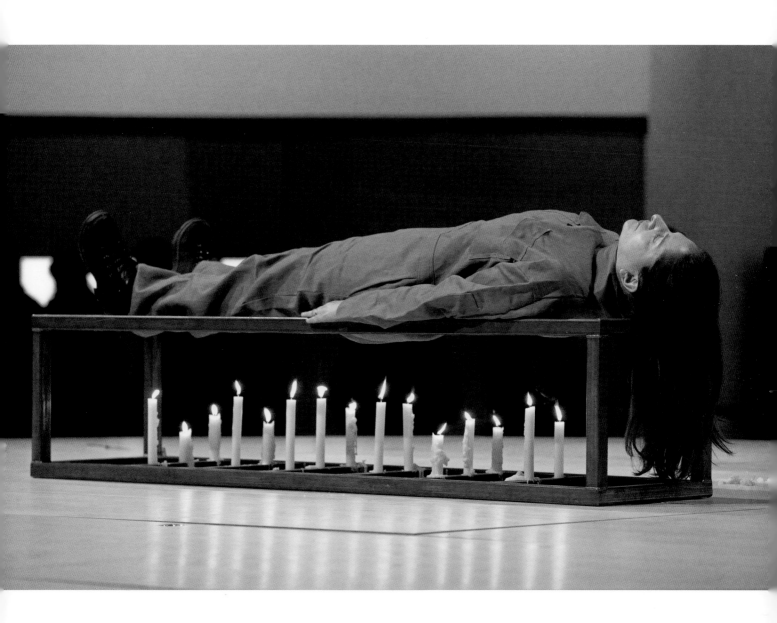

Marina Abramović performing Gina Pane, *The Conditioning: First Action of Self-Portrait(s)*
Solomon R. Guggenheim Museum, New York, 2005

Original work: Gina Pane, *Autoportrait(s): La mise en condition*
Galerie Stadler, Paris, 1973

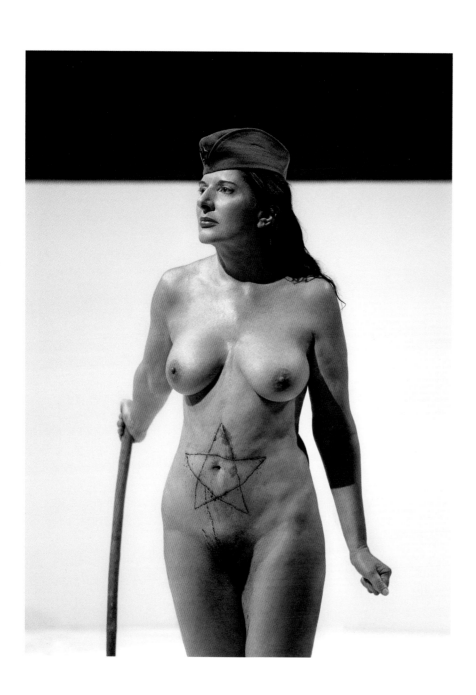

Marina Abramović, *Lips of Thomas*
Solomon R. Guggenheim Museum, New York, 2005

Original work: Marina Abramović, *Thomas Lips*
Krinzinger Gallery, Innsbruck, 1975

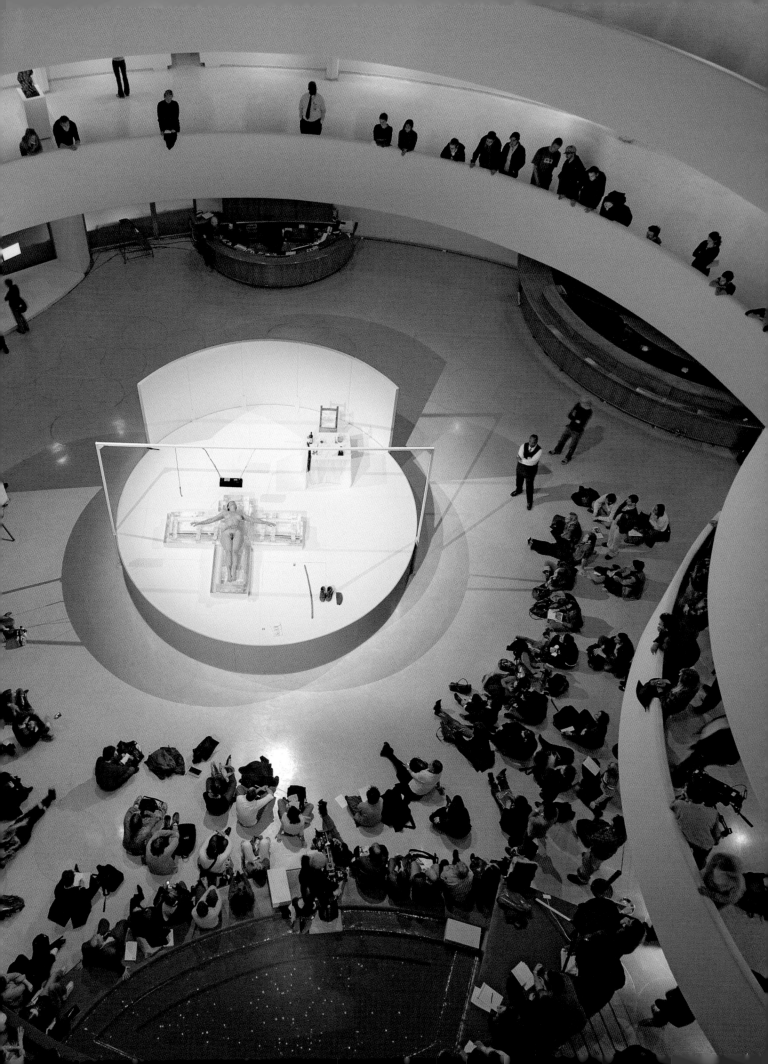

Opposite top: Marina Abramović performing Bruce Nauman, *Body Pressure*
Solomon R. Guggenheim Museum, New York, 2005

Original work: Bruce Nauman, *Body Pressure*
"Yellow Body," Galerie Konrad Fischer, Düsseldorf, February 4–March 6, 1974

Opposite bottom: Marina Abramović performing Vito Acconci, *Seed Bed*
Solomon R. Guggenheim Museum, New York, 2005

Original work: Vito Acconci, *Seed Bed*
Sonnabend Gallery, New York, 1972

Overleaf: Marina Abramović, *Entering the Other Side*
Solomon R. Guggenheim Museum, New York, 2005

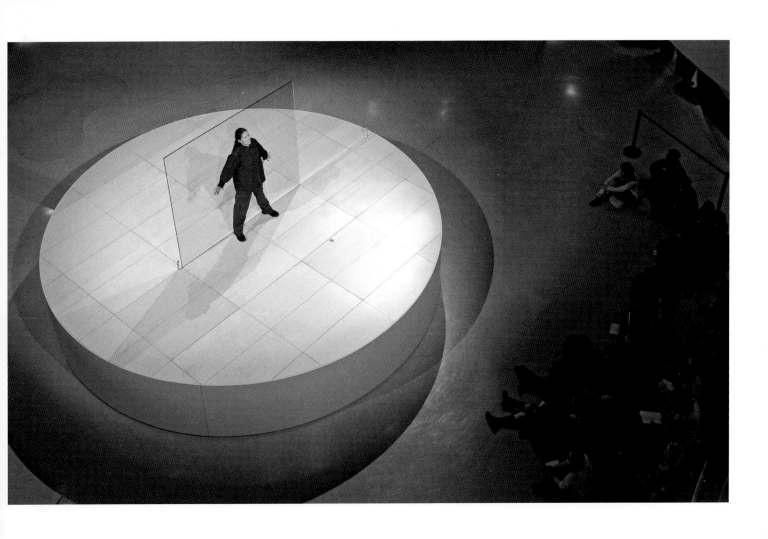

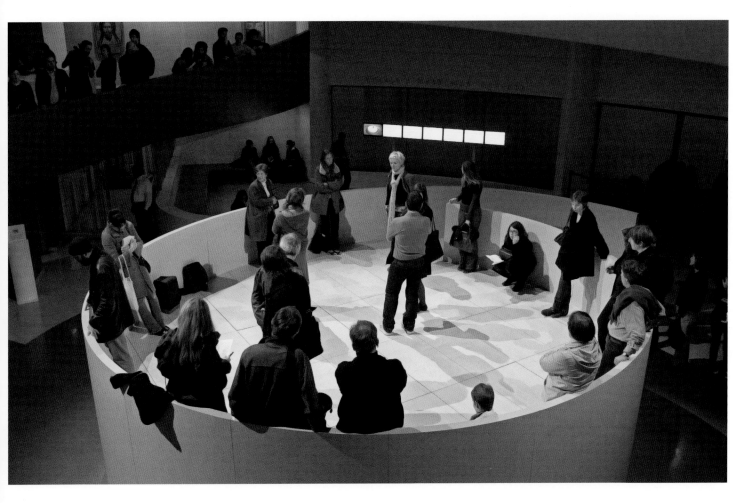

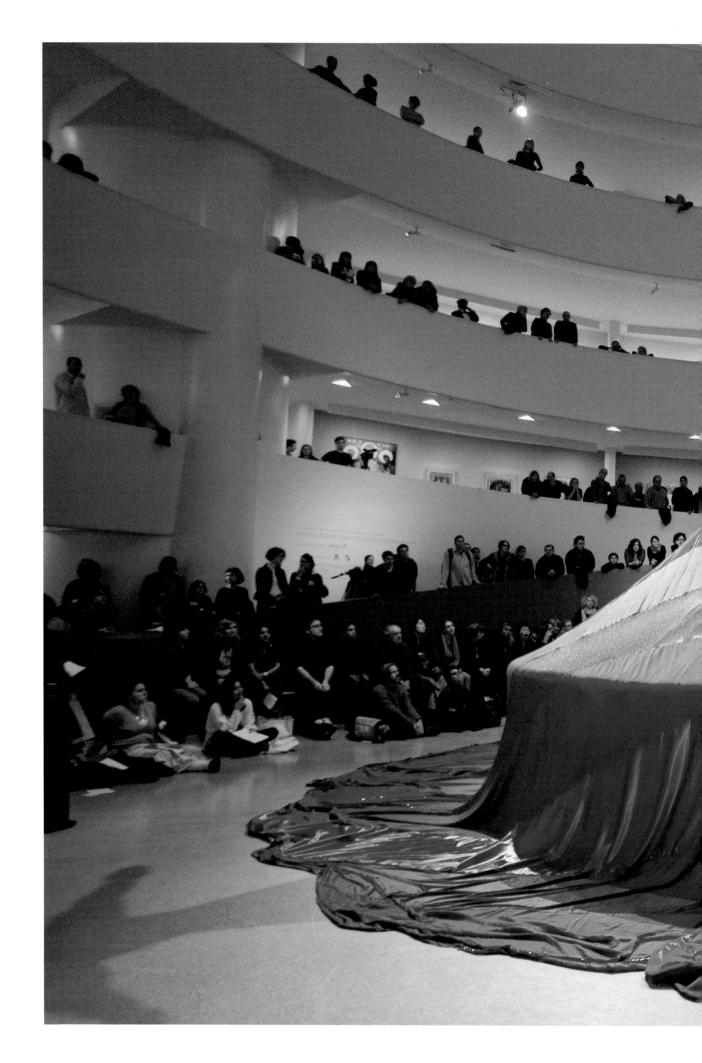

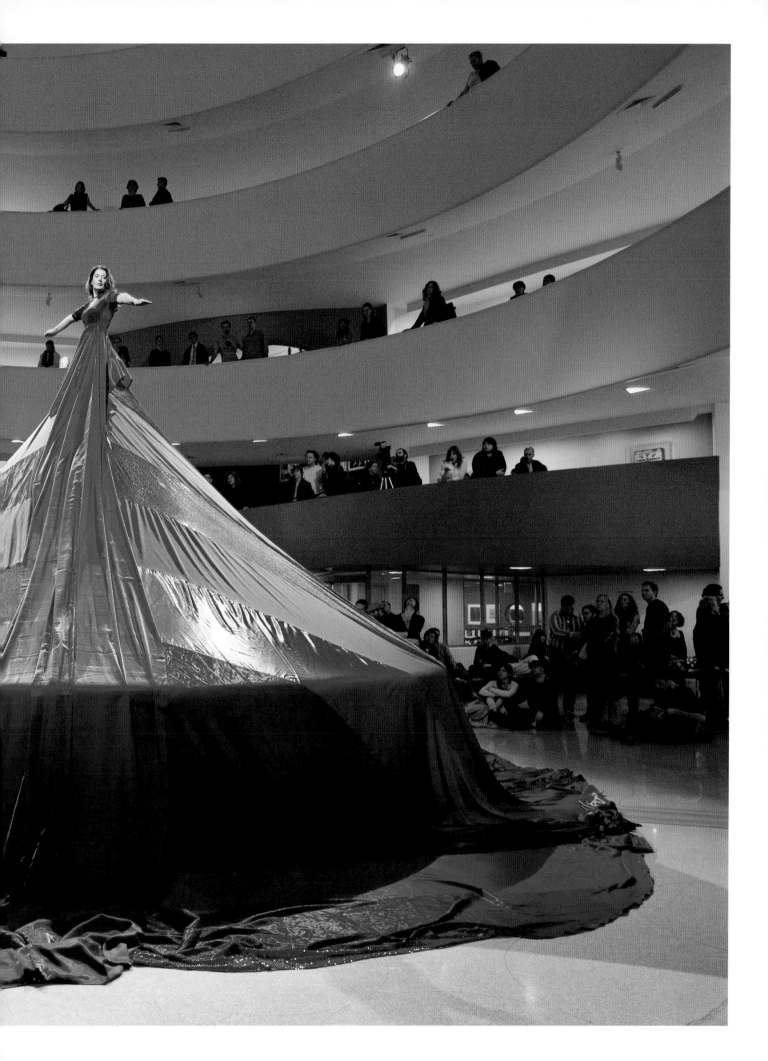

The Kitchen V: Holding the Milk, 2009
Video (color, sound), 12:42 min

214

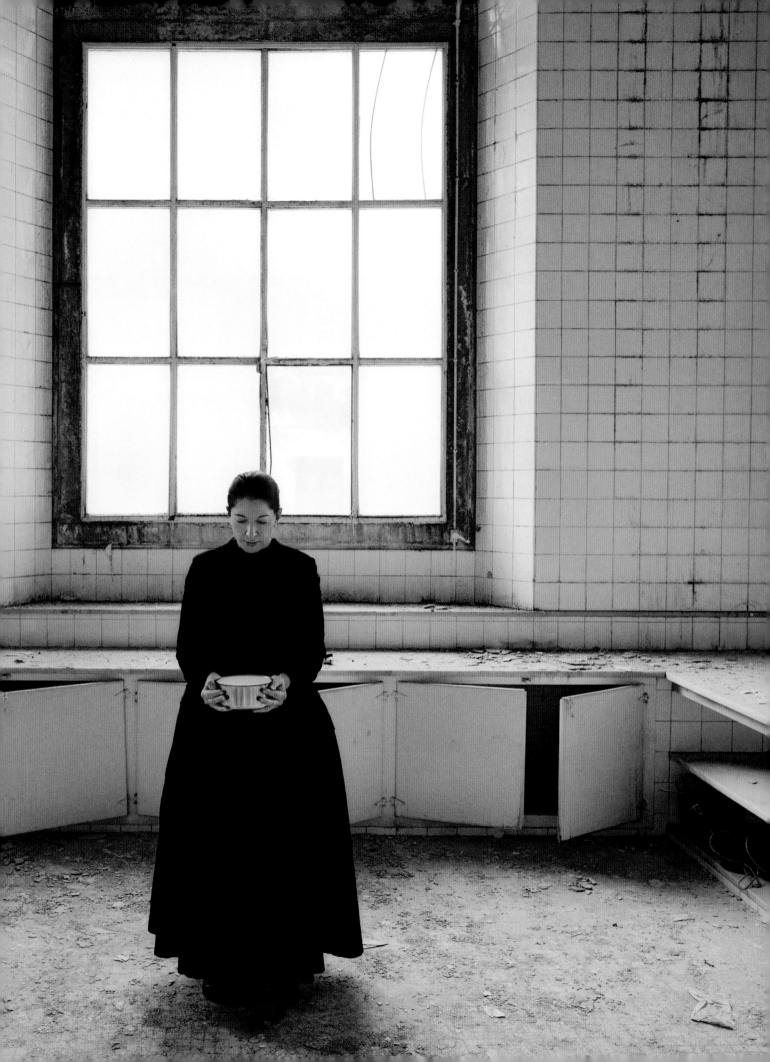

Portrait with Golden Mask, 2009
Video (color, no sound), 30:05 min

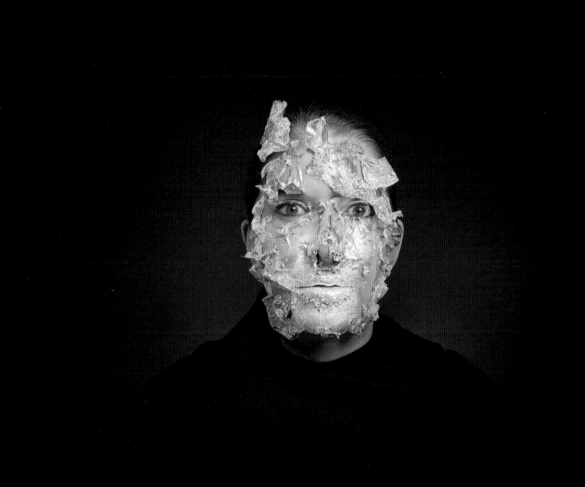

Sleeping Under the Banyan Tree, 2010
Video (b/w, no sound), 56:43 min

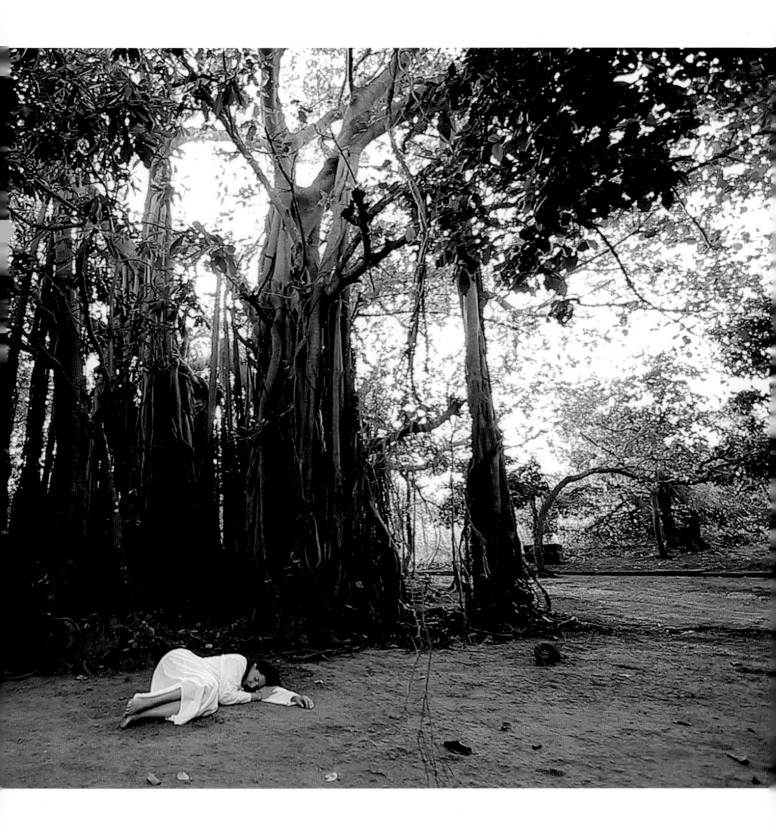

Confession

In *Confession*, I review the memories of my childhood and youth while staring at a donkey. My body, often subjected to extremely intense physical restraints, remains completely still in this subtitled video. The attention is shifted from the physical to the mental universe. Intense looks are exchanged with the animal, which gazes directly into my eyes throughout the whole film.

Performance for video, 2010
Duration: 60 minutes

Confession, 2010
Video (b/w, no sound), 60:00 min

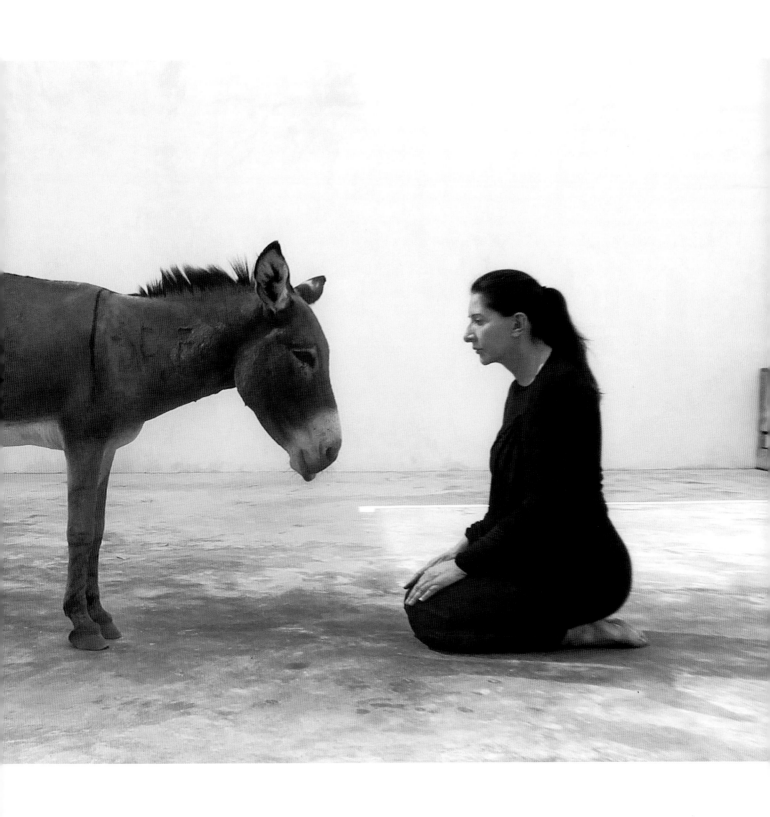

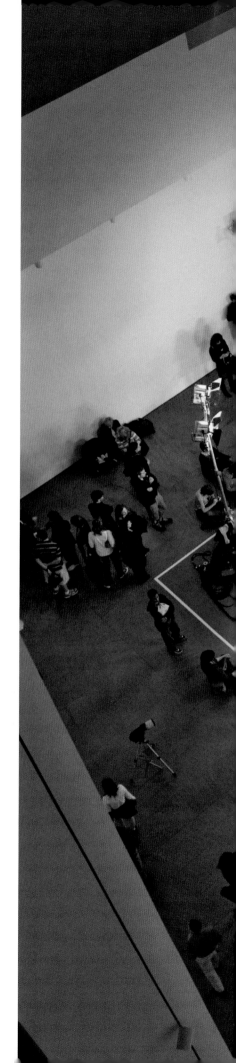

The Artist is Present

In 2010, in my retrospective exhibition at the Museum of Modern Art in New York (MoMA), I staged a performance in which I sat in a chair, completely still and in silence. Visitors were invited to sit in a chair opposite mine and stare at me for as long as they liked. I performed for 736 hours, making eye contact with 1,675 people during this time. This installation presents a replica of the furniture used at the MoMA performance. Two large screens opposite each other show the artist and visitors face to face. The work embodies my total vulnerability and openness before the public.
I always seek very simple forms in my work regarding geometry, architecture, color, elements, and the performance itself. However, over and above simplicity, I always deal with effort, as my work demands a lot of preparation. That is especially true in *The Artist is Present,* one of the most difficult performances I have ever staged. Before that, the public was not present; therefore there is no way to compare. So by the end of *The Artist is Present* I was in a state of mental and physical exhaustion such as I had never felt before. What's more, all my points of view, everything that had seemed important before, my daily life, the things I liked and disliked, everything was turned upside down.

Performance
The Museum of Modern Art, New York,
March–May 2010

The Artist is Present, 2010
7-channel video installation (6 × 16:9 projections, 1 monitor: color, no sound),
grid: 6 hours/CAM 3: 71 × 7 hour files

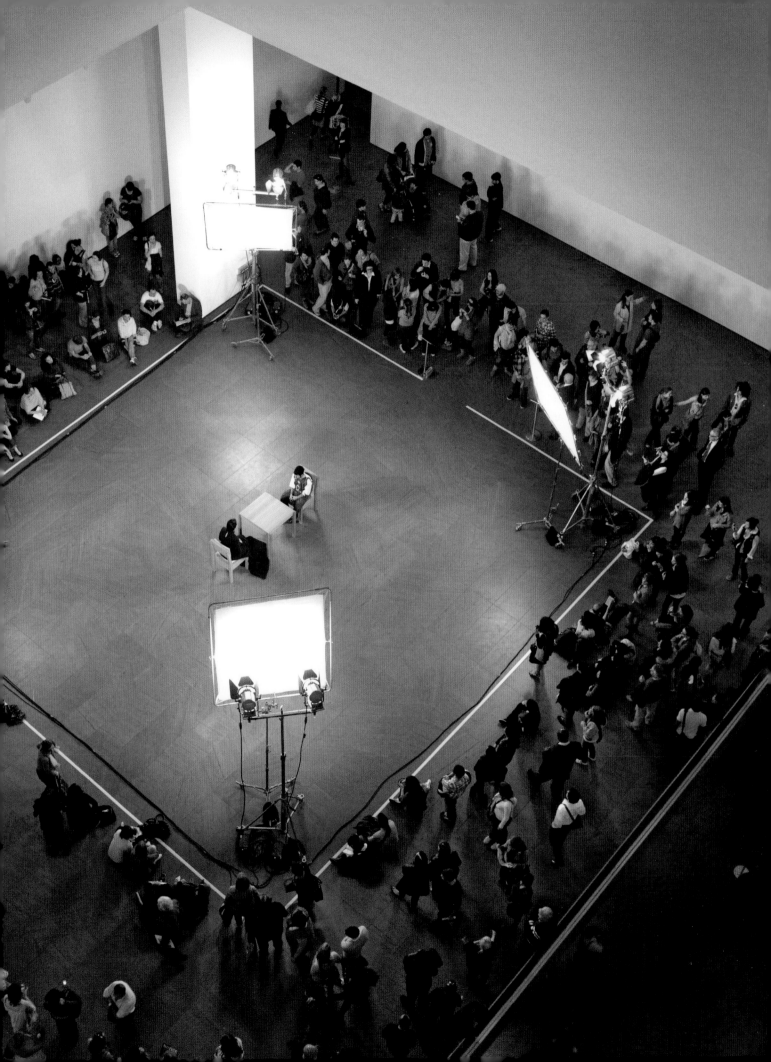

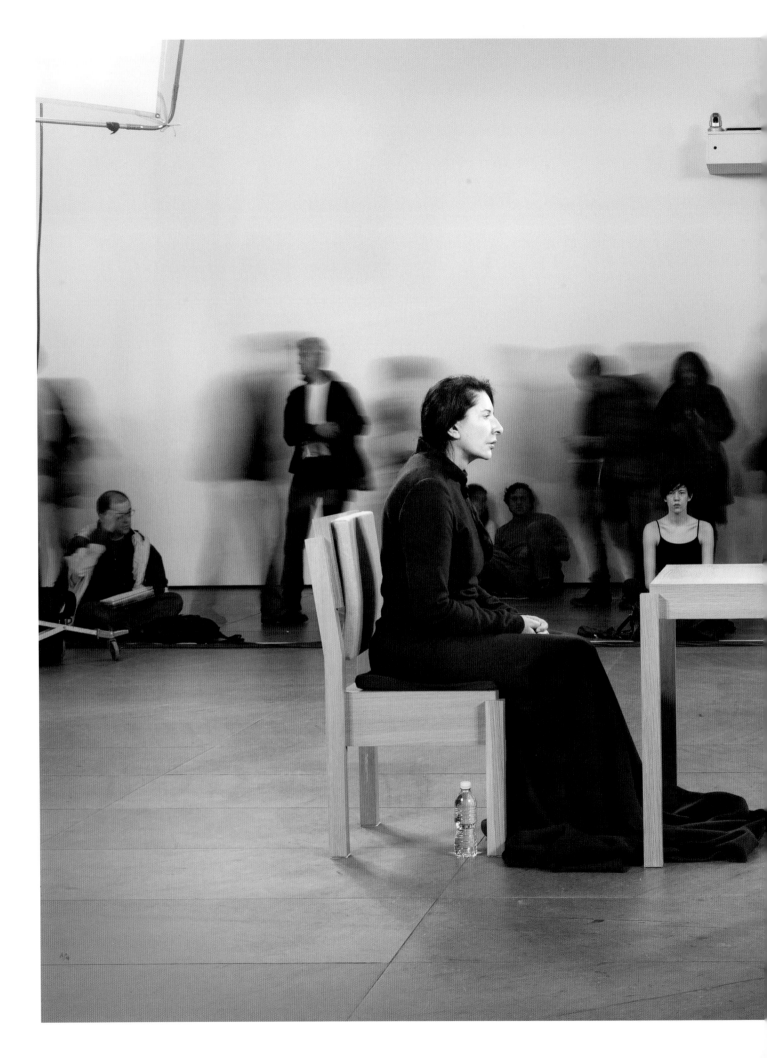

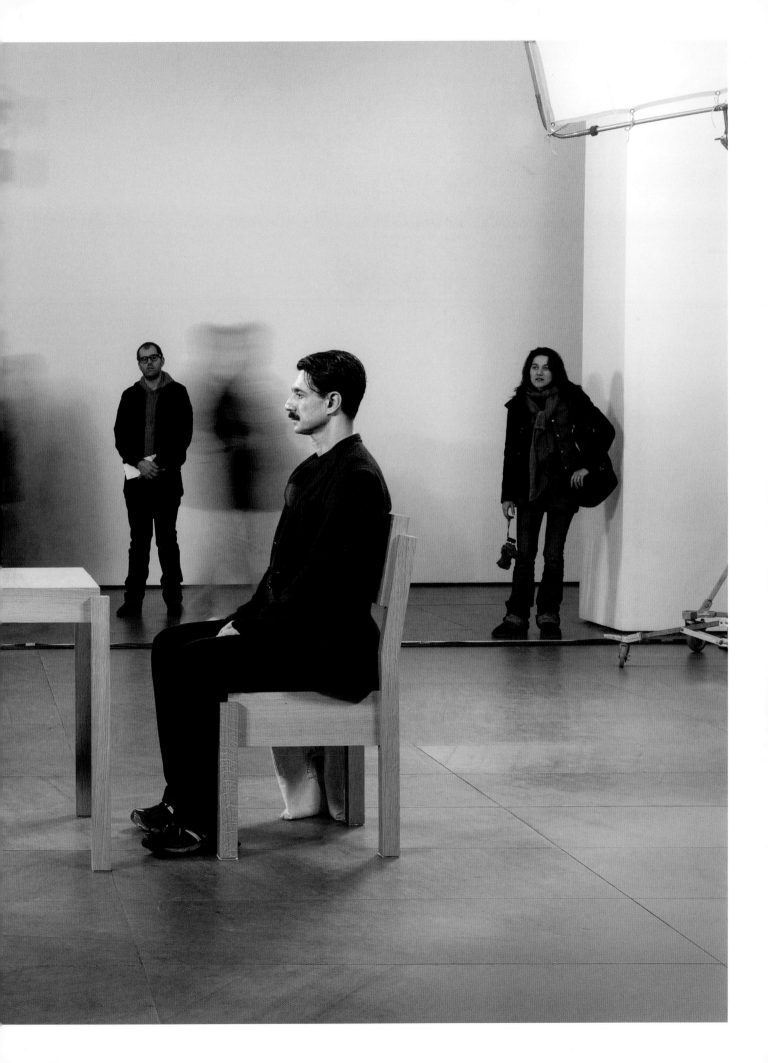

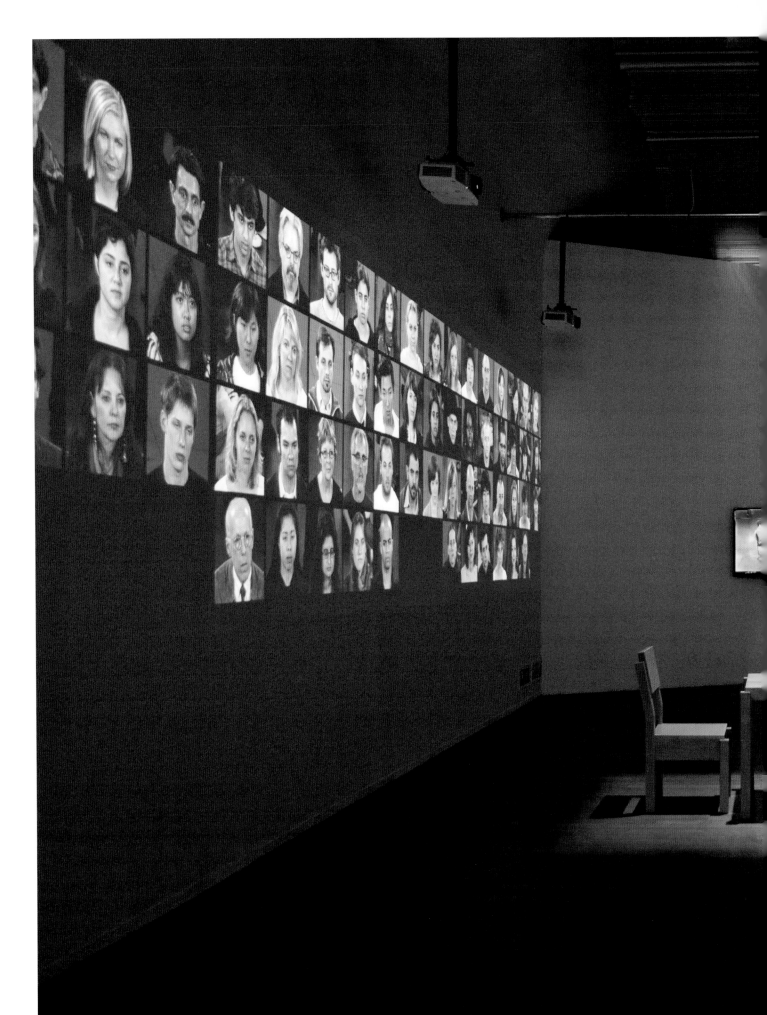

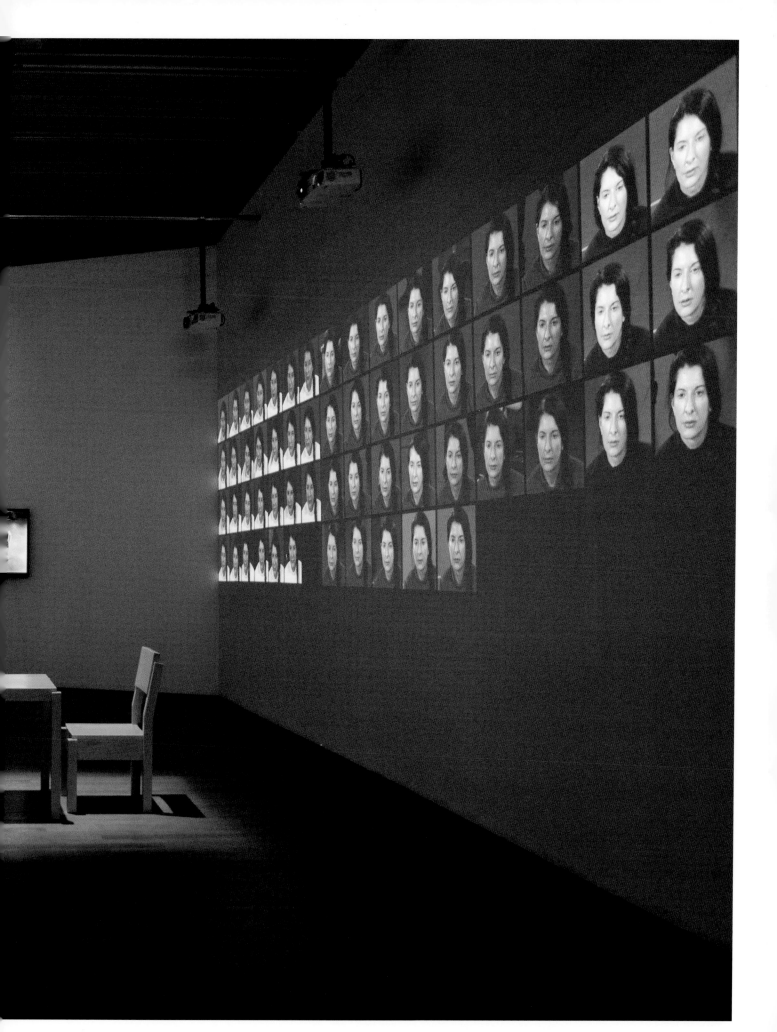

512 Hours

This performance was staged in 2014
at the Serpentine Gallery, in London.
During the exhibition, I would approach
the public directly, with no mediation,
instructions or script. Visitors had to
leave all their belongings behind and were
invited to enter in silence. Inside the
gallery they found themselves in an
empty space where the work was yet to
be created. In this space, the public
engaged in simple exercises, such as
gazing at a white wall, lying on a bed,
walking in slow motion, counting lentils
and grains of rice, or standing on a
platform. Each one of the activities
helped visitors feel their own presence in
the space; sooner or later, they developed
enough sensitivity to perceive the
collective energy. This work upset all
preestablished expectations about the
public's normal experience in an art
gallery. A new notion of time was created
and recorded daily on video by me and
my collaborator Lynsey Peisinger.

512 Hours, 2014/2017
Mixed-media installation; dimensions variable; duration: center channel:
64 hours/side channels: 20 hours

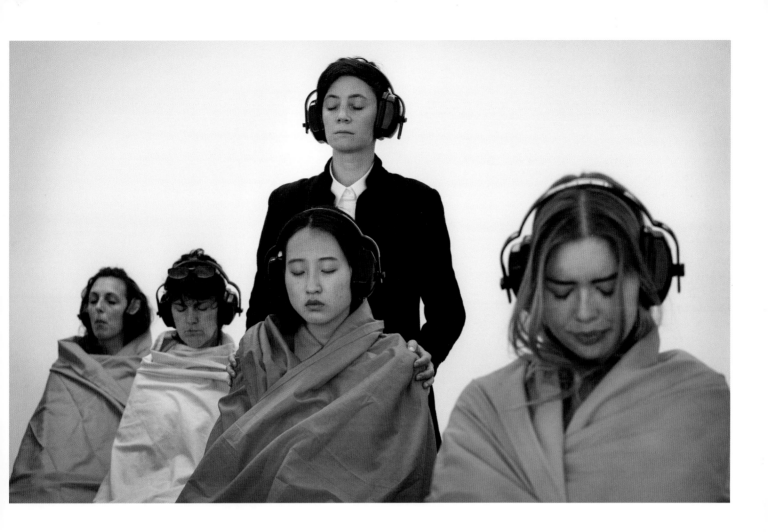

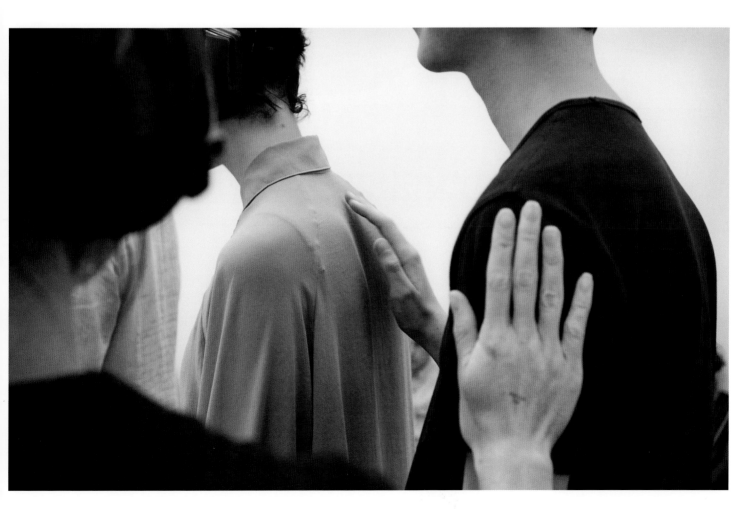

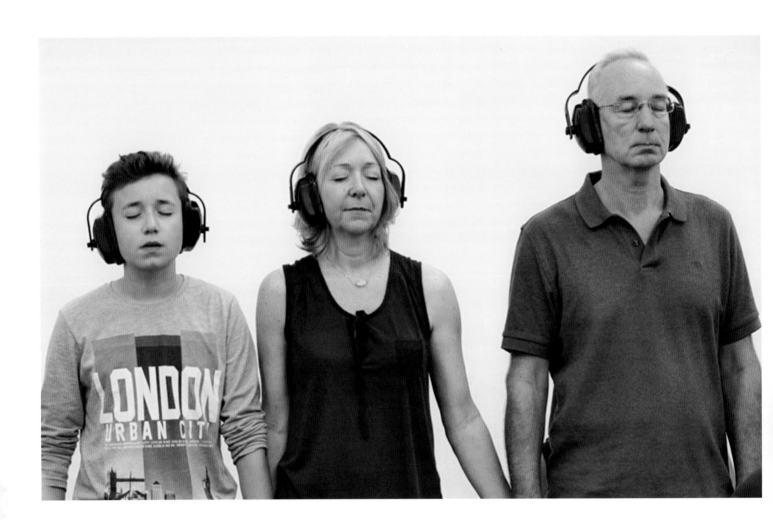

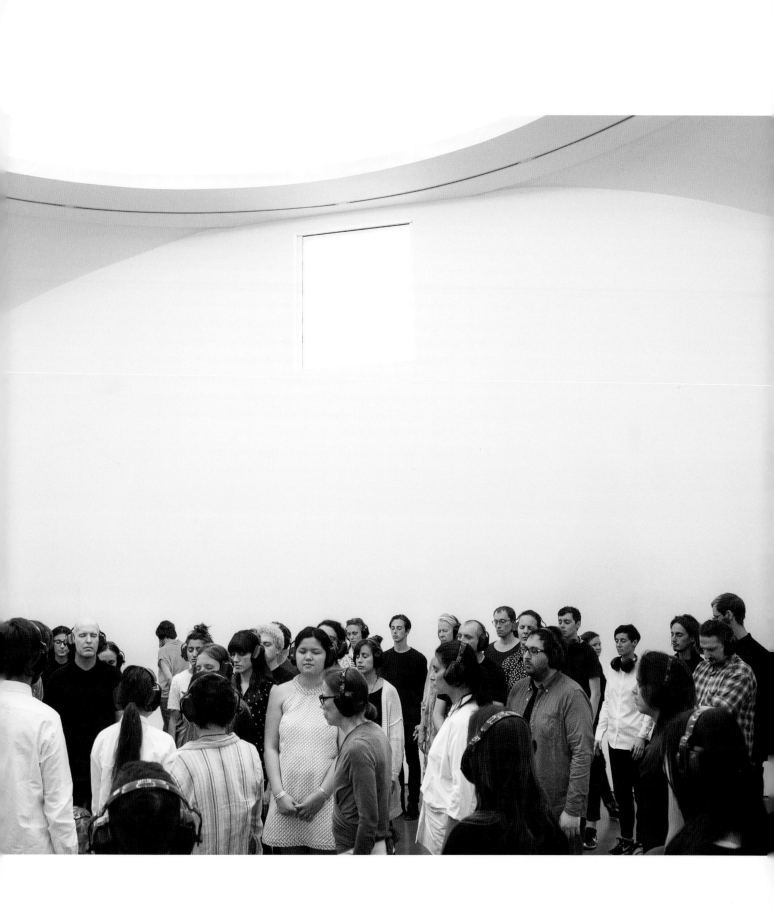

Counting the Rice

We are living in a difficult period in which
time is worth more and more because we
have less and less of it. For this reason,
I would like to give the public the
opportunity to experience and to reflect
upon emptiness, time, space, luminosity,
and void. During this experience I hope
that participants will connect with
themselves and with the present—the
elusive moment of the here and now.

Counting the Rice, 2015
Exercise for public participation from a series of workshops entitled "Cleaning
the House" (1979–); wooden table, wooden chairs, pencils, paper, white rice, black
lentils, instructions for the public, 75 × 1300 × 190 cm; duration: limitless

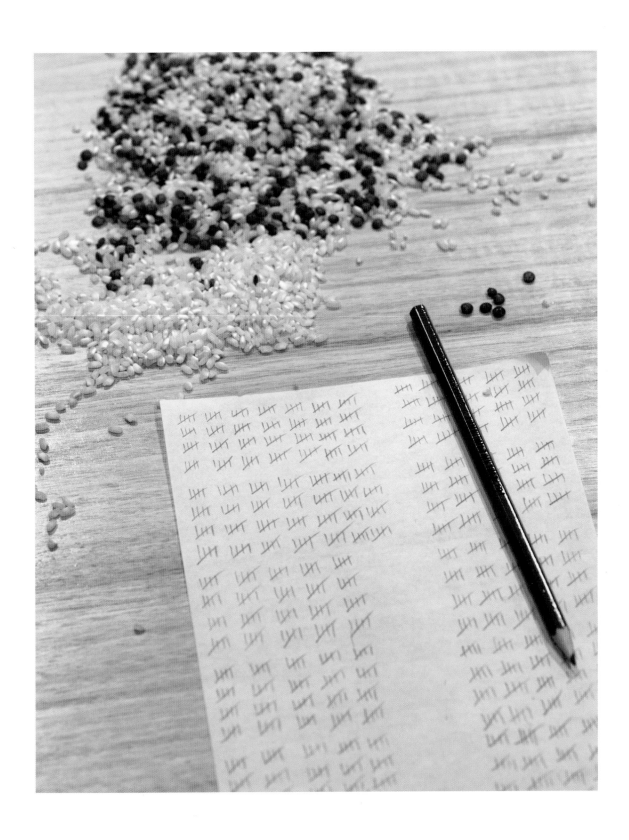

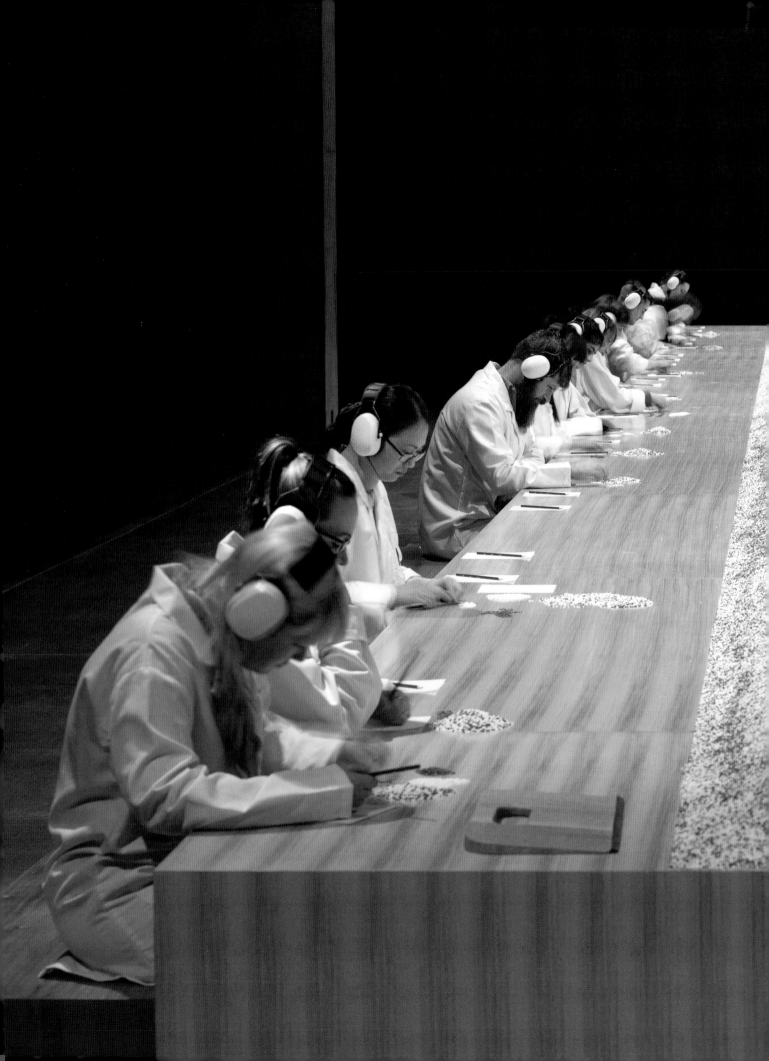

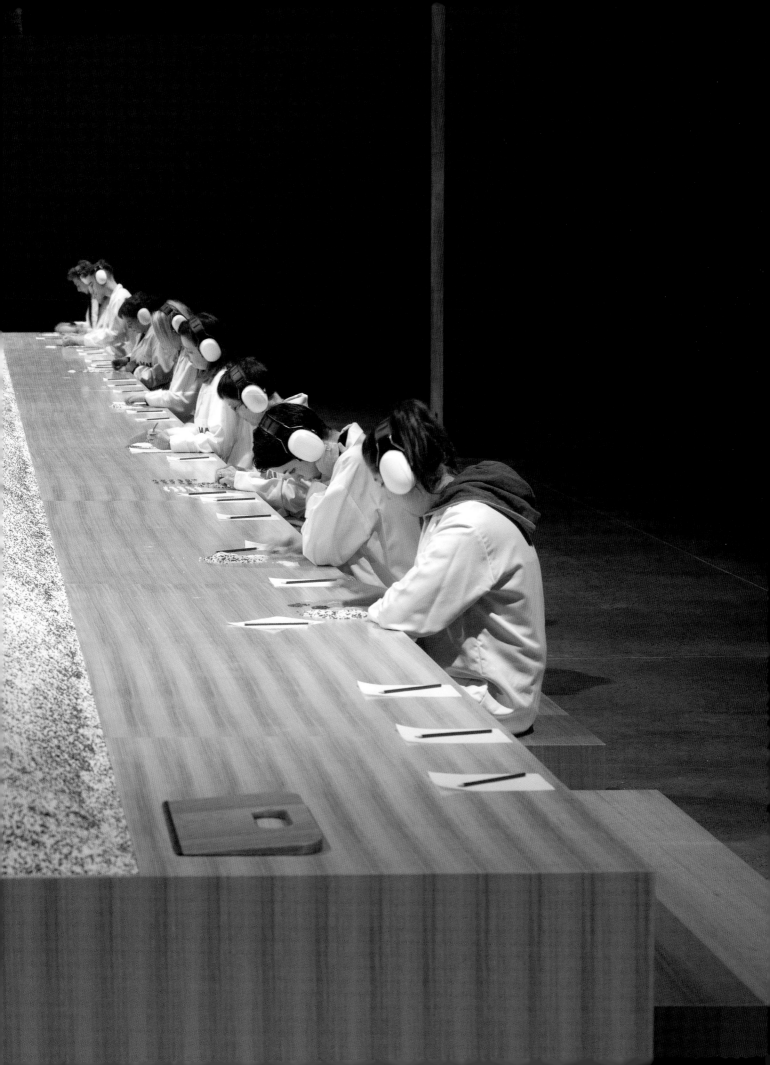

Transitory Objects

After finishing the Great Wall Walk with Ulay, I immediately began a new body of work, intending to continue the psychic cleansing of the walk and communicate my experience to the public. I began putting crystals and minerals—many of which could be found in the ground I'd walked in China—into interactive, furniture-like objects.

I had not performed solo since before meeting Ulay twelve years earlier, and did not yet have the confidence or concept to face the public alone. Through these objects, the public could perform instead, and feel something of what I had felt during my experiences in *Nightsea Crossing,* and walking the Great Wall. Through research of Tibetan and Chinese medicine, I formed a correspondence between minerals and parts of the body. Quartz represented the eyes, amethyst puntas the wisdom teeth, amethyst geodes the womb, iron the blood, and copper the nerves. I called my new pieces *Transitory Objects,* intending a double meaning: the energy given off by them was supposed to be a means of transit to a meditative, rejuvenating consciousness, and I considered the objects themselves to be temporary, to be discarded once the desired consciousness had been achieved. Despite their being heavy, expensive, solid, and even burdensome, I considered these objects to represent a step in the direction of a larger ideological goal: art without objects.

Bed for Human Use

Instructions for the public:
Sit or lie on the wooden bed.
Remain until energy is transmitted.

Duration: limitless

Chair for Human Use

Instructions for the public:
Sit on the chair.
Close your eyes.
Motionless.
Depart.

Duration: limitless

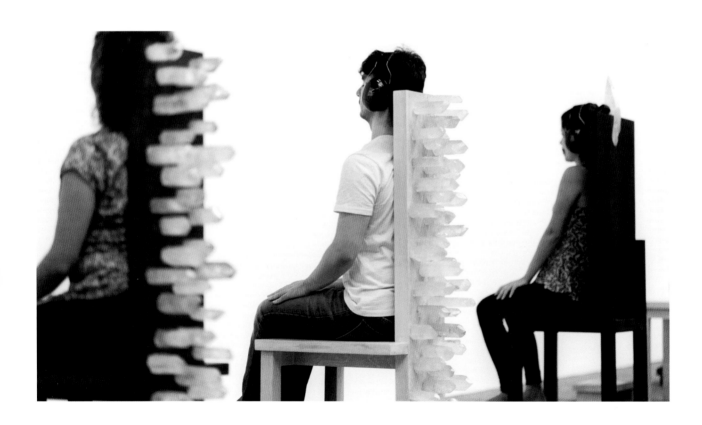

Chair for Human Use (III), 2015
Wood, quartz crystals, 110 × 65 × 80 cm

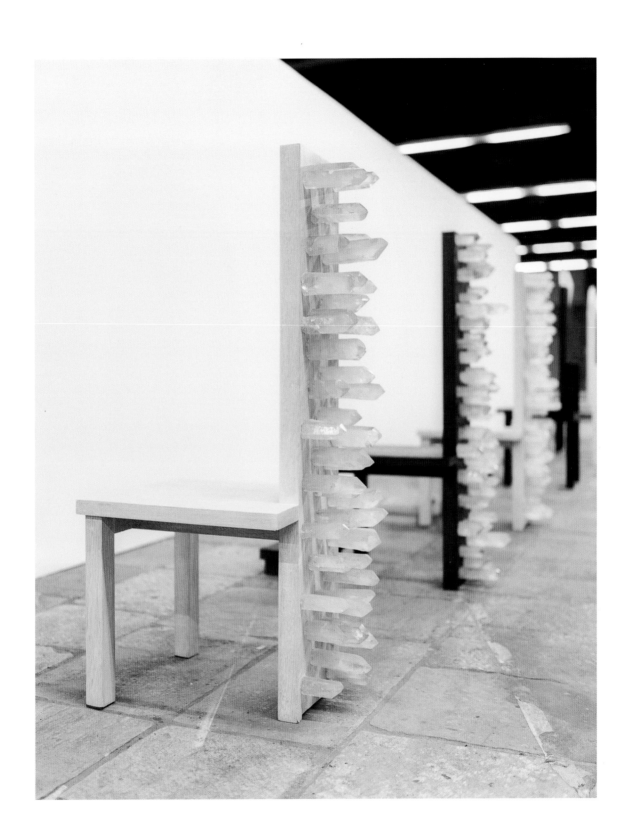

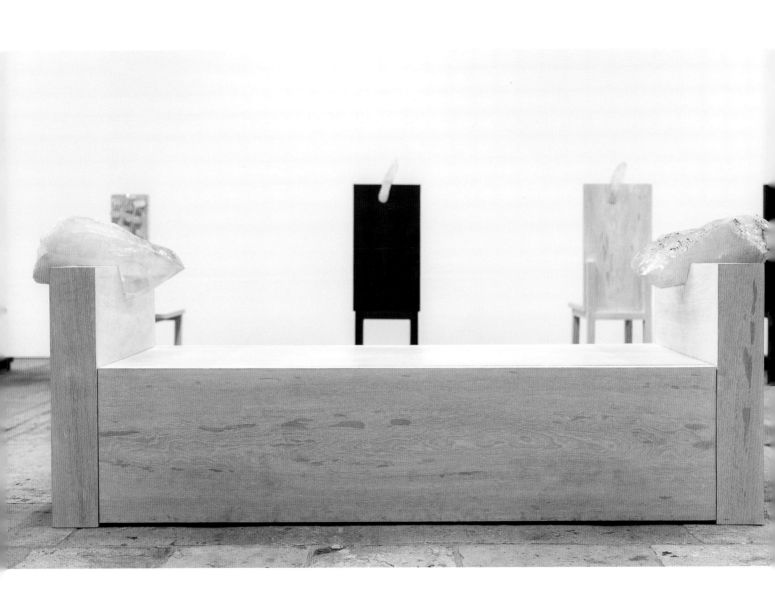

Bed for Human Use (III), 2015
Wood, quartz crystals, 80 × 77 × 218 cm

238

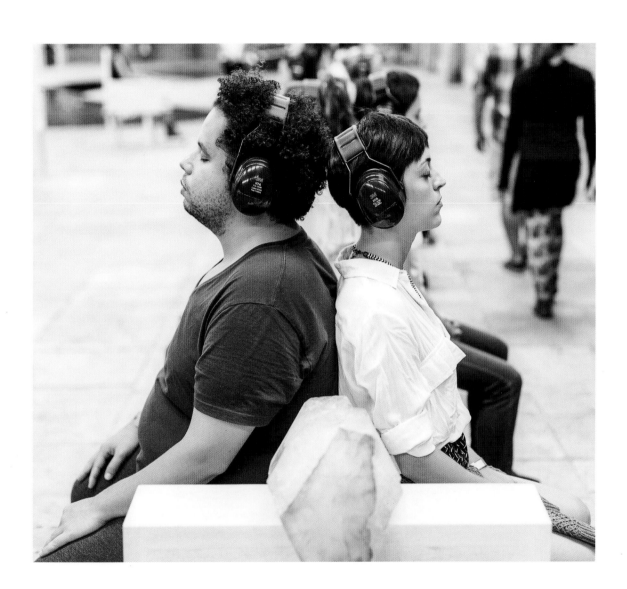

AN ARTIST'S LIFE MANIFESTO

Marina Abramović

AN ARTIST'S CONDUCT IN HIS LIFE:

An artist should not lie to himself
or others
An artist should not steal ideas
from other artists
An artist should not compromise
for himself or in regards to the
art market
An artist should not kill other
human beings
An artist should not make himself
into an idol
An artist should not make himself
into an idol
An artist should not make himself
into an idol

AN ARTIST'S RELATION TO HIS LOVE LIFE:

An artist should avoid falling in love
with another artist
An artist should avoid falling in love
with another artist
An artist should avoid falling in love
with another artist

AN ARTIST'S RELATION TO THE EROTIC:

An artist should develop an erotic
point of view on the world
An artist should be erotic
An artist should be erotic
An artist should be erotic

AN ARTIST'S RELATION TO SUFFERING:

An artist should suffer
From the suffering comes the
best work
Suffering brings transformation
Through the suffering an artist
transcends his spirit
Through the suffering an artist
transcends his spirit
Through the suffering an artist
transcends his spirit

AN ARTIST'S RELATION TO DEPRESSION:

An artist should not be depressed
Depression is a disease and should
be cured
Depression is not productive for
an artist
Depression is not productive for
an artist
Depression is not productive for
an artist

AN ARTIST'S RELATION TO SUICIDE:

Suicide is a crime against life
An artist should not commit suicide
An artist should not commit suicide
An artist should not commit suicide

AN ARTIST'S RELATION TO INSPIRATION:

An artist should look deep inside
himself for inspiration
The deeper he looks inside himself,
the more universal he becomes
The artist is universe
The artist is universe
The artist is universe

AN ARTIST'S RELATION TO SELF-CONTROL:

The artist should not have
self-control about his life
The artist should have total
self-control about his work
The artist should not have
self-control about his life
The artist should have total
self-control about his work

AN ARTIST'S RELATION TO TRANSPARENCY:

The artist should give and receive
at the same time
Transparency means receptive
Transparency means to give
Transparency means to receive
Transparency means receptive
Transparency means to give
Transparency means to receive
Transparency means receptive
Transparency means to give
Transparency means to receive

AN ARTIST'S RELATION TO SYMBOLS:

An artist creates his own symbols
Symbols are an artist's language
The language must then be
translated
Sometimes it is difficult to find
the key
Sometimes it is difficult to find
the key
Sometimes it is difficult to find
the key

AN ARTIST'S RELATION TO SILENCE:

An artist has to understand silence
An artist has to create a space for
silence to enter his work
Silence is like an island in the middle
of a turbulent ocean
Silence is like an island in the middle
of a turbulent ocean
Silence is like an island in the middle
of a turbulent ocean

AN ARTIST'S RELATION TO SOLITUDE:
An artist must make time for the
long periods of solitude
Solitude is extremely important
Away from home
Away from the studio
Away from family
Away from friends
An artist should stay for long
periods of time at waterfalls
An artist should stay for long periods
of time at exploding volcanoes
An artist should stay for long periods
of time looking at fast-running rivers
An artist should stay for long periods
of time looking at the horizon where
the ocean and sky meet
An artist should stay for long
periods of time looking at the stars
in the night sky

AN ARTIST'S CONDUCT IN RELATION TO WORK:
An artist should avoid going to the
studio every day
An artist should not treat his work
schedule as a bank employee does
An artist should explore life and
work only when an idea comes to
him in a dream or during the day as
a vision that arises as a surprise
An artist should not repeat himself
An artist should not overproduce
An artist should avoid his own
art pollution
An artist should avoid his own
art pollution
An artist should avoid his own
art pollution

AN ARTIST'S POSSESSIONS:
Buddhist monks advise that it is
best to have nine possessions in
their life:
 1 robe for the summer
 1 robe for the winter
 1 pair of shoes
 1 begging bowl for food
 1 mosquito net
 1 prayer book
 1 umbrella
 1 mat to sleep on
 1 pair of glasses if needed
An artist should decide for himself
the minimum personal possessions
they should have
An artist should have more and
more of less and less
An artist should have more and
more of less and less
An artist should have more and
more of less and less

A LIST OF AN ARTIST'S FRIENDS:
An artist should have friends that
lift his spirits
An artist should have friends that lift
his spirits
An artist should have friends that lift
his spirits

A LIST OF AN ARTIST'S ENEMIES:
Enemies are very important
The Dalai Lama has said that it is
easy to have compassion with
friends but much more difficult to
have compassion with enemies
An artist has to learn to forgive
An artist has to learn to forgive
An artist has to learn to forgive

DIFFERENT DEATH SCENARIOS:
An artist has to be aware of his
own mortality
For an artist, it is not only important
how he lives his life but also how
he dies
An artist should look at the symbols
of his work for the signs of different
death scenarios
An artist should die consciously
without fear
An artist should die consciously
without fear
An artist should die consciously
without fear

DIFFERENT FUNERAL SCENARIOS:
An artist should give instructions
before the funeral so that everything
is done the way he wants it
The funeral is the artist's last art
piece before leaving
The funeral is the artist's last art
piece before leaving
The funeral is the artist's last art
piece before leaving

AND NOW, LET'S REMEMBER…YUGOSLAVIA

Bojana Pejić

I will have spent my life trying to understand the function of remembering, which is not the opposite of forgetting, but rather its lining. We do not remember, we rewrite memory much as history is rewritten.

Chris Marker, voiceover in *Sans Soleil*, 1983

Marina Abramović has lived outside Yugoslavia since 1975. Her statements about Belgrade, especially recent ones, are very different from my own experience of the city. How could she claim that Belgrade was dull gray before she left? As a native Belgrade urbanite, I must protest: This is not true! I was there. Parts of her *Memoirs* seem to me like Cold War propaganda. Is Abramović their author or is Lawrence Durrell? During a diplomatic stint in the late nineteen-forties, the British writer spent time in Belgrade; except for the landscape, he hated everything "Titoesque" there, and even composed a music piece he called *Iron Curtain Blues*.[1] Yet soon after 1948, our socialist reality had been imagined as "colorful socialism" (in contrast to the Soviet Union's "gray socialism").[2] It's not that we lived in a *paradiso communistico*. But French philosopher Henri Lefebvre, during a nineteen-sixties conference, described our political system as "Dionysian socialism."[3]

What, then, to make of Abramović's insistence upon her "Balkan disposition"? As is known, for centuries the (often racist) Western imagination created "the Balkans" through reference to Orientalist clichés; these projections were prominent as recently as the Yugoslav wars of the nineteen-nineties. In the Western mind, "the Balkans" is a semi-primitive/semi-civilized "other." This includes the literary and cinematic representation of la *femme balcanique* embodying an "exotic," dangerous, and sexualized femininity.[4] Describing her "Balkan roots," Abramović describes her

homeland as a place where "everything is extreme, extreme tenderness, extreme hate, extreme violence, extreme feeling for heroism, for legend, and all the rest."[5] Whereas this statement may counter existing stereotypes, it also signals that an artist who has spent most of her life abroad fashions her diasporic self by insisting on difference.

Bye, Bye Yugoslavia

No matter how well they may do, exiles are always eccentrics who feel their difference (even as they frequently exploit it) as a kind of orphanhood. . . . Willfulness, exaggeration, overstatement: these are characteristic styles of being an exile, methods for compelling the world to accept your vision. . . . Composure and serenity are the last things associated with the work of exiles.[6]

Edward Said, 1990

It took me a long time to learn that my inner fight with Abramović is due to my pedantry regarding Yugoslav matters. My life as a historian is a fact-finding mission. I obsessively rechecked her publications for errors, which I found. (Of course I did: all publications contain errors.) But I have realized Abramović is not directly concerned with representational accuracy. Her real subject is memory.

Since *The House with the Ocean View*, presented in New York in 2002, Abramović has created numerous museum performances that embody an artistic philosophy formed during the nineteen-seventies, what she calls Here and Now. She either engages herself or invites her audience to reach the condition of the body/mind unity via the energy of pure presence. In this state, memory is absent. In her 1975 perfor-

mance *Freeing the Memory,* she did exactly that: over some two hours she tried to reach this body/mind state by pronouncing words and phrases repeatedly, mindlessly, in order to release her body from the language code. In contrast, around 1992, she began to produce works based on an opposite process—on the desire to remember. Upon the demise of the communist administrations in Eastern Europe and the rapid march of economic globalization, such a "memorial turn" became a worldwide cultural phenomenon, not only in historical writings but also in art. In Abramović's case, this process, it seems, was triggered by events in Yugoslavia, which in 1992 disintegrated into brutal warfare (that lasted until 1999). Indeed, Abramović's first theater performance, *The Biography,* was staged in 1992.

"I always say I come from a country that no longer exists," Abramović once stated.[7] This country used to be called the Socialist Federal Republic of Yugoslavia, which in 1963 replaced the earlier name People's Yugoslavia and distanced itself from the "people's democracies" adhering to the Warsaw Pact. This multiethnic socialist Yugoslavia died in 1992.[8] After that date we refer to it using prefixes such as *post-, ex-,* or *former* Yugoslavia. What happened to "us" was the rise of ethnic nationalism. Between 1991 and 2008 eight new post-communist, or rather post-Yugoslav, "Ruritanias" were proclaimed. One of them is Serbia.[9] Abramović's video installation *Count on Us* (2004) is filmed in Belgrade, the Serbian capital, and it contains many references to Yugoslav past.[10] Its video collage consists of several parts. One was filmed in the Belgrade school named The United Nations, where the children's chorus sings a United Nations anthem composed by a local musician. The name of the school and its anthem preserves an important aspect of the country's post-1945 history: namely, Yugoslavia was one of fifty-one founding members of the UN. In 1955, Yugoslavia even gave to the United Nations a public sculpture designed by the Yugoslav artist Antun Augustinčić, a former

partisan, a communist, and Tito's close associate during the war. The monument is an equestrian statue with a female allegory of Peace holding the globe and an olive branch. This is one version of Socialist Realism. Perhaps incidentally, in the video *The Hero* (2001), Abramović poses in a way that seems to mimic this monument, which still stands near the UN premises in New York.

The Biography, which Abramović intends to perform until her last living day, is a mnemonic device enabling the artist to *rewrite* memory— her personal memory. Memory is a volatile matter. As historians instruct us, "memories and identities are not fixed things, but representations or constructions of reality, subjective rather than objective phenomena." Therefore, "we are constantly revising our memories to suit our current identities."[11] Stuart Hall holds that this particularly true of exiles: "Diaspora identities are those which are constantly producing and reproducing themselves anew, through transformation and difference."[12]

Art historians have been traditionally trained to draw a distinction between what artists say about their experiences and intentions and what they create, the way they visualize and translate those experiences in their artworks. These days, however, such a modernist presumption hardly ever holds. And it is hard to "forget" Abramović's personal stories when you attend a performance such as *The Biography,* in which she reproduces her memories anew. Her story, though, is not a documentary, even if the narrative is seductive. In the field of memory emotions are facts, and it is with these "facts" that Abramović works. *The Biography* is informed by expressionist aesthetics and, as with any melodrama, it makes use of "gestural, visual, and musical excess," and of pathos: "Pathos, unlike pity, is a cognitive as well as affective construct."[13] To this end, Abramović's theatrical performances and videos are as much about coping with her past as with the past itself. For Vlad Morariu, the expression "coming to terms with the past" seems to be

"a down-to-earth task, the accomplishment of which promises to help us manage our own lives." Why are we then "using the words which would better fit a vocabulary of conflict?" He further asks: "Why should one cope; i.e., be in conflict with, fight with, confront, and overcome the past? Why not construct a friendlier past?"[14]

The Star (of Fire)

The star is what it is. I only placed it in another setting. I am otherwise born under the sign of the five-point star in a partisan family; the star is present from my childhood until today.[15]

Marina Abramović, 1974

This account refers to her 1974 work *Rhythm 5,* an early instance of what we now describe as body art. This was her first body piece in Yugoslavia. It was done in the yard of Belgrade University's Student Cultural Center (SKC), which had opened in 1971 and which functioned like an institute of contemporary art with intensive international programs. Around 1970, when Abramović abandoned painting, started to work with sound and photo-collage, and then turned to "de-communizing" her body, Yugoslav art entered its post-glorious age. A decade earlier, during our "sweet" nineteen-sixties, Yugoslav authorities promoted abstract, that is, modernist art as our "official" art. This ideology was at work in the country (domestic shows) and outside of it (exhibitions abroad). These were meant to demonstrate that Yugoslavia was not only a "progressive society" but also cherished "progressive art" (as abstraction was called in Western Europe during that era). Yugoslav abstraction, which in 1963 also got a mocking name, "Socialist Aestheticism," was accepted in a communist state because, like postwar European art in general, it was politically neutral. The SKC gallery, which specialized in post-object "new art" or New Art Practice, did not belong to the dissident culture; it inserted itself into the

culture of mainstream Socialist Modernism, where it became almost entirely marginalized.

The Belgrade press did not discuss Abramović's *Rhythm 5*. Given that the red five-pointed star is the prime symbol of communist ideology, this silence could have been based on a serious dilemma: is this work "political" or rather "anti-political"? Is the artist here celebrating or criticizing the collective memory of the Yugoslav anti-fascist struggle in World War II and our Revolution? Red is the color of fire, but it's also the color of blood—as we knew so well from war movies. Questions ended when the piece garnered Abramović the prize *7 sekratara SKOJ-a,* which was given to young people for their cultural achievements. (SKOJ is short for "Young Communist League of Yugoslavia.") Today the question remains whether such a prize was an attempt to co-opt or neutralize visual artists, film directors, or pop/rock musicians whom the system considered "unsuitable."

Yugoslav High Socialism of the nineteen-sixties was also an age of High Titoism.[16] Yugoslavia was a founding member of the Non-Alignment Movement, launched in Belgrade in 1961. It encompassed a large number of newly decolonized African and Asian countries, and so Tito traveled often, bringing the idea of our "different" socialism to the Third World. Back home, for the celebration of his birthday on May 25, known as the Day of the Youth, national television channels produced live broadcasts. There was nothing "modernist" about the events on viewers' screens, however, as the choreographers in charge employed traditional Socialist Realist "body art" sometimes called *telopis* (a Serbo-Croat term for "body-writing"). Pioneers, youngsters, soldiers were arranged as mass ornaments, often in the shape of a red star or the map of Yugoslavia. Abramović refreshed this collective memory in her multichannel video installation *Count On Us* (2004). It features children's bodies arranged in the shape of a star into which she inserts herself (with a skeleton).

Before she left "Titoesque" Yugoslavia in 1975, Abramović carried on a number of performances abroad, as in Edinburgh (1973), Naples (1974), Milan (1974), Innsbruck (1975). During the nineteen-seventies, many Western art critics interpreted the extreme body art emerging in Eastern Europe as evidence of "masochist impulses" the artists had to fulfill to suggest the repression of their communist states. However, this prejudice cannot hold if we think of the masochistic works made at the same time by artists such as Gina Pane, Stelark, Chris Burden, or the Viennese Actionists, who expressed discontent with the restrictions of their democratic/capitalist conditions. Recalling her beginnings, Abramović says: "Around 1970, I began to use my body as material in performances. This was very difficult in Yugoslavia, because—at the time—what I was doing was as unimaginable as the woman on the Moon. I was against society, against my professors. My mother and father were criticized for this at party meetings, there were scandals. I had to be very hard to go against everyone and to do what I felt was right. . . . I remember well, when I emigrated to Amsterdam in 1975, my greatest problem was freedom. I did not know how to deal with it; I needed boundaries."[17]

It must be said that since the early nineteen-sixties, those with Yugoslav passports could travel not only to the "communist East" (where we hardly ever desired to pop in) but also to the "capitalist West"—unless, of course, we were political dissidents. Abramović was not a political dissident, and she had a freedom of movement that was unimaginable for citizens living in Czechoslovakia, Hungary, or the GDR, who could travel and enjoy their holidays only within "their" bloc. In the course of the nineteen-sixties, the Yugoslav government relaxed its visa regime for both nationals and foreigners, setting up a sort of "velvet curtain." To put Abramović's lunar theme in context, Svetlana Boym, who spent the period in the USSR, remembers: "As we were growing up it seemed that we would travel to the moon much sooner than we would go abroad."[18]

A Cold War Romance

For Marina, China was altogether too much like Yugoslavia. She had fought against Yugoslavia all her life, trying to free herself from its dismal bleakness, its fat-hipped body-style, its humorless gaze.[19]

Thomas McEvilley, 1989

On the same page, McEvilley describes the preparations for the *Great Wall Walk*, noticing radical changes: "Marina had struggled for months at the gym to shake off the thickness of the communist body and had done so, becoming marvelously slim and athletic not only to walk the Wall but to walk past it. She really no longer looked Slavic, and apparently no longer felt it." McEvilley, a sensitive and thoughtful critic, is certainly the last person to be (posthumously) blamed for racism, but his assumption that the gym could facilitate a new (Western?) body for the artist is indeed odd. It indicates the "Western gaze" to which Abramović, coming from Eastern Europe (or "the Second World"), had been occasionally subjected. These worlds are at the core of Abramović and Ulay's performance *Communist Body/Fascist Body* (which until 1993 bore the title *Communist Body/ Capitalist Body*). The artists here played with Cold War stereotypes and the divide between "her" East and "his" West (which was performed on their joint birthday, November 30, 1979). While they were sleeping, the audience could observe props (food, newspapers, liquor, etc.) originating in both communist and capitalist countries, displayed together with birth certificates, each of which was marked by an ideological sign: hers with a five-point star, his with a swastika (as he was born in 1943, during the Third Reich).

Looking back, it seems to me that Abramović and Ulay had styled themselves as icons of the Cold War. In working together and loving each other they sent the message that the past could be overcome. Consciously or not, they embodied the dominant concern shared across

post-1945 Europe. In historian Tony Judt's words, this was the desire, common to both sides [of the Iron Curtain], to forget the recent past and forge a *new* continent."[20] In spite of the past, when their native countries had been enemies, and in spite of the Iron Curtain, the East could love the West, and vice versa. She may have remembered the Germans as they were imagined in the Yugoslav Partisan Epics, where they featured either as vicious but sophisticated generals (often playing piano) or barbaric and brutal murderers. But Ulay came from a "new" Germania, the FR Germany, which was about to start the process called *Vergangenheitsbewältigung* ("confronting the past")— which primarily meant "remembering" the Holocaust. In Germany, this painful process began with his '68 generation. In Yugoslavia, on the other hand, our '68 generation dealt with the present and did not touch upon our rather complicated WWII-era past. This past would hit us much later, in the nineteen-nineties.

When the artists started to work together, the very first condition they set for themselves was to lead a nomadic life. Between 1975 and 1988 the artists produced collaborative works summarized best by critic Jan Avgikos: "With respect to the internationality that they brought to their work, Abramović and Ulay successfully fused two different languages: one derived from 'popular culture,' concerned with alternative lifestyles, social radicalism, higher states of consciousness, cosmic experience; the other learned from the formal investigation of Conceptual and Minimal Art, focused on the questions of critique, de-materialization, clarity."[21] But as the nineteen-seventies passed, so too did internationalism. In the neoliberal nineteen-eighties, alongside Reaganism, Thatcherism, and Kohlism, the art marked turned national as well: this was the time of *German* Neo-Expressionism, *Italian* transavanguardia, and *French* "figuration chic." Abramović and Ulay did quite the opposite and turned global. Throughout the nineteen-eighties they lived and performed on several continents; their last "global" performance was their walk on the Great Wall of China in 1988. By then, their Cold War romance was already over, having a spectacularly unhappy end on the Wall, staged as a melodrama in the documentary *The Lovers: The Great Wall Walk* (dir. Murray Grigor, 1998).

Just a year later, Chinese students protested on Tiananmen Square in Beijing. Some months after that, on November 9, 1989, the European "Great Wall" in Berlin started to crumble. On that date, symbolically, if not officially, the Cold War was proclaimed over. By the end of *The Biography* (Hebbel Theater, Berlin, 1993), Abramović announced her goodbye to "togetherness," and, stealing Elsa's line from *Casablanca*, declared: "From now on you have to think for both of us, kid." (The "kid" is borrowed from Rick).

Yugoslav Wars

I could only deal with [the war] through the structure of my own family. I have to understand on an emotional level. It's my father, my mother, and the contradictions between the two of them.[22]

<div align="right">Marina Abramović, 1998</div>

In the same 1993 performance at the Hebbel Theater, recounting the events of the year "1992," Abramović not only mentions the past but also the troubled present: "War in Yugoslavia." Enter the "Balkans." At the beginning of the war, the West renamed Yugoslavia the Balkans. Throughout the nineteen-nineties, the international press and Western politicians kept reminding us that this was "a region cursed with too much history per square mile," as American scholar Maria Todorova critically notes. Too much history, it was argued, brings about too many wars. Of course, SFRY Yugoslavia once shared the Balkan Peninsula with many countries (Greece, Romania, Bulgaria, Turkey, and Albania) with which it was not at war. What became known as the "Balkan

war" was "essentially a succession struggle strictly confined to Yugoslavia."[23]

Can an artwork, such as *Balkan Baroque* (1997), contribute to a process of healing and reconciliation? In an interview given a year earlier, in 1996, Abramović clarified her position: "Remember, I left in Yugoslavia in 1975; Tito was still alive. I didn't live through all the changes leading up to this war. To me, all this is absolutely devastating. I don't defend anyone, neither the Serbs nor the Bosnians nor the Croats. My reaction is emotional; it is very painful and I feel ashamed. I have seen people suffering, on all sides, and the most important question to me is what we can do. . . . Artists react differently to such a war than do newspapers."[24] She had addressed the war already in *The Biography*, but returned to it specifically in her 1994 theater performance *Delusional*, staged with artist Charles Atlas at the Theater am Turm in Frankfurt. In this work, she performs on a platform under which she has placed hundreds of live rats, using them as an allegory of the social disorder caused by the war.[25] It was performed only once, being a rather messy piece, and it would later evolve into other works, such as the videos *Image of Happiness* (1996) and *The Onion* (1995), and, ultimately, *Balkan Baroque*. In Frankfurt, the artist presented long video interviews with her parents (filmed in Belgrade): her father talks about his years as a Yugoslav partisan; her mother mentions, among other subjects, how much she admired Greta Garbo in the 1936 film *Camille*. These interviews are later integrated into *Balkan Baroque*, where they appear as silent pictures.

The live performances and videos in which Abramović washes animal bones are undoubtedly a much stronger allegory of war than the rats. For her 1995 retrospective at the Museum of Modern Art in Oxford, David Elliott wrote a passionate essay about the artist he entitled "Balkan Baroque." He is right to assert that the artist "has constructed a mythology in order to confront the past." Considering her recent works pointing to or suggesting Yugoslavia's

belligerent breakdown, he holds: "Her past and her shame are that of Yugoslavia itself."[26]

In her two-hour live performance *Cleaning the House*, first presented in 1995 in New York and the following year at the Groningen Museum in the Netherlands and Museum Villa Stuck in Munich, Abramović cleaned a huge pile of beef bones. Even if audiences were aware that the artist was born in Yugoslavia, and may even have followed media reports about the Yugoslav war, one could attribute to these works "universal meaning": we may presume that she references the condition of war itself, rather than refer to any specific war. Yet when Abramović was asked to represent Yugoslavia (then consisting of Serbia and Montenegro) at the Venice Biennale in 1997, audiences' "universalist" reading acquired "site-specific" connotations. Invited by a curator from Montenegro, she proposed to use the Yugoslav pavilion for the video installation and to wash 1,500 beef bones in front of the building. Due to the hostile (and in my opinion idiotic) attitude of the Montenegrin Minister of Culture who intervened because of "national interests," Abramović cancelled her participation.[27] Instead, *Balkan Baroque* became part of the Biennale's international exhibition.

Abramović wanted, as she once mentioned, to give the piece "universal" and not "local" meaning. She explains: "The baroqueness of the Balkans is in its extreme love, extreme violence, extreme tenderness, extreme legend and sacrifice, in its contradictions: hate, love, and all possible situations. . . . And that's the kind of mixture, the kind of baroqueness I am referring to as I try to understand my own self and to present it."[28] The video installation consists of three parts, each of which is based on the procedure known as "womanliness as masquerade" (as Jacques Riviere put it). Abramović appears as a professor of zoology, as a dancing Balkan tavern singer (in the local parlance, these singers are simply called "sluts"), and as a daughter accompanied by her parents. In the live performance, the artist takes yet another

identity, that of professional *narikača* (Serbo-Croat, a wailing woman) who in our Slavic cultures is hired by the family to mourn the deceased. Over four days and for seven hours each day, Abramović chanted songs she remembered from different regions of Yugoslavia. While washing the bones she fashioned herself as the national allegory of Yugoslavia: the mother who mourns "her" dead and "her" dead nation. Most who attended this work in Venice, even those who were partial to Abramović's "physical realism," understood that *Balkan Baroque* was in fact a requiem for Yugoslavia. The artist received for this piece the Biennale's Golden Lion Award. Alas, she did not manage to realize her original idea. Given that the national pavilions built at the Giardini in Venice have the same status as the countries' embassies, they are official residences of their respective states. In her initial proposal for the Yugoslav pavilion, Abramović intended to bring the war back home to the place where it belonged: in Yugoslavia.

"Yugoslavia"—A Family Melodrama?

The more problematic your childhood is, the better an artist you become. I don't know if it's true for some artists, but for me it was very true.[29]
Marina Abramović, 2002

Let us now return to a central question: Why can't Marina Abramović be *friendlier* to her past? At this point, I don't think it's possible. Memories of happy conditions and "good times" do not fit in Abramović's "dramaturgy of excess." When she narrates her dreams about a lovely working-class mother in *Image of Happiness* (1996), for example, her body is hanging upside down. Peter Brooks defines the "melodramatic imagination" as "a mode of conception and expression, as a certain fictional system for making sense of existence, as a semantic field of force."[30] Abramović considers a childhood she remembers as mostly

miserable to be the chapter of her life that conditioned her future as a woman and as an artist. In her art, as the scholar Richard Dyer remarks of films more generally, "love is often not so much celebrated as agonized over."[31]

I am not sure whether her melodramatic "drive" originates in her reading too much of Hugo and Dostoyevsky, Balzac and Tolstoy in her teens. Or perhaps it comes from the Hollywood maternal melodramas shown in Kinoteka (Belgrade's Yugoslav Film Archive). When you listen to the artist discussing her parents' broken marriage, shattered friendships, labors lost, the deaths of friends, and ultimate absence, you understand that in her melodramatic and excessive mode Abramović basically takes up the challenges of loss. Melodrama is her preferred vehicle for coping with such losses in her artworks. This can be effective. As Judith Butler notes, "pathos is not negated, but it turns out to be oddly fecund, paradoxically productive."[32] In her video *The Hero* (2001), Abramović performs a mourning ritual for her recently deceased father, who was a communist, a war veteran, and a Yugoslav. She enacts an equestrian self-portrait open to a variety of interpretations, including historical references: to the heroic figure of Jean D'Arc; or to Nike, the allegory of Victory, connoting immortality; or even to Socialist Realist iconography, as I've proposed. Given her stern visage and stoicism, looking at this nearly still video image one may ask where the pathos resides. In this video it is produced by the musical score, the song "Hej Sloveni" (Hey Slavs), which her former student Marica Gojević sings beautifully a cappella. It was once the national anthem of SFR Yugoslavia. The hymn is no longer in official use, since the country, like the artist's father, is now dead and gone.[33]

This conflation of personal and national experience is similar to *Balkan Baroque,* in which Abramović wrestled with the Yugoslav wars via dissonances in her family. I would even (dare to) speculate that for Abramović, who left before its dissolution and has lived elsewhere

for several decades, "Yugoslavia" is an unmappable space that stands in for her own family.

As a divorcée, the artist's mother had to take the father's role, trying to shape her rebellious daughter into a disciplined child. In many of her interviews Abramović, in her notoriously half-mocking/half-serious manner, "fights" with her mother, accusing her of strictness (home by 10 PM, the virtue of a clean room, the importance of continuing to paint).

Therefore I think of these works as maternal melodramas. They develop the mother/daughter plot from the daughter's point of view.[34] Sometimes, mentioning her mother, the artist creates mini-scenes that recall the "bad mothers" in *Now Voyager* (dir. Irving Rapper, 1947) or *Mommie Dearest* (dir. Frank Parry, 1981). The recognition that her mother was in fact good, that she manifested her "unconditional love" in a non-melodramatic manner, came only after her mother was gone.

The absent mother resurfaces when Abramović employs in her works items that belonged to her mother, like her partisan hat with the red star or family photographs. According to Peter Brooks, these items are necessary: "The melodramatic imagination needs both document and vision, and it is certainly concerned with the exploitation from one to another."[35] These items evoke events that really took place: her mother was a communist, nurse, and fighter during Yugoslav Liberation War.

In pieces Abramović has created during the past two decades, the name "Yugoslavia" may not be used explicitly. But the references to Yugoslavia still flash here and there, often in the form of communist chic: a girl with a red pioneer scarf; a woman dressed in partisan uniform; a war cap with the five-point star her mother wore during the Second World War; or a self-portrait in which she is accompanied by a portrait of Tito. Moreover, the artist continues to re-carve her body, inscribing the five-pint star on her own belly not only in early performances of *The Biography* but also in her 2005 reenactment of her early performance *Lips of Thomas*.

Living for some forty years out-of-the-country and out-of-language, speaking English with the "continental accent" (the phrase comes from Ernst Lubitsch, another exile), Abramović rewrites her memory using various technologies of remembrance. It could be an interview where the country that no longer exists is mentioned, or it could be an artwork, a video, an installation, or a performance where we (or some of us) can detect something "about" Yugoslavia. The bond with this country had been broken long, long ago. Nevertheless, in considering the many references to her family and/or "Yugoslavia," then, it seems that Abramović can only do what Salman Rushdie, yet another exile, does when he remembers his native India: "[I]t was precisely the partial nature of these memories, their fragmentation, that made them so evocative for me. The shards of memory acquired greater status, greater resonance, because they were *remains*; fragmentation made trivial things seem like symbols, and the mundane acquired numinous qualities."[36]

Notes

1. On Durrell in Yugoslavia, see Vesna Goldsworthy, *Inventing Ruritania—Imperialism of the Imagination* (New York, 2013, first edition 1998), pp. 146–52. "Ruritania" is a country invented by the British writer Anthony Hope in his novel *The Prisoners of Zenda* (1894). He doesn't situate it in any precise geography; it exists on "the back of beyond," probably in the Balkans.

2. See my essay "The Morning After: *Plavi radion*, Abstract Art, and Bananas," in *n.paradoxa—international feminist art journal* 10 (2002), pp. 75–84. Special issue: Rethinking Revolution.

3. Milan Kangrga, *Izvan povijesnog dogadjanja. Dokumenti jednog vremena* (Split, 1997), p. 279.

4. Cf. *Vampirettes, Wretches, and Amazons—Western Representations of East European Women,* ed. Valentina Glajar and Domnica Radulescu (New York, 2004). For example, the Serbian fashion designer figures as feline *femme fatale* in the horror film *Cat People* (dir. Jacques Tourneur, 1942). In the 1982 remake, this reference is dropped.

5. Thomas McEvilley and Marina Abramović, "Stages of Energy: Performance Ground Zero?" in *Marina Abramović: Artist Body; Performances 1969–1998* (Milan, 1998), p. 15.

6. Edward Said, "Reflections on Exile," in *Out There: Marginalization and Contemporary Cultures*, ed. R. Ferguson et al. (New York and Cambridge, MA, 1990), p. 363, italics in original.

7. Sean O'Hagan, "Interview: Marina Abramović," in *The Guardian*, London, October 3, 2010.

8. In 1992, Serbian leader Slobodan Milošević confiscated the name along with our memories, proclaiming the Federal Republic of Yugoslavia, consisting of Serbia and Montenegro, which were both involved in the warmongering against other constitutive Yugoslav republics.

9. Over the past twenty years and without much difference among them, these new nation-states have practiced "ethnically clean democracies," cultivating different degrees of hatred, racism, and xenophobia while willingly tolerating revamped fascism. They became societies that are fatefully amnesiac about their own past, exposing Yugoslav antifascism during World War II and the socialist past in general to denial and even vilification (particularly in today's Serbia and Croatia).

10. Given that I am focused on Yugoslavia, I've decided to abandon consideration of Abramović's *Balkan Erotic Epic* (2005) because the artist located it in "deep" Serbia, in the region called the Šumadija. For inspiring insights into sex among Serbs after the lost war, see Dušan I. Bjelić and Lucinda Cole, "Sexualizing the Serb," in *Balkan as Metaphor—Between Globalization and Fragmentation*, ed. Dušan I. Bjelić and Obrad Savić (Cambridge, MA, and London, 2002), pp. 280–310.

11. John R. Gillis, "Memory and Identity: The History of a Relationship," in *Commemorations—The Politics of National Identity*, ed. John R. Gillis (Princeton, NJ, 1994), p. 3.

12. Stuart Hall, "Cultural Identity and Diaspora," in *Identity: Community, Culture, Difference*, ed. Jonathan Rutherford (London, 1990), p. 235.

13. Christine Gledhill, "The Melodramatic Field: An Investigation," in *Home Is Where the Heart Is—Studies in Melodrama and the Woman's Film*, ed. Christine Gledhill (London, 1987), p. 30.

14. Vlad Morariu, "Coping with the Past," in *Atlas of Transformation*, ed. Zbyněk Baladrán and Vit Havránek, (Prague, 2010), p. 127.

15. In Z. Jurčić, *OKO*, Zagreb, May 8, 1974. Cited in Olivera Janković, *Marina Abramović: rani radovi – beogradski period* [Marina Abramović— Early Works— the Belgrade Period], (Novi Sad, 2012), p. 49 [Translation mine].

16. After the demise of SFR Yugoslavia in 1992, many people in post-Yugoslav countries display a certain nostalgia for the past, known as "Yugostalgia." It is as apolitical as yet another type of collective remembering, called "Titostalgia." See Mitja Velikonja, *Titostalgia— Study of Nostalgia for Josip Broz* (2008), at http://mediawatch.mirovni-institut.si/eng/Titostalgia.pdf (accessed November 30, 2016). Serbian edition: *Titostalgija* (Belgrade, 2010).

17. In Hans-Peter von Däniken and Beatrix Ruf, "Marina Abramović in Conversation," in Beatrix Ruf and Markus Landert, eds., *Marina Abramović—Double Edge,* exh. cat. Kunstmuseum des Kantons Thurgau (Sulgen, 1996), p. 33.

18. Svetlana Boym, *The Future of Nostalgia* (New York, 2001), p. 60.

19. Thomas McEvilley, "The Great Wall Talk," in *The Lovers: Marina Abramović and Ulay* (Amsterdam, 1989), p. 106. She was later reported as saying: "But for me China was even worse: this was communism with Eastern fanaticism." In James Westcott, *When Marina Abramović Dies—A Biography*, note 16, p. 193. More on China, p. 203.

20. Tony Judt, "The Past is Another Country: Myth and Memory in Post-War Europe," in *Memory and Power in Post-War Europe—Studies in the Presence of the Past*, ed. Jan-Werner Müller (Cambridge, 2002), pp. 157 and 163, italics in original.

21. Jan Avgikos, "Go with the Flow," in *Marina Abramović: Artist Body* (see note 5), p. 242. In this volume you can also spot the photograph of 1978 (p. 429), taken in Istria, where the artists show their "Tito bread" (with his name and the star), which they personally baked.

22. In Pablo J. Rico, "On Bridges, Traveling, Mirrors and Silence . . . in Amsterdam," in *The Bridge/El Puente* (Valencia, 1998), p. 56.

23. Maria Todorova, "Introduction," in *Balkan Identities—Nation and Memory*, ed. Maria Todorova (London, 2004), pp. 2 and 8. See also Maria Todorova, *Imagining the Balkans* (New York and Oxford, 1997).

24. In Hans-Peter von Däniken and Beatrix Ruf, "Marina Abramović in Conversation" (see note 17), p. 33.

25. In one of the Yugoslav "Black Wave" films, the socially critical feature film by Živojin Pavlović titled *Budjenje pacova* (The Awaking of the Rats, 1976), the director represents contemporary Yugoslav reality, and the despair and disorientation of his characters, through the use of rats. He borrowed the film's title from a poem by T. S. Eliot.

26. David Elliott, "Balkan Baroque," in *Marina Abramović—Objects, Performance, Video, Sound*, ed. Chrissie Iles, exh. cat. The Museum of Modern Art Oxford and 5 other museums (Oxford and Stuttgart, 1995), pp. 58 and 71.

27. For more details about the local scandal, see my essay "Balkan for Beginners," reprinted in *Primary Documents—A Sourcebook for Eastern and Central European Art since the 1950s*, ed. Laura Hoptman and Tomáš Pospiszyl (New York, 2002) pp. 325–39. Originally published in *New Moment* magazine, no. 7, Belgrade, spring 1997. We handed out the journal during her performance in Venice.

28. In Pablo J. Rico, "On Bridges, Traveling, Mirrors and Silence" (see note 22), p. 56.

29. In her article "Body Art," in *Marina Abramović* (Milan, 2002), p. 27.

30. Peter Brooks, *Melodramatic Imagination: Balzac, Henry James, Melodrama, and the Mode of Excess* (New Haven and London, 1995 [1976]), p. xvii.

31. Richard Dyer, *Stars* (London, 1982), p. 51.

32. Judith Butler, "Afterword—After Loss, What Then?" in *LOSS—The Politics of Mourning*, ed. David L. Eng and David Kazanjian (Berkeley, 2003), p. 468.

33. The title of the Yugoslav national anthem, "Hej Sloveni," may be confusing for foreigners. Even if its title contains the word "Sloveni" (Slavs) it refers to the name of "Jugoslavia" in Serbo-Croat, which means "south Slavs." This mistake appears in Steven Henry Madoff's otherwise inspiring essay "The Balkan Unbound," where he identifies in *The Hero* the "Slovenian national anthem." Since 1991, the state of Slovenia has had its own national hymn. In *Balkan Epic—Marina Abramović* (Milan, 2006), p. 21.

34. Cf. Lisa Tickner, "Mediating Generations: The Mother-Daughter Plot," in *Women Artists at the Millennium*, ed. Carol Armstrong and Catherine de Zegher (London and Cambridge, MA, 2006), pp. 85–120.

35. Peter Brooks, *Melodramatic Imagination* (see note 30), p. 9.

36. Salman Rushdie, "Imaginary Homelands" (1982) in his *Imaginary Homelands* (London, 2010), p. 11, italics in original.

LUMINOSITY IN THE NORTH: LOCATING THE SPIRITUAL IN MARINA ABRAMOVIĆ'S ART

Devin Zuber

I am not particularly religious; I dislike religion because it is like an institution to me. What I do believe in is spirituality. I also believe that one of the components of a work of art should be spiritual, and this aspect is very clear in my performances.[1]

Marina Abramović, 2004

All religion relates to life, and the life of religion is to do good.[2]

Emanuel Swedenborg, 1763

The discipline of art history has long held a vexed relationship with religion and spirituality, particularly when it comes to their place (or absence) in the field of contemporary art. "The name *God* does not belong to the language of art in which the name intervenes," writes the art historian and critic James Elkins, "but at the same time, and in a manner that is still difficult to determine, the name *God* is still part of the language of art even though the name has been set aside."[3] Much critical discourse about the performance art of Marina Abramović has accordingly expressed an ambivalence towards her enthusiastic embrace of spirituality, preferring to contain her frank discussion of "energy exchanges" between performers and participants, and their attendant psychic transformations, within the safety of scare quotes and/or historicizing brackets. For better or worse, Abramović's gestures towards the shamanic, as another critic writes, "[have] continued the otherwise discredited association of art with religion."[4] When art history has situated Abramović within larger patterns of spirituality or religiosity, it has tended to focus on the East or the global South—looking at Tibetan Buddhism, the indigenous Australian people, or *umbanda* in Brazil—places where and peoples with whom Abramović has spent considerable time engaged in different forms of ritualized religious practices that have come to charge her work with uncanny resonances from elsewhere.

In view of the present exhibition, however, a retrospective that brings an unprecedented breadth of Abramović's work to northern Europe for the very first time, a different affinity might be detected between Abramović and a particular strain of European mysticism that could be said to culminate in the figure of Emanuel Swedenborg (1688–1772), the famous eighteenth-century Swedish scientist-turned-seer, someone whose life and work attempted to suture the growing gap between spiritual experience and the empirical, secularizing pressures of modernity. At first glance, this seems an unlikely, if not odd, pairing: What could Abramović possibly have in common with the theosophy of a Protestant visionary like Swedenborg? While Abramović's rich, historically attuned performances have engaged with several better-known Christian figures and mystics—from the Medieval Saint Teresa of Ávila in *The Kitchen I: the Levitation of Saint Teresa* (2009) to the figure of doubting Thomas in her early *Thomas Lips* (1975)—Abramović has not read any of Swedenborg's Enlightenment-era works, nor is she much acquainted with his substantial influence on some of the esoteric currents and writers who were important for her early on (such as D. T. Suzuki and Madame Blavatsky).

Nevertheless, Swedenborg's varieties of religious experience (with a nod towards William James) were catalyzed by many of the

Marina Abramović, *Dream House,* 2000

same elements that remain essential to Abramović's performances and her ongoing pedagogical methods. Swedenborg developed, for example, in a way that was highly atypical for mystics in the West, an attentive form of meditative breathing in order to induce altered states of consciousness. Further uncharacteristic for his eighteenth-century Lutheran context, he exhibited an interest in Lapland Sami shamanic techniques that purported to separate the soul from the body—finding parallels between his own unfolding mystical experiences and these methods of "ecstasy energumen," an ecstasy of the spirit-possessed.[5] As Abramović has been keenly invested in creating artworks that facilitate forms of collective dreaming (with her *Dream Bed* installations, and at the *Dream House* in Japan), so, too, did Swedenborg construct an elaborate psychic economy of dreams by keeping a remarkably modern journal of dream analysis and interpretation during the seventeen-forties.[6] To survey Swedenborg's catalog of dream phantasmagoria, written from the epicenter of his great spiritual crisis, is to encounter ferocious dogs, cunning kings, vast machines churning with cogs and wheels, beautiful gardens, hermaphrodites, summer clouds, women with *vaginae dentatae*. They are "wreckage on the beaches of sleep/ dreams like the ringing of bells from the deep," as the Swedish surrealist poet Gunnar Ekelöf put it; a panorama of the subconscious that in more than one place anticipates some of the recurrent leitmotifs published in Abramović's own later *Dream Book* (pictured above).[7]

Emanuel Swedenborg, *The Dream Diary (Drömboken)*, 1743–44

In contrast to other Western figures associated with the mystical tradition, such as Jakob Böhme or even Teresa of Ávila (a figure of utmost significance for Abramović), Swedenborg's singular practice of meditative hypoventilation—a slowing down of the breath to the point of cessation—has caused some, including D. T. Suzuki, to find more parallels between Swedenborg and Eastern traditions of *pranayama* than any precedents in Christendom. Swedenborg functioned as a veritable "Buddha of the North," Suzuki influentially claimed (and Suzuki cribbed this line, perhaps unwittingly, from Honoré de Balzac's earlier 1832 novel *Louis Lambert*); this transcultural conflation partially accounts for the surprising revival of interest in Swedenborg among modernist avant-gardes who so often became entangled in various forms of the non-Western Other.

In Scandinavia, this is acutely the case not only with August Strindberg (who could be said to contribute to an early development of Nordic durational performance art, through his early twentieth-century dramas that radically distort and alter time, as in *A Dream Play*), or the existentialist Søren Kierkegaard, but also with the modernist painter Ivan Aguéli, whose reading of Swedenborg helped facilitate an ultimate conversion to Sufi Islam. These earlier strands of Swedenborgian mysticism and aesthetics provide a rich context for embedding Abramović's current retrospective within a specifically Scandinavian setting: it shows how Abramović's own self-conscious attempts to function as a

"bridge" between East and West, and to restore an authentic experience of the spiritual through the vehicle of her performances, is perhaps not so alien from the supposed hyper-secularity of contemporary Europe as one might think. This essay surveys Abramović's oeuvre through the lens of what she has called "luminosity," tracing the development of her work via refractions cast by Sweden's most famous mystic.

It could be said that the association of the religious with the aesthetic was part of the very fabric of Abramović's European childhood. Her great-uncle Varnava Rosić was a revered (and martyred) patriarch of the Serbian Orthodox Church, one of the more opulently sensual and ritualistic forms of Christianity. Her grandmother Milica, who raised Marina until she was six years old, was extremely devout and observant, and often took Marina with her to Orthodox services where, in the flickering candlelight, the icons of various saints held a totemic, miraculous power. These images were further couched in extraordinary tales of painful martyrdom and heroic endurance (her own priestly great-uncle was reputedly poisoned with diamond dust, assassinated on the order of the pro-Croatian, pro-Catholic prime minister, and died from horrific internal bleeding).

Starting out as a young art student in Belgrade and continuing up to the present, Abramović has read widely and deeply in esoteric and occult traditions, Eastern philosophy, and scholarship on "world" religions pioneered by comparatists such as Suzuki and Mircea Eliade. Such readings in metaphysics were perhaps more significant than some of the contemporary artistic currents that had spiritual overtones with which Abramović occasionally had contact, such as the ascetic Slovenian OHO collective. As she pithily puts it, "artists are always inspired by something, so why should I be inspired secondhand? Rather than looking at artists for inspiration, I always wanted to look to the source."[8] In the nascent field of performance art, in which Abramović began to make a name for herself, her tran-

scendental concerns struck an immediate affinity with Yves Klein and Joseph Beuys, whose respective earlier performances contained esoteric elements—alchemy in particular in Klein's case—or invoked the mystical and the shamanic, in the case of Beuys.

Abramović's early pieces were immediately distinguished by a preoccupation with time and attempts to transcend the limitations imposed by the human body, such as the dizzying repetition of stabbing a knife quickly between the fingers of her hand in *Rhythm 10* (a dangerous and painful variation on an old Slavic drinking game). As gruesome—even sadomasochistic—as some found *Rhythm 10* and other early performances to be, Abramović emphasizes that this kind of self-inflicted pain was neither gratuitous nor an end in itself (as, perhaps, Chris Burden's contemporaneous grisly performances so often were, to spectacular effect). Rather, the pain was a gateway or door to a space beyond it; it was "a tool to reach a transcendent state of mind," as one of Abramović's biographers puts it.[9] Swedenborg, too, had written of the rending psychic pain that was necessarily part of any authentic spiritual journey to higher consciousness, as one's old self died and was born into the new: he called it a "vastation," a devastating, laying-to-waste of one's ego, a particular terminology and description that would later haunt the biographies of William James and August Strindberg in their own painful, dangerous collapses.

Time, duration, and consciousness became more pronounced upon the commencement of Abramović's artistic and life partnership with Ulay, a German artist that Abramović fatefully met on their joint birthday in 1976. Over the next twelve years, Abramović and Ulay quickly ranked among the most prominent performance artists, working together from the mid-nineteen-seventies through the nineteen-eighties. Informing much of their collaborative work of this period were ideas that came out of a life-altering, extended journey they took through the Australian outback, living with the semi-nomadic Pitjantjatjara people in the bush. While

with the Pitjantjatjara, they experienced incidents of apparent telepathy and healing that defied all Western secular paradigms (some 220 years earlier, Swedenborg had astonished his Enlightenment contemporaries by appearing to manifest telepathic insight about a devastating fire that was occurring hundreds of miles away, in Stockholm, as it happened—an internationally notorious event that attracted the interest of Immanuel Kant, and still remains, according to scholar Jeffrey Kripal, a telling irritant for the ongoing materialist reductionism of the academy).[10] Among the more well-known and grueling of the pieces inspired by this Australian experience was *Nightsea Crossing* (1981–87), a durational piece performed asynchronously for a total of ninety days at different locations around the world, in which Ulay and Abramović sat across a table from one another, locked into each other's gaze, for up to eight consecutive hours at a time—without shifting their eyes from one another or moving once in their seats (though on several occasions the pain became so great for Ulay that he had to break off the performance). Chafing against the Zeitgeist of materialistic consumerism, the increase of a "society of the spectacle," and brash Reagan- and Thatcher-era capitalism, Ulay and Abramović had made an artwork that was premised on demonstratively doing absolutely "nothing," on meditative silence—Abramović had apparently become the *anti*-material girl of the nineteen-eighties art world. They described *Nightsea Crossing* as an almost alchemical de-materialization: "Presence. Being present, over long stretches of time, until presence rises and falls, from material to immaterial, from form to formless, from instrumental to mental, from time to timeless."[11]

Abramović and Ulay ended their relationship and joint collaboration in 1988, symbolically marking the occasion with *The Lovers* project. They started out at opposite ends of the Great Wall of China, walking towards one another. When they finally met up in Shaanxi province, after ninety days of consecutive hiking, it sym-bolically concluded their fruitful years of working together. As difficult and challenging as the break-up was for Abramović, the long peregrination had given her new interests in the earth and metals—she had become fascinated by Chinese folk legends of the various dragons supposedly coiled beneath the length of the Great Wall and in the nearby mountains, apparently mirroring geo-cosmic energy flows and actual deposits of minerals and ore that lay under the surface of the earth.

As she embarked on her new solo career, Abramović did not immediately return to the bold and provocative performances that had marked her art prior to living and working with Ulay. Instead, she produced a large and varied body of semi-sculptural installations, the so-called *Transitory Objects* that were not artworks in themselves, but were meant "to trigger physical or mental experiences among the public through direct interaction."[12] Informed by her research into Tibetan and Chinese systems of traditional medicine, these chairs, pillows, beds, and other kinds of seemingly whimsical furniture were made of materials that "corresponded" to different parts of the human body and healing energy flows. Anticipating her much later performance work, which would increasingly demand particular kinds of engagement and behavior from the public (such as *512 Hours*, at the Serpentine Gallery in London, 2014), the *Transitory Objects* came with explicit sets of instructions for how they were to be engaged, sometimes in contract-like terms. If some critics were too quick to dismiss the *Transitory Objects* as New Age schlock, others understood how the material placed Abramović squarely within a tradition of the artist-as-shaman, particularly as it had been practiced by Joseph Beuys, who had put his honey, fat, and felt to similar mythopoeic use as Abramović was now doing with her copper, amethyst, geodes, and glittering crystals. Though Beuys had died earlier, in 1986, Abramović first met him, significantly, in 1974, and Beuys was an essential, early mentor

behind some of her first performances (Beuys, it should be added, readily acknowledged his deep interest in Swedenborg and Rudolph Steiner's anthroposophy—Beuys had been impressed by Swedenborg's pairing of human spiritual evolution with cosmology).[13]

Always invested in stripping away as many mediating layers as possible between a thing and the experience of it, Abramović travelled into the jungles of Brazil to work directly with the extraction of minerals in the mines where they were being taken out of the earth: going, again, directly to the source. Her labor in the space of the mines unwittingly evokes the specter of Swedenborg, who had made substantial contributions to the inchoate disciplines of eighteenth-century crystallography and geology. Swedenborg spent considerable time crawling and climbing through various copper, silver, and iron mines throughout northern Europe as part of his duties as a royal assessor on the Swedish Board of Mines (Sweden, in the eighteenth century, had the world's largest copper mine, and it was keenly interested in fostering advances in smelting technologies and supporting the nascent earth sciences). Unlike Abramović, who has coyly cited alchemical concepts on occasion, and in contrast to many of his Swedish contemporaries, Swedenborg eschewed alchemical or magical associations with the depths of the mine. In his subsequent mineralogical magnum opus, *The Principia* (1733), he formulated a different kind of enchantment of matter by plotting out (and illustrating), for the very first time in Western history, the so-called nebular hypothesis: the stipulation that the planets were formed out of a single exploding, spiral mass of solar energy. This basic concept still undergirds our present-day cosmology and understanding of how the planets and solar system came together, and in Swedenborg's accompanying illustrations (drawn and engraved by himself—he was also an artist) we have an image of planetary formation that intuits our modern idea of how life on earth is

Marina Abramović, preparatory notebook sketch for *Inner Sky*, 1990

essentially composed of the same stardust (to paraphrase Carl Sagan). If these images from Swedenborg's mining treatise could be said to distill an incipient planetary consciousness, then the mines of Brazil, 250 years later, would impart to Abramović a new global concern for her art (p. 152). She was troubled by the ethics of removing precious minerals from the earth— and had been disturbed by witnessing the open-pit gold mine at Serra Pelada, around the same time that photographer Sebastião Salgado was taking his famous pictures of

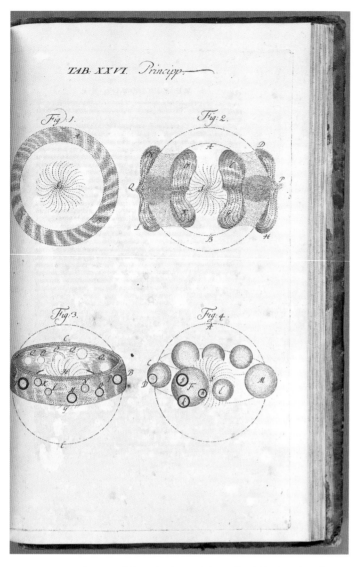

Emanuel Swedenborg, *The Principia: Or, the First Principles of Natural Things (Principia rerum naturalium)*, 1734

workers scrambling from the mine. "I am perfectly aware that I am disturbing a fine, precious balance," she said, "but on the other hand I think that we live in an age which faces emergency: our consciousness has completely separated from our sources of energy. I want to reproduce this consciousness."[14]

The early nineteen-nineties saw Abramović return to performance art with new pieces (*Biography*, 1992; *Delusional,* 1994) that, for the

first time, substantially referenced her cultural and personal history. Widely regarded as a critical breakthrough and turning point in her career, *Balkan Baroque* debuted at the 1997 Venice Biennale. Sitting atop an enormous pile of freshly slaughtered cow bones with the gristle and meat still attached, Abramović spent seven hours a day frantically scrubbing the bones with a brush while crying and singing Serbian folk songs. Three large copper vats from her *Transitory Objects* preceded the pile of bones and the spectacle (and stench—the gristle quickly began to rot) of Abramović at her task. These squat, tub-like shapes evoked early Christian baptismal fonts (in which Venice, of course, abounds). On the dark basement walls behind her, Abramović played sequences from recent videos that included interviews with her mother and father, both decorated war heroes from Yugoslavia's turbulent history. The title—*Balkan Baroque*—was apt, not only for symbolically connecting with the contemporary horror of war and genocide then unfolding across the Balkans, but also for evoking an art-historical period that had been preoccupied with inner turmoil, pain, and loss of control: the Baroque as a fusion of mystical transcendence with an excess of the rational.[15] The central image in *Balkan Baroque,* a mournful Abramović on the pile of bones, weeping and scrubbing, suggested the stylized pietas and figuration of the Baroque sculptor Gian Lorenzo Bernini (1598–1680), perhaps in particular Bernini's famous *Ecstasy of Saint Teresa of Ávila* (1647–1642) —whose life Abramović would later use for *The Kitchen: Homage to Saint Teresa* (2009), a series of photographs and videos documenting a performance in an abandoned kitchen in Spain. With Abramović embodying several scenes from Saint Teresa's late-Medieval accounts of visionary experience and levitation, *The Kitchen* remains her only work (to date) that has so overtly referenced a Christian mystic (pictured opposite).[16]

In the new performances from the nineties onward, be it *Balkan Baroque* or *The House*

Marina Abramović, *The Kitchen I: The Levitation of Saint Teresa*, 2009

with the Ocean View, Abramović continued and expanded on her preoccupation with time. In frequently disrupting the viewer's sense of time, Abramović was certainly drawing on her lifelong study of Buddhist traditions, in particular Zen. At times her work could function didactically, like a *kōan* trying to jolt the viewer into a startled new perception of the real. On the culminating evening of her *Seven Easy Pieces* (2005) at the Guggenheim in New York— a series of landmark re-performances of iconic works largely by other artists, including Beuys's *Wie man dem toten Hasen die Bilder erklärt (How to Explain Pictures to a Dead Hare)* (1965)—Abramović's *Entering the Other Side* featured the artist mounted atop an enormous blue cone that resembled some elaborate and glamorous distortion of a spun-sugar princess dress. For seven hours, Abramović slowly turned and silently surveyed the crowds that had gathered around her far below and on the spiral ramps of the Guggenheim, sweeping her arms in gestures that were like underwater ballet (this stately suspension in the air, in retrospect, seems to smartly anticipate the mystical levitation of her *Saint Teresa* in the Spanish kitchen four years later). Shortly before midnight, when *Entering the Other Side* was slated to end, Abramović suddenly announced in a slow, measured cadence: "Please . . . just for the moment, all of you. Just listen. [Pause]. I am [pause] here and now [pause], and you are [pause] here and now. With me. [Pause] *There is no time.*"

While the attempt to distill a sense of "there is no time" is classic Zen, it strikes another chord with the Western apophatic tradition, from Teresa of Ávila to Swedenborg himself. For such mystics, the insuperable gap between the eternal reality of their internal visions and the external world of linear space-time becomes ruptured, transgressed in one way or another—be it by angels or through *lectio divina,* the reading of sacred scripture. In Swedenborg's *Heaven and Its Wonders and Hell: Drawn from Things Seen and Heard* (1758), perhaps

his most popular book, Swedenborg belabors the point that "heaven" or "hell" are not future, physical places to which one goes, postmortem, but rather inner "states" of consciousness that we are located within, already here on earth.[17] There is no time or space in the ultimate reality of what Swedenborg called the "spiritual world," just varying changes of state (or perception). This pronounced aspect of Swedenborg's eschatology perhaps shares more with Buddhism than it did with the standard Christian orthodoxy of his day, as Suzuki (again) observed. In a well-known incident that occurred in Switzerland in the nineteen-fifties, Mircea Eliade and Henry Corbin (the famous scholar of Sufism and esoteric Islam) asked Suzuki if he could elucidate the parallels between Swedenborg's ideas and Mahayana Buddhism. Responding in classic *kōan*-like fashion, Suzuki spontaneously grabbed a spoon from the dinner table, brandished it aloft, and proclaimed, smiling, that "this spoon *now* exists in Paradise . . . we are *now* in Heaven."[18]

If anything, Abramović's most recent body of work seeks to expand and amplify this (perhaps heavenly) feeling of "no time" for her performance visitors, as she loops the public into ever-great degrees of participation and trust. For *The Artist is Present* (2010) at the Museum of Modern Art in New York City, visitors could sit across from Abramović for long periods at a time, looking closely into her eyes. The thick air of expectation in MoMA's cathedral-like atrium, the silence around the periphery of the sitting figures who were patiently waiting their turn, the almost nimbus-like glow of Abramović's bright, monochromatic (and Vedic) dress, were all things akin to the atmospheric hush of the devout as they approached the icon of a revered saint, an unmoving image that might nevertheless grant some miraculous transformation if it were only to be looked at in the proper, enlivening way. To engage with Abramović's eyes was to become locked into the dialectics of the sacred gaze, in David Morgan's nuanced sense of this term.[19]

But the apparatus of *The Artist is Present* did not result in Abramović being mystified or deified into some kind of lofty bodhisattva; rather, the artist was clearly equally moved by her "energy exchanges" with the members of the public who sat across from her; her eyes occasionally welled up with tears at the unfolding of pain that she witnessed in the many visages she faced. Abramović's intermittent tears strike yet another parallel with the tradition of miraculous icons in the Orthodox Church, in which the weeping image of a saint, in particular Mary, symbiotically materializes a loop of empathetic exchange between viewer and viewed. *The Artist is Present* may have intuited and opened out to reveal what the Romantic poet William Blake had seen, as he remarked in his 1793 critical satire on Swedenborg: that "all deities reside in the human breast."

Abramović once self-deprecatingly called herself the "godmother of performance art" (a statement that she now declares she hates, and regrets ever making); the popular press has frequently misremembered this quip and called her the soi-disant "grandmother" of the field. The geriatric references couldn't be more misleading. Whereas many other performance artists of her generation have either ceased working or long ago transferred their creative practice into other mediums, Abramović continues to redefine herself through risky, path-breaking performances. Her deployment of concepts taken from the world's great religious traditions and her un-ironic deployment of spirituality makes her one of the most important living artists to continue renewing Wassily Kandinsky's original challenge to the avant-garde: to heed "das Geistige in der Kunst," the spiritual in art. In his pioneering 1911 manifesto, Kandinsky writes that:

[S]piritual life, to which art belongs and of which it is one of its mightiest agents, is a complicated but definite and *simplified upward lifting movement*. This movement is one of perception. It can take various forms, but basically it retains the same inner sense and purpose.[20]

While Kandinsky was primarily thinking pictorially about shapes and colors as an abstract painter, his "simplified upward lifting movement" of the spiritual fittingly delineates Abramović's oeuvre, suggesting bodies (hers, her participants') moving simply, slowly, or in stillness through space; "upward lifting" succinctly concretizes the more recent evocations of mystical ascension (the levitation of Saint Teresa in *The Kitchen*, the towering, slow pirouetting of *Entering the Other Side*).

As Abramović's recent work turns increasingly towards public involvement and entrusted participation, the line between her interactive performances and the collective practice of spiritual exercises becomes increasingly blurred. While such ambiguity may vex the secular coordinates of art history, it continues the utopian impetus of Kandinsky's original aesthetic: the unabashed belief that art harbors the spiritual potential to radically transform society and culture. For our own times, marked as they are by climate change, economic precarity, and the resurgence of violent religious fundamentalisms, the mission of the Marina Abramović Institute to "seek productive unions between art, science, technology, spirituality, and education" is a laudable aim in and of itself, rendered more luminous through Abramović's uncompromising art; more surprising, perhaps, are the deep resonances that such efforts to reintegrate the spiritual can strike with the life and work of Swedenborg.[21]

Notes

This essay is expanded and modified from a version that appears in *Death is Waking Up: A Conversation with Marina Abramović* (London, 2017). Portions are reproduced here with the kind courtesy and permission of the London Swedenborg Society.

1. Marina Abramović, *Student Body* (Milan, 2004), p. 28.

2. Emanuel Swedenborg, *The Four Doctrines with the Nine Questions,* trans. John Potts, (New York, 1949), no. 1. As is standard practice in scholarship on Swedenborg, all citations refer to section number, not pages, irrespective of edition or translation.

3. James Elkins, *On the Strange Place of Religion in Contemporary Art* (New York, 2004), p. 116.

4. Thomas McEvilley, "Stages of Energy: Performance Art Ground Zero?" in Bojana Pejić et al., *Marina Abramović: Artist Body; Performances 1968–1998* (Milan, 1998), pp. 23–25.

5. George Dole and Robert Kirven, *A Scientist Explores Spirit: a Biography of Emanuel Swedenborg* (West Chester, PA, 1997), pp. 4, 90.

6. Emanuel Swedenborg, *Drömboken,* ed. Per-Erik Wahlund (Stockholm, 1995).

7. As quoted in Lars Bergquist, *Swedenborg's Secret: The Meaning and Significance of the Word of God, the Life of the Angels and Service to God* (London, 2005), p. 163; see Marina Abramović, *Marina Abramović: Dream Book* (Tokyo, 2012).

8. Quoted in James Westcott, *When Marina Abramović Dies* (Cambridge, MA, 2010), p. 42.

9. Westcott, *When Marina Abramović Dies* (see note 8), p. 118.

10. Jeffrey J. Kripal, "Visions of the Impossible: How Fantastic Stories Unlock the Nature of Consciousness," *The Chronicle of Higher Education*, March 31, 2014, http://chronicle.com/article/Embrace-the-Unexplained/145557/ (accessed November 14, 2016).

11. Ulay / Abramović in Bojana Pejic et al., *Marina Abramović: Artist Body* (see note 4), p. 258.

12. Marina Abramović, *Public Body: Installation and Objects, 1965–2001* (Milan, 2001), p. 84.

13. Peter von Brügge and Joseph Beuys, "Die Mysterien Finden im Hauptbahnhof statt: SPIEGEL Gespräch mit Joseph Beuys über Anthroposophie und Die Zukunft der Menschheit," *Der Spiegel* 23 (June 4, 1984), pp. 178–86.

14. Doris von Drathen, "World Unity: Dream or Reality, a Question of Survival," in *Marina Abramović*, ed. Friedrich Meschede (Stuttgart, 1993), p. 227.

15. Chrissie Iles, "Marina Abramović: Staring at the Ocean," in *Marina Abramović: The House With the Ocean View* (Milan, 2004), p. 163.

16. Mateo Feijoo and Marina Abramović, *Marina Abramović: The Kitchen* (Madrid and Brighton, 2012).

17. Emanuel Swedenborg, *Heaven and Its Wonders and Hell: Drawn from Things Seen and Heard* (West Chester, PA, 2000); see especially the section on "Time in Heaven," nos. 162–69.

18. Related to Henry Corbin, *Alone with the Alone: Creative Imagination in the Ṣūfism of Ibn 'Arabī* (Princeton, NJ, 1998), pp. 356–57.

19. David Morgan, *The Sacred Gaze: Religious Visual Culture in Theory and Practice* (Berkeley, CA, 2005), pp. 3–6.

20. My emphasis; Wassily Kandinsky, *On the Spiritual in Art: The First Complete English Translation, with Four Full Colour Page Reproductions, Woodcuts and Half Tones*, trans. Hilla Rebay (New York , 1946), pp. 13–14. See also Colette Walker, "The Language of Form and Color: Traces of Swedenborg's Doctrine of Correspondences in Kandinsky's Concerning the Spiritual in Art," *The New Philosophy: Journal of the Swedenborg Scientific Association* 117, no. 3–4 (December 2014), pp. 165–86.

21. Marina Abramović, *Marina Abramović Institute: Dedicated to Human Beings* (Milan, 2013), p. 125.

BIOGRAPHY
Compiled by Olga Krzeszowiec Malmsten

1946

Marina Abramović is born on November 30 in Belgrade, former Yugoslavia, to an affluent family with politically active parents. Vojo and Danica Abramović, who were Yugoslav partisans during World War II, continue their engagement in General Tito's communist party. For their contributions during the war they are awarded high positions in the public sector; her father works with state security and her mother becomes head of the Museum of Art and the Revolution in Belgrade. While her parents make their political careers, Marina spends her first years living with her maternal grandmother. Milica Rosic is a devotee of the Orthodox Church, and her early childhood is deeply influenced by her grandmother's faith.

1952

At the age of six, Marina Abramović moves in with her parents when her brother Velimir is born. Raising the children is primarily Danica's responsibility; the father is largely absent. Life in her parental home under her mother's strict supervision is experienced as difficult and cold. Marina is made to uphold her mother's compulsive relationship to cleanliness and order.

1953–58

The Abramović family does not celebrate holidays or festivals together and rarely expresses their emotions. The proximity to art and culture, however, is clear. From an early age Marina is encouraged to express herself creatively through drawing and painting and at twelve is given her own studio at home.

1960–65

Marina develops her drawing and painting, often through classically figurative floral still lifes and portraits.

1965–70

The young artist studies at the Academy of Fine Arts in Belgrade. During this period, her earlier figurative expressions become increasingly abstract. Abramović starts painting clouds, and the motif recurs in ever-changing forms in several of her works from her school years.

1970–73

During further studies at the Academy of Fine Arts in Zagreb, Abramović begins to use her body as a tool in her art, and eventually stops painting and drawing altogether. Marina spends most of her time at the SKC (Studenski Kulturni Centar), a student cultural center in Belgrade founded by Tito. There she gets to know young conceptual artists such as Raša Todosijević, Zoran Popović and Neša Paripović. She starts experimenting with sound and performance.

1971

Marina Abramović marries the conceptual artist Neša Paripović. She continues living with her parents and their strict 10 PM curfew.

1973

Abramović meets the artist Joseph Beuys in Edinburgh and later that year at the Student Cultural Center of Belgrade. Beuys's happenings make a strong impression on Marina and greatly influence her continued work. She collaborates with the boundary-breaking artist Hermann Nitsch. The same year, she enacts the performance piece *Rhythm 10* at the Villa Borghese, Museo d'Arte Contemporanea in Rome. The piece is the first of five performances in *The Rhythm Series,* in which she explores the limits of the body and consciousness.

1974

At SKC Marina Abramović performs the work *Rhythm 5.* The same year, *Rhythm 4* is presented at Galleria Diagramma in Milan, as well as the last work in the series, *Rhythm 0,* at the gallery Studio Morra in Naples.

1975

Travels to Amsterdam to participate in an international gathering for performance artists and meets the German artist Ulay (Frank Uwe Laysiepen, b. 1943).

With the intention of contending with her identity and past, Marina returns to Belgrade for a series of performances pieces—*Freeing the Voice, Freeing the Memory,* and *Freeing the Body* at the Student Cultural Center (SKC).

1976

Twenty-nine-year-old Abramović divorces Paripović. Throughout the marriage, she's lived with her mother; after the divorce, she flees her repressive family home and moves in with Ulay in Amsterdam.

1977–79

Abramović and Ulay create a number of works under the shared title *Relation Works.* They write the manifesto *Art Vital,* which sets the course for their artistic practice. They decide to be in a perpetual state of transit, and for the next three years they live and work in a van while traveling through Europe.

Several pieces from the *Relation Works* series are shown at the Stedelijk Museum in Amsterdam, SKC in Belgrade, Documenta in Kassel, and the Musée d'art et d'histoire in Geneva.

The performance piece *Imponderabilia* is presented by Abramović and Ulay at Galleria Comunale d'Arte Moderna in Bologna.

1980–81

The couple get an apartment in Amsterdam and come to play a central role in the artistic life of the city. They keep their van and travel to Australia and its Great Victoria Desert, where they live with the Pintupi tribe for nine months. Influenced by aboriginal culture, they create the performance piece *Nightsea Crossing.* It is shown for the first time at The Art Gallery of New South Wales in Sydney.

1982

Nightsea Crossing is performed at museums and exhibition halls in cities such as Kassel at Documenta 7, Cologne, Düsseldorf, Berlin, Amsterdam, Chicago, and Toronto.

In order to practice the meditation technique *vipassana,* Abramović and Ulay travel to Bodhgaya, India, where they meet the Dalai Lama and his oldest mentor, the *tulku* Kyabje Ling Rinpoche. They travel on to Rajasthan and the Thar Desert in Northwest India.

1983

Abramović and Ulay invite the Tibetan lama Ngawang Soepa Lucyar and the Aboriginal medicine man Charlie Watuma Taruru Tjungurrayi, their travel companion in the Great Victoria Desert, to perform a new version of *Nightsea Crossing* together. For four days, the performance piece *Nightsea Crossing Conjunction* is hosted at the Fodor Museum in the Netherlands.

1985

Marina Abramović travels to Dharamsala in India. Inspired by the mindfulness in *vipassana* meditation, she and Ulay enact their first play, *Modus Vivendi,* in Bern, Arnheim, and later in Baltimore. Since 1980, they have worked with video and photography parallel to their performative practice. *Modus Vivendi* also becomes the title of a series of large-scale Polaroid photographs.

1986

The artistic couple takes their first trip to China. Ever since the trip to the Australian desert in 1980, they had been working on an idea about a performance-walk along the Great Wall of China. They apply for support from the Chinese authorities, but are turned down. *Nightsea Crossing* ends after six years with a performance at the Musée Saint Pierre d'art contemporain in Lyon.

1987

Even though they have almost entirely broken off their personal relationship, Abramović and Ulay continue working together. They travel to China for the second time and apply again for permission to conduct their walk.

1988

After years of preparation, the walk along the Great Wall of China begins for the work *The Lovers.* Abramović walks from the Shanhai Pass at the wall's east end. From the wall's western end near the Gobi Desert, Ulay walks in the opposite direction. After ninety days, they meet. The reunion marks a definitive end to their romantic relationship, as well as a twelve-year-long artistic collaboration. Abramović and Ulay part ways and start to work on their own.

1989

The Lovers is exhibited at the Stedelijk Museum in Amsterdam and the Museum van Hedendaagse Kunst in Antwerp.

Abramović's new solo works are a series of interactive objects, known as *Transitory Objects,* influenced by geology as well as Chinese and Tibetan medicine. Among other places, the works are shown in Oxford's Museum of Modern Art, Städtische Kunsthalle in Düsseldorf, and Montreal's Museum of Modern Art.

1990

Marina Abramović moves to Paris, but keeps her apartment in Amsterdam. Through her early interests in Eastern philosophy, she's invited to participate in the notable exhibition *Magiciens de la Terre* at the Centre Pompidou in Paris. Soon after the group exhibition, *The Lovers* opens at the same museum.

1991

The artist becomes a guest professor at the Hochschule der Kunst in Berlin and at the Académie des Beaux-Arts in Paris. She travels to Brazil a number of times to continue her work on *Transitory Objects.*

1992–93

In Hamburg, Abramović becomes a professor at the Hochschule für Bildende Künste. She is awarded a stipend that includes an apartment and a studio in Berlin, as well as an exhibition at the Neue Nationalgalerie.

Abramović returns to the theater. The autobiographical play *Biography,* directed by Charles Atlas, premieres in Madrid and is also shown at Documenta 9 in Kassel.

1994

The Biography is staged at theaters in Paris, Athens, Amsterdam, and Antwerp.

Abramović and Charles Atlas travel to Belgrade to work on the forthcoming play *Delusional,* which is also based on Marina's life.

1995

A retrospective exhibition at Oxford's Museum of Modern Art.

The performance piece *Cleaning the House* is staged at the Sean Kelly Gallery in New York.

1996

Marina Abramović turns fifty. In conjunction with her birthday celebrations, a vernissage for the retrospective *Marina Abramović: Objects, Performance, Video, Sound* is held at the Stedelijk Museum voor Aktuele Kunst in Ghent.

1997

Abramović is invited to represent Serbia and Montenegro at the Yugoslavian pavilion at the Venice Biennale, but breaks off the collaboration after a conflict with the Montenegrin minister of culture. The performance piece *Balkan Baroque* is shown instead at the Italian pavilion, where it causes a stir. Abramović is awarded the Golden Lion prize for Best Artist of the Biennale. The same year, she meets the artist Paolo Cannevari, and they begin a romantic relationship.

1998

Marina Abramović becomes a professor at Hochschule für Bildende Kunste in Braunschweig, Germany. Ahead of forthcoming performative projects, she develops the workshop *Cleaning the House,* a series of exercises in concentration and presence of mind and a purification of the body and mind.

1999

In Mundgod, India, Abramović choreographs a performance together with Tibetan monks for the Festival of Sacred Music. She meets the Dalai Lama, the festival's initiator, a number of times.

2000–01

Vojo Abramović dies of cancer. The next year the video piece *Hero,* dedicated to her father, is produced.

The interactive project *Dream House* opens in conjunction with Echigo-Tsumari Art Triennial in Japan. The dream house is decorated with colors and furniture in precious materials that are meant to stimulate dreams. The work is installed permanently.

2002

Abramović and Cannevari move to New York. There *The House with the Ocean View* is also presented at the Sean Kelly Gallery. In front of visitors, Abramović spends twelve days strictly fasting and performing seemingly simple every day tasks.

2004

The Art Institute of Chicago gives Abramović an honorary doctorate. She travels to Belgrade to develop the video project *Balkan Erotic Epic* and also participates in the 2004 biennial at the Whitney Museum of American Art in New York.

2005

Seven Easy Pieces is presented at the Solomon R. Guggenheim Museum in New York. The work consists of seven re-stagings of performances by Valie EXPORT, Vito Acconci, Bruce Nauman, Gina Pane, Josef Beuys, and Marina Abramović herself. The project is a result of Abramović's work with *re-performance*—a way of holding in trust one's own as well as other artists' performance pieces.

Art Must Be Beautiful, Artist Must Be Beautiful opens at Museo Nacional Centro de Arte Reina Sofía in Madrid.

2006

Abramović and Cannevari marry in New York. Beyond the metropolis, Marina buys an estate in Hudson that becomes her private residence and a meeting place for performance art.

2007

Danica Abramović dies in Belgrade.

2010

New York's MoMA presents the extensive retrospective *The Artist is Present* with many re-performances of Abramović's works. The artist herself performs the new and demanding piece *The Artist is Present* for the duration of the exhibition and receives a huge public response. The exhibition is the largest presentation of performance in the history of the museum.

Abramović founds Marina Abramović Institute (MAI), which is to work across the sciences in order to draft a theoretical and practical platform for performance art.

2011

The Artist is Present is shown at the Garage Center for Contemporary Culture in Moscow.

The biographical play *The Life and Death of Marina Abramović* premieres at the Manchester International Festival.

2012

The documentary *Marina Abramović: The Artist is Present* premieres at the Sundance Film Festival.

The exhibition *Marina Abramović, Balkan Stories* is shown at Kunsthalle Wien.

2014

The exhibition *512 Hours* is presented at London's Serpentine Gallery. The project is a series of interactive exercises that have their starting points in the artist's own work process, in which the audience participates.

2015

The two extensive, separate exhibitions *Terra Comunal/Communal Land* and *Private Archaeology* open at SESC Pompeia in São Paulo and the Museum of Old and New Art in Tasmania, respectively.

2017–18

Marina Abramović—The Cleaner is shown at Moderna Museet in Stockholm. The exhibitions travels to the Louisiana Museum of Modern Art in Humlebæk, Denmark, and to the Bundeskunsthalle, Bonn, Germany.

SELECTED BIBLIOGRAPHY

Abramović, Marina. *Marina Abramović*. Zagreb: Gallery of Contemporary Art, 1974.

Abramović, Marina, and Danegri, Jesa. *Rhythms 10, 5, 2, 4, 0*. Belgrade: Museum of Contemporary Art, 1975.

Abramović, Marina, and Ulay. *Three Performances, Marina Abramović/Ulay–Ulay/Marina Abramović; Relation/Works*. Innsbruck: Galerie Krinzinger; Graz: Galerie H-Humanic, 1978.

Abramović, Marina, and Ulay. *30 November/30 November: Marina Abramović/Ulay*. Wiesbaden: Harlekin Art, 1979.

Abramović, Marina, and Ulay. *Two Performances and Detour: Marina Abramović/Ulay*. Adelaide: The Experimental Art Foundation, 1979.

Abramović, Marina, and Ulay. *Relation Work and Detour: Marina Abramović/Ulay, Ulay/Marina Abramović*. Amsterdam: Idea Books, 1980.

Abramović, Marina, Ulay, and Jan Debbaut, eds. *Modus Vivendi: Ulay and Marina Abramović; Works 1980–1985*. Eindhoven: Stedelijk Van Abbemuseum, 1985.

Abramović, Marina, and Ulay. *The Lovers*. Amsterdam: Stedelijk Museum, 1989.

Abramović, Marina. *Sur la voie*. Paris: Centre Georges Pompidou, 1990.

Abramović, Marina. *Departure: Brazil Project 1990–91*. Paris: Galerie Enrico Navarra, 1991.

Von Draathen, Doris. *Transitory Objects: Marina Abramović*. Vienna: Galerie Krinzinger, 1992.

Abramović, Marina. *Becoming Visible*. Montbéliard, France: Musées et Centre d'art contemporain, 1993.

Abramović, Marina, Lola Bonora, and Doris von Drathen. *Marina Abramović*. Ferrara: Palazzo dei Diamanti, 1993.

Abramović, Marina, and Friedrich Meschede, eds. *Abramović*. Neue Nationalgalerie Berlin/Stuttgart: Reihe Cantz, 1993.

Abramović, Marina, and Charles Atlas. *Marina Abramović: Biography*. Stuttgart: Reihe Cantz, 1994.

Iles, Chrissie, ed. *Marina Abramović: Objects, Performance, Video, Sound*. Oxford: Museum of Modern Art, 1995.

Pijnappel, Johan, ed. *Marina Abramović: Cleaning the House*. London: Academy Editions, 1995.

Avgikos, Jan, ed. *Marina Abramović: Boat Emptying Stream Entering (Part I and Part II)*, video [no publication]. Denton: The University of North Texas Art Gallery, 1996.

Ruf, Beatrix, and Markus Landert. *Marina Abramović: Double Edge*. Karthause Ittingen: Kunstmuseum des Kantons Thurgau, 1996.

Abramović, Marina, Ulay, and Jaap Guldemond, eds. *Ulay/Abramović: Performances 1976–1988*. Eindhoven: Stedelijk Van Abbemuseum, 1997.

Tazzi, Pier Luigi, and David Elliott. *Wounds: Between Democracy and Redemption in Contemporary Art*. Stockholm: Moderna Museet, 1998.

Abramović, Marina. *Inbetween*. Kitakyushu, Japan: Center for Contemporary Art, 1998.

Abramović, Marina, et al. *Marina Abramović: Artist Body; Performances 1969–1998*. Milan: Charta, 1998.

Jones, Amelia. *Body Art/Performing the Subject*. Minneapolis, MN: University of Minnesota Press, 1998.

Rico, Pablo J., ed. *The Bridge = El Puente: Marina Abramović*, Exposición Retrospectiva. Trans. Agustín Nieto and Brendan Lambe. Consorci de Museus de la Comunitat Valenciana/Milan: Charta, 1998.

Ulay/Abramović: Performances 1976–1988. Lyon: Musée d'art contemporain de Lyon, 1999.

Mahler, Hannes Malte. *Fresh Air*. Cologne: Salon Verlag, 1999.

——. *Unfinished Business*. Cologne: Salon Verlag, 1999.

Celant, Germano. *Public Body: Installations and Objects 1965–2001*. Milan: Charta, 2001.

Hanssen, Elisabet. *Cleaning the Mirror I: Marina Abramović*. Trans. Palmyre Pierroux. Oslo: Museet for Samtidskunst – Nasjonalmuseet, 2001.

Abramović Marina, et al. *Marina Abramović*. Fondazione Antonio Ratti/Milan: Charta, 2002.

Abramović, Marina, et al. *Marina Abramović: Student Body*. Milan: Charta, 2003.

Pejić, Bojana. *Marina Abramović: The Star*. Kumamoto, Japan: Contemporary Art Museum, Kumamoto, 2003.

Abramović, Marina, et al. *The House with the Ocean View*. Milan: Charta, 2004.

Abramović, Marina. *The Biography of Biographies*. Milan: Charta, 2005.

Westcott, James. *Marina Abramović*. Geneva: Galerie Guy Bärtschi, 2005.

Von Fürstenberg, Adelina, ed. *Marina Abramović: Balkan Epic*. Milan: Skira, 2006.

Abramović, Marina. *7 easy pieces*. Milan: Charta, 2007.

Abramović, Marina, Jimena Blásquez, Paula Llull, and Ana M. Morales. *Cleaning the House.* Cadiz, Spain: Fundación NMAC, 2007.

Abramović, Marina, Kristine Stiles, Klaus Biesenbach, and Chrissie Iles. *Marina Abramović.* London and New York: Phaidon, 2008.

Abramović, Marina, Klaus Biesenbach, et al. *Marina Abramović: The Artist is Present.* New York: Museum of Modern Art Department of Publications, 2010.

Westcott, James. *When Marina Abramović Dies: A Biography.* Cambridge, MA: MIT Press, 2010.

Anelli, Marco. *Portraits in the Presence of Marina Abramović.* Bologna: Damiani, 2012.

Viola, Eugenio, and Diego Sileo. *The Abramović Method.* PAC/Milan: 24 Ore Cultura, 2012.

Abramović, Marina. *Marina Abramović: 512 Hours.* Serpentine Galleries/Cologne: Koenig Books, 2014.

Biesenbach, Klaus, and Hans Ulrich Obrist. *14 Rooms.* Edited by Renata Catambas. Ostfildern: Hatje Cantz, 2014.

Clemens, Justin. *Private Archaeology.* Tasmania: Museum of Old and New Art, 2015

Abramović, Marina, with James Kaplan. *Walk Through Walls: A Memoir.* New York: Crown Archetype, 2016.

Volz, Jochen, et al. *Terra Comunal: Marina Abramovic + MAI.* São Paulo: Edições Sesc São Paolo, 2016.

WORKS

The Truck Accident Game, ca. 1960
Charcoal, watercolor and pencil on paper
29.5 × 27.5 cm
Courtesy of Marina Abramović Archives

Truck Accident, Study, ca. 1960
Chinese ink and acrylic paint on paper
59 × 83 cm
Courtesy of Marina Abramović Archives

Truck Accident (I), 1963
Oil on canvas
150 × 170 cm
Courtesy of Marina Abramović Archives

Truck Accident (II), 1963
Oil on canvas
151 × 132 cm
Courtesy of Marina Abramović Archives

Truck Accident, Study, ca. 1965
Pencil on paper
71 × 13.5 cm
Courtesy of Marina Abramović Archives

Body and Cloud with its Shadow, ca. 1965
Charcoal and acrylic paint on paper
67.5 × 59 cm
Courtesy of Marina Abramović Archives

Clouds Collage, ca. 1965
Mixed-media collage on paper
40.5 × 37 cm
Courtesy of Marina Abramović Archives

Body and Clouds, Study No. 1, ca. 1965–70
Charcoal and watercolor on paper
72 × 59.5 cm
Courtesy of Marina Abramović Archives

Body and Clouds, Study No. 2, ca. 1965–70
Charcoal and watercolor on paper
72 × 59.5 cm
Courtesy of Marina Abramović Archives

Cloud with its Shadow, ca. 1965–70
Charcoal and acrylic paint on paper
59 × 67.5 cm
Courtesy of Marina Abramović Archives

Self-Portrait, 1965
Oil on canvas
102 × 83 cm
Courtesy of Marina Abramović Archives

Three Secrets, 1965
Oil on canvas, cotton cloth
51 × 45 cm
Courtesy of Marina Abramović Archives

Clouds in the Shadow, 1969
Oil on canvas
177 × 146 cm
Courtesy of Marina Abramović Archives

Connect the Stars, 1969
Printed invitation
32 × 44 × 3 cm (framed)
Courtesy of Marina Abramović Archives
and Lisson Gallery, London

Cloud with its Shadow, 1970
One peanut, two pins
ca. 8 × 4 × 1 cm
Courtesy of Marina Abramović Archives

Black Clouds Coming, 1970
Oil on canvas
200 × 140 cm
Courtesy of Marina Abramović Archives

The Tree, 1971/2017
Sound environment, 10:00 min, loop
Courtesy of Marina Abramović Archives and
Lisson Gallery, London

Metronome, 1971
Sound environment, metronome
22 × 11 × 11.5 cm
Courtesy of Marina Abramović Archives

Freeing the Horizon, 1971
29 paintings on Agfa color prints
Each 7.8 × 10.6 cm
Courtesy of Marina Abramović Archives and
Lisson Gallery, London

Sound Environment—Sea, 1972
45-rpm record and sleeve
17.8 × 17.8 cm
Courtesy of Marina Abramović Archives

The Airport, 1972/2017
Sound environment, loop
Courtesy of Marina Abramović Archives
and Lisson Gallery, London

Coming and Going, 1973/2017
Silver gelatin print
9 photographs; each 18 × 18 cm
Courtesy of Marina Abramović Archives

Rhythm 10, 1973/2010
Silver gelatin prints, text
21 photographs, overall dimensions:
122.5 × 898 cm (framed); text: 21.6 × 27.9 cm
Courtesy of Marina Abramović Archives
and Lisson Gallery, London

Rhythm 10, 1973/2017
Sound installation, loop
Courtesy of Marina Abramović Archives

Rhythm 2, 1974/1994
Silver gelatin print, letterpress text panel
Two photographs, each: 100 × 76 cm
(framed); text: 26 × 18 cm
Courtesy of Marina Abramović Archives
and Sean Kelly, New York

Rhythm 4, 1974/1994
Silver gelatin print, letterpress text panel
76 × 100 cm (framed); text: 26 × 18 cm
Courtesy of Marina Abramović Archives
and Sean Kelly, New York

Rhythm 5, 1974/2011
Silver gelatin print, text panel
8 prints, overall dimensions: 125 × 908 cm
(framed); text: 21.6 × 27.9 cm
Courtesy of Marina Abramović Archives
and Lisson Gallery, London

Rhythm 5, 1974/2014
8 mm film transferred to digital video
(b/w, no sound), 8:12 min
Courtesy of Marina Abramović Archives
and Lisson Gallery, London

Rhythm 0, 1974
Slide show, table with 72 objects, text panel
Dimensions variable
Courtesy of Marina Abramović Archives
and Lisson Gallery, London

Art Must Be Beautiful, Artist Must Be Beautiful, 1975
Video (b/w, sound), 23:36 min
Statens Museum for Kunst, Copenhagen

Art Must Be Beautiful, Artist Must Be Beautiful, 1975/2017
Performance
Reperformed on occasions throughout the exhibition (Moderna Museet).
Courtesy of Marina Abramovic Archives

Role Exchange, 1975/1994
Silver gelatin print, letterpress text panel
Diptych, each photograph: 76 × 100 cm; text: 26 × 18 cm
Courtesy of Marina Abramović Archives and Sean Kelly, New York

Freeing the Voice, 1975
Video (b/w, sound), 35:26 min
Courtesy of Marina Abramović Archives and Lisson Gallery, London

Freeing the Voice, 1975/2017
Performance
Reperformed on occasions throughout the exhibition.
Courtesy of Marina Abramović Archives

Freeing the Memory, 1975
Video (b/w, sound), 50:17 min
Courtesy of Marina Abramović Archives and LIMA

Freeing the Memory, 1975/2017
Performance
Reperformed on occasions throughout the exhibition.
Courtesy of Marina Abramovic Archives

Freeing the Body, 1975
Video (b/w, sound), 51:41 min
Courtesy of Marina Abramović Archives and LIMA

Freeing the Body, 1975/2017
Performance
Reperformed on occasions throughout the exhibition.
Courtesy of Marina Abramovic Archives

Lips of Thomas, 1975/2017
Slide show, cross made of ice, wine bottle, wine glass, whip, honey, silver spoon, razor blades, wooden table, wooden chair, white table cloth, overhead metal heating lamp
Dimensions variable
Courtesy of Marina Abramović Archives

Ulay/Marina Abramović
The Van—Relation in Movement, 1975–80
Citroën type H, megaphone, audio and video installation (Relation in Movement), amplifier, monitor, small wooden boat, photographs (b/w), text
Van: 422 × 196 × 220 cm, silver gelatin print (2): 20 × 29.7 cm, silver gelatin print (12): 20.5 × 31 cm
Musée d'art contemporain de Lyon

Ulay/Marina Abramović
Relation in Space, 1976
½" video transferred to digital video (b/w, sound), 59:28 min
Courtesy of Marina Abramović Archives and Lisson Gallery, London

Ulay/Marina Abramović
Breathing in/Breathing out, 1977
½" video transferred to digital video (b/w, sound), 10:49 min
Courtesy of Marina Abramović Archives and Lisson Gallery, London

Ulay/Marina Abramović
Imponderabilia, 1977
½" video transferred to digital video (b/w, sound), 50:25 min
Courtesy of Marina Abramović Archives and LIMA

Ulay/Marina Abramović
Expansion in Space, 1977
½" video transferred to digital video (b/w, sound), 25:05 min
Courtesy of Marina Abramović Archives and LIMA

Ulay/Marina Abramović
Relation in Movement, 1977
Analogue video transferred to digital video (b/w, silent), 34:19 min
Courtesy of Marina Abramović Archives and Lisson Gallery, London

Ulay/Marina Abramović
Light/Dark, 1977
16 mm film transferred to digital video (b/w, sound), 8:15 min
Courtesy of Marina Abramović Archives and Lisson Gallery, London

Ulay/Marina Abramović
AAA-AAA, 1978
2" video transferred to digital video (b/w, sound), 12:57 min
Courtesy of Marina Abramović Archives and Lisson Gallery, London

Ulay/Marina Abramović
Installation Two, 1979/2017
Hot plate, water
Dimensions variable
Courtesy of Marina Abramović Archives

Ulay/Marina Abramović
Rest Energy, 1980
16 mm transferred to digital video (color, sound), 4:04 min
Courtesy of Marina Abramović Archives and Lisson Gallery, London

Ulay/Marina Abramović
Everything Will Be Alight, ca. 1980–81
16 mm film transferred to digital video (color, sound), 4:00 min
Courtesy of Marina Abramović Archives and Lisson Gallery, London

Marina Abramović/Ulay
Nightsea Crossing, 1982–86
Slideshow of 20 sittings: Sydney 1982; Marl 1982; Düsseldorf 1982; Berlin 1982; Cologne 1982; Amsterdam 1982; Chicago 1982; Toronto 1982; Kassel 1982; Kassel 1982; Kassel 1982; Helsinki 1982; Ghent 1984; La Furka 1984; Bonn 1984; Middelburg 1984; Ushimado 1985; São Paulo 1985; New York 1986; Lyon 1986
Courtesy of Marina Abramović Archives

Marina Abramović/Ulay
Nightsea Crossing, 1981–88
46 Silver dye bleach prints (Cibachrome) referred to as "colors"
41 × 42 cm each
Musée d'art contemporain de Lyon

Marina Abramović/Ulay
Nightsea Crossing, 1982
Various symbolic objects, sometimes placed
on the table during the performance.
List of objects: 6-sided quartz crystal,
white sheet of paper folded in the shape
of a boat, Chinese scissors, elephant
modeled in clay, four boomerangs in
black painted pine.
Dimensions variable
Musée d'art contemporain de Lyon

Marina Abramović/Ulay
Nightsea Crossing Conjunction, 1983
16 mm film transferred to digital video
(color, no sound), 3:02 min
Courtesy of Marina Abramović Archives
and LIMA

Marina Abramović/Ulay, with Rémy Zaugg
The Observer, 1984
Video (color, sound), 6:02 min
Courtesy of Marina Abramović Archives
and LIMA

Marina Abramović /Ulay
*The Sun and the Moon (Die Mond,
der Sonne)*, 1987
Polyester, two parts, high-sheen and
matte varnish
Each: 180 cm (h), ca. 110 cm (d)
Kunstmuseum Bern

Marina Abramović /Ulay
The Lovers, 1988
16 mm film transferred to digital video
(color, silent), 2 channel, 15:41 min
Courtesy of Marina Abramović Archives
and LIMA

Black Dragon, from the series *Transitory
Objects for Human Use*, ca. 1990–94
Blue quartz, chrysocolla, green quartz,
hematite, snowflake obsidian
15 objects, each ca. 11 × 19 × 11 cm
Courtesy of Marina Abramović Archives
and and Sean Kelly, New York

Waiting for an Idea, 1991
Silver dye bleach print (Cibachrome)
Diptych, each 127 × 334.5 cm
Collection S.M.A.K., Ghent, Belgium

Shoes for Departure, ca. 1991
Amethyst objects, installation
17 × 51 × 53 cm
Collection Stedelijk Museum, Amsterdam

Shoes for Departure, 1991/2015
Quartz crystal
Two objects, each ca. 20 × 55 × 35 cm
Courtesy of Marina Abramović Archives
and Luciana Brito Galeria, São Paulo

Shoes for Departure, 1991/2015
Quartz crystal
Two objects, each ca. 30 × 60 × 45 cm
Courtesy of Marina Abramović Archives
and Luciana Brito Galeria, São Paulo

Crystal Broom, from the series *Transitory
Objects for Non-Human Use*, 1995
Wood, quartz crystal
Two brooms, each 156.2 × 58.4 × 43.2 cm
Courtesy of Marina Abramović Archives
and Sean Kelly, New York

Crystal Brush, from the series *Transitory
Objects for Non-Human Use*, 1995
Wood, quartz crystal, lacquered metal base
4.5 × 10.5 × 11 cm, base: 34 × 22.8 × 8.5 cm
Private collection

Cleaning the Mirror, 1995/2017
Performance
Reperformed throughout the exhibition
for a total of 480 hours (Moderna Museet).
Courtesy of Marina Abramović Archives

The Onion, 1995
Video (color, sound), 20:03 min
Courtesy of Marina Abramović Archives
and LIMA

Double Edge, 1996
Wood, knives, steel, heating elements,
freezing elements
4 ladders, each: 400 × 60 × 7 cm
Collection S.M.A.K., Ghent, Belgium

Balkan Baroque, 1997
Three-channel video installation
(color, sound), cow bones
Dimensions variable, 12:38 min
Courtesy of Marina Abramović Archives
and LIMA

Private Archaeology, 1997–2015
Four white oak cabinets, drawers containing
mixed-media drawings
Each cabinet 138 × 98.5 × 60 cm
Courtesy of Marina Abramović Archives
and Sean Kelly, New York

Dream House, 2000/2017
Two dream books made of leather and paper,
slideshow
Dimensions variable
Courtesy of Marina Abramović Archives

The Hero, 2001
Single channel video (b/w, sound), vitrine
containing objects that belonged to Vojo
Abramovic: small pigskin leather bag, pencil
sharpener, 2 coins, 6 documents, 2 post
cards, soap box, 1 magazine clipping,
1 newspaper clipping, 14 military medals,
6 fabric military objects, 107 photographs
Dimensions vitrine: 152 × 61 cm, 14:21 min
Courtesy of Marina Abramović Archives,
LIMA, and Sean Kelly, New York

Energy Clothes (Cone Hats), 2001
Red, yellow, green, pink, and purple silk
paper, fabric, magnet
Each 123 × 17 × 22 cm
Courtesy of Marina Abramović Archives

Stromboli, 2002
Video (b/w, sound), 19:33 min
Courtesy of Marina Abramović Archives
and LIMA

Stromboli III (Volcano), 2002
Digital print, type C (Lambda)
50 × 75 cm
Courtesy of Marina Abramović Archives
and Lia Rumma Gallery, Milan

The House with the Ocean View, 2002/2017
Sound installation, bed with mineral pillow,
sink, chair with mineral pillow, table, toilet,
shower basin, shower, three ladders with
knives, metronome, water glass, clothes
Dimensions variable
Courtesy of Marina Abramović Archives
and Sean Kelly Gallery, New York

Count on Us, 2004
4-channel video installation, sound, 16:11 min
Courtesy of Marina Abramović Archives
and LIMA

Balkan Erotic Epic, 2005
Multichannel video installation (color, sound)
Duration variable
Courtesy of Marina Abramović Archives
and LIMA

Marina Abramović—Seven Easy Pieces, 2007
HD video (color, surround sound)
92:50 min
Directed by Babette Mangolte
Courtesy of Babette Mangolte, Marina
Abramović Archives and Sean Kelly Gallery,
New York

Portrait with Golden Mask, 2009
Video (color, no sound), 30:05 min
Courtesy of Marina Abramović Archives
and LIMA

The Kitchen V: Holding the Milk, 2009
Video (color, sound), 12:42 min
Courtesy of Marina Abramović Archives
and LIMA

Sleeping Under the Banyan Tree, 2010
Video (b/w, no sound), 56:43 min
Courtesy of Marina Abramović Archives
and LIMA

The Artist is Present, 2010
7-channel video installation (6 × 16:9
projections, 1 monitor: color, no sound),
Grid: 6 hours / CAM 3: 71 × 7 Hour files
Courtesy of Marina Abramović Archives
and Lisson Gallery, London

Confession, 2010
Video (b/w, no sound), 60:00 min
Courtesy of Marina Abramović Archives
and LIMA

512 Hours, 2014/2017
Mixed-media installation
Dimensions variable. Duration of video:
center channel: 64 hours / side channels:
20 hours
Courtesy of Marina Abramović Archives
and The Serpentine Galleries, London

Bed for Human Use (III), from the series
Transitory Objects for Human Use, 2015
Wood, quartz crystal
80 × 77 × 218 cm
Courtesy of Marina Abramović Archives
and Luciana Brito Galeria, São Paulo

Bed for Human Use (III), from the series
Transitory Objects for Human Use, 2015
Wood, quartz crystal
80 × 77 × 218 cm
Courtesy of Marina Abramović Archives
and Luciana Brito Galeria, São Paulo

Chair for Human Use (III), from the series
Transitory Objects for Human Use, 2015
Wood, quartz crystal
110 × 65 × 80 cm
Courtesy of Marina Abramović Archives
and Luciana Brito Galeria, São Paulo

Counting the Rice, 2015
Exercise for public participation from a
series of workshops entitled "Cleaning the
House" (1979–); wooden table, wooden
chairs, pencils, paper, white rice, black lentils,
instructions for the public
75 × 1300 × 190 cm
Duration: limitless
Courtesy of Marina Abramović Institute

Studies for unrealized projects

Untitled, ca. 1960
Chinese ink on paper
29.5 × 42 cm
Courtesy of Marina Abramović Archives

*Traces of Planes and Sun Rays,
Study for Sky Project, No. 1*, ca. 1970
Pen and colored pencil on paper
20.5 × 12 cm
Courtesy of Marina Abramović Archives

*Traces of Planes and Sun Rays,
Study for Sky Project, No. 2*, ca. 1970
Pen and colored pencil on paper
20.5 × 12 cm
Courtesy of Marina Abramović Archives

*Traces of Planes and Sun Rays,
Study for Sky Project, No. 3*, ca. 1970
Pen and colored pencil on paper
20.5 × 12 cm
Courtesy of Marina Abramović Archives

*Traces of Planes and Sun Rays,
Study for Sky Project, No. 4*, ca. 1970
Pen and colored pencil on paper
20.5 × 12 cm
Courtesy of Marina Abramović Archives

*Traces of Planes and Sun Rays,
Study for Sky Project, No. 5*, ca. 1970
Pen and colored pencil on paper
20.5 × 12 cm
Courtesy of Marina Abramović Archives

Untitled, ca. 1970
Pen and colored pencil on paper
30 × 20.5 cm
Courtesy of Marina Abramović Archives

Untitled, ca. 1970
Pen and colored pencil on paper
24 × 35 cm
Courtesy of Marina Abramović Archives

Untitled, ca. 1970
Pencil on paper
25 × 35 cm
Courtesy of Marina Abramović Archives

Untitled, ca. 1970
Pen and colored pencil on paper
25 × 27 cm
Courtesy of Marina Abramović Archives

Untitled, ca. 1970
Pen and colored pencil on paper
25 × 35 cm
Courtesy of Marina Abramović Archives

Untitled, ca. 1970
Pen and colored pencil on paper
29.5 × 21 cm
Courtesy of Marina Abramović Archives

Untitled, ca. 1970
Pen and colored pencil on paper
25 × 35 cm
Courtesy of Marina Abramović Archives

Untitled, ca. 1970
Pen and colored pencil on paper
35 × 50 cm
Courtesy of Marina Abramović Archives

Untitled, ca. 1970
Pencil on paper
30 × 42 cm
Courtesy of Marina Abramović Archives

Untitled, ca. 1970
Pen and colored pencil on paper
30 × 42 cm
Courtesy of Marina Abramović Archives

Untitled, ca. 1970
Pen and colored pencil on paper
30 × 42 cm
Courtesy of Marina Abramović Archives

Untitled, ca. 1970
Pen and colored pencil on paper
30 × 42 cm
Courtesy of Marina Abramović Archives

Untitled, ca. 1970
Pen and colored pencil on paper
30 × 42 cm
Courtesy of Marina Abramović Archives

Untitled, ca. 1970
Pencil on paper
30 × 42 cm
Courtesy of Marina Abramović Archives

Untitled, ca. 1970
Pen and colored pencil on paper
30 × 42 cm
Courtesy of Marina Abramović Archives

Untitled, ca. 1970
Pen on paper
10 × 13 cm
Courtesy of Marina Abramović Archives
and Lisson Gallery, London

Study for Burned Island, 1970
Ink marker on paper
10 × 12.6 cm
Courtesy of Marina Abramović Archives
and Lisson Gallery, London

*Study for Body and Sound Performance
with 13 Points*, ca. 1970
Ink marker on paper
25.2 × 20 cm
Courtesy of Marina Abramović Archives
and Lisson Gallery, London

*Permanently Coming Close, Simultaneously
Going Far from the Same Direction*, ca. 1970
Pen on paper
25.2 × 20 cm
Courtesy of Marina Abramović Archives
and Lisson Gallery, London

*Boats Coming and Going from the
Perspective of the Bridge*, ca. 1970
Pen on paper
25.2 × 20 cm
Courtesy of Marina Abramović Archives
and Lisson Gallery, London

Are You Happy, Are You Happy, ca. 1970
Ink marker on paper
20.1 × 25 cm
Courtesy of Marina Abramović Archives
and Lisson Gallery, London

Untitled, ca. 1970
Chinese ink and pencil on paper
70 × 70 cm
Courtesy of Marina Abramović Archives
and Lisson Gallery, London

Study for Labyrinth, ca. 1970
Ink marker on paper
58.5 × 55 cm
Courtesy of Marina Abramović Archives
and Lisson Gallery, London

Sound Cross (Underground London), 1974
Pencil and colored pencil on paper
10 × 13.5 cm
Courtesy of Marina Abramović Archives
and Lisson Gallery, London

Studies for realized projects

*Parallel Thinking for Different Projects
on a Small Piece of Paper*, ca. 1970
Ink marker on paper
10.8 × 13 cm
Courtesy of Marina Abramović Archives
and Lisson Gallery, London

Study for Rhythm 10, 1973
Ink marker on paper
10.4 × 13 cm
Courtesy of Marina Abramović Archives
and Lisson Gallery, London

Study for Rhythm 5, 1974
Pencil on paper
10 × 13.5 cm
Courtesy of Marina Abramović Archives
and Lisson Gallery, London

Study for Rhythm 0, 1974
Ink marker on paper
10.3 × 13 cm
Courtesy of Marina Abramović Archives
and Lisson Gallery, London

Study for Lips of Thomas, 1975
Colored pencil on paper
18 × 14.4 cm
Courtesy of Marina Abramović Archives
and Lisson Gallery, London

Study for Lips of Thomas, 1975
Colored pencil on paper
18 × 14.2 cm
Courtesy of Marina Abramović Archives
and Lisson Gallery, London

Archival Material

The exhibition includes a considerable
amount of documentary material.
Photographs, notebooks, and other items
have been generously lent by the Marina
Abramović Archives.

There will be slight variations in the selection
of works between venues. Please contact each
institution for a specific list of works included.

IMAGES

For the works on display in the exhibition, see Works.

Ulay/Marina Abramović
The Citroën Van, Art Vital (Detour), 1977
Photograph (b/w)
Courtesy of Marina Abramović Archives
[p. 10]

Ulay/Marina Abramović
The Brink, 1979
Performance at the 3rd Biennale of Sydney
4:30 hours
Courtesy of Marina Abramović Archives
[p. 12]

The Abramović Method, 2015
Courtesy of Bienal de Performance BP.15
[p. 14]

The Life and Death of Marina Abramović, 2011
Theater performance by Bob Wilson at the
Manchester International Festival
Courtesy of Marina Abramović Archives
[p. 27]

As One, 2016
Seven minutes of silence, Athens
Courtesy of NEON and MAI
[p. 30]

Practicing the Abramović Method, 2015
Terra Communal, SESC, São Paulo
Courtesy of MAI
[p. 31]

Emanuel Swedenborg
The Dream Diary (Drömboken), 1743–44
Courtesy of the Collection of the National
Library of Sweden
[p. 254]

Preparatory notebook sketch for
Inner Sky, 1990
Ink on paper
Courtesy of Marina Abramović Archives
[p. 257]

Emanuel Swedenborg
*The Principia: Or, the First Principles of
Natural Things (Principia rerum naturalium)*,
Dresden & Leipzig, 1734
Collection of the National Library of Sweden
[p. 258]

*The Kitchen I: the Levitation of
Saint Teresa*, 2009
Color, fine art pigment print
Courtesy of Marina Abramović Archives
[p. 259]

AUTHORS

Tine Colstrup is curator at Louisiana Museum of Modern Art in Humlebæk, Denmark, and works across the field of modernism and contemporary art. She has recently been Louisiana's curator of *Hilma af Klint—A Pioneer of Abstraction* and *Louise Bourgeois. Structures of Existence: The Cells,* and curated an exhibition on *Paula Modersohn-Becker.*

Lena Essling is curator at Moderna Museet, where she has realized exhibitions like *Adrián Villar Rojas: Fantasma*; *Cindy Sherman: Untitled Horrors*; *Eija-Liisa Ahtila: Parallel Worlds*; and *Tabaimo.* She has produced commissions or screenings with artists including Harun Farocki, Natalia Almada, Yinka Shonibare, Omer Fast and Wael Shawky. At the 56th Venice Biennale 2015, she curated the Swedish participation of Lina Selander.

Adrian Heathfield is a writer and curator working across the scenes of live art, performance, and dance. He is the author of *Out of Now,* a monograph on the artist Tehching Hsieh, and editor of *Perform, Repeat, Record* and *Live: Art and Performance.* He will curate the Taiwan Pavilion at the 57th Venice Biennale 2017. Heathfield is professor of performance and visual culture at the University of Roehampton, London. www.adrianheathfield.net

Bojana Pejić is an art historian, living in Berlin since 1991. She was curator at the Student Cultural Center of Belgrade University, and has been guest professor at the Humboldt University, Berlin, the Institute for Cultural Studies at the University of Oldenburg, and the Central European University, Budapest. She was chief curator of the touring exhibitions *After the Wall: Art and Culture in Post-Communist Europe*, and *Gender Check*. She recently curated *Good Girls_ Memory, Desire, Power* and co-curated *HERO MOTHER: Contemporary Art by Post-Communist Women Rethinking Heroism.*

Devin Zuber is an associate professor for American studies, religion, and literature at the Graduate Theological Union in Berkeley, California. He has published widely on topics ranging from Don DeLillo and Walter Benjamin to Romantic ecocriticism. A monograph, *The Language of Things: Swedenborg and American Environmental Imaginaries,* is forthcoming.

ACKNOWLEDGMENTS

Marina Abramović would like to thank:
Daniel Birnbaum, Lena Essling, Poul Erik Tøjner, Tine Colstrup, Rein Wolfs, Bernard Spies, Susanne Kleine, Olga Krzeszowiec Malmsten, Katarina Swanström, Catrin Lundqvist, Ulf Eriksson, Teresa Hahr, Maria Therming, Ulrik Staal Strange Dinesen, Giuliano Argenziano, Polly Mukai-Heidt, Cathy Koutsavlis, Lynsey Peisinger, Paula Garcia, Allison Brainard, Hugo Huerta Marin, Ulay, Nicholas Logsdail, Claus Robenhagen, Greg Hilty, Alex Logsdail, Sean and Mary Kelly, Cecile Panzieri, Lauren Kelly, Lia Rumma, Paola Potena, Luciana Brito, Guy Bartschi, Barth Pralong, Ursula Krinzinger, Kim Brandstrup, Marit Gillespie

Moderna Museet would like to thank the following for their generous support in connection with the performance of Marina Abramović at the Skeppsholmen Church, realized in collaboration with Eric Ericson International Choral Centre:
Lena and Per Josefsson, Pontus Bonnier and Åke Bonnier, Oscar Engelbert, Johannes Falk, Paul McCabe

Moderna Museet would also like to extend a special thanks to all involved in live performance in the exhibition and at the Skeppsholmen Church.

PHOTO CREDITS

This book is published in conjunction with the exhibition *Marina Abramović—The Cleaner*

The exhibition is organized by Moderna Museet, Stockholm, in collaboration with Louisiana Museum of Modern Art, Humlebæk and Bundeskunsthalle, Bonn. Curators: Lena Essling, Moderna Museet, with Tine Colstrup, Louisiana Museum of Modern Art, and Susanne Kleine, Bundeskunsthalle.

Moderna Museet, Stockholm
February 18–May 21, 2017

Louisiana Museum of Modern Art, Humlebæk
June 17–October 22, 2017

Bundeskunsthalle, Bonn
April 20–August 12, 2018

Exhibition

Moderna Museet

Curator
Lena Essling

Curator, program
Catrin Lundqvist

Exhibition assistant
Olga Krzeszowiec Malmsten

Exhibition coordinator
Desirée Blomberg

Conservator
Thérèse Lilliegren

Technicians supervised by
Fredrik Andersson

Exhibition architects
Calle Jägnefält, Gustav A Toftgaard
Jägnefält Milton

The exhibition at Moderna Museet
is supported by

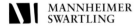

MANNHEIMER
SWARTLING

Panasonic BUSINESS

Louisiana Museum of Modern Art

Curator
Tine Colstrup

Curatorial coordinator / Registrar
Maria Therming

Conservator / Exhibiton producer
Ulrik Staal Strange Dinesen

Kunst- und Austellungshalle der Bundesrepublik Deutschland GmbH / Bundeskunsthalle

Director
Rein Wolfs

Managing director
Bernhard Spies

Curator
Susanne Kleine

The exhibition at Bundeskunsthalle
is supported by

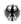 Die Beauftragte der Bundesregierung
für Kultur und Medien

Catalog

Editor
Lena Essling

Managing editor
Teresa Hahr

Picture editor
Guy Engström

Copyediting
Irene Schaudies

Translations
Glen Garner (Colstrup, from Danish)
Saskia Vogel (Essling, from Swedish)

Graphic design
Miko McGinty and Rita Jules
in collaboration with Hugo Huerta Marin

Typesetting
Tina Henderson

Production
Ines Sutter, Hatje Cantz

Typefaces
Fakt and Plak

Paper
LuxoArt Samt, 150 g / m^2

Reproductions and printing
Longo AG, Bolzano

Binding
Gruppo Padovana, Padua (PD)

© 2017 Moderna Museet, Stockholm; Hatje Cantz Verlag, Berlin, and authors

© 2017 for the reproduced works by Marina Abramović and Ulay: VG Bild-Kunst, Bonn, the artists, and their legal successors

Moderna Museet exhibition catalog no. 394
ISBN 978-91-86243-82-1 (Moderna Museet)

Published by
Hatje Cantz Verlag GmbH
Mommsenstrasse 27
10629 Berlin
Tel. +49 30 3464678-00
Fax +49 30 3464678-29
www.hatjecantz.de
A Ganske Publishing Group company

Hatje Cantz books are available internationally at selected bookstores. For more information about our distribution partners, please visit our website at www.hatjecantz.com.

ISBN 978-3-7757-4261-0 (English)
ISBN 978-3-7757-4262-7 (German)
ISBN 978-3-7757-4263-4 (Swedish)

www.modernamuseet.se
www.louisiana.dk
www.bundeskunsthalle.de

Printed in Italy

Front cover:
The Cleaner, 2010
Photo: Marco Anelli

Back cover:
The Hero, 2001
Photo: TheMahler.com